GLOBALIZING ART

GLOBALIZING ART

*Negotiating Place, Identity and Nation
in Contemporary Nordic Art*

With a Postscript by John Tomlinson

Edited by Bodil Marie Stavning Thomsen
& Kristin Ørjasæter

Acta Jutlandica
Humanities Series

 Aarhus University Press

Globalizing Art
Acta Jutlandica. Humanities Series 2011/8
© The authors and Aarhus University Press 2011
Cover design: Jørgen Sparre
Cover illustration: © Michael Elmgreen & Ingar Dragset/billedkunst.dk. *Plass til fler –
 Tid til mer (2005)*
Type setting: Grafisk SIGNS
Type: Arno Pro
Printed at Narayana Press, Gylling
Printed in Denmark 2011

ISSN 0065-1354 (Acta Jutlandica)
ISSN 0901-0556 (Humanities Series 8)
ISBN 9788779345720

Aarhus University Press
Aarhus
Langelandsgade 177
8200 Aarhus N

Copenhagen
Tuborgvej 164
2400 Copenhagen NV

www.unipress.dk
Fax 89 42 53 80

International distributors:
Gazelle Book Services Ltd.
White Cross Mills
Hightown, Lancaster, LA1 4XS
United Kingdom
www.gazellebookservices.co.uk

The David Brown Book Company
Box 511
Oakville, CT 06779
USA
www.oxbowbooks.com

Published with the financial support of The Aarhus University Research Foundation, The
Nordic Council, The Learned Society in Aarhus, Letterstedtska föreningen and the Norwegian
University of Science and Technology.

GLOBALIZING ART
Negotiating Place, Identity and Nation
in Contemporary Nordic Art

Established identity categories under transformation

New types of transnational communities and social relations

Postscript

Introduction

By Camilla Møhring Reestorff, Carsten Stage, Bodil Marie Stavning Thomsen, and Kristin Ørjasæter

The so-called Cartoon Crisis that followed the publication of twelve drawings of the Muslim prophet Mohammed in the Danish newspaper *Jyllands-Posten* in September 2005 clearly showed how local affairs could quickly turn into global news and again affect local matters. Domestic integration politics had been put forward ahead of this event to protect Danish culture and traditions within the context of the nation-state. However, the debate that followed the unexpectedly strong actions taken in primarily Middle Eastern countries was a major wake-up call to the effects of globalization, and since then legislation on global migration as well as discussions about what belongs to or characterises Danish identity in terms of art and culture as well as democratic institutions and history have been some of the key issues defining the Danish political climate. The public debate on whether the responses to the situation (demonstrations, the burning of Danish flags, and arson attacks on Nordic embassies) were caused by political disregard of Islamic groups or staged by Islamic religious communities in Denmark is not of primary concern for the contributions to this book. These chapters are far more interested in describing how cultural globalization, as exemplified by the crisis and its repercussions, effectively initiated an awareness of a global gaze (Lull 2007) 'outside' a national or regional (Nordic) self-understanding, which has subsequently changed the approach of various cultural and artistic manifestations towards a global orientation and transnational relations.

It is quite noteworthy that the Norwegian and Swedish knock-on effects of the Danish crisis had a different impact on the domestic policy of these countries that was not of the same magnitude as that in Denmark. A Norwegian cartoonist directly commented on the Danish cartoon crisis in June 2008 by drawing a partly naked suicide bomber wearing only a turban and a t-shirt with the inscription 'I am Mohammed and nobody dares to print me'.

The drawing was printed in *Adresseavisen*, based in Trondheim, and according to this local paper the cartoonist was taken by surprise when this caused a reaction from the Islamic Council in Norway. Yet this incident did not affect the general political climate in Norway as strongly as the Cartoon Crisis did in Denmark. The Swedish cartoon incident created by artist Lars Vilks in July 2006, when his drawings of Mohammed as a dog were printed in the Swedish newspaper *Nerikes Allehanda*, based in Örebro, caused only some reverberations in the art exhibition world. At first Vilks' Mohammed-dog drawing was simply left out of a few planned exhibitions due to fear of repercussions. Later, however, the controversies have escalated into almost the same proportions as in Denmark. Regardless of the different impacts on domestic politics, these drawings and the responses to them caused the Nordic public to concede to the fact that global, immediate transmission of news often influences local cultures directly, and thus that the region cannot be thought of as self-contained.

The fact that a local manifestation like a cartoon in a newspaper can turn into an object of global interest has in recent years resulted in several works of art with which contemporary artists seek both a broader audience and a new platform for renegotiating culture. These artworks are characterised by an awareness of the global impact on national identity and culture, namely that the places and spaces we inhabit are deterritorialized and not naturally inherited by birth, spoken language, or cultural background. Since the Nordic region in recent years has been designated as a rather successful and coherent region on the Northern hemisphere, we – the inhabitants – increasingly have to question the possible cultural contents in new global contexts; these questions are to a great extent raised by contemporary art.

This book sets out to offer documentation and analysis of how the impacts of globalization are registered and responded to within various contemporary media and art forms in the Nordic countries. The featured articles all contend that contemporary Nordic artists play an important part in the abovementioned reflections by challenging established ways of thinking about local, national, and Nordic identities but also by imagining new types of communities. The different academic contributions to the book cover a wide range of artistic practices and media types by authors with a profound knowledge of Nordic art. This framing was chosen to emphasise that global political issues and media forms are reflected and even incorporated in material art practices, that thus intentionally or unintentionally often become politically involved and culturally productive for the creation of new transnational or global communities. However, using the

Nordic countries as an analytical starting point does not mean that we perceive them as a coherent unit. Instead 'Nordic', in this context, signifies a discursive construction of a community, and our point of investigation is transnational in the sense that we analyse how the intertwining of the national, regional, and global are negotiated in contemporary artistic practice.

Nordicness as a construction

The term 'Nordic' is throughout this book used within a discursive perspective, implying that its meaning is constructed through cultural negotiations and therefore always in transformation. However we are well aware that it is often used as some kind of entity with historical roots closely connected to the emergence of the term 'Scandinavian'. It might be possible to argue that the idea of some kind of 'Nordicness' was initiated with the Kalmar-Union, a political union of Denmark, Norway, and Sweden that existed between 1397 and 1523. Centuries later, in the latter half of the 18th century, the idea of the Nordic countries as a community was established within an academic context at a gathering in London of scientists from Denmark, Norway, and Sweden. They communicated without language problems and they decided that it was unnecessary to translate scientific material from English to more than one of their languages. Thus 'Scandinavia' can be referred to as a community idea built on the concept that Denmark, Norway, and Sweden are culturally so closely related that they might be one community, partly because of their related languages, partly because of a territorial notion of being part of the same neighbourhood. In the 19th century political approaches aimed at developing better transportation links between these three countries were dominant. Likewise the currency systems and the postal services were improved in order to ease communication and transportation of goods across the borders. The national customs were obstacles to this exchange, however, until the 1950s when it became possible to cross the borders without a passport.

After World War I, Iceland and Finland became part of the attempts to direct the Nordic societies with similar laws and systems. The Nordic Union (Foreningen Norden) increased cooperation between the Nordic countries. And in The League of Nations (later the UN) the Nordic governments cooperated and represented each other at the meetings. The Nordic cooperation continued in international assemblies as well as in Nordic ones throughout the 20th century. In 1952 The Nordic Council was founded, which includes Denmark, The Faroe

Islands, Finland, Greenland, Iceland, Norway, Sweden, and Åland. To this day the Council still initiates development of the laws in the different countries in order to ease the transportation of people, goods, and ideas. It also initiates and funds economic, cultural, and educational cooperation.

In this book we acknowledge that the term 'Nordic' designates historically strong relations between the countries involved. But it is important to keep in mind that the term is a cultural and political construction. When using the term 'Nordic' we thus refer to a constructed community idea that holds several national imagined communities (Anderson 1983) and has a regional character. Furthermore it is important to stress that despite the fact that it is a politically convenient construction, the term 'Nordic' cannot be *reduced* to this. However, the construction of the 'Nordic' community has, over time, actually resulted in a variety of political, economical, social, and cultural collaborations that have lead to a structural and regional connectivity in the region that affects a variety of political, economical, social, and cultural conditions in the countries involved. As the construction of Nordic collaborations has been an ongoing process throughout history, the de- and reconstruction of the term 'Nordic' is also an ongoing process influenced by political, economic, and cultural change.

Art as intervention and cultural production

The contemporary art scene in the Nordic countries gives the general impression that Nordic artists seem to embrace and reflect on the new conditions of global connectivity rather than fight them. One of the first artistic political manifestations to reach an unexpectedly large media public through the Internet and global news system was the art installation "Snow White and the Madness of Truth" by Gunilla and Dror Feiler, which was exhibited in Stockholm's National Antiquities Museum in January 2004, accompanied by Bach's cantata "My Heart Swims in Blood". It 'featured a boat floating in a pool of red liquid with a photo of the Palestinian suicide bomber Hanadi Jaradat attached to the mast as if forming the sail of a little toy boat on a pool of blood' (http://www.artcrimes.net/snow-white-and-madness-truth). On the opening day it was attacked by the Israeli ambassador in Sweden, Zvi Mazel, who interpreted is as 'sympathetic to the terrorism against Israel' (ibid.). This caused a diplomatic crisis between Sweden and Israel. The artists who expounded their artwork as a statement 'against violence' were taken by surprise, just like the cartoonists in Denmark and Norway, by the impact of media intervention. Even though

this art and media event did not have the long-term effects of, for instance *The Satanic Verses* by Salman Rushdie it clearly demonstrated how 'global processes involving mobile texts and migrant audiences' can 'create implosive events that fold global pressures into small, already politicized arenas, producing locality in new, globalized ways' (Appadurai 1996: 9).

During the last decade a variety of Nordic artworks have investigated the mechanisms of globalization by creating performative and interactive events of all sorts. Many of these interventions have been presented in new, globally distributed media or have made use of the convergence of media in the new network societies. An example of a globally oriented and activist aesthetic practice is *The Democracy Project* by the Danish artist Claus Beck-Nielsen, who, mocks, among other things, the notion of democracy as something that can simply be carried across borders. In this yet unfinished artwork documented in Danish newspaper articles, a webpage (http://www.dasbeckwerk.com/), books, CDs, various performances, exhibitions, and lectures it has become evident that the conditions of politically reflexive aesthetic practices are changing. Claus Beck-Nielsen simply looks beyond the established aesthetic venues. He has given up his name and personal identity in favour of the art group Das Beckwerk that has no attachment to a body and no national civil identification number. Thus questions of what constitute identities whether national, sexual, or civil as well as negotiations of new, ethically engaged boundaries in global politics and culture become central in the art production of Das Beckwerk. Its transnational activities have in the Nordic region been contrasted by aesthetic practices, which reflect the concepts of 'home' and 'locality'. In the so-called *Håkki* art project by artists Tomas Eriksson, Mats Stenslet, and Bjørn Kowalski Hansen, the figure of Håkki is set to express local values and belonging to a local place in a globalized world. The figure of Håkki is nevertheless a constructed entity (incarnated by Tomas Eriksson) that mainly appears on the webpage www.haakki.com. The name of the figure emerged from the rather denigrating idea of a hockey haircut associated with rural Swedish provinces. A local acoustic image of hockey would be spelled 'håkki' in Swedish, Norwegian, and Danish and this name has been taken as a trademark to brand the local values of living in the small town of Ljungawerk in Ånge Municipality, Västernorrland County, Sweden.

The Håkki art project and the projects of Das Beckwerk will be further elaborated on in two articles of this book. The main issue in most of the artistic discourses analysed in the book's collection of articles is to localise the gaze in

connection with global events, as is also indicated by Norwegian poet Inger Elisabeth Hansen in *Trask* (2003). The importance of positioning a voice and considering what a local point of view might mean is common to all the art projects presented. They all more or less reflect the transformation of local lifeworlds due to media technologies intertwining global events with everyday life. Electronic and digital media as well as the increase in travel and migration has challenged the idea of a local cultural homogeneity, which is at the core of traditional nationalistic notions of cultural and national identity. The internal cultural complexity of societies has, in other words, been rendered visible and therefore it motivates debates concerning the nature of local cultural values. In this way globalization fuels an ongoing process of negotiating Norwegian, Danish, Swedish, Finnish, Icelandic, Faroese, and Greenlandic national cultures and a common understanding of a specific Nordic culture.

Contemporary art is not only intervening in the social structure and the political sphere in increasingly direct ways. Art production also seems to be the object of intensified interest in contemporary debates concerning domestic policy in relation to local identity, integration, and cultural security. From 2004 onwards the Danish government, lead by the liberal party (Venstre) and the conservative party (De Konservative), initiated a hotly debated canonisation project. Its aim was to construct or define certain lists of cultural artefacts (literature, visual arts, architecture, film, etc.) that were considered to be cornerstones in the legacy of Danish identity and culture. This canonisation project can be regarded as an example of how the government and its supporting party, The Danish People's Party (Dansk Folkeparti), wish to strengthen the idea of a common national culture as a 'safeguard against globalization' – a formulation used by the Minister of Culture at the time, Brian Mikkelsen (see Reestorff 2007-2011).

Defining globalization

The term 'globalization' of course needs to be defined and explained. When discussing globalization in this book we refer to the empirical fact that exchanges of money, people, information, goods, and images across national and regional borders are increasing compared to earlier stages in the process of modernisation (Appadurai 1996, Tomlinson 1999, Held et al. 2000). The movements or 'flows' of different symbolic forms, objects, and subjects simply transcend national borders with an unprecedented intensity. This social condition char-

acterised by the rapid enhancement of transnational interconnections is called 'complex connectivity' by John Tomlinson and can be seen as the climax of a modernisation process that has been underway since the 18th century. It is nevertheless not as much the *existence* of exchanges and interconnections, but rather their contemporary *quantity* and *intensity*, which makes it appropriate to talk about globalization as a new cultural and sociological situation. Earlier exchanges across borders were simply not as regular, relatively cost free, and ingrained in human existence as it is the case in the developed societies of late modernity. In this perspective 'globalization' is a historical term describing a certain phase in the modernisation process, which began approximately in the 1980s and gained strength in the 1990s and the beginning of the 21st century.

The complex connectivity of globalization first of all changes the role of places and territories because of their incapacity to confine or enclose cultural processes. Living on a national territory in other words no longer defines what cultural impulses a human being can expect to meet; cultural identities are less and less entangled with specific territories. Different localities are connected globally through media, which enables each individual to choose, find, consume, and interpret cultural impulses more independently. Media technologies play an extremely important role in globalization processes by 1) saturating the local with external impulses and experiences; 2) creating the potential for global awareness in relation to certain events; 3) enabling locals to transact and create social relations to other 'distant locals'; and 4) making locality itself available for external inspection. Looking at globalization from a media perspective the ability to disseminate information, pictures, and news stories across vast distances through media is of course not something that is entirely new (Thompson 1995, Appadurai 1996, Jansson 2004, McNair 2006, Silverstone 2007, Lull 2007). As John B. Thompson explains, postal systems were an integral part even of the Roman Empire. It was nevertheless not until the 19th century and the beginning of the 20th century that communication was regularly and effectively played out on a global scale. The development of the telegraph and underwater cables in the 19th century enabled communication across the Atlantic with no or very little time delay. News agencies were also founded in the 19th century, which divided the world between them, making it possible to receive news from the other side of the world within an acceptable time frame. Last but not least, the spread of electromagnetic communication in the first half of the 20th century (e.g. radio and TV) made it even easier to communicate effectively across substantial distances (Thompson 1995).

The dissemination of satellite and digital communication technologies especially during the last decades of the 20th century is a landmark in the globalization process because it allows for an extreme amount of simultaneity in transnational human interactions and relations. The growth of the Internet in the late 1990s, for example, made it possible to create well-functioning online communities without any direct face-to-face communality among the users. Satellite-based news broadcasting also changed the idea of what a news event is: from something that *has happened* into something that is *happening right now* (McNair 2006). If something extremely dramatic is going on, we expect that we will be able to watch it as it happens. Brian McNair furthermore stresses that transnational news channels like CNN, Sky News, and BBC World make it possible to create a global public of viewers watching the same event at the same time. Formulated boldly, global media networks hence motivate an interesting shift in the modernisation process by substituting a logic of progress, development, and change with a logic of immediacy. Or with the words of Appadurai: 'globalization introduces spatiality, simultaneity, horizontality into a kind of sequential, temporal, vertical developmental impulse' (Rantanen 2006: 11). Globalization as a term simply addresses a new kind of modernity based on liveness and immediacy, not on moving forward or being more effective. As an example, only the immediacy of commercial interaction and the simultaneity of local reactions to fluctuations in exchange rates can explain the sudden collapse of the global economy that happened in late 2008. Although media technologies are extremely important, other technological and infrastructural developments must also be mentioned. The effectiveness and affordability of airline transportation, the introduction of high-speed trains, and the general improvement of infrastructure across large parts of the world are just a few examples of requisites that facilitate the flows of global modernity.

These larger systemic technological developments change local life by offering new ways of experiencing the distant in relation to the local. When the distant is routinely accessible through the media or cheap air flights, the meaning of geographical distance simply changes (Tomlinson 1999). Tomlinson makes a useful distinction between *connectivity*, which is an empirical fact (exchanges across national borders are increasing), *proximity*, which is a metaphor for a certain way of experiencing the distant as not-so-distant, and *accessibility*, which is the factor that changes how the distant is perceived. As an example, the status of the city of Berlin has changed in the last few years – at least from a Danish point of view. It is possible to travel to Berlin from quite a few towns

in Denmark for only 25 euros. The accessibility of the town creates a feeling of proximity, which furthermore amplifies connectivity, because people are more inclined to visit the city. The affordability of the city of Berlin has recently made it one of the main 'Nordic' contemporary art colonies. Several artists who had their professional training in Denmark, Finland, Iceland, Norway, or Sweden, live and have their studios in Berlin.

But does connectivity always create a feeling of proximity? This question leads us to an important clarification. Globalization depends of course on new improved technologies of transportation and communication and the improvement of infrastructure, but these technologies do not determine how the cultural processes of globalization will proceed. Perceiving distant events in a certain region 'as they happen' can also make the distant seem strange and motivate feelings of incongruity and otherness. Thus we are not advocating a sort of technological determinism, equating technology with proximity, responsibility, and homogenization. Technology is not necessarily going to make everything seem accessible or intimate. The various trajectories of the cartoon crisis in the Nordic countries powerfully illustrate that connectivity, proximity, and accessibility are not inherently connected and do not form straightforward causal links between each other.

The effects of globalization are not only changing the potential for physical movement; they also alter local ways of acting and thinking. They simply create a new horizon for local actions, which can be identified in e.g. contemporary ways of consuming in more sustainable ways. Phenomena such as fair-trade consumption and climate friendly or CO_2 reducing cooking only make sense if we acknowledge that consumers are increasingly acting with an awareness of the globe as a unity and are generally showing that they are alert to the fact that local actions can have global consequences. Globalization changes the way we evaluate the reasonableness of local actions and therefore it also motivates new ways of acting that are more sustainable and globally responsible. What we argue in this book is that the rising local awareness of global interconnectedness also motivates new aesthetic practices, which therefore must be described within a new theoretical and analytical horizon. We simply cannot grasp properly what is going on in many contemporary Nordic artworks without taking globalization and its dimensions into consideration. The articles in this anthology all attempt to do just that.

Cultural deterritorialization/reterritorialization

It is quite common to describe globalization as having three dimensions: economic, political, and cultural. Although these dimensions always overlap and intertwine they can be useful as a way of explaining different areas where the rise of complex connectivity can be traced. Starting with the economic dimension, we are experiencing the consequences of global connectivity in a very tangible way today due to the global economic crisis; companies, banks, and private households share problems across borders because of the interrelatedness of what used to be self-contained economies. Economies can no longer be understood as national entities, but must be described as connected dots in a global economy. Political globalization manifests itself in the creation of transnational political institutions, which implies that political sovereignty is not exclusively linked to the national territory. From a cultural perspective one can examine how globalization has consequences for symbolic production, community building, and identity construction. Tomlinson describes the aim of a cultural approach to globalization in the following way:

> [...] what we are concerned with is how globalization alters the context of meaning construction: how it affects people's sense of identity, the experience of place and of the self in relation to place, how it impacts on the shared understandings, values, desires, myths, hopes and fears that have developed around locally situated life. (Tomlinson 1999: 20)

The artworks described in this book are concerned with how the larger systemic changes creating global connectivity affect people's understanding/construction of places, identities, and communities. In other words, we investigate how globalization motivates new ways of thinking about locality, established identity categories, and new communities in contemporary Nordic art.

According to Appadurai, the contemporary motors of cultural change are the mediated movements of information and of people through travelling and immigration – both on a global scale. In theories about globalization there is nevertheless strong dissent on how one should characterise the overall cultural consequences of globalization. Is the world slowly becoming one homogeneous society? If so, what characterises this society? Or is the world rather becoming a battleground for differing cultures? It is possible to identify at least four different positions describing the cultural consequences of the

abovementioned global interconnectedness (see Stage 2009 and Reestorff and Stage 2010).

The first is presented by Marshall McLuhan, who in *Understanding Media* (1964) for instance, stresses that globalization creates a global village, which implies that the exchanges across national and regional borders will motivate a process of cultural homogenisation, in which people around the globe build more intimate relationships with one another (McLuhan 1987: 5). A second position underlines how the increase in transnational interconnections most of all creates a 'clash of civilization', as described by Samuel Huntington (Huntington 1996). A third position can be found in Benjamin Barber's *McWorld vs. Jihad* (1995) and Michael Hardt and Antonio Negri's *Empire* (2000). Despite their differences in theoretical and philosophical preferences, both Barber and Hardt/ Negri focus on how globalization spreads values and logics of capitalism (Barber 1995, Hardt and Negri 2000). Globalization therefore equals cultural imperialism. Theories describing globalization in this way often use the term 'globalism', referring to the idea that globalization is really all about ideologically empowering capitalism and Western countries. These narratives of globalization all have some truth in them, but neither the concept of 'the global village', nor 'the clash of civilizations', nor 'cultural imperialism' describes the overall cultural processes of globalization in a sufficiently nuanced way. Our approach will therefore be based on a fourth position, which describes globalization as creating a range of both deterritorializing and reterritorializing cultural dynamics. This position is represented by Tomlinson, Appadurai, and Roland Robertson, among others.

The concept of deterritorialization basically describes the relative independence of culture from place/territory as a key consequence of globalization: '[A] central defining characteristic of deterritorialization is the weakening or dissolution of the connection between everyday lived culture and territorial location', as Tomlinson states (Tomlinson 1999: 128). Place of residence is no longer a clear indication of where you were born, what language(s) you speak, what religion (if any) you believe in, and which media platforms you use. Of course, the link between culture and territory has never been complete and uncontested, but the illusion of homogeneity used to be easier to uphold because everybody looked more alike, talked the same language, and watched the same TV programmes. The concept of deterritorialization can be used to describe the ways in which the cultural dynamics of territories are changing because of the evident destabilisation of the culture/place relation and the territorial co-existence of different cultural groups.

19

Nor will this increasing separation of culture from place ever be complete, because the human experience is bodily embedded and therefore closely linked to places and the other human beings who live in those places. Most people still spend the majority of their lives – at least for long periods – in the same place. From this perspective, the construction of common ideas, rituals, and understandings will always develop through place-related interactions and thus maintain a certain phenomenological anchoring of cultural processes. A dimension of this anchoring is the creation of ideas of the 'homely' and 'homely spaces'. In this way, deterritorialization and reterritorialization co-exist. According to Tomlinson the interplay allows for reterritorialization to exist as 'the numerous, small, routine ways in which individual human subjects attempt […] to make themselves "at home" in the world of global modernity' (Tomlinson 1999: 148-149). The consequences of globalization are thus negotiated in the interplay between deterritorialization and reterritorialization. The tension between the experience of a destabilised connection between culture and place and different attempts to make places homely for some, thereby excluding others, thus describes the basic cultural dynamics of globalization. Hence globalization not only affirms the severing of any stable tie between culture and territory, it can also be traced in, for example, a nostalgic interest in local/national authenticity and distinctiveness.

For that reason, the term 'globalization' has recently been criticised for creating inaccurate connotations, implying an irreversible movement from locality to a unitary globe. This is obviously not true, since the increase in interconnections and interdependences does not mean the end of locality. Sometimes globalization even creates an increased awareness of the local, since it also involves 'the reconstruction, in a sense the production, of "home", "community" and "locality"' (Robertson 1995: 30). Ulrich Beck therefore suggests that we ought to replace the term 'globalization' with 'cosmopolitanization' in order to stress that the creation of global networks and relations are unconsciously creating a new way of thinking about the world when framing local actions (Rantanen 2005: 249). Ulf Hannerz furthermore describes a rising tendency among commentators to think the consequences of globalization in terms of a 'spontaneous, everyday, banal cosmopolitanism' (Rantanen 2007: 25). As early as 1995, Roland Robertson used the neologism 'glocalization' as a term that does not presuppose a discourse of delocalised homogenisation, but describes global movement as intrinsically connected to local contexts.

In this book we choose to make use of the term 'globalization' because the notion of cosmopolitanism has some unfortunate connotations. First of all,

the everyday use of the word refers historically to an elite travelling between metropolises. This is unfortunate since it excludes the notion that these global processes actually transform the localities and affect all inhabitants, including the majority for whom the metropolitan lifestyle and travelling are not accessible. Secondly, 'cosmopolitanism' often entails a naïve assumption of the end of the local, that is, it disregards the processes of reterritorialization. For the same reason we have not highlighted the concept of 'postnationalism' (Appadurai 1996, Hauge 2003) because it seems to proclaim the death of the nation while the patient is still breathing. Nationalism is without doubt in a state of crisis because contemporary cultural dynamics do not respect the idea of culturally homogeneous communities inhabiting enclosed territories. But whether this crisis will lead to the *end* of the idea of the nation or rather to new *rearticulations* of nationalism is still difficult to predict. In other words, the crisis of nationalism is for now best understood and investigated by using an analytical approach, which examines both the ways culture and place are increasingly pulled apart, and how ideas of culture/place relations are produced. This approach ensures a focus on the ongoing detectable processes, instead of installing a temporal perspective that makes conclusions about an unpredictable future (cf. the 'postness' of nationalism).

Furthermore, 'globalization' has become the most widely used concept for the sociological processes that we see reflected in contemporary Nordic artworks in this book. We follow Appadurai, who acknowledges the problem with the term 'globalization' by stressing that its flaw is that 'it suggests that the world was never connected before'. We nevertheless still use it to describe 'a type of interactivity among regions, nations, societies, identified with the last three decades of the 20th century, and of course the first decade of this century, and especially connected with new media, with the net, but also with other macro factors' (Rantanen 2006: 8).

Finally, we would like to point at a different way of using the concepts of deterritorialization and reterritorialization that is relevant to some of the articles in this book. While the definition suggested by Tomlinson is used to describe cultural transgressions and the construction of homeliness, Gilles Deleuze and Félix Guattari defined them first in a different and more flexible way. In their *Mille Plateaux* (1980), the usage of the terms deterritorialization and reterritorialization covers a broader range of description, meaning destabilisation/ stabilisation, deformation/formation, transgression/dwelling, moving/staying, etc. in the workings of art, culture, and politics alike. So these concepts can also

be fruitful in analysing the micro-processes of aesthetic practices exploring the technological possibilities of new media. Thus we argue that de- and reterritorializations can also take the form of translocal negotiations of the global media situation in, for example, film and video works that comment on, or are remediated reactions to, the expanding digital image-production.

The articles: investigating place, identity, and transnationalism

Following these theoretical reflections, the main aim of this book is to investigate how contemporary Nordic artists participate in the investigation of the processes of deterritorialization and reterritorialization. The concept 'Nordic' is, as mentioned, used in a pragmatic way to designate a discursive construction. The articles in the book therefore are not primarily focused on the Nordic as a cultural category; it is not the idea of a common Nordic culture or identity that interests us. The primary reason for addressing aesthetic practices in Nordic countries is that we wish to transgress the perspective of the self-sufficient nation-state and instead analyse how globalization is negotiated aesthetically across different local contexts. In choosing the Nordic countries as a pragmatic point of departure, our analyses and perspectives become multi-contextual and more concentrated on aesthetic strategies and tendencies than the transformation of a singular national context. In other words, we are able to identify certain tendencies in the aesthetic responses to globalization across different contexts by using the Nordic countries as our field of investigation.

The first main claim of the book is that the investigation of globalization as a new social condition goes hand in hand with a transformation of the social role of art itself. By reflecting on globalization, art becomes culturally analytical in a very explicit way. The works of art analysed in this book were chosen because they were made by Nordic artists, but more importantly because they actively consider the effects and potentials of globalization. This leads us to the second main claim of the book: that the investigation of globalization in contemporary Nordic art follows three tendencies. These are all related to the overall logic of deterritorialization and reterritorialization, but they direct their attention towards different dimensions of the globalization process. The tendencies will of course often intersect, but we nevertheless want to argue that they can be approached as distinct trajectories that help us to qualify the understanding of contemporary aesthetic reflections on globalization in the

Nordic countries. These tendencies comprise an increasing aesthetic interest in:

- the construction of new, mediated glocal and translocal places
- established identity categories under transformation
- new types of transnational communities and social relations

These tendencies form the organizing principle for the presentation of the book's individual contributions in the following.

The construction of new, mediated glocal and translocal places

The main interest of the first tendency, the construction of new, mediated glocal and translocal places, is to deterritorialize the conception of local places in order to renegotiate its distinctiveness in a global context or, by way of media intervention, to experiment with the way time and space have been distributed so far. This aesthetic practice uses various forms of performative displacements and stratifications of particular places. It can also take the characteristics of media as its starting point and thus create new forms of translocal time-spaces in various constellations of disparate or displaced images.

Ulla Angkjær Jørgensen presents one such project. In her article "Håkki TM at Home: the Remediation of a Local Place" she examines the collaborative art project Håkki TM, which apparently is defending local values of style and behaviour in the remote town Ljungaverk in Sweden in opposition to alienating global processes. It does so through a performance of a masculine character, Håkki, complete with a Swedish haircut, Volvo, and attitudes. But as this 'average' guy is staged with all kinds of masculine traits from popular culture, the local place of Ljungaverk that he incarnates can thus be seen as the quintessence of 'local community'. Through analysing the project's production of postcards and videos, as well as the other effects of the Håkki trademark in local culture, Jørgensen discusses the mediation of the local. By relating Nicolas Bourriaud's use of the Marxian term 'interstice' (non-profit inter-subjective exchanges) to Scott Lash and Celia Lury's description of contemporary global culture industry and branding she concludes that Håkki's mediation of the local is a creative negotiation with the terms of globalization: the de- and reterritorializing trading of the project create a reinvented locality that is virtual and real at the same time. It is

delocalised, i.e. the 'natural' relationship between culture and socio-geographical territory is questioned.

In "The Deterritorialization of Film", John Sundholm explores possible constructions of translocal places. He studies three Finnish artists' film and video works in order to outline various forms of 'translocal ambiguities' in the contemporary art practices of the moving image: 1. Sami van Ingen's re-edited version of an amateur footage, in which the image is altered from the inside; 2. Eija-Liisa Ahtila's short film stories on ambivalent identity production within shifting spaces, in which the significance of the cut is expanded and thus accentuated; 3. Pekka Niskanen's video-work on the fusion and complex hybridity of physical spaces, places, and identities in which image-framing is perpetually prevented by split screens and other techniques. In accordance with D.N. Rodowick's diagnosis of the electronic video image as 'discontinous, fluctuating and pointillist' (Rodowick 2007: 138), Sundholm concludes that the contemporary moving image is both ubiquitous and not assigned to classical conceptions of time and space – and thus deterritorialized. So even though the silent film from its start was able to 'disconnect culture from territory' and thus mark the ephemeral attraction of modernity as a flux of time and memory, the potential of the digital image of globalization is that it can create events and translocal connectivity. This might take place within the procedures of the spatial simultaneity of real-time interfaces, but it might just as well happen within the strategies of de- and reterritorialization of cinematic space, which can be explored on the contemporary art scene.

Likewise, Bodil Marie Stavning Thomsen discusses how translocal places can be constructed within photographic media. In "Spatializing Time", she explains how the indexicality of photography can be replaced by allegorical creations of time-spatial connections. With Walter Benjamin's analysis of artistic practice in the age of (modern) reproduction, revised by Boris Groys' exposition of the (postmodern) relationship between original and copy as a point of departure, Thomsen addresses the contemporary art practice of the documentation of life. The Danish artist Søren Lose, a photographer working mainly from Berlin, has brought found footage and new photographic versions of the same subjects together in various installations. The new constellations of slightly offset time-images manifest 'time passing by', and the allegorical dislocations of space created interfere with the indexical status of photography. In these renegotiated time-spaces alternative narratives and memories (of, for instance, Danish national identity) can take place. These allegorical 'installa-

tions might open for a productive, political engagement discovering the ways in which spaces and places are constantly being de- and reterritorialized'. As an effect of the allegorical creation of time-space, history may be retold, creating new deterritorialized understandings of the far-reaching impact of space in time.

In their collaborative article "The Body As 'The Place of a Passage'", Ulla Angkjær Jørgensen and Bodil Marie Stavning Thomsen explore how Olafur Eliasson engages people by creating alternative perceptions of time and space, thus establishing translocal connections on a global scale. In his Berlin studio, where he employs 30 artists, architects, and scientists, Eliasson has established a creative space for numerous experiments with light, ice, and water. In framing the art practice of Eliasson's study within a theoretical line of thought from Henri Bergson via Deleuze and Brian Massumi, Jørgensen and Thomsen argue that the common trait of the exhibitions *The Weather Project* and LAVALAND and the book *The Goose Lake Trail* is the deconstruction of 'the relational world of the western body and mind'. This is effected by making bodies engage directly with space, just as we encounter light, water, and weather conditions in nature. The creation of 'movement-vision' allows no space for a view at a distance, Jørgensen and Thomsen argue. By making this condition linger, Eliasson's art installations supply the experiencing mind-body with a potential access into the hyper-complexity of globalization, in which interfaces rather than reflective distances between an object (artwork) and its representation are produced. They conclude by stating that Eliasson's creation of 'spatial time' within singular perceiving experiences of individual bodies holds the potential for a deterritorialization of art that embraces a reterritorialization of a body-mind connection in a globalized nature-culture.

Established identity categories under transformation

An increasing aesthetic interest in the transformation of established identity categories (national and regional) generated by globalization processes has also become evident. In this type of artwork, the limitations and problems of cultural imaginaries and their character of (discriminating) social construction are underlined. The core questions are related to different symbolic ways of distinguishing 'us' and 'them'. Questions about who 'we' are in relation to 'the others', and whether or not 'we' do exist as an entity, are asked in creative ways that might even suggest alternative definitions of identities and communities.

The authors of this book agree that national identity is a construct made up by mythical narratives, implemented on symbolic artefacts. Lotte Philipsen demonstrates how this process works in "Nordic Jaywalking in Contemporary Visual Art". In order to understand how the Nordic has been put to work, she investigates the globalized art institutional framework in the form of the 2009 Venice biennial. In her analysis of the location of the different Nordic pavilions at the biennial, Philipsen establishes a connection between the institution of art, curating practices, and the specific artworks. She explains how art is defined on a national level even in a glocal site like the biennial, a renowned global showcase of art. Her analytical focus is the joint venture between the Nordic and Danish pavilions in exhibiting *The Collectors*, which contained works by several different artists, provided by the Danish-Norwegian curator couple Michael Elmgreen and Ingar Dragset. This exhibition could be seen as a negotiation of the given conditions for exhibiting art. It authorises 'multiple authorship' (Groys 2008) amongst other things by centering on differences and similarities between private collections and art collections, and by highlighting the dissemination of objects as well as artefacts. Philipsen concludes that the 'complex cultural space of the idea of "Nordic art" is constituted by multiple authorship and institutional and discursive site specificity' in a contemporary, global art world.

Well-established identity categories under transformation are also the subject of Eva Zetterman's inquiry into why contemporary Nordic artists address the process of globalization through a renegotiation of national identity. In "Crossing Visual Borders of Representation", Zetterman examines the impact of Nordic landscape paintings on the formations of national identities. In the late 1990s, the Swedish photographer Annica Karlsson Rixon shot a series of photographs in California called "Portraits in Nordic Light". The photographs in the series paraphrase canonised Nordic National-Romantic paintings. By comparing the National-Romantic motifs from the late 19th century with the new photographic versions, where localities as well as the sex and skin colour of human subjects are altered or reversed, Zetterman illustrates how Karlsson Rixon's photographic series is able to question vital aspects of national narratives. Zetterman argues that '[t]he constructed character of light and water representing a 'Nordic' geographic territory becomes apparent and the myth of these visual elements as site-specific 'Nordic' is revealed'. Zetterman reaches this conclusion through investigating the shift of media (from painting to photography) and the remediation of the meaning of 'light' within the two media forms.

Carsten Stage also contributes to the discussion of the transformation of established identity categories. 'Nationalism is bound to create problems in an era when migration and flows of people are increasing', he states in his article "Beyond Predatory Nationalism". Since nationalism traditionally unites people within a community by excluding others from the same community, it holds a significant strategic role in the discussion of the global flow of culture and people. To highlight the complexity of the different strategies at stake, Stage discusses nationalism as a Janus-faced discourse and analyses several artistic approaches to disintegrating or reformulating Danish national identity. The art performances and productions of HuskMitNavn (a pseudonym, meaning 'Remember My Name'), Superflex, Ellen Nyman, and Lise Harlev are among the many examples of projects that Stage analyses in his argument. Throughout this analysis, Stage outlines various forms of criticism of an exclusive reproduction of nationalistic identities, suggesting that even the widespread slightly altered reproductions of, for instance, Danishness within the global flow of art and mediated information might have a discursive impact on identity formations.

Christian Refsum focuses on linguistic practices in his contribution to the study of the aesthetic transformation of established identity categories. In his article "Multilingualism in Contemporary Nordic Literature" he considers how the notion of multilingualism could be used to reflect on questions of politics and identity raised in relation to transcultural literary expressions. Examining the Swedish author Jonas Hassan Khemiri's two novels *Ett öga rött* (2003) and *Montecore. En unik tiger* (2006), Refsum argues that multilingualism is, if not a new motif, at least a new multiethnolect style in Scandinavian literature responding to the ongoing deterritorialization of languages. In his analysis Refsum point out the numerous ways in which Khemiri's multiethnolect mixing of Swedish, French, Arab, and English allows him to underline how easily an individual can be excluded from sharing and possessing a language (and thus understanding the so-called 'public opinion'). When, on the other hand, this kind of 'minority' literature 'becomes a means of pushing and exploring the borders of literary language' within the 'majority' literature of a nation, new 'hybrid' forms of world literature and culture can inspire 'newness in the world', in Homi Bhabha's sense. Refsum concludes his analysis of Khemiri's deliberate defamiliarisation of the Swedish language with the suggestion that multilingualism might also be viewed as an ongoing anglification of language and literature.

Lill-Ann Körber contributes to the study of artistic transformation of identity with the article "Figurations of the Hybrid. Julie Edel Hardenberg's Visions for a Post-Postcolonial Greenland". She examines the particular relations of the local and the global, and identity and space, in the postcolonial context of contemporary Greenland. In her book *The Quiet Diversity*, nominated for the Nordic Council's literature prize in 2006, Greenlandic artist Julie Edel Hardenberg intervenes in her country's nation building process by presenting diversity and hybridity as a phenomena that can have cultural, political, and aesthetic implications. Körber argues that this kind of intervention strategy might generate potential answers to existential issues in a part of the world where the global and the colonial still overlap. Moreover, the sheer existence of Greenland as part of the Danish Kingdom as presented in *The Quiet Diversity* challenges the imagined community and homogeneity of the Nordic countries in terms of kinship, language, and territory.

In his contribution "Emotional Landscapes: The Construction of Place in Björk's Music and Music Videos", Mathias Bonde Korsgaard focuses on the relation between popular music and place in globalization. Korsgaard expands on the notion that our understandings of popular music are informed by our understandings of place and vice-versa by showing how the global cycles of popular music involve a sense of both spatial fixity and fluidity, as he explores how the Icelandic singer Björk attempts to construct a specifically Icelandic popular musical identity in her music and music videos. Here, Björk persistently negotiates what it means to be Icelandic in the face of globalization. She does so by way of interweaving markers of an Icelandic identity with impulses from other local musical cultures and from the global repertoire of popular music, leading to a complexly hybridized, composite musical identity. In using different reterritorializing strategies to relate music to place, Björk is able to instill her particular brand of global popular music with a distinctively Icelandic 'otherness' while at the same time taking the deterritorializing forces of globalization and digital media technology into account. Björk's music and music videos often seem to revolve around the traditional dichotomy between nature and technology; by deconstructing this apparent dichotomy and interlocking the two into the same continuum, she succeeds in shaping a popular musical identity that is arguably both global and Icelandic at the same time.

New types of transnational communities and social relations

In several contemporary art practices we identify a transnational interest, i.e. art that participates in negotiations and constructions of new, less territorially bound communities, territories, and social relations. Here the experience of deterritorialization marks a 'point of no return', transforming the old national communities into anachronisms. Globalization is approached as an epochal shift creating new social conditions, problems, and possibilities. A key question could be: where do we go from here? In other words, the main interest seems to be the new spaces of experience and action made possible in a globalized situation. The main themes are the opportunities for transnational interaction, the interconnections between distanced localities, the compression of time and space, and also the ethical and political problems raised by the mediated access to distant catastrophes and suffering people (cf. Boltanski 1999, Silverstone 2007).

This aesthetic practice is at the heart of Kristin Ørjasæter's article "Art, Aid and Negotiated Identity". With postcolonial theory on the production of cultural differences as her point of departure, Ørjasæter studies how Kristian von Hornsleth repeats the Western discourse on Africa with a slight, though very important, performative difference in his photographic display of village people from Uganda. In displaying this local, black community holding identity cards that prove that they all have taken the name Hornsleth in exchange for the ownership of a living pig (the most widespread animal living in Denmark), the artist deliberately exhibited how exploitation in aid programmes works. The photographs that document the project were put on display in an exhibition and a book, *Hornsleth Village Project Uganda 2007. We want to help you, but we want to own you*, causing fierce reactions among the Danish media and art establishment. The domestic audience blamed the artists for the exact same kind of exploitation that the project wanted to point out. It is Ørjasæter's main point to demonstrate that even if cultural globalization allows for a broad knowledge of different cultures, power structures are not necessarily altered. But in the case of Hornsleth's provocative art and media events, an important discursive space is opened for the articulation of the fact that discrimination is taking place in the eyes of the beholder. Leaning on Gayatri Chakravorty Spivak (1999), Ørjasæter asks what it takes to make the audience look for the voices of the participating subalterns.

New types of transnational communities and social relations are also at stake in artist Adel Abadin's work, Anita Seppä concludes in her article "Na-

tional Identity Goes Queer with Adel Abadin". Seppä analyses the reception and possible impact of various parodic identity performances by Abadin, who emigrated from Iraq to Finland in 2000. In a blatant and outspoken style Abadin performs his own difficulties in attuning to the Finnish language and identity. The visitors of art galleries, where the videos are displayed, cannot escape the feeling that the sense of 'Orientalism' and of national belonging is produced in the eyes of the beholder in witnessing the awkward or 'queer' imitation of the Finnish language and identity production. The question raised in this article in relation to the deterritorialized performance of Otherness within a globalized nation-state is whether or not Abadin's performances are strong enough to inspire what Appadurai has named 'new neighborhoods' and 'deterritorialized ethnolandscapes'. Towards the end of the article, in presenting Abadin's video installation *Baghdad Travels* (2007), which was presented in the Finnish pavilion of the Venice biennale, Seppä notes that the deliberate mix of information about beautiful places and their destruction reveals the interrelationship between war and tourist discourses in a somewhat grotesque manner. Yet this fusion of conflicting discourses about Abadin's lost native territory might allow the articulation of former incommunicable abysses of real losses as well as an awareness of the constructed nature of all claims to national 'essential' values.

The question of how to build new types of transnational communities and social relations is also discussed by Camilla Møhring Reestorff in "Band Attack – Deterritorializing Political Borders". Following Tomlinson, Reestorff states that contemporary art is provided 'with the opportunity to act in the arena of global political intervention and mark out a symbolic terrain of meaning construction'. However, in the ongoing renegotiation of national culture, the role of art is renegotiated too. Within contemporary politics voices against a 'cultural elite' (including artists interfering in politics) have been heard concurrent with the layout of a domestic identity formation though an artistic demarcation of 'Danishness'. Reestorff analyses how the performative practice of Das Beckwerk seeks to expand the field of art by interfering discursively in Danish domestic politics with (among other things) the album *Freedom of the March*. She studies the political potential of the artistic position of Some Body, the remarkable lead singer of the band who 'incarnates the paradoxical death of Claus Beck-Nielsen by being *somebody* and therefore not dead, yet *some body*, that is an amount of body', and Some Body's reproduction of the cultural utterances of politicians at war, such as George Bush, Jr. and Donald Rumsfeld. With emphasis on the cultural debate in Denmark, Reestorff outlines how all socially inscribed bodies

of Denmark are entangled in the war on Iraq. She concludes by discussing the potential of Das Beckwerk's performative intervention strategy of (re)shaping a political battle (war on terror) within an artistic model and thus (re)creating them as artistic events. This renders discourses visible and audible and paves the way for future negotiations of the discursive power of nation-states on the common grounds of identity formation within culture.

Works Cited

Andersen, Paal Bjelke (2003). "Intervju med Inger Elisabeth Hansen". Accessed July 7, 2003: www.nypoesi.net.

Anderson, Benedict [1983] (1991). *Imagined communities: Reflections on the Origin and Spread of Nationalism*. London and New York: Verso.

Appadurai, Arjun (1996). *Modernity at Large: Cultural Dimensions of Globalization*. Minneapolis and London: University of Minnesota Press.

Barber, Benjamin (1995). *Jihad vs. McWorld*. New York: Corgi Books.

Boltanski, Luc (1999). *Distant Suffering*. Cambridge: Cambridge University Press.

Hansen, Inger Elisabeth (2003). *Trask. Forflytninger i tidas skitne fylde*. Oslo: Aschehoug.

Hardt, Michael and Antonio Negri (2001). *Empire*. Cambridge, Massachusetts & London: Harvard University Press.

Hauge, Hans (2003). *Post-Danmark*. Copenhagen: Lindhardt & Ringhof.

Held, David, Anthony McGrew, David Goldblatt, and Jonathan Perraton (2000). "Globale transformationer – Politik, økonomi og kultur." In Mikkel Thorup (ed.): *Kosmopolitik*. Aarhus: Aarhus University Press.

Huntington, Samuel (2006). *Civilisationernes sammenstød?* Copenhagen: Informations Forlag.

Jansson, André (2004). *Globalisering – kommunikation og modernitet*. Lund: Studentlitteratur.

Lull, James (2007). *Culture-On-Demand*. Oxford: Blackwell.

McLuhan, Marshall (1987). *Understanding Media*. London: Ark Paperbacks.

McNair, Brian (2006). *Cultural Chaos. Journalism, news and power in a globalised world*. London: Routledge.

Rantanen, Terhi (2005). "Cosmopolitanization – now!: An interview with Ulrich Beck". *Global Media and Communication* 1:3, 247-263.

Rantanen, Terhi (2006). "A man behind scapes: An interview with Arjun Appadurai". *Global Media and Communication* 2:7, 7-19.

Rantanen, Terhi (2007). "A transnational cosmopolitan: An interview with Ulf Hannerz". *Global Media and Communication* 3:1, 11-27.

Reestorff, Camilla Møhring (2007). "Kulturpolitiske kanonkugler: Kulturkanonen og kulturens nationalstatslige forankring." *Kultur og Klasse* 104: 35. årgang, nr. 2. Copenhagen: Forlaget Medusa.

Reestorff, Camilla Møhring (2007-2011). *Kulturpolitisk kanon og kunstpolitisk praksis i den globaliserede nationalstat*. Ph.D. Dissertation project, Aarhus University (work in progress).

Reestorff, Camilla Møhring and Carsten Stage (2011). "Canons and Cartoons: On national identity, strategies of reterritorialization and the role of universality in the Danish cartoon initiative and canon projects." In *Confronting Universalities*. Aarhus: Aarhus University Press.

Robertson, Roland (1995). "Glocalization: Time-space and homogeneity-heterogeneity." In Mike Featherstone, Scott Lash, and Roland Robertson (eds.): *Global Modernities*. London: Sage.

Rodowick, D.N. (2007). T*he Virtual Life of Film*. Cambridge, Massachusetts & London: Harvard University Press.

Silverstone, Roger (2007). *Media and morality*. Cambridge: Polity Press.

Spivak, Gayatri Chakravorty (1999): *A Critique of Postcolonial Reason. Toward A History of the Vanishing Present*. Cambridge, Mass. & London: Harvard University Press.

Stage, Carsten (2009). *Et andet Danmark. Konstruktionen af national identitet i danske medier under tegningekrisen*. Ph.D dissertation. Aarhus University.

Thompson, John B. (1995). *The Media and Modernity. A Social Theory of the Media*. Stanford: Stanford University Press.

Tomlinson, John (1999). *Globalization and culture*. Oxford: Polity.

The construction of new, mediated glocal and translocal places

Håkki™ at Home:
the Remediation of a Local Place

By Ulla Angkjær Jørgensen

This essay discusses how the local is renegotiated in both a phenomenological and imaginary sense through an outside, globalized, tourist gaze. Using brand theory, an explanation will be given of how the existing town of Ljungaverk is being reinvented by global concepts of branding and design. [1] Through the performance of local identity in cyberspace a displacement of the local takes place and it is now possible to think of it in terms of an 'anywhere'. Local places may well be deterritorialized in the flow of global culture, but they are just as easily reterritorialized, as is the case with Ljungaverk, which has been reinvented through the lens of the Håkki art project (2001-). However, the artists behind the project, Tomas Eriksson, Mats Stenslet, and Bjørn Kowalski Hansen, began with a rather different assumption; they think of the local and the global in terms of oppositions. Håkki™ is built around the philanthropic idea of promoting 'the local', or rather, it questions what the local means, or if it even exists at all. On the project website *Welcome to Ljungaverk* it is introduced thus:

> Håkki™ is a project that uses business and art to question globalization and to preserve the cultural and local identity of a small town in northern Sweden. Ljungaverk is a town that has suffered some negative consequences of an increasingly globalized world and the majority of the people living there emigrated following the closing of the local factory plan in the late 1990s. Håkki™ is an interesting piece of social design that utilizes a traditional business approach, but because of its insisting on preserving a local focus also serves as an original artistic and social reinvention of community identity. (www.haakki.com)

The project clearly perceives globalization as something opposed to the local, a force with negative consequences for local communities. For the Håkki team, globalization means the homogenization of culture and economy and the

disastrous consequences of this for local communities. The project is deeply embedded in the global flow of cultural communication, though it sincerely wants not to be. It is itself an example of what Ronald Robertson calls *glocality*, meaning the local absorption of global culture and media in different ways (Robertson 1995). In global visual cultural forms such as webpages, stickers and flyers, T-shirt production, fashion catalogues, YouTube videos, etc., Ljungaverk is constructed as an imagined community, a place of belonging. Although Ljungaverk is an existing town, it is also presented as an imaginary place by the project. This mixture of the real and the imaginary also applies to the main character Håkki, the project's namesake, played by Eriksson. The Håkki figure acts as a catalyst for the 'artistic and social reinvention of community identity'. He is a construct like any other protagonist of a film, play, or novel, and is informed with a sketchy history, but he also has some of Eriksson in him. For instance, Håkki likes to go ice-skating, which is a favorite pastime of Eriksson and his friends during the frozen winter in Ljungaverk. There is a true mixing of art and life in the project.

Håkki's body

In 2001, the three artists invented a narrative about Håkki from Ljungaverk, inspired by Eriksson, who grew up there. According to this narrative, two Norwegians called Stenslet and Kowalski meet a Swedish man with a funny name on a trip to the Swedish border. He tells them stories from his hometown and has a fantastic 'hockey hair cut'. They name him Håkki, which is the phonetic transcription of 'hockey' into Swedish; in addition, hockey is the most popular sport in Sweden. Stenslet and Kowalski think Håkki has the potential to promote local communities and district policy, and as a salute to the mechanisms of celebrity culture they bring him back to Trondheim and use his character as a *brand*.

The opening picture of Håkki on the website is a slow motion video clip of him sitting in the middle of a stream eating a sausage. The sun is shining; he wears Ray Bans, shorts, and a smart denim waistcoat over his naked torso. At one point he caresses his leg and arm and in a mimetic act the camera zooms in on his face and upper body. The score to accompany the clip is Elvis Presley's "Take Another Little Piece Of My Heart". The lyrics do not mean anything in this particular context (as there is no love story in the Håkki narrative), but the song is used to place Håkki in a context of popular music and culture, and the

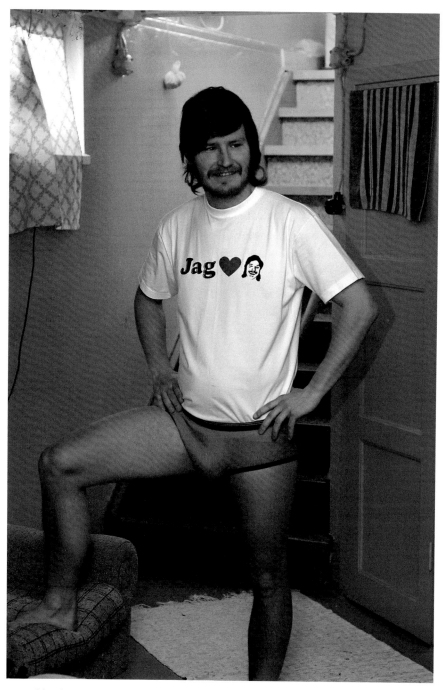

© Håkki™ by Tomas Eriksson, Mats Stenslet, Bjørn-Kowalski Hansen. Photo by Kim Ramberghaug.

lyrics may also be understood to underscore Håkki's devouring of the sausage. Everything is performed with self-reflection and humor, evident in the hackneyed nature of all that is said and done: the slow motion filming, the worn out clichés, the masculine love of self, and even the voice of Elvis repeating 'come on, come on, come on' one time too many. The art of copying with playfulness and style is a driving force in the project. Håkki is cast as a soft tough guy and a hillbilly. He is a simple character who is entertained by activities that are popular in non-urbanised communities far away from the theatre, the art museum, the cinema, and the amusement park. These people entertain themselves with games, sports, market days, car cruising, outdoor parties, story telling, and the like. In local communities social life unfolds at such events, and not in the foyer of the opera between acts. But Håkki also draws on the American youth culture that is circulated in the mass media and spread throughout the world. He is especially fond of car cruising and performing the self according to popular American masculine models; he self-performs as an adult who does not want to grow up. This stands out distinctly in the book (Hansen 2005), in which the special combination of the global popular and Northern Swedish culture comes into its own (Kellner 1995: 5).

The book about Håkki has the format of a lifestyle magazine, and the life of Håkki is presented as if it were in *Vogue*; even the setting of location has its media prehistory (Hansen 2005). Ljungaverk is staged in the matrix of David Lynch and Mark Frost's early 1990s television serial drama *Twin Peaks*, which is already a meta-level collection of clichés and media references. This is not only evident in the many location shots, but also comes through in a direct reference in a movie clip on the website. Ljungaverk is represented as a mock-up version of the *Twin Peaks'* intro with the exact same shots and soundtrack. The project revolves around Håkki's body and the styling of his body through indoor and outdoor posing in different places in Ljungaverk, and the marketing of the project's own brand T-shirts for which Håkki serves as a model.

In these settings the masculine love of self is displayed. Håkki is proud of his body, and unlike other comic male characters in mass media such as Frank Hvam in the Danish television series *Klovn* (Clown),[2] or other art projects like the Russian *Blue Noses Group*, and Danish artist Peter Land's *Pink Space* and *The Cellist* (Gade 2005), Håkki does not denigrate, or make a fool of masculinity, the male body, or male obsession with sexual drive; rather, he celebrates it. But these different projects do share a fondness of play with word and image in

vernacular speech, local slang, and popular imagery. Popular idioms and visual tags dominate Håkki T-shirts and accessories, and popular oral culture and provincial tales turn up in the stand-up Christmas shows[3] and in communication with young people, as when Håkki goes on a tour to local schools in the districts of Norway. In a lecture called "The Power of Glesbygd",[4] he promotes the idea that his audience, the schoolchildren, should be proud of where they come from.[5] On this occasion he makes heavy use of the powerful method of popular hyperbolic storytelling and bodily language in the Bakhtinian sense, only in this case there is no carnivalesque impetus for the performance (Bakhtin 1984). Håkki doesn't need to turn his world upside down in an act of ritualised and controlled rebellion. His world is perfect as it is.

Art and the brand

If popular culture constitutes the cultural framework of the project, art can be seen as the method or toolbox used to convey the message. Though the term has been much disputed, I choose to frame Håkki™ within the scope of relational aesthetics. According to Nicolas Bourriaud, who coined the term in 1998, the avant-garde of today is much less idealistic and teleological than it used to be. It does not produce visions of utopia on a grand scale; rather it experiments on a small scale with 'microtopias'. Though, today's art is still carrying on the fight indicated by Enlightenment philosophers, artists now produce perceptive, experimental, critical, and participatory models (Bourriaud 2002: 12). Bourriaud sums up the change in avant-garde practice as 'learning to inhabit the world in a better way' (ibid: 13). The dialectical mode of early and high modernist avant-garde art has been replaced by dialogically structured projects and the art institution is being used as one platform among many others for social exchange, e.g. Rirkrit Tiravanija's curry dinners.

The logic of these contemporary relational projects is to join in societal subsystems within e.g. science, economy, law, social services, mass media, cultural institutions, communication, and behavioural practices under which the art system itself is perceived as just another system among others. The structural intervening in systems makes way for an art that at its best makes alterations to the existing structure, rearranging the real. Though Bourriaud claims that relational projects are responses to social alienation, some hard line Marxist critics find his examples less convincing. The Radical Research Collective (RCRC) does not find that playing with "the existing real" and being content

with whatever comes out of that game suffices as a contemporary avant-garde of transformation. In fact, they believe that Bourriaud's examples of relational aesthetics '[represent] the 'liberalization' of the avant-garde project of radical transformation' (RCRC 2007: 2). His projects do not try to change the system of social relations that from their Marxian point of view means capitalism. However, the critical research collective accepts that Bourriaud has managed to articulate tendencies in contemporary art such as performativity, process, openness, social contexts, transitivity, and the production of dialogue under one name. This is also my main argument for bringing the notion of relational aesthetics into the Håkki context. The concept Bourriaud uses to describe the new avant-garde method is that of the 'interstice', a term he borrows from Marx:

> The *interstice* term was used by Karl Marx to describe trading communities that elude the capitalist economic context by being removed from the law of profit: barter, merchandising, autarkic types of production, etc. The interstice is a space in human relations, which fits more or less harmoniously and openly into the overall system, but suggests other trading possibilities than those in effect within this system. (Bourriaud 2002: 16)

It is significant that Bourriaud returns to Marx as he underlines the commercial situation of human communication. The interstice refers to an unmaterialistic situation within the materialist system. This non-profit exchange model is normal in non-monetary societies. Under these circumstances the social-symbolic exchange often takes precedence over the exchange of material value. It is the handling process of relations in human social exchanges that is the basis of Bourriaud's theory of the new art form. His general term 'relational aesthetics' covers the 'materialism of encounter' (with a loan from Louis Althusser), that points to the inter-subjective exchange as the fundamental feature of human life (ibid.: 18).

To some it may seem yesterday's news that the work of art instigates inter-subject relations. Bourriaud is often criticised for putting new wine in old bottles, but the radicalization of the participation of viewers as interactive producers more than engaged recipients is a fundamentally new feature of late modern art. Håkki™ exchanges actual products such as specially designed T-shirts and accessories for money, which then returns to Ljungaverk in the form of Free Hair Cut

Days, ping pong tables for the local youth club, and uniforms for the local girls' football team; it has also helped finance a local T-shirt production factory. The economic circuit is, however, a closed one, and the Håkki team is surely not in it for the accumulation of profit. Rather, their focus is on the production of social exchange, or in their own words, social design. The team has chosen the system of brand culture as their medium within which they create the project's own artistic platform. As a sponger the project has chosen its host, which it exploits for the benefit of its own artistic purpose. Today, brands have replaced companies' traditional market strategies. The brand unifies different products with the specific values, expressions, attitudes, and abstract attributes of a company. The brand creates an aura around the product; it creates experience; it communicates emotional values. According to Jesper Kunde any company who wants to succeed on the global market must build a strong brand religion, meaning a set of values: The Body Shop's brand religion is caring cosmetics, Harley-Davidson's is freedom, and Nike's is victory (Kunde 2000: 65). And we can now add that the brand religion of Håkki™ is the performativity of place.

In order to understand how brand culture works as part of global culture I shall turn to Scott Lash and Celia Lury. From their perspective, the brand is emblematic of global culture industry as opposed to commodity in classical culture industry, as described and criticised by Theodor Adorno and Max Horkheimer. It is their thesis that in global culture industry the brand is the mediation of things (Lash and Lury 2007: 4). The commodity is a single, fixed product, which determines its consumers; the brand does not. Unlike the commodity, the brand is a source of production; it is alive and it works through the production of difference, but it is in fact created on the basis of a range of commodities. Commodities are, obviously, still being sold and therefore classical culture industry is still at work, but the mediation of things is a new cultural product developed over the past three decades, the brand being one such cultural product. The brand is a collective manifestation for a number of goods. But branding can also take the shape of a physical environment, for example, in the designing of a soundscape for a shoe store. In this case, branding creates a concrete environmental sense experience, a feeling even, for customers. These experiences will all be different as each experience is a function of the combination of subject, moment, and other criteria. In the production of experiences, brands trigger the imagination of consumers and make them participate in cultural production:

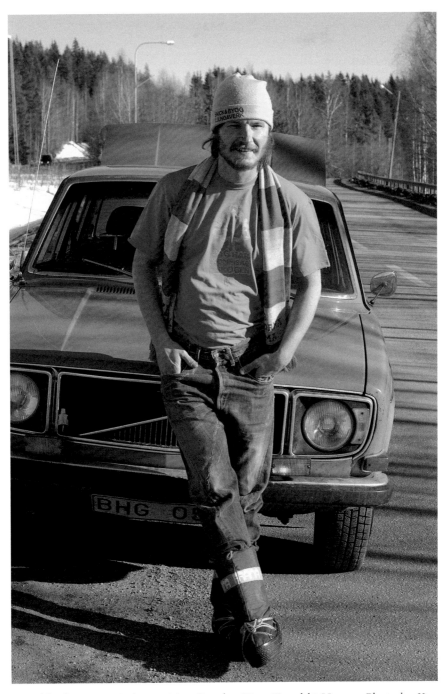

© Håkki™ by Tomas Eriksson, Mats Stenslet, Bjørn-Kowalski Hansen. Photo by Kim Ramberghaug.

[...] cultural entities [e.g. brands] spin out of the control of their makers: in their circulation they move and change through transposition and translation, transformation and transmogrification. [... they] take on a dynamic of their own; *in this movement*, value is added. In global culture industry, products move as much through accident as through design, as much by virtue of their unintended consequences as through planned design or intention. (Lash and Lury 2007: 5)

At the end of the day, the brand is, of course, supposed to market goods for sale and is therefore an instrument for capitalist reproduction. However, the social and cultural impact of brands is obviously difficult to control. One main tenet of much of contemporary culture theory is that today's consumers, as well as art viewers and audiences, are the main producers of cultural imagination. And as in the case of the art audience, the consumer is now also seen to enjoy aesthetic pleasure.

In view of the fact that cultural production is thought of as taking place outside the cultural object itself, and that even commodities can bring about cultural imagination, different cultural spheres of reception converge. Arjun Appadurai finds that the organising principle of modern consumption is one of the aesthetic of ephemerality (Appadurai 1996: 83). Consumers are disciplined to enjoy the pleasures of the transient: in the short life of products, in fashion change, and in the transience of television products. As Appadurai states, an aura of periodisation hangs over both products and lifestyles in the imagery of mass media (ibid.: 84).

The aesthetic of ephemerality also applies to contemporary art experience: not only in the fact that art institutions increasingly seem to function as players on the scene of global culture industry, in the branding of art and museum experience, and in the commodification of art into marketable products, but also within art itself as contemporary art deploys multimedia. Seen from the horizon of art history, art is now seen to inhabit the age of the post-medium condition according to Rosalind Krauss, meaning that the specificity of one single medium, as was the credo of modernist art, is no longer valid (Krauss 1999: 32). The rationale behind this argument is that in the age of mass media art has moved beyond its former preoccupation with the medium, as now all kinds of media are embraced by art. Since the 1960s the spread of electronic mass media has influenced art and created works preoccupied with the transient aesthetic experience as for instance is the case with the international Fluxus-movement.

The focus on movement, moment, and exchange in art since the 1960s has also brought attention to the aesthetics of ephemerality. Furthermore, today's global production of cultural imagery through the mediation of electronic mass media and globally accessible products enhances the subjective and transient experience – and surely also the intensity of that experience. Håkki™ questions whether the classical critique in the modernist sense of the term is still possible. First, as a promoter of art outside the art institution and infiltrated in a system (culture industry) that would have compromised the modernist work of art, second, as the user of that same system in order to initiate cultural production at a global level. This deterritorialization at the level of the artwork takes place as new global economic, political, and cultural modi operandi increasingly confront the elevated isolation of the modern Western art institution, and as new audiences join in.

Designing place – redesigning the North

Håkki™ seems at first to answer the question of place in the time of deterritorialization by what appears to be the reclaimation of a lost, initial locality. In the project's own words, it means to bring forth what is essential about local community culture, and at the same time it wants to question globalization by combining business and art, as mentioned above. Yet what I have put forward so far is that art today and business are both subjugated to globalization, meaning that neither can be regarded as objective tools 'free' of global market influences. Furthermore, the worldwide dissemination of culture does not mean the homogenization of all cultures into one big melting pot; globalization is not to be understood as the antithesis to locality and a threat to local communities, rather it provokes the 'reconstruction and in a sense the production of "home", "community"' and "locality"', according to Robertson (Robertson 1995: 30). Håkki™ seems to be such a case in point. What I believe the project to be objecting to, unwittingly perhaps, is the construction and controlling of all kinds of borders by the nation-state. Håkki™ promotes the feeling of local community in what I see as a reformulation of the North through an outside gaze. It is an example of the production of locality in a world that has become deterritorialized. For, as much as Ljungaverk is a specific geographical place in Northern Sweden, its neighbourhood with its masculine love of cars and the display of identity through fashion design and media references will also prove well known to many around the globe. Tomlinson prefers the term 'deterrito-

rialization' to 'dis-placement' and 'delocalization' as he finds it more inclusive. As he leans against Garcia Canclini he stresses that the term includes the loss of a 'natural' relationship between culture and socio-geographical territory (Tomlinson 1999: 106-7). However, the deterritorialization of culture does not mean that people stop living local lives. They may still be at home in their locality, which may prove to be of a somewhat 'phantasmagoric' nature as foreign features, such as the shopping mall, are placed there. Still, this does not alienate people, who are perfectly capable of feeling at home in a shopping mall, though the phenomenon is not homegrown, so to speak:

> So the experience of 'displacement' in modernity is not one of alienation, but one of ambivalence. People 'own' their local places phenomenologically in a sort of *provisional* sense, recognizing, at some level, the absent forces, which structure this ownership. [...] It is important to stress this ambivalence and therefore to distinguish the condition of deterritorialization from the claim that global modernity, in its massifying, centralizing moment, is *destructive* of real localities. (Tomlinson 1999: 107-8)

We are able to grasp the cultural conditions of globalization with the term 'deterritorialization' as situations of foreign influence penetrating the local without losing the sense of locality. It means that the level of cultural experience is global, but that the place it is lived in is local; it is an inevitable consequence of global modernity. This is opposed to influential theories on modernity that have stressed the elements of displacement and alienation in modernity's processes for decades. Media and communications technologies, especially television and the internet with features such as Facebook, Twitter, and YouTube, are increasingly helping to deterritorialize our daily experiences, as they lift us out of our discrete localities and open up our lives to a larger world (ibid.: 180).

Just as Håkki™ is a case in point for the argument of deterritorialization, it is also an example of its reaction: reterritorialization. Global modernity with its manifold foreign cultural influences seems to compel reterritorialization. In many different ways and circumstances people seems to try to make themselves 'at home' by re-establishing 'invented homelands' (ibid.: 148-49). The question of belonging in global modernity has its counterpart in business and markets as well. In using the trademark sign, Håkki™ enters the global market arena. The trademark identifies something as so-called intellectual property, like copyright. It is used worldwide as a distinctive sign, or indicator, to verify

to consumers that a product, or service, originates from a unique source. The trademark refers to its source by way of the icon, as it is typically a name, word, phrase, logo, symbol, design, image, or a combination of these, contrary to copyright, which by index refers to the authorised original. These are markers for the global market; however, they are subject to different national legislation. The copyright is discrete and fixed in a medium, whereas the trademark is not necessarily fixed in one specific medium, but can cover a range of products and services.

Both the trademark and copyright indicate ownership to cultural products by its producers; copyright's relation is one of authentic identity between product and place of origin whereas the trademark could be said to respond to the deterritorializing/reterritorializing order of things. Interestingly, the question of product ownership has recently been challenged by the Swedish website The Pirate Bay,[6] which has claimed free ownership for users of any cultural item available on the internet. Had it not been put to an end by several national courts of law, this would have meant the unlimited dissemination of cultural products on the internet. These rulings confirm the status of the nation-state as the definitive authority in defining territory. Yet this status is constantly being challenged by mass migration and electronic mediation. As Appadurai claims, 'the nation-state relies for its legitimacy on the intensity of its meaningful presence in a continuous body of bounded territory' (Appadurai 1996: 189). Nation-states construct a 'natural' connection between territory and subject based on the myth of origin, and they manifest this relation repeatedly in museums, monuments, national holidays, capitals, and the like. Nation-states are based on the contradiction of creating a contiguous and homogeneous space of nationness, and of setting up distinct places and spaces of discipline and order across this homogeneous space for the surveillance and control of its boundaries.

These boundaries are, however, increasingly under threat from the creation of different *spatial* as well as *virtual neighbourhoods*, according to Appadurai (ibid.: 189). The combination of mass migration and electronic mass media has paved the way for delocalised community building: ways for displaced people to keep connected with the home they left behind as well as to join in a globally shared exchange of cultural communication. New forms of electronically mediated communication (especially computer-mediated) have helped in creating virtual neighbourhoods. These are transnational and not subject to traditional territorial boundaries and surveillance defined by the nation-state,

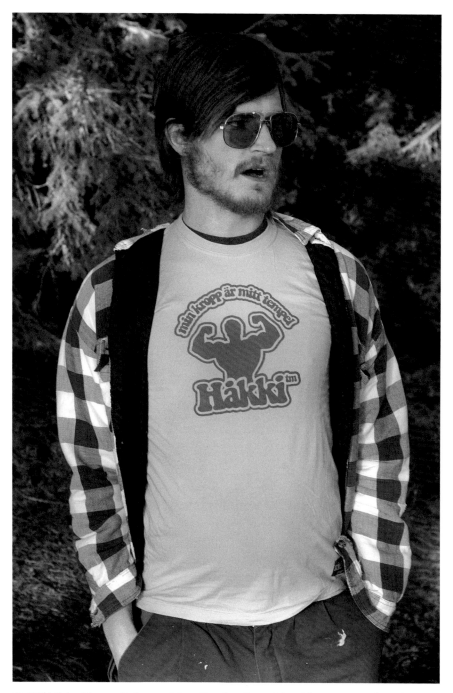

© Håkki™ by Tomas Eriksson, Mats Stenslet, Bjørn-Kowalski Hansen. Photo by Kim Ramberghaug.

such as passports, taxes, elections, and other political diacritics (ibid.: 195). Virtual neighbourhoods are the quintessence of the deterritorializing yet re-territorializing processes of contemporary global modernity. The most used internet platforms plus ordinary e-mail and websites as well as the blogosphere all help to keep global communication and exchange across national boundaries running.

In promoting the concept of local community and inviting everybody to join in, Håkki™ is an attempt to design a virtual neighbourhood. The narrative about Håkki and Ljungaverk brings together brand experience and neighbourhood feeling, making way for a worldwide movement of local constructions of the everyday. Håkki™ urges participants to love daily life and find peace in caring for their local communities. Through the mediation of internet platforms such as the project's website and YouTube videos and the booklet in the format of a fashion magazine, Håkki™ initiates the imaginary Ljungaverk. It is significant, though, that in spite of the global media platforms used, and the potential for creating a virtual neighbourhood, the general impression regarding the project is that the impact is very local, confined to the cult status of the Håkki figure among young people in Norway and Sweden. Still, the identity of Håkki and Ljungaverk is constructed through an outside global gaze, as the ways of global media and behaviour dictate the content.

Equally, there seems to be ambivalence in Håkki's production of Ljungaverk: the place is constructed both as the experience and love of the ordinary, and as a place with a distinct quality in postcard-like imagery characteristic of the *tourist gaze*.

In John Urry's definition, 'the tourist gaze is directed to features of landscape and townscape, which separates them from everyday experience' (Urry 2002: 3) and it is also engaged in 'identifying [a] place's actual and potential material and semiotic resources' (Urry 2001: 1). How can this be explained? On the one hand, the tourist gaze takes pleasure in the unfamiliar, the spectacular; on the other, it can also produce the familiar, or any ordinary place, as something worthy of desire. It is merely the gaze from without, and this explains why tourism scholars speak of 'everyday tourism'. It is the self-reflexive process of being able to look at your own world from the position of the other – and taking pleasure in what you see. During the 1990s the tourist gaze has become an integrated part of everyday life. It is everywhere: on TV, in advertising, and in our heads. We have learned to frame our local streets, plazas, and cafés in the schemata of a tourist's sight.

The tourism industry has, like so many other cultural phenomena, become globalized. The temporary movements of tourists across national borders have grown to become the largest ever 'migration' of people (Urry 2001). But these mass movements of real bodies are not the only providers of the tourist gaze. According to Urry, 'we can talk of the globalizing of the tourist gaze, as multiple gazes have become core to global culture sweeping up almost everywhere in their wake' (ibid.: 8). To put it bluntly, there is no way to escape the tourist gaze. Besides corporeal travelling, it has its virtual forms on the internet and its imaginative forms through phone, radio, and television, and corporeal travelling has only increased since the introduction of virtual and large scale imaginative travelling. Many powerful global brands now being associated with travel, leisure, and tourism have become an integrated part of lifestyle construction. Everywhere you turn, products are being associated with tourist destinations and being on the move, indicating that becoming a tourist destination means entering the global flow of communication.

In 2008, Håkki goes on a pilgrimage from Sundsvall in Sweden in his old Volvo Amazon along highway E14, following an old medieval pilgrim path to the cathedral in Trondheim.[7] He visits the small communities of Ljungaverk, Bräcke, Östersund, Åre, Meråker, and Stjørdal before finally arriving in Trondheim. His mission is to meet with people and discuss prejudices and old feuds between neighbouring towns, in order to make inhabitants take a critical look at their bad habits with help from his outside position. During the tour he produces postcards from every town to be sent across the world by viewers of the final show running at Trondheim Central Station during the summer of 2008. The ordinary small towns are represented in the format of a postcard; pictures of un-picturesque non-highlights are combined with statements of prejudice from the neighbouring towns printed on top as decorative bands. In a way these are anti-postcards, as the views displayed are shot in insignificant places on grey days. But as the postcard is such a strong cultural (de)sign, carrying with it undisputed connotations of beautiful and important sights, the mere use of the format signals the need for an outside gaze.

Eriksson plays the foreign tourist who comes to town with a fresh and positive look. He embodies the tourist's curious and desiring gaze that is capable of taking in anything new and unfamiliar as its object. And at the same time he uses the positive look to try to transform old and bad habits. In this way the traveller-artist becomes an operator of social reality, in this case one who wants to benefit of the community and make everybody feel good about themselves.

Conversely, in choosing the postcard format Eriksson makes use of a circuit of exchange that is different from Håkki™'s usual one. By using the snail-mail materiality of the traditional postcard as opposed to the virtual communication form of the internet, you would expect him to get hold of another audience, previously unfamiliar with the cult status of Håkki. The deployment of a wide range of media points to an actual awareness of different audiences and a true ambition to reach beyond the traditional art institution.

Where art meets the global popular

Though Håkki™ is in many ways an anti-modernity project, as it rejects city culture for the benefit of life in the provinces, it still embraces global modernity. Håkki™ is the reformulation of the North in the global eye as it skips all nation-state boundaries; its relation to Stockholm and Swedish national history on a grand scale is irrelevant. Instead, there is a direct connection between Håkki/ Ljungaverk and the world; on a national level no intermediaries such as the art institution, or any other kind of institution, are involved. Whenever the project gets close to linking the myth of origin with the articulation of place, this is immediately overturned by the massive presence of global culture mediations. In the deterritorialized global world Ljungaverk is reterritorialized through the mediated tourist gaze of the outsider that is thrown at the local community. In the many displays of Håkki's body, Ljungaverk is mapped out as a place of emotional investment. It is through the design and performativity of Håkki's body that the local is reinvented. In working through stylizations and reinstallations of copies such as Elvis Presley and *Twin Peaks*, Håkki™ appropriates Ljungaverk as its own special local context. So, to return to our introductory question: does the local exist? The project seems to answer both yes and no. No, if the local means some sort of untainted, original place. Yes, if the local means the performativity (meaning a self-reflective act) of local place. Håkki™ shows how local subjects re-construct the local according to their own ideas and needs through global modernity.

In her discussion of relational aesthetics, Claire Bishop (Bishop 2004) is critical of Bourriaud's promise of democracy in relational art. His claim that the structural open-endedness of these works in itself makes them democratic is, to her mind, nonsense. She emphasises that Bourriaud's microtopia cannot be seen as a reliable model for democracy. The microtopia is merely a space where members identify with each other. True democracy, by contrast, is

characterised by sustained conflicts, or antagonism. The happy togetherness that also seems to distinguish Håkki™ does not reflect on social relations, rather it creates them. Nonetheless, it is possible to argue that Håkki™ produces antagonism within a greater democratic community and therefore still has the potential for subversive small-scale change. Its subversive potential lies in its direct communication with users by urging them to take part in the reformulation of their local community, the fact that it addresses groups beyond the conventional museum-going public, and also its independence from any institutional accreditation or backup. Håkki™ is a brand concept that may generate infinite numbers of new projects for the sake of a good cause. With its focus on both playfulness and aspirations to change, the project seems to be a strange hybrid of popular culture and avant-garde strategy. In the age of the post-medium condition, art itself has been turned into a medium for the playful reformulation of local place.

Works Cited

Appadurai, Arjun (1996). *Modernity at Large. Cultural Dimensions of Globalization*. Minneapolis: University of Minnesota Press.

Bakhtin, Mikhail M. (1984). *Rabelais and His World*. Bloomington: Indiana University Press.

Bishop, Claire (2004). "Antagonism and Relational Aesthetics." *OCTOBER*, 110: 51-79. Massachusetts Institute of Technology.

Bourriaud, Nicolas [1998] (2002). *Relational Aesthetics*. Dijon: Les presses du réel.

Gade, Rune (2005). *Kønnet i kroppen i kunsten. Selvfremstillinger i samtidskunsten*. Copenhagen: Informations Forlag.

Hansen, Bjørn-Kowalski (ed.) (2005). *Håkki TM*. Published by Håkki TM.

Kellner, Douglas (1995). *Media Culture: Cultural Studies, Identity, and Politics between the Modern and the Postmodern*. London: Routledge.

Krauss, Rosalind (1999). *'A Voyage on the North Sea': Art in the Age of the Post-Medium Condition*. London: Thames and Hudson.

Kunde, Jesper (2000). *Corporate Religion*. London: Financial Times, Prentice Hall.

Lash, Scott and Celia Lury (2007). *Global Culture Industry*. Cambridge: Polity Press.

Radical Culture Research Collective (RCRC) (2007). *A Very Short Critique of Relational Aesthetics*. Accessed February 9, 2011: http://transform.eipcp.net/correspondence/1196340894/print.

Robertson, Ronald (1995). "Glocalization: Time-Space and Homogeneity-Heterogeneity." In Mike Featherstone et al. (eds.): *Global Modernities*. London: Sage Publications.

The Håkki Project. Accessed February 9, 2011: http://www.haakki.com/.

The Pilgrim project. Accessed February 9, 2011: http://www.romforkunst.no/prosjekt/pilgrim/.

Tomlinson, John (1999). *Globalization and Culture*. Cambridge: Polity Press.

Urry, John [1990] (2002). *The Tourist Gaze*. London: Sage Publications.

Urry, John (2001). *Globalising the Tourist Gaze*. Accessed August 7 2009:
http://www.comp.lancs.ac.uk/sociology/papers/Urry-Globalising-the-Tourist-Gaze.pdf.

Notes

1 Ljungaverk is a small town situated in the woodlands of Norrland, Sweden, approximately 400 km north of Stockholm.

2 The Danish channel TV2 Zulu.

3 Performed at Teaterhuset Avant Garden in Trondheim December 2006 and 2007.

4 *Glesbygd* is Norwegian for 'rural areas'.

5 In spring 2008 he toured as part of a government sponsored initiative in order to promote cultural events to schoolchildren in the outskirts of Norway called Den Kulturelle Skolesekken (The Cultural School Bag).

6 www.piratebay.org is no longer accessible through Danish internet service providers due to a ruling of the Danish High Court on January 29, 2008.

7 http://www.romforkunst.no/prosjekt/pilgrim/, accessed February 9, 2011.

The Deterritorialization of Film

By John Sundholm

In 2002, critic, curator, and programmer Chris Dercon suggested that we have reached a breaking point for film and the moving image and that therefore Andre Bazin's seminal question for a philosophy of cinema, 'Qu'est-ce que le cinéma?', what is cinema?, should be substituted with 'Où est le cinéma?', where is cinema? (Dercon 2003).[1] In the same essay Dercon also provides an answer to his question, namely 'everywhere'. Of course cinema is not taking place everywhere, but nowadays the cinematic, that is, moving image culture, is taking place and space at so many different venues and locations that it has become futile to limit film and the moving image to its previous dominant places of appearance: the cinema theatre and the TV set.

Bazin's original aim was to establish an ontology for film, which he placed in the photographic image. Dercon in turn moves the ontology of the moving image from that of the image into a non-place, an 'everywhere', an act that is as problematic as Bazin's. Nevertheless, the issue that Dercon raises is of such magnitude that there is less reason to look for the ontology of the new situation, than to focus on – as in all profound interrogation – understanding the dimensions of the question. In the context of this book, however, the themes of the non-place of cinema and of de- and reterritorialization will be of special interest.[2] Thus, I will in a very general sense equate deterritorialization with cinema's non-place; cinema does not have to be restricted to a fixed place anymore and due to the transition to digital media moving image, aesthetics has become more focused on space than on time. Whereas cinema used to have a fixed place and the screen displayed various manipulations of time, today it is the other way around. When entering a gallery we do not know at first where to look, and once we have found the screens or monitors we are invited to experience different gestures rather than narratives. We are exposed to an audiovisual environment in which the common building block of the cinematic,

the shot, and its extension, the narrative, has been substituted with a multitude of cinematic events. Hence, the non-place of the moving image is not only a question of where film is taking place but also of how both medium and object have become increasingly displaced.

The question regarding the poetics and politics of the deterritorialization of film is one of the most urgent when it comes to current moving image culture. As I will show, Dercon's suggestive question is not only a meaningful way of dealing with the complicated amalgamation of discourses on globalization, but it is also indicative when it comes to the analysis of the aesthetics in current film, which are characterised by an increasing spatialisation. Moreover, the issue is of great importance regarding cultural analysis in general. Territory and nation have long been the common point of departures for cultural analysis that has fostered a 'methodological nationalism', to use a term coined by Ulrich Beck (Beck 2007). According to Beck, this methodological nationalism has led to a problematic and inappropriate binary, the use of either/or categories. Thus, another part of the objective of this chapter is to analyse contemporary Finnish artwork that shares the common trait of striving to overcome those dichotomies criticised by Beck.

Although the artists in question are all of Finnish origin they do not address 'Finnish questions', nor Finnish identity. Instead, their use of different material, films from the US or India, dialogue in different languages, and actors of different nationalities point implicitly to the standpoint that the space in which identity formation takes place is ambiguous – and furthermore, that the depiction of the process of identity should not be forced into an either/or standpoint. Thus there is congruence between the non-place of the medium and the non-place of identity. The displacement forces the themes and the objects to a borderland in which new articulations are negotiated. This is of course an inherent problem in the concept of identity as such, to be the same and different simultaneously. Hence, it is not Finnish identity that is under question, but how the issue is re-articulated by Finnish artists and agents.

Another dichotomy that haunts contemporary discussions of globalization is that of the local and the global. This has caused Beck to call for empirical glocal studies of culture as every global moment, in order to have true impact, has to include the local too (Beck 2000). Thus, Beck has suggested that the question is not so much of a dialectics between oppositional terms as one of a fundamental ambivalence, of being both local and global at the same time, of being able to have different affinities and identities. This ambivalence – and

displacement – Beck has coined as 'inclusive distinction', that is, a new mode in which different loyalties are possible simultaneously (ibid.: 51). Such a mode is not beyond boundaries in any utopian way, though; it is not a third way either, a synthesis or imaginary solution to a contradiction, but a question of an ambivalence that also creates new boundaries. Hence, what characterises 'inclusive distinction' is that it is both localised (and therefore able to create new meanings and demarcations) and delocalised, due to its momentary and inclusive character; thus what characterises the global locality is its 'translocal' quality. As Beck puts it, being global is simply the question of being 'in several places at once' (ibid.: 46). The advantage of approaching the question of deterritorialization and the non-place as a query about the translocal is that certain anti-modern strands in cultural theory that are linked with the concept of non-place may be avoided.[3]

Beck's notion of 'inclusive distinction' and perspective on the translocal is close to what both MacKenzie Wark and Sean Cubitt have coined as the 'vector', although they use the term for analysing two different phenomena (Cubitt 2004; Wark 1994). Wark focuses on global media events whereas Cubitt traces one of the elementary aspects of film. According to Cubitt, the aesthetics of the vector is undergoing a revival due to the digital change; moving image media have become heterogeneous, creating places and constellations for media convergence.[4] Wark's idea of the vector is similar in scope to John Tomlinson's elaboration of the nexus of de-/reterritorialization (Tomlinson 1999). Tomlinson is also of the opinion that the current situation does not imply the disappearance of limits or localities as such, but that a more ambivalent and intricate situation is created: 'deterritorialization cannot ultimately mean the end of locality, but its transformation into a more complex cultural space' (ibid.: 149). Accordingly, every act of deterritorialization includes its other, namely reterritorialization, in the same way as identity presupposes otherness or difference.

Consequently, global media events, such as the death of Princess Diana or Michael Jackson, can be defined as connecting two otherwise non-relational sites or points. A street in Paris breaks into a home in a small industrial town in Scandinavia, for example, and establishes a relation of mourning into which local aspects may also be projected, such as the loss of a family member. Suddenly a global media icon and a global event enables a deterritorialized person such as Diana (who as a global media image is more virtual than real) to be reterritorialized, becoming almost like a family member in a local setting. The point is that although this event is detached, it is real, and it also has local consequences.

Cubitt's analysis, on the other hand, goes directly into the core of moving image aesthetics, and it is mainly his perspective that I will make use of in this chapter. Cubitt traces three elementary principles of cinema in his book *Cinema Effects*: 1. the pixel, 2. the cut, and 3. the vector.[5] Whereas the pixel is the mode of focusing on the cinematic event, the iteration of time and sensation, the cut centres on what Cubitt calls 'the objection of space' (Cubitt 2004: 97), that is, narrative and representation. The vector is characterised by 'the production of meaning' and therefore Cubitt claims that it is essentially concerned with sign and signifier, the question of that which is being conveyed and that which will happen. Another way of explaining Cubitt's rather intricate typology is to say that the pixel is based on the idea of the sensation of the documentary and is therefore concerned with the real, whereas the cut is the mode that we are familiar with from narrative film; it is here that stories and meanings are constituted by the manipulation of space and time.

According to such a scheme the vector becomes the most abstract principle. While the pixel is a form that claims that 'this happened', the cut constructs a narrative, and the vector is a constant extension of something, a mode beyond that of sensation/representation (pixel) and narrative (cut). Therefore Cubitt posits the animation film, and especially classics such as Emile Cohl's early animations, as the first forms that adhere to the principle of the vector. It is here that the author may take 'a line for a walk', as he puts it, referring to Paul Klee, in order to surprise the viewer and create an unbounded aesthetics of the moving image.

The artistic practice of translocal ambiguity

I have dwelled on Cubitt's distinctions because I think that they describe both the elementary principles and the basic differences of three Finnish artists who mostly or exclusively work with audiovisual media, namely Sami van Ingen, Eija-Liisa Ahtila, and Pekka Niskanen. I will not argue that one principle is more progressive than the others or that any of them would be more appropriate for describing the current situation of the audiovisual arts; the principles are three different modes for dealing with the strategies and thematics of de- and reter-ritorialization. However, I find Cubitt's typology to be instructive for pointing to the aesthetic differences in van Ingen's, Ahtila's, and Niskanen's work, thus I regard Cubitt's distinctions to be of heuristic value rather than constituting a theory as such.

In conclusion then, van Ingen approaches the nexus of the cinematic trans-localisation by grounding his aesthetics on the pixel, Ahtila in turn uses the cut, while Niskanen explores the translocal by adhering to the principle of the vector. Accordingly, Dercon's initial question, where is cinema?, may be explored and expanded in order to pose the question of the non-place of film, a question with both internal and external consequences, that is, in terms of internal aesthetics or in terms of actual placement of the moving image apparatus and its conventions.

It is worth stressing that Cubitt's typology should not be treated as a way of constructing a progressive history of different modes. Without doubt early cinema rose with the pixel as the objective and moved into the narrative mode in order to guarantee the creation of a stable commodity for an international film market. The latter move meant that, in terms of aesthetics, a formula and grammar for telling stories with sound and picture emerged. Thus, a good film and a good film script – according to the narrative formula – always aimed to form separate scenes that followed the same logic: the placing of the narrative through an establishing shot and the development of a scene according to fixed rules about depicting time and space.[6] Film became linear progression, a narrative machine: something always happened somewhere which in turn always led to something else. Such a grammar for film may be criticised for being the dominant one, but I think that it would be the result of excessively schematic teleological thinking to view any deviation from the norm as a progressive act as such. The rules of the dominant film grammar have always been questioned and recent film and video artists are not by any means the first who have attacked, or who have been able to break with, the norms – a story often told in recent video art historiography.[7] Instead the situation should be viewed as one of give and take, or, better still, of a Beckian ambivalence. The heterogeneous global media environment has heightened awareness of the possibility of viewing past forms in different ways. That is, I would claim, the essential lesson from new media archaeology.[8] Thus, the aim should not be to construct new teleological histories, but to see new connections and paths, enabled or hindered because of social circumstances and new technological means. The quest is not to track down acts of deterritorialization or symptoms of the non-place of film, but to study how de- and reterritorialization interact in the creation of more complex cultural places and heterogeneous aesthetics.

A critical position regarding any teleological strand is important, because if we view film history from the perspective of globalization it turns out that

globalization and the history of film go hand in hand. Film was one of the first dominant global forms and silent film soon became a major global commodity. In terms of aesthetics, early film was close to that of the dominant form of today's media culture, for example, merging the pre-cinematic Kinetoscope with that of the post-cinematic QuickTime, as Lev Manovich and Melinda Blos-Jáni have pointed out (Blos-Jáni 2009; Manovich 2001). Hence, early cinema came to inspire both film historians and artists to rewrite and review film history.[9] It is also worth paying attention to the fact that silent film was from the beginning a mode that disconnected culture from territory. From such a perspective, cinema may be viewed as working along a vectoral logic in Wark's sense.

Hence, in this chapter I will follow Beck's notion of ambivalence and translocality; that is, I will concentrate on how the artists van Ingen, Ahtila, and Niskanen intervene in film history, displacing and creating non-places and translocal sites through the use and re-use of film and moving image media. These interventions are comments on various strands of globalization. The strategies these artists use should not be seen as constituting a break with tradition, but rather as a way of intervening in a historical situation that encompasses changes both in culture and aesthetics. The concept and term I would like to coin for both tracing the strategies and enabling an analysis of the change is that of 'translocal ambiguities'.

Pixel: Van Ingen and the recirculation of images

Van Ingen has recently worked extensively with found footage, that is, re-editing other film material. The technique in itself is almost as old as film, but it became a major genre of experimental filmmaking in the 1960s.[10] Found footage may be considered as a privileged form for exploring a postmodern attitude to history. Meanings are constructed; hence the question is not so much of capturing an external reality as exploring the recirculation of images and signifiers. The growing phenomenon of globalization has made it more and more difficult to separate referent from signifier. It is the global media messages, images, and signifiers that make up our reality. Consequently, the best thing to do is to interrogate and investigate the signifiers at play, not to try to anchor them: the event and cause are absent; it is the aftermath that we experience and interpret.

In the film *Fokus* (2004), van Ingen investigates and re-edits an amateur reel shot by his grandmother, which depicts the royal Indian court procession

Fokus (2004) © Sami van Ingen.

of Dussera in Mysore. According to van Ingen, the Dussera procession is not indigenous. It was constructed by the British Empire in the early 19th century as a way of consolidating a peace process. The East India Company overthrew the last Mogul of India in Mysore and installed a puppet government in order to keep the peace. The royal Indian court procession was part of this colonial act of peacemaking. The original footage ends with a highly symbolic image; it shows a man collecting excrement from the animals that have taken part in the procession.

Van Ingen blows up the original 16 mm footage of *Fokus* into 35 mm, and changes the speed, focus, perspective, and direction, to extend the original film into a 40-minute wide-screen experience that destabilises the position of the viewer. What the camera has recorded is both questioned and amplified through the process of re-editing. The film sets off from the material base of the celluloid, grain, light, and detail in order to end up with a depiction of the original film. Thus, van Ingen is both aestheticising and criticising the original material. The enjoyment of the rich colours in the original film material merges with a questioning of the deployment of the camera, of its means of capturing an exotic other and portraying a colonial act of power. Van Ingen offers no solution or answer, but allows the viewer to be immersed in the highly ambiguous

film, changing focus constantly without adhering to any single perspective on that which is being projected onto the screen. This displacement of the original film and the current viewer – who constantly has to review the screen, figures, and colours in order to search for meaning – creates a translocal space for the spectator, a poetics and politics of the mode of the pixel in which translocal ambiguity is explored.

Whereas audiovisual installation has become the common strategy for creating multiple viewpoints in order to establish a temporal and spatial polyphony, van Ingen amplifies or lightens up specific areas of the projected picture on the screen in the manner of Peter Tscherkassky's modern classic *Outer Space* (1999). This is already a clear trait in *Fokus* but he uses the technique extensively in his 35 mm and 5-minute film *The Sequent of Hanna Ave.* (2006). Whereas the historical burden was that of colonial history in *Fokus*, *The Sequent of Hanna Ave.* focuses on the history of film aesthetics. Through the manipulation of an original B-movie that works according to the tight rules of the established cinematic grammar (establishing shot, master shot, etc.), van Ingen creates another spatial and temporal experience. Now the viewer scans the whole screen and is denied a stable location from which to look, an aesthetic that forces the viewer to relocate the delocalised material.

Cut: Ahtila and the interplay of identities and narratives

Ahtila, Finland's best known contemporary audiovisual artist, usually works with narratives that address psychological issues. Despite this clear thematic core and an overt narrative structure, Ahtila's films are very difficult to describe, mostly due to their highly condensed character in which music or sound, camera movement, and distinctive characters immediately set the tone and the atmosphere for that which is to come.

Ahtila's early cinematic works *Me/We, OK,* and *Gray* (1993) are brief, dense and intense audiovisual pieces that last no longer than ninety seconds. They depict stories but without creating a standard linear narrative time, or a coherent whole with agents and a plot. *Me/We* tells a story about a family with the voice of the father as the omnipotent narrator, though all three characters in the family talk and act on the screen. This piece introduces a common theme in her *oeuvre*; that of how the relationships within a family reflect and constitute the identities of the individuals. By presenting her topic in ninety seconds she is able

to create an intensely felt portrayal of a family constellation, which instead of offering anything conclusive or an overall image, displays the complexity of the whole situation. Furthermore, the condensed glimpses are meant to be exhibited as audiovisual interludes, noise, or enigmas in the culture of the cinematic mainstream. Besides constituting a three monitor DVD installation for the art scene (museums and galleries), the three films (that is, if shown as separate pieces) are meant to be inserted as trailers or between adverts on television (Ahtila 2003). They also function, because of their episodic and ephemeral structure, as audiovisual junctures and translocal stations in today's culture of the moving image, while being neither dramas, films, nor adverts, and yet all of these genres at once. Thus, Ahtila's short pieces point both to the actual generic transformations taking place in the field of audiovisual culture, posing the question 'where is cinema?', and to the thematic core of the films, questioning fixed identities and roles. Ahtila even addresses the question directly to the audience in an introduction to *Me/We*:

> The father directs his words to viewers. His voice also speaks the other character's lines, with the others opening and closing their mouths in the appropriate rhythms. Who in the end is speaking, what is an individual and where are the boundaries of the self? (ibid.: 33)

The subject of the localisation of identity is followed up in later and longer pieces of which *Today* (1996-97) and *Love is a Treasure* (2002) are the most interesting. The length of these films (10 and 55 minutes) makes them more traditional when it comes to narrative (*Today*, especially, is a contemporary translation of the classical American family melodrama). The focaliser in *Today* is the daughter in the family. In a generalising gesture she draws the viewer directly into the story by throwing and bouncing a ball against the lens of the recording camera. The three stories that constitute the film are shown simultaneously in the installation version. The simultaneity stresses Ahtila's view of how the formation of identity and the self is interrelated with all the other people in a family. Although the story in the film version is firmly anchored in the point of view of the girl, the intense episodic structure resists any simple placing of the narrative. This relational character, the idea that identity and meaning is a result of translocality and not that of territory, is stressed further in the installation version of *Today*, with Ahtila's own words:

Today (1996-97) © Eija Liisa Ahtila.

> In the installation version the three parts are repeated on the screens forming
> three sides of a rectangle. The three episodes run consecutively going from
> one screen to the next. The positions of the different family members and their
> situation in the story, along with the repetition of various elements disrupts
> the time of the narrative and the chronology of the events. **TODAY** explores
> narrative structures and the construction of time in a story, along with the
> formation of an idea of self and seeing yourself in the gestures of other family
> members. (Ibid.: 101)

Ahtila thus adheres to the principle of the cut, changing scenes and creating
relations between different scenes. She elaborates and expands traditional nar-
rative cinema through her employment of a multiple screen projection that
enables the simultaneous representation of different points of view. Compared
with van Ingen, she is not interested in focusing upon the material. In Cubitt's
words she instead strives to 'convert the play of pixels into objects, worlds,
identities' (Cubitt 2004: 49).

Narrative as an instrument for interrogation and for contrasting different
stories in the construction of identity is one of Ahtila's trademarks; she uses the
cinematic principle of the cut in order to make the argument that the placing of
a subject – and the key to understanding any individual conduct – is to view it as

relational, as in the image that shows the daughter looking at her father. Identity is formed in the relations between people, real or virtual, hence the question of identity is not territorial; it does not reside anywhere, instead identity is the result of the interplay between de- and reterritorialization. As filmmaker/artist Lynn Marie Kirby has pointed out in an interview with Trinh T. Min-ha that the digital has shifted our focus towards gestures, different constellations in space, which in turn enables a relational aesthetic that moves away from fixed objectivity and linearity (Min-ha 2005). Although Ahtila still adheres to the principle of the cut and scenic structures, her use of the mode of the installation enables her to create constellations of constant processes of translocal ambiguity, processes in which identity is always related to its other. In fact, a family is a matrix for being in several places at the same time.

Vector: Niskanen and the heterogeneous space of film and identity

My last example, Niskanen's *Ryokan Mother Tongue/Hotelli äidinkieli* (2002), or 'Hotel Mother Tongue' as it is named in Finnish, also takes the question of identity as its point of departure. However, Niskanen's elaboration is totally different from Ahtila's work. *Ryokan Mother Tongue* is designed as a two screen installation in which the picture on each screen is constantly in motion and split into disparate actions and movements. The camera follows three characters who tell personal stories to each other, narratives that partly involve all three of them, and are partly without any particular addressee.

A key feature in the work is the dialectic between the private and the public. Language is by definition highly private and an instrument for emotional belonging – a mother tongue – but also a social tool, part of a public apparatus that is beyond private control. The hotel of the mother tongue is thus the social apparatus that both enables and restricts the possibility of private experiences.

In Niskanen's *Ryokan Mother Tongue* the characters visit public places while talking about highly private experiences. The buildings are mostly public sites of historical significance: the House of Culture and Helsinki University of Technology for example, both planned by the famous architect and modernist Alvar Aalto. Niskanen's protagonists inhabit these public buildings, playing tennis, washing clothes, cooking, eating, and sleeping in a kind of postmodern gesture, claiming that the modernist buildings by Aalto were built during an

Ryokan Mother Tongue (2002) © Pekka Niskanen. Photo by Minna Kurjenluoma.

era when universalism and a clear demarcation between the private and the public was still possible. Accordingly, Niskanen creates a space for what Tomlinson has coined 'public intimacy' (Tomlinson 1999: 167), a heterogeneous vectoral space in which both the camera and the characters may enter and exit different sites and places, creating an ongoing dialogue about identity. A very significant trait is Niskanen's moving camera; it never stands still, contesting the viewer's search for a stable viewpoint. If the walking line was the key feature in Cubitt's definition of the vector, it is replaced by the moving camera in Niskanen's *Ryokan Mother Tongue*. The camera scans the spaces and people in a way that echoes one of the most remarkable shifts of point of view in film history, namely when Marion Crane has been killed in Alfred Hitchcock's classic *Psycho* (1960) and the camera and the viewer are left aloof and forced to find a new order and vantage point for the narrative. While the shift in *Psycho* is primarily a stable one, from one body and gender into another, Niskanen's shifts are persistent and ongoing. The true home of identity in *Ryokan Mother Tongue* is thus a translocal ambiguity, a fact that is stressed in the last scene when two of the three protagonists – a male and a female – change clothes, not in order to find a true place that signals who they are, but merely to stress that cross-dressing is a sign of cultural hybridity, of being constantly on the move, creating new inclusive distinctions that always end up in new ways of framing.

That the new frames are merely temporary ones is stressed by Niskanen's use of the split screen: a frame may suddenly split into a new constellation.

Translocal technological ambiguities

There is another dimension of cinematic displacement that unites van Ingen, Ahtila, and Niskanen. Van Ingen shoots and exhibits on celluloid, but he is in part reworking his films digitally. Ahtila shoots on film, but commonly projects her work as digital multiple screen projections. Niskanen shoots and exhibits digitally. All this is proof of the fact that, as D.N. Rodowick has put it: 'Our audiovisual culture is currently a digital culture, but with a cinematic look' (Rodowick 2007: 133). As I have shown, van Ingen, Ahtila, and Niskanen follow basic cinematic principles although their technological means are hybrid and impure; as such, digital technology questions the very basis of the cinematic. According to Rodowick:

> The film projector produces movement by animating still images. But as presented on electronic displays, the image *is* movement or subject to continual change because the screened image is being constantly reconstituted, scanned, or refreshed. Being in a constant state of reconstruction through a process of scanning, the electronic image is never whole present in either space or time. Moreover, it is fundamentally discontinuous; that is, it is never identical with itself in a given moment of time. This means that the "video image" does not exist as such, or rather, that it does not persist in space as an undivided unit of time. A discontinuous, fluctuating and pointillist image, both spatial and temporal unity are unknown to it. (Ibid.: 137-38)

Consequently, on a technological level the digital is the deterritorialization of film, which on the other hand is constantly reterritorialized by the social apparatus of cinema, its principles, grammar, rules, and set conventions. In essence, this is the translocal technological ambiguity under which van Ingen, Ahtila, and Niskanen work, each appropriating the technology and apparatuses by creating glocal practices, their own ways of intervening and posing an answer to the question of where today's cinema is taking place. Whereas the medium of celluloid, that is, film proper, was and is the medium of montage and representation, or, as Gene Youngblood put it, 'a stream of audiovisual events in time', the digital has stressed the act of postproduction, of endless spatialisation and reconstruc-

tion (Yongblood 2003: 156). Thus, the digital cinematic turn has fostered the aesthetics of re- and deterritorialization, stressing the fact that remediation is one of the key features of media in the age of globalization.

Accordingly, the deterritorialization of film is a symptom of globalization. Film, once the primary machine of modernity, has become part of the super-genre of the moving image, forcing artists and practitioners to become translocal agents. Whereas the cut and the moving image or, the cut and the pixel as Cubitt puts it, constituted the elementary modes of the moving image media of modernity, the vector has become an essential mode of moving image media in the age of globalization. This does not mean that one mode is substituted for the other, rather, as I have shown, they all co-exist as available means; what is new is the ambiguous translocal situation. As Arjun Appadurai has stressed in an interview, modernity and globalization are related to each other, but while modernity – like traditional film – was primarily a 'one-way temporality', the new hybrid media formats that allow multiple exhibition practices deterritorialize what we once knew as film into 'globalization [that] introduces spatiality, simultaneity, horizontality into a kind of sequential, temporal, vertical, developmental impulse' (Rantanen 2006: 11). It is in this translocal ambiguous situation that artists like Ahtila, van Ingen, and Niskanen work, and deterritorialize film.

Works Cited

Ahtila, E-L. (2003). *The Cinematic Works*. Helsinki: Crystal Eye.

Beck, U. (2000). *What is Globalization?* Cambridge: Polity Press.

Beck, U. (2007). *Cosmopolitan Vision*. Cambridge: Polity Press.

Blos-Jáni, M. (2009). "Designed for the Kinetoscope but Formatted for the QuickTime. On the Mediality of Contemporary Silent Films". Unpublished paper, NECS.

Cubitt, S. (2004). *The Cinema Effect*. Cambridge, Mass.: MIT Press.

Dercon, C. (2003). "Gleaning the Future from the Gallery Floor". *Senses of Cinema* 28. Accessed June 23, 2009: http://archive.sensesofcinema.com/contents/03/28/gleaning_the_future.html.

Manovich, L. (2001). *The Language of New Media*. Cambridge, Mass.: Massachusetts Institute of Technology.

Minh-ha, T. (2005). *The Digital Film Event*. London: Routledge.

Rantanen, T. (2006). "A Man Behind Scapes. An Interview with Arjun Appadurai". *Global Media and Communication* 2: 1, 7-19.

Rodowick, D. N. (2007). *The Virtual Life of Film*. Cambridge, Mass.: Harvard University Press.

Tomlinson, J. (1999). *Globalization and Culture*. Cambridge: Polity Press.

Youngblood, G. (2003). "Cinema and the Code". In J. Shaw and P. Weibel (eds.), *Future Cinema: The Cinematic Imaginary after Film*. Cambridge, Mass.: Massachusetts Institute of Technology Press.

Notes

1 Originally published in *Vertigo* 2002 and deterritorialized in *Senses of Cinema*. I will use cinema, film, and moving image as synonyms in this essay, that is, to signify the institution of the moving image, its conventions, materials, grammar of understanding, and intrinsic aesthetics.

2 I have dealt with the same question in relation to national film politics in the essay "Contemporary Cinematic Work from Finland. The Non-Place of Cinema and Identity", *New Cinemas: Journal of Contemporary Film* 4: 2 (2006).

3 For example, Marc Augé's work *Non-places: Introduction to an Anthropology of Supermodernity* (London: Verso, 1995); and Pierre Nora's work on memory sites, see Pierre Nora and Lawrence D. Kritzman, eds., *Realms of Memory: Rethinking the French Past. Vol. 1: Conflicts and Divisions* (New York: Columbia University Press, 1996).

4 This has led scholars like Lev Manovich to claim that we live in a post-media age. This is both a problematic and paradoxical claim since Manovich himself often uses a specific media as point of departure for analysing new media. Manovich is of course right when it comes to the quest for ontology of media. However, if media is considered to be a social apparatus it is both a meaningful and necessary concept.

5 I will use Cubitt's very sophisticated analysis in a somewhat simpler manner in this essay. For a comprehensive philosophical discussion of Cubitt's book and its philosophical foundations see Roger Dawkins' review of *The Cinema Effect* in *Senses of Cinema* 35 (2005).http://archive.sensesofcinema. com/contents/books/05/35/cinema_effect.html, accessed June 23, 2009.

6 For a classical analysis of the establishing of these rules, see David Bordwell, Janet Staiger, and Kristin Thompson, *Classical Hollywood Cinema: Film Style and Mode of Production to 1960* (London: Routledge, 1988).

7 For example, in Marit Paasche's interview with Maria Lind, "Transcending the Format", in Stian Grøgaard et al., eds., *An Eye for Time: Video Art and Reality* (Oslo: Pax Forlag, 2004).

8 See for example Lars Gustaf Andersson and John Sundholm, "Amateur and Avant-Garde: Minor Cinemas and Public Sphere in 1950s Sweden", *Studies in European Cinema* 5: 3 (2008); Thomas Elsaesser, "The New Film History as Media Archaeology", *Cinémas* 14: 2-3 (2004); or Jared Gardner, "Greenaway's Suitcase Cinema and New Media Archaeology", *Studies in European Cinema* 5: 2 (2008).

9 Anne Friedberg, *Window Shopping: Cinema and the Postmodern* (Berkeley: University of California Press, 1993); Tom Gunning, "The Cinema of Attractions: Early Film, Its Spectator, and the Avant-Garde", *Wide Angle* 8: 3-4 (1986); or Bart Testa, *Back and Forth. Early Cinema and the Avant-Garde* (Toronto: Art Gallery of Ontario, 1992).

10 For a history and theory of found footage film see Patrik Sjöberg, *The World in Pieces: A Study on Compilation Film* (Stockholm: Aura, 2001).

Spatializing Time

– On the Creation of Allegoric, Global Connections between Local and Auratic Sites

By Bodil Marie Stavning Thomsen

In recent interviews and presentations Danish artist Søren Lose (b. 1972), one of many contemporary Nordic artists living and working outside their native country, underlines his interest in dealing with memory and space.[1] Although he is first and foremost known as a photographer, it could be said that the most significant feature of his work is the way he integrates photography into his installations. The effect of the photographic material is thereby transformed from giving indexical traces of reality to documenting or creating spaces for memories or for the construction of narratives. An important aspect of this article will therefore be to understand this photographic documentation as an example of the postmodern practice to 'reterritorialize the copy', as Boris Groys terms it in *Art Power* (Groys 2008: 63).

Groys is referring to Walter Benjamin's well known idea in "The Work of Art in the Age of its Technological Reproducibility" (1936) that the modern practice of copying and distributing classic artworks dilutes the 'aura' of the original, since it was previously connected to certain site-specific uses (such as religious rituals). Groys explains Benjamin's concept of 'aura' as 'the relationship of the artwork to the site in which it is found – the relationship to its external context' (Groys: 62). As a reproduced copy, the artwork is removed from its site and becomes 'virtual, siteless, ahistorical'. It is 'deterritorialized […] into the network of topologically undetermined circulation' (ibid.: 62). Whereas Benjamin witnessed the rise of modernity and therefore had to stress the loss of aura, its 'here and now, its unique existence at the place where it happens to be' (Benjamin 2008: 21), in the reproduced copy, it is Groys's claim that the

copy can be reterritorialized in the postmodern art documentation that we witness today, for since

> the distinction between original and copy is entirely a topological and situ-ational one, all of the documents placed in the installation become originals. If reproduction makes copies out of originals, installation makes originals out of copies. (Groys: 64)

The documenting art installation can actualise the 'potential multiplicity' of the reproduction, precisely because it is 'virtual, siteless, ahistorical' and thus 'deterritorialized' (ibid.: 62). Groys refers to contemporary art exhibitions, where you no longer see art *presented* but merely documented (ibid.: 52), and he emphasises the quality of the new networks of circulation, through which you can reterritorialize life by experiencing its documentations, its reproduced traces. He understands this trend as a result of our biopolitical age in which life is shaped and controlled politically by new technologies including 'planning, decrees, fact-finding reports, statistical inquiries, and project plans' (ibid.: 55). Since this implies that 'time, duration, and thus life as well cannot be presented directly but only documented', Groys argues that art has taken this 'artificially fashioned lifespan […] as its explicit theme' (ibid.).

The prevalent documentation of art as life in contemporary exhibitions might however just as well be due to the never-ending transmission of real-time events by the ubiquitous global media. Groys's point, that the definition of life is that it 'can be documented but not shown' (ibid.: 57), has certainly been questioned in recent media development, as all kinds of life forms all over the globe can now be subjected to surveillance and direct broadcasting on television and data transmission on the internet. So Groys's argument that '(post)modernity enacts a complex play of removing from sites and placing in (new) sites, of deterritorialization and reterritorialization, of removing aura and restoring aura' (ibid.: 64) ought to be supplemented with Arjun Appadurai's view from *Modernity at Large* (1996). Appadurai states that global exchanges in culture and art practices are highly influenced by the impact of transmitted data. Electronic broadcasting and digital networks have certainly increased the speed of both information acquisition and control, and this has indeed been decisive for the new interdependencies of local and global events.

With John Tomlinson's definition of the relationship between globalization and modernity in "Globalization and Cultural Identity" in mind – that 'globali-

zation is really the globalization of modernity, and modernity is the harbinger of identity' (Tomlinson 2003: 271) – we might state that what we (people belonging to Western modernity) have hitherto experienced as 'the abstraction of social and cultural practices from contexts of local particularity, and their institutionalization and regulation across time and space' (ibid.: 272) is now being globally distributed to other cultures, producing new claims on identity related to institutions and politics of 'gender, sexuality, class, religion, race and ethnicity, nationality' (ibid.). So just as modern identities and the institutions of modernity can no longer be attributed to an 'original' culture or to a lived experience within a local territory, the idea of the originality (or aura) of art belonging to a specific site or cult has long since (as recorded by Benjamin) been deterritorialized and replaced with the copy, the reproduction. The notion of aura as well as the loss of it is in other words embedded in the emergence of modernity. In contemporary art practice – that is the practice of installation, re-enactment, and performativity – the reproduced material, the copy, on the other hand 'acquires through the installation an aura of the original, the living, the historical' as it gains a new kind of site, 'the here and now of a historical event' (Groys: 64). So Groys's 'aura' is neither situated in the 'body' nor the 'site' of the artwork but in the documenting or contextualising creation of an 'event'.

This perception of life and art as something that has to be documented and re-situated in order to gain new significance will be consistent in the following interpretation of Lose's work. What is especially interesting in the photographic practice of Lose is that he almost always takes as his starting point found foot-age in the form of recovered photographic material.[2] With these documents of distant times and places (often tourist sites) he sets out to photographically actualise the very same sites. The result is then staged in an installation where the invisible yet perceptible time span between the old representation and the new is documented. In this way the tourist sites once photographically reproduced and disseminated all over the world are re-contextualised and re-territorialized. The time span created 'in-between-images' of past and present documentations makes the site reemerge as an existing place of life and change.[3] This documentation of time making an imprint on the sites once auraticised by a tourist's gaze encourages the spectator to reterritorialize the site in imagi-nation, remembrance, and narration. Lose's ambition might more precisely be explained as the invisible yet noticeable depiction of time passing between two (or more) reproductions of the same site.

In this context it is interesting that the documentation of an identical (tourist) site holds a rather long time delay, as the photographic procedures of modernity are often displayed alongside Lose's own exposures of the site in a globalized world. Through this procedure the installations invite the spectator to explore the invisible time span between images as a here-and-now situating event documenting global processes of deterritorialization and their lasting impression on life itself, forming memories, identities, and stories. In the following this procedure will be explored analytically in connection to Tomlinson's (and Giddens') framing of deterritorialization in globalization:

> The idea of deterritorialization [...] grasps the way in which events outside of our immediate localities – in Anthony Giddens's terse definiton of globalization, 'action(s) at a distance' – are increasingly consequential for our experience. Modern culture is less determined by location because location is increasingly penetrated by 'distance'. (Tomlinson 2003: 273)

Distant occurrences increasingly have an impact on local decisions and actions as the pace of deterritorializing processes increases (Appadurai 1996). In this context a closer look at Lose's installations will demonstrate how photographic documentation can re-situate topographic, local, and often auratic places in between past and present manifestations of historical time.[4] The following will explore the procedure of this allegorical practice, in which global and local sites are made to correspond within the framework of an installation.

A post-Romantic gaze

One of Lose's ongoing works for a period of ten years, *HOME (1996-2006)*, was presented at Storstrøms Kunstmuseum, Maribo, in 2006.[5] In *HOME* Lose documented unemployment and poverty by photographing the ruins of abandoned houses in the flat landscape of Lolland, Lose's native island in the southern part of Denmark. This part of Denmark has – like all local regions on the outskirts of big cities in the nation-state – suffered severely from the demands of modernity. In a stylistic mixture of realistic and modernistic pictures Lose's installation showed the ruins of poverty and resignation, where the scattered documentations of lived lives were mixed by coincidence in piles of waste, indifferent to distinctions of family, sex, age, or wealth. Yet the strikingly beautiful and aesthetically framed photographs of doors with peeled-off paint,

Søren Lose: *Blue, yellow, green.* 60 x 80 cm. Light-jet print, framed. © 2002 Søren Lose.

of wrecked wallpaper, and of trash and litter together with the found footage of private photos also exhibited the touristic gaze of Lose documenting the abandoned houses. The colourful photographs were supplemented with video documentation of the process of demolishing a house, adverts presenting the current market value of the houses, and the land register as well as an installation in the exhibition room of outdated furniture from a flea market. This was a powerful manifestation of how the processes of modernity can indeed empty the meaning of the word 'home'. But, as previously mentioned, the strong presence of the tourist's gaze within the photos exhibited was just as manifest. The photographs were blown up, showing a lot of detail and shades

of colour as if presenting auratic sites of beauty instead of abandoned houses and flat landscapes.

This specific gaze of Lose's belongs to the global traveller of artists and intellectuals, for whom 'living and travelling have become synonymous' (Groys 2008: 106). The post-Romantic gaze of this traveller emerges in the era of globalization and mobility, when 'people, things, signs, and images drawn from all kinds of local cultures [...] are now leaving their places of origin and undertaking journeys around the world' (ibid.: 105). The big cities are no longer the only centres of attraction in the 'global village'. On the contrary: the claim for specific attractions and sights in famous cities (Paris, Rome, New York) or the exportation of universal ideas or valid essences in art and design have paved the way for media networking and mobility on a bigger scale in which local customs are just as valid as ideas aspiring to universality. And so the utopia of the city has prepared the way for a new utopia 'of transcending the antagonism between immobility and travelling; between sedentary and nomadic life, between comfort and danger, between the city and the countryside' (ibid.: 109). But this ambition to transcend old dichotomies also indicates that the post-Romantic gaze can provide everything with 'the dignified aura of monumentality' (ibid.: 103), since the fluid life of places visited is evidently transformed 'into a monumental image of eternity' (ibid.). This is what we all do with our digital cameras, videos, or cell phones. We participate in 'the relentless process of monumentalization, demonumentalization, and remonumentalization that is unleashed by the Romantic tourist's gaze' (ibid.: 104).

Lose's exhibition *HOME 1996-2006* not only documented the fact that this process of de- and reterritorialization is taking place everywhere by everyone with a camera and a post-Romantic gaze that matches a globalized world. He also made it clear that this gaze is distinctly different from the melancholic gaze of Benjamin's Angel of History,[6] who with his back to the future witnesses the pile of ruins from the storm of so-called progress. With a sharp yet distant gaze Lose unravels the components of this new tourist gaze at the same time as he applies it in the portrayal of the desolate ruins of his native soil. He simply shows us that litter can originate from anywhere and that piles of waste and found footage can characterise 'any-space-whatever'. The global world is imbedded in every local region and the local can be found everywhere in a post-Romantic world.

Søren Lose: *Preben Funch ½-92.* 60 x 80cm. Light-jet print, framed. © 1998 Søren Lose.

Pre-conceived spaces

In his installation *Outward bound! Abroad. Homeward bound!* (2006) the clas-sic romantic gaze of the tourist is further deconstructed and explored in order to create alternative documentations of life lived. This exhibition took place on Lose's initiative in the first Danish art museum, Thorvaldsen's museum in Copenhagen.[7] Bertel Thorvaldsen (1770-1844) was a Danish sculptor who lived in Rome from 1797 to 1838. His fame throughout Europe was consider-able.[8] Thorvaldsen was a contemporary of Immanuel Kant, who in *Kritik der Urteilskraft* (*Critique of Judgement*; 1790) was the first to describe the tourist's gaze in search of sublime events. Kant's conception of sublimity applied to 'the

"capacity we have within us" to judge and enjoy without fear the very things that threaten us' (Groys: 104; Kant 1987: 99). His description of the tourist's gaze also showed that the human imagination is prior to the experience or knowledge of things and facts in the world. The tourist basically wants to 'confirm his own superiority and sublimity in regard to nature' (Groys: 104).

This approach to the outer world is also the precondition for the Romantic gaze that 'romanticizes, monumentalizes, and eternalizes everything that comes within its range' (Groys: 103). A well known representative of the Romantic gaze was the Danish author H. C. Andersen (1805-1875). He went on numerous formative trips to Italy, England, Scotland, France, Spain, Portugal, Switzerland, Italy, Africa, and the Balkans when travelling was still very difficult, slow, and troublesome. These travels influenced his literary descriptions of nature and foreign cultures as untamed yet picturesque. In a globalized, post-Romantic world his Romantic phrase 'Travelling is living' has

Søren Lose: *Partial view over Forum Romanum, seen from the rear.* 83 x 103 cm, Light-jet print, framed. © 2006 Søren Lose.

become an important impulse for self-realisation, in which the travel industry offers 'authentic' reproductions of the first tourist's conquest of untouched territory.

In *Outward bound! Abroad. Homeward bound!* Lose established a relationship with Thorvaldsen's huge collection of paintings of Rome by his contemporaries, which were exhibited in the museum. This collection of picturesque 'souvenirs' from the eternal city of Rome represented the 'found footage' that Lose's photographs set out to copy – with a displacement in time of about two hundred years. He chose the exact same motifs and the exact same points of view laid down in the artistic gaze of the 18th century by the painters, who had first transformed 'temporariness into permanence, fleetingness into timelessness, ephemerality into monumentality' (Groys: 103) in order to present Rome as the utopian ideal of Neo-Classicism. Lose's photographic copies simultaneously showed two things, which will be described separately in the following two paragraphs:

1. As the now famous views were doubled in Lose's installation, the spectator first of all became involved in defining the invisible time span between the contemporary (photographic) and the past (painterly) representations of Rome. This dialogue between now and then in which the distance in time was almost erased in other words documented the effort of the post-romantic tourist's gaze to identify with the romantic imagination. While the paintings portrayed an ideal of the city of Rome that became a sort of prefabricated diagram for the touristic search for sublimity, the photographic copy of this ideal rather revealed that everything everywhere could be an auratic site for a post-romantic tourist's gaze. Yet this could not be embedded in a melancholic interpretation since Lose succeeds in recontextualizing the copy in the 'here-and-now' of the installation. Therefore the spectator is invited both to question the production of aura *and* to fill the time span between then and now with imagination and narration (cf. Groys: 64). Lose de- and reterritorialized the gaze of Thorvaldsen and his contemporaries by exhibiting photographic copies of their painterly creations of an ideal. These copies were exhibited with their originals in the very monument, Thorvaldsen's museum, that still represents the Danish constitution and its aspiration to universal ideas of equality, freedom, and brotherhood (cf. notes 7 and 8).

2. Furthermore, Lose's photographs were not just copies of touristic views of historical sites, since they were all filled with bodies of contemporary tourists anno 2004 taking part in the de- and re-monumentalization of Rome's famous sites – posing in raincoats and sneakers trying to capture a photographic copy of the immortal sight with digital cameras and mobile phones. These bodies

functioned as hindrances to the spectator at the exhibition, who was prevented from gaining the perfect view of the famous archaic sites. The far-from-ideal bodies were so to speak a documentation of the ephemeral life of the eternal city, recalling the temporariness of tourists and inhabitants alike. In this installation the timely body clearly obstructed the perfect view and thereby questioned the quest for auratic views.

This combination of the performative dialogue between original and copy *and* the obvious hindrance in contemplating the exposed sight in depth (because of the displayed bodies) invited the spectator to inquire into their preconceptions of spatial experience. The invisible space of life lived throughout the intermediary time span of two hundred years between the paintings and the photographic copies was certainly re-contextualized and reterritorialized in this installation. It asserted that historical time can indeed be actualised in the contexts of contemporary life by way of artistic interpretation. One could extend this argument by relating it to Thomas Y. Levins proposal in "Rhetoric of the Temporal Index: Surveillant Narration and the Cinema of 'Real time'" (2002) that the 'indexical rhetoric' of truth related to the photographic documentation of space in modernity survives in the form of 'the *temporal indexicality* of the real-time surveillant image' in our digital age. This is due to the assumption that transmissions of this kind are 'supposedly not susceptible to post-production manipulation' (Levin 2002: 592). In this context it is noteworthy that although Lose manipulated the photographs according to the working method used by the painters of the time – by combining various sketches (or snapshots) into an ideal picture of a visual impression – the spectator got an impression of time passing in the actual viewing process. This was as a result of the installation of long-established painting sites next to post-Romantic photographic points of view. Although or maybe due to the fact that both viewing perspectives were manifestly constructed as archaic sites, the spectator was bound to become aware of the intermediary time span between those partly identical, partly different documentations of sites in Rome. Through this procedure the components of visual constructions of auratic sites – then and now – were laid bare.

The allegoric supplement

The documentary practice of Lose and other contemporary artists might be unravelled in the light of Craig Owens' now famous essay "The Allegorical Impulse: Toward a Theory of Postmodernism" (Owens 2003 [1980]), in which

the allegoric figure as presented by Benjamin in his book *Ursprung des deutschen Trauerspiels* (*The Origin of German Tragic Drama*; Benjamin 2003 [1928]) is elaborated in order to grasp the postmodern appropriation of historical images. The allegorical figure was developed in the Greek rhetorical tradition to designate an expression that contains another content than the one formally described or shown. This figure can in other words hold two – often very dissociate – meanings in one, and hence it is more complex than the metaphor, which only attracts one value.[9]

In *The Origin of German Tragic Drama* Benjamin related the allegorical figure of the German baroque *Trauerspiele* to modernity and a modernistic art practice. In the *Trauerspiele* time is presented in spatial form and the relationship between the events described is fragmentary and ruinous. This baroque use of the allegoric figure represents according to Benjamin the true conception of modern history and art, since the events presented holds no resolution. Thus time becomes undisclosed, spatial, and (with Craig Owens) postmodern. Owens elaborates on Benjamin's uses of allegory relating it to postmodern art (especially to American site-specific art and photomontage) in order to unravel its procedure. His essay was written in a very convincing style and it almost became a manifesto of postmodern appropriation art in the 1980s:

> Allegorical imagery is appropriated imagery; the allegoric artist does not invent images but confiscates them. He lays claim to the culturally significant, poses as its interpreter. And in his hands the image becomes something other (allos = other + agoreuei = to speak). He does not restore an original meaning that may have been lost or obscured; allegory is not hermeneutics. Rather, he adds another meaning to the image. If he adds, however, he does so only to replace: the allegorical meaning supplants an antecedent one; it is a supplement. (Owens 2003: 1027)

Owens underlines that 'allegory *is* extravagant, an expenditure of surplus value; it is always in excess' and that since '[i]t takes the place of an earlier meaning, which is thereby either effaced or obscured' its supplement to an existing work of art (its 'found footage' or original) can 'be mistaken for its "essence"' (ibid.: 1032).

This contribution to our contemporary use and understanding of the allegory is unrivalled. But Walter Benjamin's inclusion of the perception of time as spatial in the allegoric structure of the *Trauerspiele* is not very present in Owens' application. It is clear, though, that this characteristic is important

when it comes to describing both the force of postmodern allegory as well as the special notion of an unspecific time span, memory, or sensation of something invisible within the photographic installations such as Lose's or Christian Boltanski's. The concepts of the event and time as becoming, as presented by Gilles Deleuze, might be more intimately linked with Benjamin's notion of history as fragments within a spatial continuity of a transforming time with no end. John David Dewsbury and Nigel Thrift have in their article "'Genesis Eternal': After Paul Klee" formulated the relation between space, events, and time as becoming in a convincingly simple way: '[t]he relation of Deleuze and space […] addresses an immanent and becoming world. It maps a world of events not places' (Dewsbury and Thrift 2006: 106). In qualifying the events that can be captured in art they cite O'Sullivan's essay "The Aesthetics of Affect: Thinking Art beyond Representation" (2001) in which he writes:

> In the realm of the virtual, art – art *work* – is no longer an object as such, or not only an object, but rather a space, a zone, or what Alain Badiou might call an 'event site': a point of exile where it is possible that something, finally, might happen. At any rate art is a place where one might encounter the affect. (ibid.: 106, citing O'Sullivan 2001: 127)

The experience of being performatively involved in the 'event site' of an allegoric art installation can bring affective access to real, virtual worlds of past or distant history that are immanently active (yet invisible) in the actual world we inhabit. The photographic allegories of time-space that sometimes employ digital manipulation, visible within the original or in its remediation, function as translators or mediators between worlds (cf. Thomsen 2011).

These installations might open up a productive, political engagement, discovering the ways in which spaces and places are constantly being de- and reterritorialized. Or the fragmentary documentation with found footage and other evidences might encourage the spectator to re-contextualise the indexes and 'reterritorialize the copy', as Groys proposes. British sociologist Chris Rojek, who has worked with the construction of the tourist sight, is likely to agree. In "Indexing, dragging and the social construction of tourist sights" (1997), he describes the ways in which touristic sites are both indexed as 'signs, images and symbols which makes the site familiar to us in ordinary culture' (Rojek 1997: 53) and created as mass-mediated events that '[drag]' and combine 'elements from separate files of representation to create a new value' (ibid.: 54). Instead

of relating his observation to Benjamin's diagnosis (the loss of aura and the production of phantasmagoria), Rojek argues that the indexing and dragging experience of a global television culture, in which transmissions from war zones are mixed with reality shows and fictions, can be seen as a source of pleasure, since '[d]ifference – even if it is artificially constructed – is an immediate source of curiosity' (ibid.: 71).[10]

Constructing time spans for imagination and remembrance

The last exhibition of Lose's that I want to mention here is *Phantasmagorie* (2009), which documented the demolition (2008) as well as the construction (1973-76) of the foremost monument of DDR in Berlin, the Palast der Republik. It housed the parliament amongst other things.[11] In actual photographs, found footage, and various spatial installations the story and the monumental significance of this building was documented. The public opinion as to whether or not it should be demolished after the fall of the Berlin Wall was disparate.

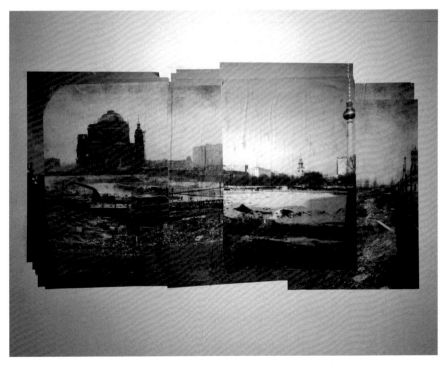

Søren Lose: *History in reverse.* Ca. 50 x 75 cm. Collage of 35 photocopies. © 2009 Søren Lose.

Søren Lose: *Phantasmagorie.* Installation view, Overgaden. © 2009 Søren Lose.

For some it might serve as a monument and remembrance of the socialistic DDR, for others it represented a violent regime and the separation of Germany after 1945. The exhibition showed this disagreement through fragmented photographic representations of the building in its various stages of construction and deconstruction. The performative element of the installation was intensified by the creation of 3D models and spatial installations of parts of the now vanished building.

Benjamin's concepts of history as allegory, the fragmented ruin, and the loss of aura as well as the ever-changing phantasmagoria of modern capitalism are indeed re-contextualised in this photographic re-enactment of the construction and demolition of the Palast der Republik. But although the site of Lose's allegorical supplement to Benjamin's concepts was past and present Berlin, the exhibition took place in Copenhagen (in Overgaden, Institute for Contemporary Art). This spatial displacement is due to the fact that Lose is more famous in his native country than in Berlin, where he lived and worked at the time. It is significant, however, that his allegorical creation of events in between images belonging to different time periods transgresses spatial borders.

National borders as well as former borders between local and global mani-festations are generally challenged in Lose's work. In *HOME*, for example, this challenge is effected by making explicit the gaze of the contemporary global traveller, who is able to re-install aura even in remote and abandoned local places of the (former) nation-state of Denmark. In *Outward bound! Abroad. Homeward bound!*, national borders are challenged by the allegorical re-staging of distant but pre-conceived spaces of the European Neo-Classicistic ideals of universality staged in Italy, which had a significant impact on the artistic and imaginary construction of the Danish nation-state. In *Phantasmagorie*, the ac-tual construction of allegoric ruins for the creation of new and future contexts and memories of a Berlinian past are photographically documented, since the challenging questions to a postmodern and global world according to Lose might be: 'What kind of city do we want? What kind of history do we want to present?'[12]

Contemporary photographic documentations and installations can indeed create images in between spaces and times in the mind, reaching an affective level beyond representation. The interesting thing in this context is that they might be able to unravel and re-inscribe aura in spaces and places where it was never present. This may be done by constructing new allegorical relations be-tween past and present narrations of the nation-states, local and global construc-tions of so-called universal idea(l)s, historical sites, memorials, and buildings.

Works Cited

Appadurai, Arjun (1996). *Modernity at Large*. Minneapolis: University of Minnesota Press.

Benjamin, Walter [1936] (2008). "The Work of Art in the Age of its Technological Reproducibility". In Michael W. Jennings, Brigid Doherty, and Thomas Y. Levin (eds.): *The Work of Art in the Age of its Technological Reproducibility and other Writings on Media*. Cambridge, Mass. and London: Harvard University Press.

Benjamin, Walter [1928] 2003. *The Origin of German Tragic Drama*. Introduced by George Steiner and translated by John Osborne. London: Verso.

Dewsbury, John David and Nigel Thrift (2005). "'Genesis Eternal': After Paul Klee". In Ian Buchanan and Gregg Lambert (eds.): *Deleuze and Space*. Edinburgh: Edinburgh University Press.

Giddens, Anthony (1990). *The Consequences of Modernity*. London: Polity Press.

Groys, Boris (2008). *Art Power*. Cambridge, Mass. and London: The MIT Press.

Kant, Immanuel [1790] (1987). *The Critique of Judgement*. Translated by Werner S. Pluhar. Indianapolis: Hackett Publishing Co.

Levin, Thomas Y. (2002). "Rhetoric of the Temporal Index: Surveillant Narration and the Cinema of 'Real time'". In *CTRL [SPACE] Rhetorics of Surveillance from Bentham to Big Brother*. Karlsruhe: ZKM.

O'Sullivan, P. (2001). "The Aesthetics of Affect: Thinking Art beyond Representation". *Angelaki* 6: 3. London: Taylor & Francis Group, Routledge.

Owens, Craig [1980] (2003). "The Allegorical Impulse: Toward a Theory of Postmodernism". *October Journal*, Spring and Summer 1980. In Charles Harrison and Paul Wood (eds.): *Art in Theory*. USA, UK, and Australia: Blackwell Publishing Ltd.

Rojek, Chris (1997). "Indexing, dragging and the social construction of tourist sights". In Chris Rojek and John Urry (eds.): *Touring Cultures: Transformations of Travel and Theory*. London: Routledge.

Sandbye, Mette (2001). *Mindesmærker. Tid og erindring i fotografiet*. Copenhagen: Rævens Sorte Bibliotek.

Thomsen, Bodil Marie Stavning (2011). "The Haptic Interface. On Signal Transmissions and Events". In Søren Bro Pold and Christian Ulrik Andersen (eds.): *Interface Criticism. Aesthetics Beyond Buttons*. Aarhus: Aarhus University Press.

Tomlinson, John (2003). "Globalization and Cultural Identity". Accessed March 13, 2011: www.polity.co.uk/global/pdf/GTReader2eTomlinson.pdf.

Notes

1 Cf. http://www.kopenhagen.dk/interviews/interviews/interviews_2009/interviews_m_soeren_lose/, accessed March 13, 2011. During his study and afterwards Søren Lose has often lived in Germany (Frankfurt and Berlin) and has exhibited his works in many places across Europe.

2 Working with found footage in film and photography describes the creation of new contexts and meanings for photographic or filmic material that is not produced by the artist himself. In Lose's case found footage also emphasises the general reproductive practice of photography, since he handles it as original negatives. In analogue photographic reproduction the original to the copy is indeed the negative. Whether it is a negative or a found footage the original is removed in time and space from the here-and-now of the exposure. So the found and photographed scene of aura is destined to be lost in all analogue photographic reproduction, even though it bears an indexical trace of the exposure.

3 This phrase refers to one of Søren Lose's installations and the catalogue for it, *Mellem-billeder* (2006), which contains his series *The Rhodes Lead* and *Rhodes revisited* as well as his *Panorama* and *Hotel* series from classical touristic sites. These works will not be commented on separately here.

4 Søren Lose is not the only contemporary photographer taking this position. Historical reference could be made to Ed Ruscha, who is normally related to pop-art and the conceptual photographic tradition. Ruscha made allegoric readings possible in making photographic paintings and thereby questioning both the represented idea and the different media reproductions. A contemporary example of an allegorical and documenting photographic practice that has also embraced installation art is that of Christian Boltanski, noteworthy in his exploration of the traumatic realism of the past (cf. Sandbye 2001).

5 Cf. http://www.sorenlose.dk/, accessed March 25, 2011.

6 Full text in *On the Concept of History* IX, often referred to as *Theses on the Philosophy of History*, in *Walter Benjamin: Selected Writings, Vol. 4, 1938-40* (Cambridge, Mass.: Harvard University Press, 2006).

7 The building of the museum was initiated in 1839 and opened in September 1848, nine months before The Constitutional Act of Denmark was verified in June 1849. Lose's exhibition, which in many ways reflected the construction of the nation-state in relation to universal notions of archaic (Greek and Roman) humanity, was made on Lose's initiative. Cf. http://www.thorvaldsensmuseum. dk/udstillinger/tidligere/ud_ude_hjem_, accessed March 13, 2011.

8 His sculptures were interpretations of Greek and Roman mythology within the framework of New Classicism. The famous sculpture *Jason with the Golden Fleece* (1803) came to represent the post-revolutionary ideals of freedom, equality, and brotherhood.

9 In this context of Thorvaldsen's museum it is interesting that the allegoric figure was banned in Neo-Classicism and in the post-revolutionary literature and art in favour of the much more transparent figure of the symbol.

10 The research fields of emotional geography, tourist studies, and event culture that have been outlined by Chris Rojek, John Urry, Scott Lash, Nigel Thrift, Joe Pine, and Jim Gilmore among others have since the 1990s opened up new interpretations along this line of argument.

11 The royal Stadtschloss Berlin in the style of a baroque castle was previously situated here. It was damaged in World War II and was later demolished by the GDR authorities in order to make space for the Palast Der Republik and other buildings. After the demolition of the Palast der Republik private funding has initiated a reconstruction of the facade of the castle that is planned to house a first class hotel as well as shops, restaurants and a Business Centre (http://www.stadtschloss-berlin. de/, accessed March 13, 2011). If realised this monument of the former Prussian regime will also be an effective erasure of 44 years of GDR history from the city-plan of Berlin.

12 Cf. http://www.berlinaut.um.dk, accessed March 13, 2011.

The Body As 'The Place of a Passage'

On the Spatial Construction of Time in Olafur Eliasson's Installations

By Ulla Angkjær Jørgensen and Bodil Marie Stavning Thomsen

Few would argue against positioning Olafur Eliasson's art production in the context of globalization, although the argument for doing so might prove rather complex. Since he finished his studies at the Royal Danish Academy of Fine Arts in Copenhagen in 1995, Eliasson's works have been shown in the Nordic hemisphere and Europe as well as in influential art museums in North America and lately Japan. In the following we will relate the context and considerations of globalization to different analytical encounters with some of Eliasson's works. Our main point of departure will be the way Eliasson's installations manage to involve the visitor's body in the exposure and sensation of time in space. Many art critics agree that his works reflect how science as well as aesthetics has objectified the world in order to seize it and raise the conception of a Western, (self)controlling subject on its behalf.

However, this deconstructive approach does not account for the positive and unanticipated experience of a relational connectivity formed between the 'world' of the installation and the visitor's sensation of her own bodily presence. The embodiment of time constructed within spatial orientation seems to be a key to the creation of affect in Eliasson's works. With exhibition and work titles such as *Minding the World* (2004), *Your space embracer* (2004), and *Your negotiable panorama* (2006), he brings our bodily positioning in the world to our attention by foregrounding the fact that our sense experience is always prior to conceptualisation and judgment. A certain set of ethical questions about sharing and sustainability is also raised almost immediately by his novel use of common materials like light, ice, and water. The materials are familiar to everyone, and they are bound to elicit questions about the flux of life and our common environment.

In this article we want to relate the broad questions of global awareness and ecological sustainability that Eliasson seems to embrace to various readings of his works through one of his own well known inspirations, namely the philosophy of Henri Bergson, which has later been approved by Gilles Deleuze, Félix Guattari, and Brian Massumi. It is our opinion that the particular positioning of the body that runs through all of Eliasson's works must be evaluated on these philosophic grounds in order to be properly understood. The basic insight that local places are always created within the spatial sensation of time as change allowed within global connectivity is the crux of our interpretation. In the words of Jonathan Crary, commenting on *Your Colour Memory* by Eliasson (2004), one becomes aware of 'one's own body generating chromatic events and transformations' (Crary 2004). The impossibility of reading a clear-cut message due to the involvement of the visitor's body is thus given a positive, reterritorializing force, since Eliasson's works invite us to inhabit the non-inclusive representational space that has become so familiar to us in all kinds of museums. This was indeed the case in one of Eliasson's most popular installations, *The Weather Project* (Tate Modern, 2003-04): people brought blankets and pillows to lay on in order to feel the full power of the rays of the gigantic sun-installation. Our article will also include readings of how involvement is created in the installations *Beauty* (1993) and *Your Watercolour Machine* (2009), how time is appreciated as an aspect of space in the travelling art conversation book *The Goose Lake Trail* (2006), and how the exhibition space of *LAVALAND* (2007) includes the haptic sensations of images and bodies alike.

In his introductory article "From observer to participant" in the encyclopaedic presentation *Studio Olafur Eliasson* (2008), Philip Ursprung raises the question of globalization in relation to Eliasson's work. Ursprung's analysis is based on the definition of Michael Hardt and Antonio Negri, who state that: 'history has been suspended and a kind of eternal present has become the hallmark of globalization' (Ursprung 2008: 19). He notices that Eliasson's art practice bears neither national (Danish or Icelandic) nor regional (Nordic) characteristics. On the other hand, he explains the term globalization in comparison with the Scandinavian company IKEA. The massive scale of IKEA stores worldwide, the use of space to create 'spectacular "installations"', and the impression of a never-ending capacity to implement 'new designs to suit consumer lifestyles' (ibid.: 19) is likened to Eliasson's use of 'space as material for his art' (ibid.: 18), which gives us a capacity to direct 'our gaze to a historical process that for a brief moment becomes visible' (ibid.: 19). In our opinion, this very broad

description needs to include the observer's sensation in order to connect to and inhabit creatively the newly opened spaces of globalization. It is in this spatial experimental zone, in which the construction of time as sensation is central, that we see the potential force of Eliasson's art practice.

Nothing is ever the same

Eliasson, who was born and raised in Denmark by Icelandic parents, lives at present both in Copenhagen and in Berlin, where his study is situated. The Studio Olafur Eliasson employs about thirty people with various skills in art, workmanship, architecture, and science. The creation of an open experimental atmosphere, where the outcome of an experiment is neither sure nor restricted by time-lines, is very important for Eliasson. In 2009 he was appointed Professor of the Institute for Spatial Experiments (affiliated to the College of Fine Arts at the Berlin University of the Arts) and in the programmatic intro, "Nothing is ever the same", he states that it is his ambition for the institute to 'leave behind the representational distance cultivated by traditional art academies' in order to create 'a necessary and immediate relation to the world'.[1] This citation clearly brings the philosophy of Henri Bergson to mind.

According to Bergson's thesis in *L'évolution créatrice* (1907) each of us are involved in a constant interpretation of time and space that are intertwined in perception as well as in memory. Since, by habit, our thinking is more turned towards the intellectual identification of the movement of matter in order to survive and create solutions to many different challenges, we are not always aware of the workings of our intuitive and creative skills. Those are more orientated towards life as such and can be recognised 'wherever a vital interest is at stake' (Bergson 1998: 268). From the point of view of intuition the sensation of life is creative since it gives us 'more power to act and to live. For, with it, we feel ourselves no longer isolated in humanity, humanity no longer seems isolated in the nature that it dominates' (ibid.: 270). Bergson considers individual life as 'nothing else than the little rills into which the great river of life divides itself, flowing through the body of humanity' (ibid.: 270). These sentences, which were first published in 1907, underline the interrelatedness of everything in a *durée* of the life forces: 'the smallest grain of dust is bound up with our entire solar system, drawn along with it in that undivided movement of descent which is materiality itself' (ibid.: 271). Bergson was positively interested in the ability of the free will of the brain (i.e. intuition) to affirm life in a rapture

(*élan vital*). In explaining intuition further Bergson compares it to a lamp that only momentarily lights up the sensation of life itself. Deleuze comments on this in *Cinéma 1: L'image-mouvement* (1983), as he emphasises that Bergson's lamp is not to be conceived as consciousness illuminating things; rather 'it is not consciousness, which is light, it is the set of images, or the light, which is consciousness, immanent to matter' (Deleuze 1986: 60f.). Deleuze thus makes a very important distinction between Bergson and phenomenology, since light shines on consciousness and things alike. They both take part in matter, just as the concept of individuality represents a single division of 'the great river of life' (ibid.).

Eliasson expresses a similar way of reasoning about time and space in his presentation of Institute for Spatial Experiments in Berlin:

> Time and space are considered inseparable even at a methodological level. Space cannot be externalized; it isn't representational and nor are the experiments with which we work. To work spatially does not necessarily entail the creation of representational distance, and we can precisely avoid that distance, essentially static and unproductive, by insisting that time is a constituent of space. (http://www.raumexperimente.net/text-en.html)

In an extended interview in Danish, *At se sig selv sanse* by Anna Engberg-Pedersen and Karsten Wind Meyhoff (2004), he further relates space to the ability to be affected, which has sadly been neglected in the 'regime of transparency' attributed to modernity (Engberg-Pedersen and Meyhoff 2004: 139).

This ambition of Eliasson's to deterritorialize the classical conception of representational, static space and to reterritorialize space as the creation of our sensation of time has not been left unnoticed by art historians. In her article "Light Politics" (2007), Mieke Bal has given one of the best descriptions of the difference between representing space as a landscape on canvas and Eliasson's works that create 'a landscape on the spot and in the moment' noticing that 'this quality of "surroundings surrounded" thus implicates the sense of space itself' (Bal 2007: 156). She continues:

> Experience is at the heart of this approach, and although the experiences the works induce are artificial, isolated from 'life' outside the gallery as it is the mission of 'art' to propose, something real happens during the brief suspension of

disbelief that transforms the subject's sense of self. No longer measurable and external, space, here, is a subjective sensation of being-in-time. (Ibid.)

On this basis she proposes a political reading of Eliasson's work, stating that it 'offers liberation from the myths of our culture and the indifference promoted by representation' and the "I"/"you" exchange across the cultural borders' within which 'otherness' is constructed (ibid.: 178).

In other words, Eliasson's works change our ways of seeing by making us – the visitors – sense ourselves, with Deleuze, as 'a set of movement-images; a collection of lines or figures of light; a series of blocs of space-time' (Deleuze 1986: 60f). The movement-image has in other words escaped (painterly or filmic) representation and narration within a whole, and – with all its techno-logical procedures laid bare – the body within the art installations becomes, with Bergson's words from *Matière et memoire* (1886), 'the *place of a passage* of the movements received and thrown back, a hyphen, a connecting link between the things which act upon me and the things upon which I act, – the seat, in a word, of the sensori-motor phenomena' (Bergson 2004: 197).

The body can be sensed as a confused image of outside and inside just as the ability to represent can be sensed as being part of the perceiving experi-ence, and therefore 'past or even present perceptions [cannot be localised] in the brain: they are not in it; it is the brain that is in them' (ibid.: 196). With the undermining acts of Bergson and Deleuze towards the conception of brain (consciousness), subjectivity, and representational (distance to) matter, it is possible to understand Eliasson's art practice as implicating the body as 'the place of a passage' that is always affected by its surroundings and thus creat-ing time. In an interview, "Of Microperception and Micropolitics" (2008), contemporary philosopher Brian Massumi, who is inspired by Bergson and Deleuze, sums it up: 'affect is not in time, it makes time, it makes time present, it makes the present moment, it's a creative factor in the emergence of time as we effectively experience it; it's constitutive of lived time' (McKim 2008: 9). Sensation of time is in other words produced within the experience of being affected by and perceiving space.

Globalization and the body in space

Whereas Bergson's conceptualisation of intuition and *durée* is linked to past, present, and future life connecting all matter and all spaces on a timescale that might be called global, the present conceptualisation of globalization is far more intermingled with historical processes. To use Arjun Appadurai's reasoning in the interview "A man behind scapes" (2006), modernisation 'has a kind of one-way temporality whereas globalization has more spatiality' that is further qualified as 'simultaneity' and 'horizontality' (Rantanen 2006). This observation is materially qualified first and foremost by the global workings of new media. Massumi supplies Appadurai's observation in acclaiming this 'hyper-complex situation of flow and variation over which there's no effective oversight' (McKim 2008: 13). He continues: '[T]here is no vantage point from which you could encompass it all; there is no shared perspective from which to find a common language or build a consensus or share a rationality' (ibid.). He proposes (with Stengers and Guattari) a new kind of 'ecological politics' in which 'affective intensity and an aesthetics of varying life potential' are the main elements. This politics can also be applied to aesthetic events:

> Aesthetic politics brings the collectivity of shared events to the fore, as differential, a multiple bodily potential for what might come. Difference is built into this account. Affective politics, understood as aesthetic politics, is dissensual, in the sense that it holds contrasting alternative together without immediately demanding that one alternative eventuates and the others evaporate. It makes thought-felt different capacities for existence, different life potentials, different forms of life, without immediately imposing a choice between them. The political question, then, is not how to find a resolution. It's not how to impose a solution. It's how to keep the intensity in what comes next. (Ibid.: 12)

This description covers Eliasson's power to create non-representational spaces in which the differential thought-felt sensations of space can be activated in time as a becoming of new possibilities. The de- and reterritorialization of space – whether geographic space or space constructed in an installation by various media – is held open, non-conclusive. And in this momentum (of an exhibition or a journey) the spatial creation of time can be sensed and even conceptualised. Eliasson reflects on this in *Studio Olafur Eliasson. An Encyclopedia* (2008) as he

imagines his body to be 'a stick of measurement' measuring space as he moves in the landscape known as the Goose Lake Trail in the Icelandic Highlands:

> With this conception of the journey, depth is suddenly seen as originating in the person moving; to journey thus means to apply depth to a space – which is very abstract, of course. When I'm standing still in the Icelandic landscape, it looks like a painting, and it's impossible to judge distances. But then I move, and the speed and the way in which my body engages with the space begin to constitute a journey. It's the memory of the distance I've already covered that becomes the measurement of space. Measurement is thus internalized. (Eliasson and Engberg-Pedersen 2008: 219)

This quotation relates to Eliasson's trip with art critic Hans Ulrich Obrist in 2005. Their journey-conversation in a jeep (with a panoramic cupola built on top) was later documented with photographs, maps, and words in the book *The Goose Lake Trail (Southern Route). A road conversation between Olafur Eliasson and Hans Ulrich Obrist* (Eliasson and Eidar Art Center 2006) can be viewed as an artwork in which the art critic acts as a performative stand-in for the reader. The pictures in the book (except for one) represent either different landscapes with no signs of territorialization, the car in the landscape, or Obrist in the car looking out into the landscape. He becomes the 'substituted body' for the reader acting as a 'stick of measurement' to create the sensation of shifting spatiality. Obrist appears in only one picture, photographed standing with the landscape behind him, wearing white trousers, jacket, and hat. He looks so peculiar and

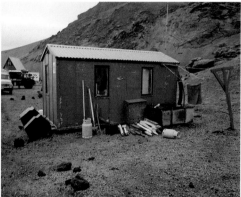

Photo: Olafur Eliasson. © 2005 Olafur Eliasson.

strange in the landscape that it is impossible not to look at him as a case: the case of the art critic outside the walls of the art institution figuring as a deterritorialized 'measuring stick'.

The transformation of place into space

The joint exhibition and book *LAVALAND* (2007) with the Icelandic painter Jóhannes S. Kjarval (1885-1972) is an examination of human experience of spatial landscape. In the exhibition Eliasson's own initial experience of the Icelandic landscape as a painting, as mentioned above, is transformed into what he experiences when moving about in that same landscape. Art historians have usually contextualised Kjarval's work within the frames of National Romanticism with the purpose of making a determining and essentialist link between his works and the specific geographic sites of Iceland (Kielgast and Juul Petersen 2007: 121). Eliasson criticises this endeavour to have Kjarval's work represent a notion of mythical Icelandic landscape. He, for one, sees other potentials in Kjarval's works:

> If [...] we disregard the relation between the artist and nature and instead focus on the relation between the work and the viewer, the question is what relevance a picture painted in, say, 1940 has to us today? Here, it's important to focus on a subjective, individual experience of Kjarval's works. The acceptance of that specific individual approach has largely been rationalized away by the modernist view of art. (Ibid.)

According to Eliasson, the combination of, on the one hand, art history's nation building project, and, on the other hand, the modernist rationale of objective universalism disregard the viewer's own encounter with landscape. We will now take a closer look at Kjarval's work with Eliasson's eye-body-movement point of view of the viewer.

In *Hellisheidi* (1942), Kjarval deploys a classical landscape composition with foreground, middle ground, and background, and due to conventional reading codes of observing at a distance, the viewer is likely to take the picture in as a full wide angle panorama view, and perceive it as a representation of an Icelandic alpine plateau. However, viewers seldom stay in a fixed position; they move about; their bodies move to and fro along the canvas; and they take closer looks at details at close range: all while moving. We never experience pictures from one static point. Though the picture is nailed to the wall, the viewer's percep-

tion is not. Moreover, in *Hellisheidi* the act of movement in space is painted onto the actual canvas surface. Seen up close the foreground of the painting dissolves into millions of particles and formless matter and nature seems to present itself to the viewer as a physical and moving phenomenon, rather than being represented by a fixed landscape with a pictorial outline. This ever-moving dialectic aesthetic between the close-up, haptic qualities of the painting, the micro-level, and the macro-level optical overview that endow the painting with pictorial tradition produces a viewer in motion, is perceptible in most landscape paintings by Kjarval. It is this aesthetic quality in Kjarval's work that transforms Icelandic nature into rhizomatic relations, which Eliasson recognises and identifies with.

Eliasson can be said to take over where Kjarval left off, as he explicitly presents us with a meeting of moving elements. In each of Eliasson's own photo series for the exhibition, for instance *The glacier series* (1999), *The ice melting series* (2002), and *The island series* (1997), all the photographs depict the same motive, yet every single picture is different from the others. There is difference in the actual shapes of the single elements (glacier, ice floe, island) that appear as landscape fragments, and light and colour shift from one picture to the other producing different effects. Together with the repetition of the serial format all these features generate displacement of the sign. But the movement of the viewer's eyesight and body also enhances the displacement of the sign. The viewer perceives single pictures as well as totality, as the human eyesight is capable of two simultaneous reading modes. Humans are capable of both focusing on a single spot and perceiving the totality of the background, or viceversa, focusing on background details and simultaneously retaining what goes on in the foreground. Thus, the movement of a body in a physical milieu and the principle of ever-changing relations question the nature of sign production, or rather, make it a matter of multiple connections, a rhizomatic venture, as described by Deleuze and Guattari in *Mille Plateaux* (1980):

> Let us summarize the principal characteristics of a rhizome: unlike trees or their roots, the rhizome connects any point to any other point, and its traits are not necessarily linked to traits of the same nature; it brings into play very different regimes of signs, and even non-sign states. The rhizome is reducible neither to the One nor the multiple. It is not the One that becomes Two or even directly three, four, five, etc. It is not a multiple derived from the One, or to which One is added ($n + 1$). It is composed not of units but of dimensions, or rather direc-

tions in motion. It has neither beginning nor end, but always a middle (*milieu*) from which it grows and which it overspills. (Deleuze and Guattari 1988: 21)

Eliasson brings 'non-sign states' into places, by which he transforms them into space understood as movement in time. Space is not characterised by the fixed identity of a landscape, nor does a certain staged relation between subject and landscape characterise it; this is his criticism of the Romantic conception.

In the Romantic tradition landscape is constructed as a function of a single axis of sight: the painter-subject seated in nature paints his subject as if it were a picture at the end of his axis of sight, and later the viewer, by way of identification, places herself in that exact same position of the painter and observes the same view. This staging constructs a determinate relation between landscape and painting mediated by the painter's body and later to be consecrated by the viewer. The conception endows the painting with an identity linked to a specific geographical place. It is the result of what Massumi in his *Parables for the Virtual. Movement, Affect, Sensation* (2002) would call 'mirror-vision', or the vision of a single line, a vision that is motionless (Massumi 2002: 48). It produces an objectifying gaze, one that works through identification and representation. The Romantic landscape tradition situates the viewer on that line of vision and forces an objectifying gaze on nature.

Eliasson deploys what Massumi would call *movement-vision*. In contrast with mirror-vision, movement-vision, which we also use, but which is invisible to ourselves, consists of constantly moving positions and hence perspectives. Mirror-vision and movement-vision are discontinuous and the cleft between them cannot be filled, but it may be crossed. You can never see yourself move as others see you move. If you could you would have moved radically into the position of the other; since you cannot concretely move outside yourself this cannot be done. Movement-vision is relational and is guaranteed by an observer. However, it is possible for the subject to assume this observer-position *virtually*. By assuming the virtual position, the subject moves outside herself (Massumi 2002: 50). In *Lavaland* there is one such situation, in which the viewer is made aware of the virtual position and can observe herself in the act of moving and perceiving, in the installation *Color Motoric Entrance* (2004).

Color Motoric Entrance is a mirror the size of a door covered with a colour effect filter and mounted on a wall opposite a staircase of floating stairs. The walls are covered top to bottom with black and white photos from Eliasson's

Olafur Eliasson: *Colour motoric entrance*, 2004. Wood, colour-effect filter glass, mirror, 210 x 85 x 15cm. Courtesy of the artist; neugerriemschneider, Berlin; and Tanya Bonakdar Gallery, New York. © 2004 Olafur Eliasson.

Cartographic series. The room is somewhat claustrophobic and as an exhibition space it is, in fact, a bit hopeless. Eliasson, however, uses it to his advantage to make the viewer see herself in the act of perceiving. The colour effect filter on

the mirror splits light into colours and produces a three-dimensional effect. When moving up the stairs, which spiral upwards in a half circle, and looking in the mirror on the other side of the room you perceive yourself moving away from yourself in three-dimensional space in the mirror. The mirror brings about the realisation of the virtual position. *Hydro Mobile* (2003), too, deals with this problematic, though in a different way, as it does not allow you to see yourself, but instead to sense the presence of something moving behind you. It is a big mixed media mobile placed in front of *The glacier series*. It consists of three arms, one holding a lava stone, one holding a rhombic triakontaeder (mounted with c-prints of landscape) and one holding a mirror crystal. In watching *The glacier series* and moving in front of it you would sense fragments of lava, light reflections (from the mirror crystal), and multi-perspective landscape views behind you as real, but virtual, presences within your moving radius.

Lavaland presents the world in a multi-faceted perspective where there is no vantage point, no history, and no opportunity for projections of the I or the Other onto the landscape. It is the Earth seen from positions that give back anonymity to nature, and yet it places human experience at the heart of its investigation; it is in their physical state of being that viewing bodies are drawn into a relation with the works. Eliasson's open works stage globalization processes at the exchange level of humans and milieu and as such they are potentially open to all physical bodies moving in space independent of cultural background. To paraphrase Deleuze and Guattari (1988: 11-12), the viewer performs a mapping in her interaction with the works. They prefer the map to tracing as tracings always refer back to something. The rhizome performs its own mapping with multiple entryways. It does not reproduce, but produces: 'What distinguishes the map from the tracing is that it is entirely oriented toward an experimentation in contact with the real' (ibid.).

Looking at *Cartographic series III* (2004), it strikes you how the reading of it fits the following quotation by Deleuze and Guattari that has, in fact, the form of a precept:

> Always follow the rhizome by rupture; lengthen, prolong, and relay the line of flight; make it vary, until you have produced the most abstract and tortuous of lines of n dimensions and broken directions. (Ibid.)

The *Cartographic series III* consists of thirty square memory-like cards of black and white photogravure shot from the air at a right angle down towards Earth.

Olafur Eliasson: *Cartographic series III*, 2004. 30 colour photogravures, (blue, green and violet), series: 249,8 x 300 cm; each: 51,7 x 51,7 cm. Photo: Jens Ziehe. Courtesy of the artist; neuger-riemschneider, Berlin; and Tanya Bonakdar Gallery, New York. © 2004 Olafur Eliasson.

They form thirty autonomous topographic maps, the world in pieces, of land-scape fragments on the brink of being unrecognizable: curved and winded lines, dots, stripes, waves that produce abstract patterns. Hence the Earth appears as horizontal, rhizomatic movements in which one type of sign can easily develop into another type, depending on how the cards are placed in relation to each other, and it seems as if the cards are welcoming any other arrangement you would prefer.

In choosing the name LAVALAND (land of lava), Eliasson wants perhaps to free the land of Iceland from the storytelling of the nation-state and instead have us sense and experience our particular, bodily encounters with nature. It could be argued that ICE-LAND would have been as good a title with its ref-erence to the natural and specific phenomena of the country, the ice glaciers. However, considering that ICE-LAND, as well as GREEN-LAND, remind us

of the first territorialization of the Nordic region and the powerful imagination of the Vikings, the first European explorers of the North, the new name of LAVA-LAND is Eliasson's way of getting 'post' the semantics of both colonial and nation-state pasts.

The weather project

In the interview with Hans-Ulrich Obrist in *The Goose Lake Trail*, Eliasson talks a great deal about the weather. His sensitivity to the wind is like that of a sailor. In an opening remark he says: 'South behind us, north in front. The wind, as you can hear, is blowing from north-north-east' (Eliasson 2006: 9). He can almost tell the coordinates from sensing the wind in a particular place, and also perceives how the weather changes landscape:

> For example, in the mere fifteen minutes since the beginning of this interview, the wind has turned south, creating a very strange situation in which we have blue sky and sun overhead but less than a kilometer, maybe a half kilometer, in the distance, the rainy clouds loom above the glacier. The wind therefore makes this little strip open for us. (Ibid.: 15-16)

The preoccupation with the weather is symptomatic of his interest in the changeability and particularity of time/space relations.

In 2003-2004 the installation *The Weather Project* attracted more than one million visitors to see the massive, hazy sun in Tate Modern's colossal Turbine Hall. The considerable number of photos available on the internet show what a real popular hit it was, something that is very rare for a single art object. Eliasson transformed the Turbine Hall into a misty atmosphere of yellow-orange light, which evidently created a feeling worth travelling for. People gathered on the floor in front of the big sun just to be there, stay there, and wonder at it. The installation was in a sense very simple; it consisted of a mirror in the ceiling, which effectively doubled the size of the hall, and a half sun made of two hundred mono-frequency lamps that was also doubled by the mirror and essentially formed a full circle. Clouds of light fog would now and then blow into the space producing the misty atmosphere. The native country of J.M.W. Turner (1775-1851), Eliasson's single most weather-oriented predecessor, was an obvious place to exhibit the sun: within the Tate organisation and on the opposite riverbank of Tate Britain, which houses a substantial collection of

Turner paintings. Like Eliasson's reworking of Kjarval's paintings it is possible to read *The Weather Project* as a reworking of Turner.

Turner, too, was very preoccupied with the sun. He painted countless pictures of sunsets and sunrises and his ability to have his subject dissolve into light and colour is outstanding in art history. In his studies of sky and sea, the landscape becomes a saturated atmosphere of light and water as if the motif is transformed into its status among Earth's elements. Turner's ability to keep his subject on the threshold of abstraction and his tendency to leave larger areas in his paintings to pure abstraction, together with his pioneering studies of light, colour, and atmosphere, have earned him a status as an anticipator of Impressionism. In Turner's pictures there is also an interplay between haptic and optical perspectives, between the haptic, abstract, atmospheric areas of light and colour, and the optical perspective created by the vanishing point. Often the background, formed by a cloud of atmospheric light and colour in the viewer's perception, is dragged into the foreground in front of the vanishing point, actually questioning the construction of illusionistic space.

As a true Romantic, Turner was on the quest for the sublime and as if he were aware that the sublime cannot be given visual form, as it is for the subject to experience, he instead created hundreds of singular moments of haptic beauty for viewers to experience from their singular positions. Browsing through a book of Turner pictures is like going through a chain of unique moments of which repetition seems to be a key feature. The repetition reminds you that 'something' – hidden in the misty colour and light – always escapes formation. In Turner the singular movements of the viewing body-subject are therefore inscribed in the endless repetitions of the same, but always different, motif of light and colour.

Eliasson carries on Turner's project in *The Weather Project*, in works such as *Beauty* (1993) and *Your Watercolour Machine* (2009). He places the physical moving body of the viewing subject at the centre of colour production. *Beauty* is a simple installation in a dark room. A projector faces a 'curtain' made of fine drops of water. The water sprays out of the nozzles of a hose directly onto the floor. If the visitor stands in a particular place at the proper angle, she will see a rainbow. A child of a different height will see another rainbow. Moving or changing one's position will allow different colours of the spectrum to become visible (Eliasson 2004: 65). In *Your Watercolour Machine*, made for the COP15-exhibition *Rethink Relations* at The National Gallery of Denmark (2009), a projector casts a ray of light on a prism that splits light into the colours of the rainbow. The beam of colours is then reflected in a basin of water,

which is rolled by a motor producing waves. From the vibrating water level the ray of colours is projected onto a black screen, making a moving image of the rainbow and always creating a different moving image. It is a mechanical signal transmitter, as it were. The three works all demonstrate the constant emerging of colours from light by means of the subject-body moving in space. The different situations created by different viewers will produce singular experiences. You and I can never be sure that we have the exact same experiences of the colours in the rainbow, as the real colour-experience cannot be measured. As Brian Massumi states in his critique of the gaps of science:

> [T]he objective color-dimensions of hue, saturation, and brightness that can be defined in terms of wavelength properties of light cannot account for the full range of real color-experience. The scientific truth of light accounts very well for the possibility of color in general. But the reality of color extends to objectively impossible effects of relationality as they figure in *this* perception and *this* one … and *this* other one. By shunning those singular quasi-causal effects, science usefully limits its empiricism. It pays a price for that functionality: the glow. The glow does not exist for it. The unique color-quality of a sunset does not exist for the scientific observer. But then what can you do with the glow of *this* sunset anyway? Just wonder at it. (Massumi 2002: 239)

The glow, the wonder; perceptions are always different. Massumi's statement more or less covers Eliasson's own reflections in *The Goose Lake Trail*:

> I think we, and a few older generations, are the first to understand that one should be careful not to talk about color and landscape in universal terms. A sensory experience may be valid for you and me in the present, but the danger lies in imposing our excitement and the sensual engagement in our great journey on others as more or less essential qualities. I am passionate about discussing colors, and I don't think it's wrong to voice emotions if I've just had a moving personal experience, but the responsibility that I have, or my generation have, is to be able to talk about something amazing, a beautiful color for instance, without imposing these universal value systems onto our contemporaries – the way former generations did. So I am perhaps in a situation right now where I would like to keep the colors to myself. (Eliasson 2006: 30)

We think it fair to conclude that what is undertaken in the works of Eliasson is a deterritorialization of art at the level of representation, since 'art' as well as the sensation of time emerges in moments by means of the physical and situated participation of the viewer. On the other hand a reterritorialization is taking place at the level of 'nature', which is now staged as art. Eliasson's art practice acknowledges the body-in-motion and addresses this 'place of a passage' as something that is very different from the I/eye of a viewer belonging to a representational art practice. The conditions of globalization, in which local as well as global surroundings can physically affect bodies, are articulated in such a way in Eliasson's works that the possibility of 'ecological politics' can be envisioned.

Works Cited

Bal, Mieke. (2007). "Light Politics." In M. Grynsztejn (ed.): *Take your time: Olafur Eliasson*. San Francisco Museum of Modern Art: Thames & Hudson.

Bergson, Henri [1886] (2004). *Matter and Memory*. Cambridge, Mass.: The Massachusetts Institute of Technology Press.

Bergson, Henri [1907] (1998). *Creative Evolution*. New York: Dover Publications.

Crary, Jonathan (2004). "Your Colour Memory: Illuminations of the Unforeseen." In Olafur Eliasson and Gitte Ørskou (eds.): *Olafur Eliasson: Minding the world*. Aarhus: ARoS Aarhus Kunstmuseum.

Deleuze, Gilles [1983] (1986). *The Movement-Image*. Minneapolis: University of Minnesota Press.

Deleuze, Gilles and Félix Guattari [1980] (1988). *A Thousand Plateaus. Capitalism and Schizohrenia*. London: The Althone Press.

Eliasson, Olafur (2004). *Your Lighthouse. Works with Light 1991-2004*. Ostfildern-Ruit: Hatje Cantz Verlag.

Eliasson, Olafur and Eidar Art Center (eds.) (2006). *The Goose Lake Trail (Southern Route). A road conversation between Olafur Eliasson and Hans Ulrich Obrist*. Cologne: Verlag der Buchhandlung Walther König.

Eliasson, Olafur and Anna Engberg-Pedersen (eds.) (2008). *Studio Olafur Eliasson. An Encyclopedia*. Hong Kong, Cologne, London, Los Angeles, Madrid, Paris, Tokyo: Taschen.

Eliasson, Olafur (2009). "Nothing is ever the same." Accessed June 17, 2010: http://www.raumexperimente.net/text-en.html.

Engberg-Pedersen, Anna and Karsten Wind Meyhoff (eds.) (2004). *At se sig selv sanse. Samtaler med Olafur Eliasson*. Copenhagen: Gyldendals Bogklubber.

Kielgast, Anne and Lotte Juul Petersen (2007). "A Conversation with Olafur Eliasson about LAVALAND." In Maj Dannemand, Anne Kielgast, and Lotte Juul Petersen (eds.): *LAVALAND. Olafur Eliasson & Jóhannes S. Kjarval*. Copenhagen: Kunstforeningen Gl. Strand.

Massumi, Brian (2002). *Parables for the Virtual. Movement, Affect, Sensation*. Durham & London: Duke University Press.

McKim, Joel (2008). "Of Microperception and Micropolitics. An interview with Brian Massumi, 15 August 2008." *INFLeXions: A Journal for Research-Creation* 3, October 2009 (www.inflexions.org).

Rantanen, Terhi (2006). "A man behind scapes: An interview with Arjun Appadurai." *Global Media and Communication* 2006 2: 7 (http://gmc.sagepub.com).

Ursprung, Philip (2008). "From Observer to Participant." In Olafur Eliasson and Anna Engberg-Pedersen (eds.): *Studio Olafur Eliasson. An Encyclopedia*. Hong Kong, Cologne, London, Los Angeles, Madrid, Paris, Tokyo: Taschen.

Witzke, Anne Sophie and Sune Hede (eds.) (2009). *Rethink Relations. Contemporary Art and Climate Change*. Aarhus: Alexandra Instituttet, Aarhus University.

Notes

1 http://www.raumexperimente.net/text-en.html, accessed June 17, 2010.

Established identity categories
under transformation

Nordic Jaywalking in Contemporary Visual Art

By Lotte Philipsen

It is a fact that the world of contemporary visual art is globalized today. On an institutional level, galleries, museums, dealers, auctions houses, and art fairs engage in exchanges and collaborations across the world, and successful artists spend a large part of their time travelling between venues preparing for new exhibitions. Therefore, it makes little sense to speak of Nordic contemporary art as something that exists 'in itself'. Yet the idea of 'Nordic art' is articulated as a form of strategic essentialism in the art world – just like other national or regional brands such as 'Chinese art' or 'art of the Middle East' – and it is the aim of this article to investigate how Nordic art is articulated in different ways, by whom, and eventually why. In order to demonstrate concretely how artistic strategies and institutional mechanisms generate a number of theoretical de- and reterritorializations in this field, the text will take its point of departure in a specific work of art: *The Collectors* (by Elmgreen and Dragset) at the Venice Biennial in 2009.[1] After introducing this work and its institutional circumstances, the article shall discuss the issue of site-specificity in relation to contemporary art, and then move on to analyse how authorship – of Nordic art among others – is constituted through the acts of collecting and presenting. Finally, the motives for establishing such authorships of Nordic art are discussed.

Institutional organization

In order to understand how the Nordic was at work in Venice 2009, a basic understanding of the background is necessary. The Venice Biennial was established in 1895 as the world's first biennial of contemporary art, and its organisational principle is that each participating country has its own pavilion, for which the country selects one or more of its artists to exhibit.[2] Like most other countries

Denmark has its own pavilion, and the Danish Arts Council appoints the exhibiting artist(s) for each biennial, along with a commissioner who is responsible for the practical and financial aspects of the exhibition. Sweden, Norway, and Finland, however, share a pavilion, the Nordic pavilion, which is located right next to the Danish pavilion. Accordingly, Sweden, Norway, and Finland need to cooperate on the exhibition in the Nordic Pavilion. They achieve this by rotating the responsibility of hosting the pavilion, so that in 2009, Norway's Office for Contemporary Art was officially the host that initiated the project, in 2007 it was the Finish Foundation for Art Exchange, and in 2005, it was Sweden's Moderna Museet.

In addition to being a part of the Nordic pavilion, Finland has its own separate pavilion located in another part of the biennial area, which they often rent out to Iceland; it is not possible to build more pavilions in the main biennial area – a number of countries new to the biennial rent exhibition venues all over the city of Venice outside the area reserved for the biennial. Altogether this constitutes a rather heterogeneous and illogical institutional picture of the Nordic representation in Venice: Sweden, Norway, and Finland share one pavilion, but Finland has one of its own, too, and Denmark is not part of the Nordic pavilion, but has its own pavilion right next to the Nordic one.

The complex structure dominated by inconsistent demarcation lines (of nationality, regionality, and concrete territory) that exist in relation to Nordic art at the Venice Biennial perfectly mirrors the ambivalence of the Nordic in general, which is a balance between a physical region and a political idea based on historical alliances and colonisation – for instance Greenland is generally considered more Nordic than Great Britain is. And the complexity of the biennial structure is likely to increase as the process of Nordic decolonisation develops. Thus independent presence at the biennial of Greenland or Sápmi may emerge in the future, just as Palestine and the Roma people, among other cultures or societies with no country of their own, have had pavilions in Venice.

In 2009, the adjoining Nordic and Danish pavilions collaborated for the first time, when the national art councils involved agreed to commission the Danish/Norwegian artist couple Michael Elmgreen and Ingar Dragset to be in charge of one overall project including both the Danish and the Nordic pavilions (the separate Finnish pavilion was not included in the project, since it exhibited an installation by Jussi Kivi). The commissioners, who have been working together as artists since 1995 under the name Elmgreen & Dragset,

executed the installation work *The Collectors* and hence not only fused the artist's and commissioner's roles, but also linked the institutional structures normally separating the two pavilions (the Danish Arts Council and The Nordic Pavilion). We shall turn to the work itself to see how.

The Collectors

The general idea was that both pavilions were staged as private homes – one being offered for sale (indicated by the sign of an Italian estate agent in front of the house), while in front of the other, a body assumed to be that of the owner floated in the swimming pool. The houses had similar letterboxes outside, one reading 'A. Family' and the other 'Mr. B', but otherwise they were – as the pavilions always are – in different architectural styles. In order to create the illusion of private homes, both pavilions were staged with furniture and decoration, most of which turned out to be singular works of art in their own right, by various artists.

One example that may illustrate how the projects staged a constant oscillation between a fictive private home and a 'real' public art exhibition was the photo album on the coffee table in the Family house, which was actually a work by Thora Dolven Balke – an almost absurdly huge, heavy, bound album, with only a few tiny, unfocused, and abruptly cropped Polaroid photos in the centre of each leaf. Flipping through the pages of the album seemed to reveal decades of private, visual memories of the family in and around a Swedish cabin, but at one point a fragment of another house in wintertime turns out to be the very building of the Danish pavilion, which had an uncanny effect on the viewer, since the exhibition opened in June.

Of course, the viewer is at all times well aware that this is an art exhibition, and as a consequence, any private and personal authenticity related to the objects on display is suspended and replaced by their exhibition value in this spatial and discursive setting. Yet in the 'private' photos showing fragments of the *pavilion* in winter (and not a Swedish cabin like in most of the photos), the illusory privacy invades the *temporal* dimension, which catches the viewer off guard and renders the discursive foundation shaky: in the context of the biennial, this is an art installation that we pretend is a private home and which includes an exhibition object that we pretend is a private photo album, but now it seems that this privacy extends backwards in time, *prior* to the period in which the installation and the object exist *as art*. The diegetic 'private' authenticity that is framed

Installation shots from *The Collectors*. The Danish & Nordic Pavilions, 2009, 53rd International Art Exhibition – La Biennale di Venezia. Photographs: Anders Sune Berg.

by the exhibition discourse suddenly seemed to transgress this discourse, and frame the exhibition itself. Thus a deterritorialization was at work between authentic privacy and artistic publicity, insofar as the former is seen in the work of art, while at the same time the latter is staged as if it were a private domain. And the work consequently points to the fact that institutionally the national – or, in this case, regional – pavilions at the biennial are national 'homes'.

In addition, we may speak of a deterritorialization of the relation between the singular *work* and the institutional framework of the *exhibition*, since the album exemplifies a general indeterminacy about whether *The Collectors* is a work of art or an art exhibition. Balke is only one of 24 artists (from Nordic and other countries) whose works are curated in the exhibition – among them Elmgreen & Dragset themselves, who contributed several single works of art to the larger work. A web of (almost tautological) relations thus exists between specific works of art (like Balke's album), *The Collectors* as the overall work of art, and the curatorial and architectural framework of Nordic art at the Venice Biennial. The traditional way of creating exhibitions, in which the curator se-

lects a pre-existing work and presents it in a pre-existing gallery, is increasingly being replaced by other procedures, as in this case, which make it difficult to distinguish between the art and the framework presenting it. Since the artistic tendency of the 1970s known as Institutional Critique, artists have focused their attention on the institutional framework, and with the rise in the 1990s of New Institutionalism, the art institutional apparatus has increasingly invited artists to engage in the discursive presentation of art.[3] The increased engagement between art and institutional framework can be regarded as a consequence of the fact that the concept of art at work in contemporary art is in accordance with institutional art theory – meaning that art is defined neither by sensuous nor normative qualities, but by descriptive inclusion in the art institutional apparatus through its professional agents.[4]

Discursive displays

The fact that the pavilions at the biennial function as national art homes demonstrates in itself the global dimension of the art world, because the idea of globalization invokes the bringing together of specific territorial cultures (local or regional) across the globe into large networks of different types – or large 'scapes' as described by Arjun Appadurai.[5] Though the specific territorial origin of a cultural phenomenon may not be of great significance once it is part of a broader global culture, the *idea* of territorial origin seemingly plays a significant role – as is testified by the importance ascribed to the Venice biennial. It is therefore interesting to look into the concept of site-specificity, which, according to art historian Miwon Kwon, strongly characterises contemporary art.[6] Kwon considers site-specificity in art along three different paradigms: *phenomenological* site-specificity (experimenting with and challenging the viewer's experience of a specific physical site), *social/institutional* site-specificity (considering specific politics of representation, visibility, and exclusion) and *discursive* site-specificity, in which the site 'is not defined as a *precondition*. Rather, it is generated by the work (often as "content"), and then verified by its convergence with an existing discursive formation' (Kwon 2004: 26). Applying Kwon's ideas on site-specificity to *The Collectors* in the following allows us to elaborate on the relationship between the work and the Nordic.

A phenomenologically and physically site-specific dimension of the work is invoked by the fact that a number of the works by other artists curated by Elmgreen & Dragset in *The Collectors* relate directly to the specific context of

The Collectors as the overall work – for instance, as mentioned above, the photo album by Balke includes references to the Danish pavilion in winter. In addition, *The Collectors* as the larger work was physically site-specific through its intense staging of the exhibition's architectural framework. Rather than treating the two pavilions as empty buildings whose job it was to contain the work(s) of art, the existing architecture constituted a set of important points of reference for *The Collectors*, through the very application of an artistic home metaphor. This physical site-specificity of the work, however, strongly invoked a second, *institutional*, site-specificity, since the pavilions' representational function as 'homes' of the Nordic on international territory became a theme in the work.

It is important to stress that the fact that Elmgreen is a Danish citizen and Dragset a Norwegian does *not* add to the work's Nordicness in any physical or indexical manner, since today the successful artist is constantly on the move between the biennials and metropolises of the world – Kwon makes use of the term 'itinerant artists'. In any case, when not travelling Elmgreen & Dragset are based in Berlin.

In addition to the physical site-specificity (manifested by singular works specifically relating to the architecture of the pavilions) and the institutional site-specificity (of *The Collectors'* implicit discussion of the home of Nordic art in a globalized world of contemporary art), a discursive site-specificity permeated *The Collectors* and constituted its Nordic-ness. This was invoked by what art theorist Boris Groys terms 'multiple authorship',[7] which he characterises in this way:

> When confronted with an art exhibition, we are dealing with multiple author-ship. And in fact every art exhibition exhibits something that was selected by one or more artists – from their own production and/or from the mass of readymades [and/or from the production of other artists, we may add]. These objects selected by the artists are then selected in turn by one or more curators, who thus also share authorial and artistic responsibility for the definitive selec-tion. In addition, these curators are selected and financed by a commission, a foundation, or an institution [who] also bear authorial and artistic responsibil-ity for the end result [...] From this circumstance result multiple, disparate, heterogeneous authorships that combine, overlap, and intersect, without it being possible to reduce them to an individual, sovereign authorship. (Groys 2005: 93-97)

According to Groys, then, the process of selecting and presenting – at many different levels – defines the fundamental form of art exhibitions today, and in the above statement, he accurately accounts for the mechanisms implicitly involved in the creation of *The Collectors* at a structural or formal level. However, this process was explicitly articulated at the thematic level of *The Collectors*, too, as the title suggests, since both fictive homes included collections of their own.[8] To mention a couple, the Family house included a collection of flies neatly pinned and ordered in hanging display cases in the library (Fredrik Sjöberg's 'Fly Collection'), and in the dining room, a collection of beggars' signs from all over the world was on display – each sign in its own golden frame, with a small plate giving the name of the city from which the sign originates.

Likewise, the home of Mr. B contained a collection of underpants – again, neatly framed with plates revealing the names of, presumably, their former owners. The presence in Mr. B.'s house of drawings, videos, and other items depicting sexual motifs from a gay universe suggested that the underpants were collected as trophies from love affairs. In general, many of the works in *The Collectors* included more or less explicit references, which, taken together, formed a homoerotic theme throughout the project. To the viewer with background knowledge of Elmgreen & Dragset, this theme contributed to the deterritorialization between authentic privacy and artistic publicity

Jani Leinonen: *Anything Helps*, 2005-2009, Begging signs, frames. Dimensions variable. Courtesy of the artist. Photograph: Anders Sune Berg.

Han & Him: *Butterflies*, 2009, Steel frame, glass, fabric. 180 x 150 x 6 cm. Courtesy of the artists. Photograph: Anders Sune Berg.

mentioned above, since Elmgreen and Dragset used to be a couple in their private life, too.

The extensive presence of actual collections (especially in the Family house) pointed directly to the act of selecting and displaying. However, the exhibition's catalogue also invoked this dynamic interplay of multiple author roles through a constant oscillation between the discursive domains of works of art and mere objects.

The catalogue did not come in the form of a book, but in the form of a canvas bag holding a number of different items, such as an Italian salami (vacuum packed) selected by artist Maurizio Cattelan, one tiny bronze pea in a sachet by artist Nina Saunders, a collection of nine postcards by artist Martin Jacobson, and a notebook with the story (seemingly handwritten) *The 'Curiosity' and its Owner* by poet Annelie Axén, just to mention a few.[9] Unpacking the catalogue items was therefore a physical experience, rather than an intellectual reading of texts about the work, since the catalogue buyer finds him- or herself deeply immersed in uncovering, twisting, turning, and investigating the treasures hidden in the bag, and rather than describing or analysing the work, the catalogue seems to extend the work itself into the private sphere of the visitor. Only this time it is the 'reader' her- or himself who becomes the collector of strange objects.

Accordingly, the catalogue provides the experience of the actual exhibition with a certain *Nachträglichkeit*, insofar as it adds further artistic layers to the installation. In contrast to most catalogues, the added layers do not belong to critical or academic domains, but are aesthetic texts (in the broadest sense) that remain within the discourse of the work of art. For instance, a calendar – with personal notes by Elmgreen & Dragset printed on certain dates – includes a story entitled *Another Death in Venice* by Dominic Eichler.[10] Though Mr. B has drowned in his own pool within the fictive framework of the exhibition text, he addresses us in the first person in this written text in the calendar, which begins with the sentence 'You can imagine my surprise to learn that I have been pronounced dead' (Eichler 2009). Just as the title of the story paraphrases Thomas Mann's famous *Der Tod in Venedig* (1912), the narrator makes a comment to the homoerotic theme of the pavilion by stating that 'I have absolutely no intention of popping an artery on a dirty Lido beach watching oil tankers drift by, stressed out to the max by an unattainable golden youth' (Eichler 2009). Clearly, the points of reference on the diegetic inside of the narrative do not evoke associations to anything particularly Nordic. The Nordic dimension of the narrative rests in its discursive outside – its material existence in a catalogue bag specifically produced for the Nordic pavilion. From this story we also learn that most of the objects in Mr. B.'s house (including the collection of underpants) are works of art belonging to his art collection, and this piece of information introduces yet another discursive distinction into *The Collectors*. Roughly, it orders the many different objects in Mr. B.'s house as belonging to one collection (of art), whereas the many collections in the Family house are separate entities.

Having learned about the fictive art collection of Mr. B.'s house from the catalogue, a strange tautological effect arises: we are aware at all times that we are looking at art (as we are at the Venice Biennial), yet we immerse ourselves in the installation, pretending that the objects are domestic and private interiors. Hence, when the objects are referred to as *art* within the *fictive* logic of the story in the catalogue calendar, they are presented as fictive works of art at the same time that we know they actually do exist as works of art outside the context of the installation. As a result the physical materiality of the objects seems to evaporate, emphasising the discursive framing of art as such as the most profound presence in the 'home'. It is through its explicit references to the multiple authorships – which are normally not pointed out directly by the work of art itself – that *The Collectors* articulates a discursive site-specificity that refers to the concept of (art) exhibition as such.

Thus, even though the physical objects in question might, in principle, appear the same, the difference between a private person collecting and displaying insects, beggars' signs, or the underpants of his sexual partners, and a private person collecting a work of art is of paramount importance, because it radically changes the way we comprehend the object/work.

In the case of the collected *object*, the authorship is ascribed to the person who collected it. The collector picks up the object in an everyday context, and inserts it into a new order of meaning; in doing so, the object is transformed from a random piece of cardboard with a text asking for help, for instance, into an item belonging to a collection of beggars' signs, and as such, an object that refers to, and hence helps constitute, the identity of the collector. In addition, by including the object in his or her collection, the collector creates not only him- or herself – by claiming the authorship of that object – but also the object in question. Paraphrasing Rosalind Krauss' canonical essay, *Sculpture in an Expanded Field* (1978), art historian Lars Kiel Bertelsen describes this process in his investigation of objects in an expanded field.[11] Bertelsen's point – clearly inspired by Foucault – is that:

> [O]bjects become objects only when they are given a name. Hence, the material of the world comes together as significant entities only when the language calls them by name. Accordingly, we assume that an intimate relationship exists between objects and words – a relationship that is expandable to a relationship between objects and order, since the words tend to cluster in formations that

generate meaning and establish systems, structures, and distinctions – in short: order. (Bertelsen 2009: 30, my translation)[12]

Following this line of thought, and in accordance with institutional art theory, Nordic art does not exist as a given category for works of art to belong to or not – rather it is a category used by 19th-century nation builders, current art councils, art historians, etc. to establish order in the strange and heterogeneous phenomenon of art.

Since objects are things, Bertelsen sees collections as places that turn 'no-thing' ('ingen-ting') into 'thing' ('ting'). Though the erotic and sexual dimensions of *The Collectors* are not the main focus in this article, it is worth mentioning that Bertelsen claims that most collectors are male, that objects are considered 'feminine', and that the collector is driven by 'raw fetishism, a haptic desire to touch and handle the powerful objects – apparently with no end other than the objects themselves, which is why a strange, masturbatory, lonely fate rests upon the private collector' (Bertelsen 2009: 28, my translation)[13]. Exploring the catalogue bag the visitor suddenly finds him- or herself in that very position while unpacking, since this is something you do not do in a busy

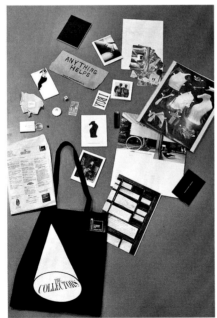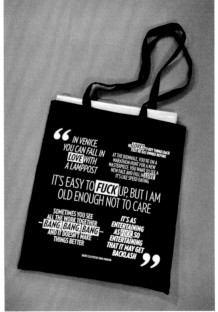

The catalogue for *The Collectors*. Photograph: Torben Nielsen.

public place, because the numerous odd-sized and tiny items in the bag make up a chaotic pile of incomparable 'texts'.

Instead, the heterogeneous character of the catalogue calls for the bag to be unpacked at a huge, blank desk, by which the curious 'reader' can study and immerse herself in the strange findings. Hence, *The Collectors* not only displays the collector's desire for objects, but, through the catalogue, imposes this desire directly on the visitor, who is confronted with his or her own desire for objects – with both hands in the cookie jar, so to speak. Consequently, the visitor finds him- or herself engaged in authorship too. Bertelsen continues:

> [O]ne may claim that the private collection ceases to be a private collection the moment its owner […] wishes to exhibit or simply present the collection, because fetishism is then replaced by exhibitionism, which displaces the desire from an autoerotic handling of the object to a social exchange of its cultural value. (Bertelsen 2009: 28-9, my translation)[14]

Recollecting Walter Benjamin's distinction between cult value and exhibition value in his essay *Das Kunstwerk im Zeitalter seiner technischen Reproduzierbarkeit* (1935),[15] it is this difference between the private/public discourses of collecting/exhibiting that is at work in *The Collectors*, as the collections in the Family house are presented as private, and the objects in Mr. B.'s house are presented as works belonging to the owner's art collection. In the latter case, the owner does not adopt full authorship of the objects, since it is the authorship of *the artists* that guarantees the objects' identities as works of art – and consequently their financial value.[16] Accordingly, the art collector eagerly sustains the artist's 'original' authorship of the object, while attempting to downplay his own role as collector-as-creator.

The relevance of Groys' idea on multiple authorships thus becomes even more obvious, as it is not only a matter of the multiple authorship of Elmgreen & Dragset and the other artists presented in *The Collectors*, but a matter of adding what we may term 'virtual authorships' to the objects on display, which anchor them in different discursive site-specificities of 'object in a private collection', 'work in a private collection', and mere interior that just happens to be there (for instance, floor tiles or power sockets). However, this last category of mere interior or architecture is also transformed, labelled and presented by Elmgreen & Dragset (as collectors' 'homes'), and incorporates the pavilions themselves in the work of art.[17] As a result of this transformation of the pavilions from ex-

hibiting to being exhibited, the architecture loses its transparency, and is looked upon as an artistic artifact in itself, from which it follows that the institutional framework that presents the pavilions as holders of Nordic and Danish art becomes highly visible as author, too. In this sense, we may consider the very erection of the Nordic pavilion in the 1960s as a powerful statement, an act of naming, that brings such a thing as Nordic art into existence.

Hence, in a globalized contemporary art world, the pavilion's status as an architectural work is of minor importance, compared to its significance as an institutional framework – despite its architectural refinements. Just as objects come into being by being named, Nordic art is constituted by the institution-authors that present it – today that would be the national art councils of the Nordic countries and cross-Nordic initiatives. And by naming and constituting Nordic art the councils in effect constitute their own identities, the identity of governmental departments of culture, and, eventually, national identity.

Nordic art as a result of globalization

But why do we even have national art councils, pavilions, and authorship in a time when the majority of the contemporary art world is globalized? It is fair to assume that the apparent urge for Nordic art councils and similar national or regional institutions to name, frame, and hence create Nordic art today results exactly from the globality of the art world, or what sociologist Roland Robertson has termed 'glocalization'.[18] Due to the complexity of the field of Nordic contemporary art Robertson's terminological distinctions between 'globalization', 'globality', and 'glocalization' are useful here. While the term globalization suggests a temporal process – as in the globalization of contemporary art since the late 1970s – 'the issue of space is more specifically and independently [from questions of modernity] raised via the concept of *globality*' (Robertson 1995: 27). Hence, regarding the Venice Biennial, it would be correct to state that it is characterised by globality, since the arrangement of bringing together contemporary art from different geographical territories that relate to different contexts of artistic modernities forms a territory of spatial synchronicity. In this sense we may speak of different localities coming together in globality.

However, those localities do not necessarily exist 'out there' – or 'up there' in the North – waiting to be 'collected' by the international art world. The idea of a neutral global art world detached from – or floating above and surveying – local art communities is absurd. A global art world exists only insofar as

a number of networks form different 'scapes' (to use Appadurai's term) that relate to art as well as to other phenomena. For instance the (global) art market is part of a larger finance-scape, while the popularity of the biennial format for exhibiting contemporary art may be considered to be related to a media-scape or an ideo-scape, depending on whether one considers the biennial as a place for communicating works of art or a place for art in itself. Thus, according to Robertson, localities may result from globalization:

> Globalization has involved the reconstruction, in a sense the production, of 'home', 'community' and 'locality' [...] To that extent the local is not best seen, at least as an analytical or interpretative departure point, as a counterpoint to the global. Indeed it can be regarded, subject to some qualifications, as *an aspect* of globalization. (Robertson 1995: 30)

It is this fundamental relation between the local and the global that Robertson refers to as glocalization, and which – in this case – we may refer to as institutional reterritorialization of the locality of the Nordic. The home of *The Collectors* (the Danish and Nordic pavilions) results from the process of globalization in the world of contemporary art, insofar as the work's institutional authors (the national art councils involved) to some extent need to present art as 'local' or 'regional' in order to be part of globality.

In accordance with Robertson, sociologist John Tomlinson states in *Globalization and Culture* that 'Where there is deterritorialization there is also reterritorialization [...] So deterritorialization cannot ultimately mean the end of locality, but its transformation into a more complex cultural space' (Tomlinson 1999: 148-9).[19] Today, this complex cultural space of the idea of Nordic art is constituted by multiple authorship and institutional and discursive site-specificity. In other words: the institutional frame determines both whether something is 'Nordic' or not and whether it is 'art' or not, and thus both belong to a completely public domain. In the case of *The Collectors* the apparent privacy related to entering the 'homes' in Venice allowed the guests to reflect on the straightforward, descriptive, and all but cynical mechanisms of the art institutional framework in an odd manner of aesthetic jaywalking between different discourses.

The fact that Nordic art is a matter of discursive framing rather than an essential substance in the works of art or the artists is stressed by this announcement, released in April 2010:

> The Nordic Commison have together adopted a new format for future col-
> laboration in the Nordic Pavilion at the Venice Biennale. This will take effect
> with the next Venice biennale in 2011. To revitalise the exhibiting conditions
> for this important manifestation, one Nordic country will take responsibility
> for the management and curating of the exhibition in the pavilion. The rota-
> tion begins with Sweden in 2011, Finland in 2013 and Norway in 2015. The
> two countries not responsible for the pavilion, will establish alternative venues
> in Venice during the Biennale period independently, at yet to be designated
> venues. (Press release, Office for Contemporary Art Norway, April 12, 2010)

Thus the idea of a common Nordic pavilion is being abandoned in favour of a
strictly national discourse, which enables the countries to promote themselves
better. Promoting or branding a nation at the Venice Biennial, however, does not
imply that the artist(s) represented or the work(s) shown in the national pavil-
ion need to originate from that same nation. On the contrary, the nation may
wish to signal that it recognises and acknowledges the international character
of the contemporary art world by having foreign curators and/or artists occupy
the nation's pavilion. Today it is a fact that the scene for contemporary art is
indeed international, rather than national or regional, which was manifested, for
instance, by the selection of British artist Liam Gillick to represent the German
pavilion in Venice in 2009. In this sense, works of art that are institutionally
presented by national frameworks are not necessarily national in themselves.
In accordance with this line of thought the Danish Arts Council has appointed
the Greek art historian Katerina Gregos to curate the Danish pavilion in 2011.
According to the council Gregos was

> [C]hosen among five international curators from all over the world […] invited
> to propose an exhibition in the Danish pavilion. The intention behind this
> screening procedure has been to challenge the national representation at the
> Venice Biennial and secure a curatorial approach that in a reflected manner
> positions Danish contemporary art and culture in an international context.
> (Press release, Danish Arts Council, May 11, 2010, my translation)[20]

These future developments in the representations of Nordic art at the Venice
Biennial are examples of Tomlinson's idea that localities are transformed 'into
a more complex cultural space' that makes their place in globality a matter of
institutionally national branding rather than national art.

Works Cited

Appadurai, Arjun (1996). *Modernity at Large*. Minneapolis: University of Minnesota Press

Benjamin, Walter [1935, third version 1939] (1968). "The Work of Art in the Age of Mechanical Reproduction". In Hannah Arendt (ed.): *Illuminations*. New York: Schocken Books.

Bertelsen, Lars Kiel (2009). "Ting i et udvidet felt". In K. Handberg and P.O. Pedersen (eds.): *The Picadilly Line # 1*. Aarhus: Forlaget Asterisk.

Danish Arts Council (2010). *Kurator udpeget til Venedig Biennalen 2011*. Press release, May 11, 2010. (Accessed March 2, 2011): http://www.kunst.dk/nyhedsbreve/pressemeddelelser/kuratorudpegettilvenedigbiennalen2011/.

Danto, Arthur C. (1964). "The Artworld". *Journal of Philosophy* Oct., 571-584.

Dickie, George (2001). *Art and Value*. Malden, Mass.: Blackwell Publishers.

Eichler, Dominic (2009). "Another death in Venice". In *The Collectors* (exhibition catalogue). Oslo: Office for Contemporary Art Norway.

Ekeberg, Jonas (ed.) (2003). *New Institutionalism*. Oslo: Office of Contemporary Art, Norway.

Groys, Boris [2005] (2008). "Multiple authorship". In B. Groys (ed.): *Art Power*. Cambridge, Mass.: Massachusetts Institute of Technology Press.

http://www.danish-nordic-pavilions.com (Accessed: May 25, 2010)

Kwon, Miwon [2002] (2004). *One place after another – site-specific art and locational identity*. Cambridge, Mass.: Massachusetts Institute of Technology Press.

Office for Contemporary Art Norway (2010). *The Nordic Commission announces: The rotation of the Nordic Pavilion 2011-2017 at the international art exhibition – La biennale de Venezia, Venice, Italy*. Press release, April 12, 2010 (accessed March 2, 2011): http://www.oca.no/press/rotation.shtml

Philipsen, Lotte (2010). *Globalizing contemporary art*. Aarhus: Aarhus University Press.

Robertson, Roland (1995). "Glocalization: Time-Space and homogeneity-Heterogeneity". In Mike Featherstone et al. (eds.): *Global Modernities*. Newbury Park, CA: Sage Publications.

Schultze-Sasse, Jochen (1989). "The Prestige of the Artist under Conditions of Modernity". *Cultural Critique* 12, 83-100.

Stallabrass, Julian (2004). *Art Incorporated – the story of contemporary art*. Oxford: Oxford University Press.

Tomlinson, John (1999). *Globalization and Culture*. Cambridge: Polity Press.

Welchman, John (ed.) (2006). *Institutional Critique and After*. Zürich: JRP, Ringier Kunstverlag AG.

Notes

1 For information on *The Collectors*, see http://www.danish-nordic-pavilions.com.

2 In addition to the original concept of national pavilions a large international exhibition has emerged at the biennial since the 1980s in which works of art from most parts of the world are exhibited together under one curatorial concept. Artists from the Nordic countries are often represented in these exhibitions, too. This article, however, focuses specifically on the Nordic pavilions.

3 See John Welchman, ed., *Institutional Critique and After* (Zürich: JRP, Ringier Kunstverlag, 2006); AG and Jonas Ekeberg, ed., *New Institutionalism* (Oslo: Office of Contemporary Art, Norway, 2003)

4 See Arthur C. Danto, "The Artworld", *Journal of Philosophy* (Oct. 1964): 571-584; and George Dickie, *Art and Value* (Malden, Mass.: Blackwell Publishers, 2001).

5 Arjun Appadurai, *Modernity at Large* (Minneapolis: University of Minnesota Press, 1996).

6 Miwon Kwon *One place after another – site-specific art and locational identity* (Cambridge, Mass.: Massachusetts Institute of Technology Press 2004 [2002]).

7 Boris Groys, "Multiple authorship", in B. Groys, ed.: *Art Power* (Cambridge, Mass.: Massachusetts Institute of Technology Press, 2008).

8 For elaboration on the difference between the institutional and thematic levels of art, see Lotte Philipsen, *Globalizing contemporary art* (Aarhus: Aarhus University Press, 2010).

9 For a list of all catalogue items, refer to http://www.danish-nordic-pavilions.com/_pag/publication. html, accessed May 25, 2010.

10 Dominic Eichler, "Another death in Venice", in *The Collectors* (exhibition catalogue; Oslo: Office for contemporary art Norway, 2009).

11 Lars Kiel Bertelsen, "Ting i et udvidet felt", in K. Handberg and P. O. Pedersen, eds.: *The Picadilly Line # 1* (Aarhus: Forlaget Asterisk, 2009).

12 'at ting først bliver ting, når de navngives. Verdens materialitet samler sig således kun til betydningsfulde enheder, når sproget kalder dem ved navn. Vi antager altså, at der eksisterer en intim forbindelse mellem ting og ord, – en relation mellem ting og orden, fordi orderne har det med at klumpe sig sammen i betydningsdannende formationer, der etablerer systemer, strukturer og distinktioner, – altså orden.'

13 'en rå fetishisme, et haptisk begær efter at berøre og håndtere de kraftfulde ting – tilsyneladende uden anden begrundelse end tingene selv, hvorfor der da også hviler en sær, masturbatorisk, ensom skæbne over privatsamleren'

14 '[På den baggrund] kan man hævde, at privatsamlingen ophører med at være privatsamling i samme øjeblik dens ejermand […] ønsker at udstille eller blot fremvise samlingen, fordi fetishismen da erstattes af en ekshibitionisme, der forskyder begæret fra den autoerotiske håndtering af tingen til den sociale udveksling af dens kulturelle bytteværdi.'

15 Walter Benjamin, "The Work of Art in the Age of Mechanical Reproduction", in H. Arendt, ed.: *Illuminations* (New York: Schocken Books, 1968).

16 For an elaboration on the artist's constitutive role in the work of art, see Jochen Schultze-Sasse, "The Prestige of the Artist under Conditions of Modernity", *Cultural Critique* 12 (1989): 83-100; and for elaboration on the art market, see Julian Stallabrass, *Art Incorporated – the story of contemporary art* (Oxford: Oxford University Press, 2004).

17 For instance, for *The Collectors*, Elmgreen & Dragset have added new levels to the floor in the Nordic pavilion, thus altering the 'raw' architecture of the pavilion. But unlike some of their other installations in the pavilion (e.g. the swimming pool) this alteration is not listed as a work of art in the colophon of the catalogue calendar.

18 Roland Robertson, "Glocalization: Time-Space and homogeneity-heterogeneity", in Mike Featherstone et al., eds.: *Global Modernities* (Newbury Park, CA: Sage Publications, 1995).

19 John Tomlinson, *Globalization and Culture* (Cambridge: Polity Press, 1999).

20 'udvalgt bland i alt fem internationale kuratorer fra hele verden ([som Statens Kunstråd…]) inviterede til at komme med forslag til en udstilling i den Danske Pavillon. Intentionen med denne udvælgelsesprocedure har været at udfordre den nationale repræsentation på Venedig Biennalen og sikre en kuratorisk tilgang, som på reflekteret vis sætter den danske samtidskunst og kultur ind i en international sammenhæng.'

Crossing Visual Borders of Representation. Images of 'Nordicness' in a Global Context

By Eva Zetterman

This article investigates the series *Portraits in Nordic Light* (1997-1999) by Annica Karlsson Rixon. The aim is to identify the series as an early example of visual redefinitions of a Nordic regional discourse through the impact of globalization processes and changing cultural identities. Arguing against assumptions of globalization as a process of homogenising the world into a 'global village' and 'destroying' cultural identities, John Tomlinson describes globalization as the most significant force in the creation and proliferation of cultural identities through an interplay between globalization processes of deterritorializing by modern mass media and communication technologies, and different orders of localising forces (Tomlinson 2003: 270). Tomlinson recognises different orders of localising forces on two levels. On one level there are socio-cultural movements of the kind Manuel Castells (1997) focuses on, based around identity positions such as gender, sexuality, religion, ethnicity, and nationality, and on another level there are the 'cultural effort exercised by nation-states in binding their populations into another cultural-political order of local identification' (Tomlinson 2003: 270). These simultaneous tripartite cultural processes – of globalization, nation-states, and identity positions – are reflected in some Nordic artworks that take a critical approach to an art historical discourse with constructions of the nation-state through landscapes and nature as found in the Nordic National Romantic tradition.

One such an example is Juan-Pedro Fabra Guemberena's video *True Colours* (2002), which represented Sweden in the Venice Biennal 2003. The 45-minute video loop show a group of Swedish soldiers in the landscape of the island of Gotland. Leaning against a rock in frozen positions and hardly moving, their

dark green camouflage uniforms make them merge with the landscape into a still image recalling paintings of camouflaged animals in nature by the National Romantic painter Bruno Liljefors. The word 'True' in the title of the video work harbors a political dimension of globalization processes, socio-spatial connections, and changing cultural identities in relation to hostile nationalism, military defence of bordered geographical territories, and violence. A second example referring to paintings by Liljefors is the photographic series *Back to Nature* (1992-1993) by Annika von Hausswolff, in which half naked and naked bodies of women are pictured laying on their stomachs on a sloping rock, in a forest, a ditch, and the reeds of a lake. Their seemingly dead bodies, which appear to have been thrown out into nature, address a connection between a gendered nature, National Romantic landscapes, and crime. Not as overtly political as these artworks, the series *Portraits in Nordic Light* raises questions in more subtle ways by intervening in the visual discourse of Nordic National Romanticism.

Portraits in Nordic light

Like von Hausswolff, Karlsson Rixon belongs to a successful generation of artists using the camera as their main tool; a shift took place on the Swedish art scene in the early 1990s, and photography and video became prominent high art media. This shift in media and technology use in the art field, reflecting the impact of globalizing, deterritorializing communication technologies, occurred on the international art scene in the 1980s, and included a postmodern visual aesthetic encompassing appropriations, references to popular media, irony, and eclectic sampling. In Sweden this postmodern aesthetic was introduced through the exhibition *Implosion – a postmodern perspective* (1987) at the Museum of Modern Art in Stockholm, to which camera-based artists such as Cindy Sherman, Barbara Kruger, Louise Lawler, Laurie Simmons, Nam June Paik, Dara Birnbaum, and Gretchen Bender made contributions (Nittve and Helleberg 1987).

Educated in the 1980s as a photographer in a documentary tradition, Karlsson Rixon's artistic breakthrough came with the exhibition *Same as – Contemporary Swedish Photography* (*Lika med – Samtida svensk fotografi*) in 1991 at the Museum of Modern Art in Stockholm, which included parts of her series *Untitled I–VI* (1990). She has been an art faculty doctoral student at the University of Gothenburg since 2004, working with a research project entitled "Artist Portraits – representation of the artist as model for cultural image, mystique and

construction of history".[1] Her recent work includes the DVD-work *Resonance* (2005-2006) and two video- and photo-based installations together with Anna Viola Hallberg, *State of Mind* (2006-2008) and *Code of silence* (2008-), which together with *Resonance* form a trilogy about different kinds of socially and culturally constructed group identities departing from the concepts profession, gender, and sexuality (Karlsson Rixon and Hallberg 2008).

Karlsson Rixon's most highlighted work so far, however, is still *Portraits in Nordic Light*, which has gained a place in Swedish art history. Comments on the series are mainly concerned with the postmodern practice of appropriating canonised historical paintings, and the artist's use of female subjects in the images in comparison to the male subjects in these canonical paintings. In the following I want to elaborate on the analysis of appropriations of historical paintings by relating the series to the tripartite processes of globalization, the nation-state, and changing identity positions. As it deals with historiography and visual representation, the series can be looked upon as an early example of an imaginary intervention in a visual discourse of 'Nordicness', where 'the Nordic' is represented as a geographic region with a site-specific topography and a homogeneous group of citizens, excluding subjects with other regional or cultural origins. This visual discourse, containing anachronistic and stereotyped representations of the Nordic, is contradictory to a Nordic socio-cultural landscape that has been reshaped during the last decades by flows of migration and the presence of new ethno-scapes, a concept used by Arjun Appadurai for the 'landscape of persons who constitute the shifting world in which we live', since 'groups are no longer tightly territorialized, spatially bounded, historically unselfconscious, or culturally homogeneous' (Appadurai 2008: 33, 48). With the term 'imaginary intervention' I refer to another of Appadurai's concepts, which in his distinction from fantasy – understood as private and divorced from projects – corresponds to a staging ground for action providing a 'positive force that encourages an emancipatory politics of globalization' and a 'faculty through which collective patterns of dissent and new designs for collective life emerge' (Appadurai 2008: 7; 2005: 6). As an imaginary intervention in the National Romantic visual discourse of 'Nordicness' that began in the late 1800s and now spans more than a century, artworks like the series by Karlsson Rixon enter what Saskia Sassen has defined as frontier zones of different spatiotemporal orders of the global and the national, marked by operations of power and domination (Sassen 2005: 261). In a passage I want to relate to the portrait series, Sassen reflects on different temporalities and the elusive time of the national:

It is constructed of a past filled with the nation's founding myths and a future set to inherit the state as the necessary consequence of the nation – that is, the national is a time that looks to the past and inherits a future. As such, work that interrogates the past and locates it in the present is especially compelling. (Sassen 2005: 269)

As a cohesive work, *Portraits in Nordic Light* consist of ten individual images captured in the late 1990s in the areas of Los Angeles and Marin County north of San Francisco.[2] The word 'Portraits' situates the series in a particular genre indicating a mimetic aspect: representations of specific individuals in specific settings. The words 'in Nordic light' situate the portraits within a specific geographic region, as well as relating them to a specific visual discourse: Nordic National Romanticism. Finally, the word 'light' harbors a double meaning: a specific ontological element of a Nordic geographic region and/or something seen from a Nordic 'perspective'. Each individual work in the photographic series shows staged scenes paraphrasing compositions of canonised fin-de-siècle paintings by Scandinavian artists of the National Romantic tradition. Why do contemporary artists in Sweden addressing processes of globalization, the nation-state, and changing identity positions refer to the National Romantic tradition? What is the impact of this tradition?

The impact of Nordic National Romanticism

The visual discourse of Nordic National Romanticism was established by a generation of young Scandinavian artists who, critical of the art academies in their home countries, studied painting in Paris in the 1880s. Once they returned to their native countries, they formed transnational enclaves (such as the Skagen colony in Denmark), where the aims and methods of *plein air* painting, naturalism, and impressionism brought back from Paris were collectively applied to manifest national themes, nationalistic sentiments, and a Nordic topographic distinctiveness in a style termed *National Romanticism*. The human subjects represented in these images are light-skinned men and women – often the artists themselves, their spouses, colleagues and friends – in bourgeois settings or rural environments surrounded by landscapes. Using colour and light as ontological features of a site-specific Nordic topography/location, these visual elements were applied as carriers of atmosphere and emotion; nature became a mirror of a 'national soul' and the landscape a 'soul landscape' (Edwards 2000: 18). The

visual affirmation of a site-specific 'Nordic character' is represented by distinctive romanticising features – such as summer evenings, unspoiled sceneries, sparkling water, and shimmering lakes and seas. In a Swedish context, prominent artists of this generation include Albert Edelfelt (Finland), Erik Werenskjold (Norway), P.S. Krøyer (Norway/Denmark), Anders Zorn (Sweden), Bruno Liljefors (Sweden) and Carl Larsson (Sweden). Receiving recognition by critics and the public during their lifetimes and supported by influential collectors and patrons, their paintings were quickly considered as *the* representative art of the time, and constitute core collections in Scandinavian public art museums. National Romanticism by fin-de-siècle painters from Scandinavia were launched on an international scene in the 1980s by large touring exhibitions such as the first *Northern Light* (1982) in the US, for which the curator confirmed in the catalogue the painters' pronounced agenda: '"Nordic-ness" became a characteristic goal of Scandinavian landscape painting' (Varnedoe 1982: 19). The core visual element associated with the Scandinavian geographic region and a Nordic temperament, typified as melancholic, is signalled by the exhibition title: 'the Nordic light'.

Ideas of a specific 'Nordicness' launched through painting also passed over into music, literature, architecture, and other visual media, such as photography and design, in which light and nature turned into signifiers of the 'Nordic' and 'Scandinavian' was related to 'blondness' as a normative code. In Sweden, both documentary and art photography from the 1920s onwards passed on the visual discourse of National Romanticism in landscapes and cultural-historic images in a gamut defined as 'blond' and which were in accordance with a common style called 'Swedish grace' (Sandström 1988: 437-439). Modified in the 1930s towards a unified 'blond tone' in landscapes and everyday scenes, the National Romantic ideal lived on after the Second World War in amateur photographic associations and photo journals, and was further spread in booklets and magazines of the Swedish tourist association aimed at experiences of nature (Lärkner 2007: 220). Editions of readers in public schools (*Folkskolans läsebok*) with illustrations by Bruno Liljefors have a similar focus, directed at Swedish nature, that is, the 'Swedishness' of Swedish nature (Hägg 2003: 439).

In Swedish interior design aesthetic ideals are highly influenced by the National Romantic tradition, in particular Carl Larsson's imagery of the nuclear home idyll with bright interior designs and lush outer gardens. Twenty watercolours by Larsson in the 1897 Stockholm exhibition inspired Ellen Key's aesthetic principles for nuclear homes in the influential educational article

"Beauty in the Home" ("Skönhet i hemmen", 1897; Widman 1988: 469). This ideal was further promoted through Larsson's own books, such as his illustrated *A Home* (*Ett hem*, 1899) and four additional books in which close to 50 interiors were reproduced (Widman 1988: 470). The components in this new aesthetic ideal for Swedish interior design were 'simplicity', 'light', and 'blondness', which became important ingredients in the 'Swedish modern' style a couple of decades later (Widman 1988: 470). In the 1950s Scandinavian countries began to market design together with industrial objects in a style known as a 'blond Scandinavian style', which was later developed into the brand 'Scandinavian Design' (Robach 2005: 261-263). And in today's global economic market, this ideal is spread further by the furniture company IKEA, which brands itself through a 'Swedish' aesthetic profile (Werner 2007).

To summarise the impact of National Romanticism, the narrative paradigm of this visual discourse is the 'Nordicness' of Scandinavian nation-states, where the fixation of meaning of light and nature have been so conventionalised that they are perceived as natural, becoming signs of what Michael Billig calls 'banal nationalism', a concept used to cover the ideological habits by which territorially defined nation-states are routinely reproduced and articulated as nations through established repetitive visual signs, such as flags, royal portraits, stamps, official buildings, and rural landscapes (Billig 2008). The National Romantic art heritage in which light and nature are used as signifiers of a Scandinavian geographic region, has been successively established in a cultural consciousness and collective visual memory by the circulation of reproductions: in catalogues, as posters and postcards, on trays, cookie jars, cups, napkins, t-shirts, films, etc.[3]

Through the impact of National Romanticism on visual culture, a representation of 'the Nordic' has been formed in which the borders of the Nordic as a concept are naturalised and 'the Nordic' has acquired its own individual character and objectively given identity. This ideological construction has received a hegemonic position in defining *how* 'the Nordic' is visually represented, by *whom* it is represented, and *what* it represents, that is, what it stands for, what specific ideas and values it signifies. Notions of 'the Nordic' are mixed up in self-referring intertextual links between a geographic territory, a common culture, national identity, and a 'people', and these categories of social identities as regional, cultural, national, and ethnic allow themselves to slide over into one another, change place, and interact.

The visual discourse of National Romanticism easily lends itself to hostile and xenophobic projects. One example is a leaflet distributed to households

in Sweden for the European Parliament election in June 2009, sent from the political party 'Sverigedemokraterna' (the democrats of Sweden). On the front cover of the leaflet is a photographic reproduction of two 'Swedish' children, a boy and a girl with blond hair and fair complexions, walking on a dirt road in a sunny summer landscape with lush green vegetation and a lake with blue water in the background. In the upper part of the image is a short text that describes the party's nationalistic values, in the lower part the call 'Give us Sweden back!' ('Ge oss Sverige tillbaka!').[4] The image on the leaflet's front cover is an example of a type of stereotyped representation of national identity which according to Stuart Hall departs from associations of national cultures and identities with particular landscapes, since 'when we think of or imagine cultural identity, we tend to "see" it in a place, in a setting, as part of an imaginary landscape or "scene". We give it a background, we put it in a frame, in order to make sense of it' (Hall 2008a: 268). The visual discourse of Nordic National Romanticism has these kinds of associations as its core. Against this kind of representation there is a need for imaginary interventions delivering alternatives. As Appadurai writes:

> In many theories of the nation as imagined, there is always a suggestion that blood, kinship, race, and soil are somehow less imagined and more natural than the imagination of collective interest or solidarity. The trope of the tribe reactivates this hidden biologism largely because forceful alternatives to it have to be articulated. (Appadurai 2008: 161)

Questioning visual discourses of the Nordic as an essence constituted by blondness/whiteness, the series *Portraits in Nordic Light* delivers such a forceful alternative articulation.

Reframings of 'Nordicness' in California

As previously mentioned, *Portraits in Nordic Light* consists of images captured in the areas around Los Angeles and San Francisco. The US state of California, where Annica Karlsson Rixon lived from 1994 to 1999, is a geographic region with long traditions of immigration because of its spatial closeness to Mexico and Latin America and disparate historical-political periods of moving people, including undocumented and documented migrant workers, political refugees, expatriates, and exiles. After enrolling on a Masters Degree in free art at the

California Institute for the Arts in Los Angeles in 1995, she documented a performance in 1997 addressing these immigration processes, *The Cruci-Fiction Project* by the US-Mexico border artist Guillermo Gómez-Peña (Gómez-Peña 1997: 150). In the same year began work on the portrait project, which she described thus:

> I photographed my friends in Los Angeles paraphrasing well-known Nordic fin de siècle painters. There are of course great differences [...] but there are also many similarities, for example that we too were a group of Nordic artists who chose to live in something that could be described as an artists' colony. (Karlsson Rixon, Ambjörnsson, and Sandqvist 2006: 58)

By moving the representation of national subjects from one geographic location to another, reframing it, and giving it a new background with 'the Nordic' imagined at a distance, the images in the series take part in a process of *deterritorialization* of which a central defining characteristic according to Tomlinson 'is the weakening or dissolution of the connection between everyday lived culture and a territorial location' (Tomlinson 1999: 128). At the same time the photographs of her friends are *reterritorialized* within the visual 'frame' of 'Nordicness' and a regional aesthetic tradition of Nordic National Romanticism is re-localised in the context of California. Through this re-localisation the individual photographs in the series start a dialogue with the paintings being alluded to. In the following I will discuss some of these dialogues from two angles: the representation of individuals as Nordic cultural subjects, and the representation of a geographic territory defined as Nordic.

Representations of a geographic territory defined as Nordic

The image *Early Summer Evening in Los Angeles* (1997) is a direct comment on Richard Bergh's large painting *Nordic Summer's Evening* (1899-1900; Ill. 1 and 2). Bergh's National Romantic *magnum opus* is a fictitious motif worked on for several years and based on a large number of sketches (Facos 1992: 155). The setting is Ekholmsnäs villa on the island of Lidingö north of Stockholm, and the two subjects in the final version are the singer Karin Pyk and the artist Prince Eugen. With their bodies facing each other in profile they are leaning against massive wooden posts of a balcony railing, dividing the pictorial space into two spatial areas: the semi-interior space of an open veranda painted from the

villa's upper balcony and a background exterior painted from the villa's lower floor. The exterior space shows a garden lawn sloping down to the sunlit gulf of Kyrkviken, the water reflecting the bright sky, followed by a forest in the distance bathed in a summer evening light. The patches of light are dotted over the pictorial surface in an even pattern, which makes one wonder where the light is coming from. The light on the massive balcony poles, the back of Karin Pyk and the front of prince Eugen's lower body is falling into the scene from left, while the light falling in through the balcony railing seems to come from above and the background, since thin shadows of blue on the floor are laid in straight verticals heading towards the spectator. The light on the forest in the distance seems on the other hand to come diagonally from the top right and from the villa, since the upper part of the forest is sunlit while the lower is in shadow. The light is thereby represented as an ever-present part of the landscape and an example of how representations of landscapes become naturalised and appear as 'self-evidently true' (Mitchell 2008: 163).

As Don Mitchell has noted, landscapes and landscape representations are not neutral, but 'a product of social struggle, whether engaged over form or over how to grasp and read that form' (Mitchell 2008: 162). Mitchell claims that apart from knowing the struggles that went into its making, 'one cannot know a landscape except at some ideal level, which has the effect of reproduc-ing, rather than analysing or challenging, the relations of power that work to mask its function' (Mitchell 2008: 164). The two national subjects looking down on the landscape in Bergh's image appear as two vertical shapes that are emphasised by the vertical poles and green areas of trees behind, which encapsulates them visually and locks them in a static condition with no signs of motion. With their faces turned away from the spectator towards the lake, they seem frozen in eternal contemplation of the summer evening landscape figuring as the essence of 'Nordicness'.

In Karlsson Rixon's image *Early Summer Evening in Los Angeles* the pictorial space is different. Standing on a sloping ground, the two subjects – Karlsson Rixon to the left and Colleen Hennessey to the right – lean against a fence that covers most of the image surface in an oblique grid pattern. Behind the fence is a narrow strip of deep soil furrows followed by a flat sunlit area and the skyline of downtown Los Angeles, vaguely discerned through the smog. The two images have a conspicuously dissimilar focus. In Bergh's the background landscape is the essential; in Karlsson Rixon's it is the two women in the foreground – not the background scenery, from which a distance is maintained by the separating

Richard Bergh, *Nordic Summer's Evening* (1899-1900). Oil on canvas, 170 x 223, 5 cm. Gothenburg Art Museum. © Public domain.

Annica Karlsson Rixon, *Early Summer Evening in Los Angeles* (1997), Los Angeles, California. C-print, 120 x 160 cm. © Annica Karlsson Rixon.

fence and blurring throughout this part of the image. In Bergh's painting there is an outspoken hierarchy between viewing figures and viewed landscape. The two subjects are placed in a position *above* the landscape, which they take in possession and 'own' with their gaze. Here time has lost its character of continuation and becomes a continuum, the landscape an object. In Karlsson Rixon's image the two subjects are situated *within* the environment, which appears as a 'non-landscape' devoid of 'nature' with forests and lakes. Through the blurred suburban space with the hardly visible cityscape of Los Angeles on the horizon, it appears as what Marc Augé has termed a 'non-place' (Augé 2006).

The spatially dividing fence serves as a sign of a border or marker of an outside-inside subject position, where the two women are situated in shade in front of a sunlit background area. Do they belong to a group community separated from an area into which they are not eager to take part – a social context they have opted out of? Is it the opposite: are they caught in a structure, excluded from a socio-cultural system? Or are they shielded? A couple of years before the photograph was taken and following the police assault of Rodney King in 1991, tensions among disparate ethnic groups in suburban spaces of Los Angeles the following year led to clashes watched by the media that have been described as 'the worst riots in the American history' (Fiske 1996: 56). From this perspective the fence against a suburban L.A. 'landscape' can be read as a socio-cultural demarcation line, identifying the two women as white middle class subjects and therefore representatives of a privileged group in society. In addition, they have access to a global mobility and freedom to come and go, enter and leave, which is impossible for economically driven migrant groups since bordercrossings are highly dependent on citizenship, national 'origin', and type of passport. These aspects of globalization processes related to removals of visa restrictions and tougher immigration controls have, according to Zygmunt Bauman, made access to a global mobility one of the most important signs that divide groups of national/cultural subjects in a new global structure of stratification (Bauman 2000: 83). While the intertextual visual dialogue between the two images reveals how a geographic territory defined as Nordic is structured by representations of light and landscape, Karlsson Rixon's image also raises questions of 'access' and 'belonging' to site-specific environments depending on socio-cultural group.

The representation of light as part of a geographic territory defined as Nordic is also highlighted in Karlsson Rixon's image *Winter Morning at Santa Monica Beach* (1997). In previous readings of this image it has been associated with one

of P.S. Krøyer's best-known motifs, *Summer Evening on Skagen's Southern Beach* (1893), in which the artists Anna Ancher and Marie Krøyer are pictured walking arm in arm along the beach, away from the spectator, and from a distance in a top down perspective. In Karlsson Rixon's image, the two subjects – Karin Johansson to the left and Maria Karlsson to the right – are situated closer to the foreground and heading in the direction of the spectator, who is positioned as if on the beach at the same height as the women. A painting that is more closely related to the composition of Karlsson Rixon's image, which contains more sea and less beach than the previously mentioned painting by Krøyer, is his *Summer Evening at the Beach at Skagen: The artist and his wife* (1899). Here the two subjects are closer to the foreground and facing the viewer with their bodies slightly twisted towards the sea, and in the photograph's relation to this painting a more obvious appearance is created between the two images of topography, water and light. The geographic relocation of these visual elements from Skagen in Denmark to Santa Monica in California decode the water and light of their 'Nordic character' and reload them with new meaning: they become signifiers of a site-specific geographic topography defined as 'Californian'. The National Romantic construction of the Nordic through light that signifies a specific season and time of day is also transformed by way of the picture's title: from summer to winter and from evening to morning. The constructed character of light and water representing a 'Nordic' geographic territory thereby becomes apparent and the myth of these visual elements as site-specific to the 'Nordic' is revealed.

Representations of individuals as Nordic cultural subjects

In the image *Double Portrait* (1998; Ill. 3) we see two women – Katja Perrey to the left and and Brenda McIntyre to the right – sitting at a table in a white-painted room. Behind the two subjects are transparent white curtains framing a half-opened window and through the window-glass one can glimpse a sunny garden with lush vegetation. This image refers to the National Romantic tradition of double portraits of marital couples, painted by artists such as Bergh and P.S. Krøyer.[5] In a departure from these portraits representing white middle class heterosexual couples in stiff positions, the portrait by Karlsson Rixon shows two smiling women with different skin colours turned towards each other, touching each other with their arms.

Annica Karlsson Rixon, *Double Portrait* (1998), Venice, California. C-print, 86 x 108 cm. © Annica Karlsson Rixon.

The background area bathed in light and the blurring throughout this part of the image accentuates the two subjects in the foreground, visually almost pushing them towards the spectator – whose gaze through the visual ordering of formal elements in the composition is directed to the woman in the right foreground. The inclusion of a woman with a dark complexion highlights how the construction of 'Nordicness' encloses the complexion of Nordic cultural subjects as white. She does not 'fit' the norm. As Stuart Hall has noted on the decisive discursive role representation plays for identity formation of cultural subjects:

> [A]ctually identities are about questions of using the resources of history, language and culture in the process of becoming rather than being: not 'who we are' or 'where we came from', so much as what we might become, how we have been represented and how that bears on how we might represent ourselves. Identities are therefore constituted within, not outside representation. (Hall 2008b: 4)

The representation of 'the Nordic' constructed through nature and light in the visual discourse of National Romanticism metonymically transfers light to skin colour and whiteness. Light linked to whiteness thereby works as a gatekeeper of what a cultural subject representing 'the Nordic' can look like. In his book *White* (2008) Richard Dyer points out the importance of noticing whiteness in visual representation, since 'racial' imagery is central to the organisation of the modern world, where whiteness is the norm and white people count as non-raced people. 'Whites are everywhere in representation', he writes, not as *a* race but *the* human race – as 'normal' (Dyer 2008: 10). Dyer's claim that whiteness is considered to be a *human* condition corresponds to the visual discourse of Nordicness, in which the representation of 'Nordic' cultural subjects is constructed as a *white* condition – excluding visible differences of skin colour. Whiteness in a Nordic context is described by Anne-Jorunn Berg as an unmarked majority position which often remains silent because of its seeming self-evident naturalness (Berg 2008). As a visually communicated component, the staging of identity in relation to the category of whiteness is, according to Berg, an everyday practice we all exercise and are a part of, and silencing whiteness as a dominant majority position helps keep this position in place. Both Dyer's claim about whiteness in visual imagery and Berg's about whiteness as staged as a majority position within the framework of the nation-state are examples of what Gayatri Chakravorty Spivak has called *chromatism*, the tendency of paying attention to visible differences of the surface of the body and 'basing everything on skin colour' (Spivak 1999: 164-165; Spivak 1990: 62).

Whiteness as an identity card for 'Nordicness' is also touched upon in the image *The Artists' Luncheon* (1997), paraphrasing P.S. Krøyer's *Artists' Luncheon* (1883; Ill. 4 and 5). Both serve as strategic group portraits marketing artist friends. In P.S. Krøyer's painting the names of each portrayed subject are written along the bottom edge.[6] In Karlsson Rixon's photograph the names are given in a list of works in an exhibition catalogue.[7] Most of them have 'non-Nordic' sounding names and in addition to a gender shift from men to women, diversity is represented by appearance, connoting different geographical origins and skin colours. The representation of this diversity can be compared to a description by Billig of the painter Norman Rockwell's images of 'America' (i.e. the US), where Billig appeals for a diversity of national subjects and 'more human faces':

> In Rockwell's America, the people are 'naturally' presented with white, Anglo-Saxon faces. Blacks and Hispanics are as rare as recognizable Jewish faces. [...]

Pictures such as Rockwell's can no longer be innocently painted. More faces
are to be painted in. But if they are, it is still an America which is being painted.
(Billig 2008: 147)

Annica Karlsson Rixon, *The Artists' Luncheon* (1997), Los Angeles, California. C-print, 82 x 61 cm.
© Annica Karlsson Rixon.

P.S. Krøyer, *Artists' Lunch-eon* (1883). Oil on canvas, 82 x 61 cm. Skagen Museum. © Public domain.

Billig's conclusion touches upon a definition of the nation-state that goes beyond multiculturalism, with multiculturalism understood as an attempt to subsume a plurality of cultures within the framework of the nation. This perspective is reflected upon by Judith Butler in *Who Sings the Nation-State?*, in which she comments on the singing of the US anthem in Spanish in various Californian cities such as Los Angeles and San Francisco, which she describes as a fissure between multiculturalism and a single notion of the nation (Butler and Spivak 2007: 112). The images in Karlsson Rixon's series linger around this fissure, depending on the interpretative horizon and different subject positions identified with 'I am a Nordic national subject'. The inclusion of non-white-skinned subjects in these two images opens up the visual framework of Nordicness by introducing multiculturalism *within* the visual discourse of the Nordic. But at the same time this abridged visual framework representing a diversity of Nordic cultural subjects leads to a *transformation* of the visual discourse of the Nordic,

implying a possibility of change where a single notion of the nation departing from a National Romantic paradigm can be replaced.

Visual strategies for imaginary interventions

Reflecting the simultaneous tripartite cultural processes of globalization, the nation-state, and changing identity positions, *Portraits in Nordic Light* interrogates the visual discourse of 'Nordicness' through the postmodern aesthetic of appropriation by using the photographic medium. The visual link between the photographs and the National Romantic paintings is established through composition, and this reference to the National Romantic art heritage is the visual code of the series. Commenting on the portrait series, Karlsson Rixon has stated: 'I paraphrase works not to acknowledge a tradition, but to create a new story with comparative allusions to an earlier narrative' (Karlsson Rixon, Ambjörnsson, and Sandqvist 2006: 59). The strategy of appropriation through paraphrase operates as a process of repetition: not by copying or reproducing but quoting or imitating elements, themes, or compositions and thus clearly pointing to previous statements, and by repeating in other ways and by moving visual elements from one context to another a distanced and changed meaning is created. Writing about discursive change of meaning, Chantal Mouffe has noted that statements about ascribed as well as self-defined identities are constantly changing but are, at the same time, relatively locked into concrete historical and social situations, implicating a restrictive framework of which identities can be adopted and what kind of statements can be accepted as meaningful (Mouffe 2005: 17). Since verbal language usage – as well as visual imagery – refers back to previous discursive structures, one must, according to Mouffe, build on meaning already established in order to make oneself understood, but with the possibility in concrete discursive practices of combining elements in new ways and thus stimulating change. Departing from changing identity positions through the impact of contemporary globalization processes and raising questions about 'the Nordic', *Portraits in Nordic Light* is an example of a concrete discursive intervention in the historically established visual discourse of Nordicness that is effected by confronting National Romantic art images enrolled in this discourse.

While the paraphrase is used in the portrait series to locate the past in the present and confront a discursive visual structure, the tool for entering what

Sassen has defined as a 'frontier zone' of the national and the global marked by operations of power and domination is found in the photographic medium. The individual photographs of the series are often in large formats and have some distinctive formal elements, such as saturated colours, shimmering glossy surfaces, and crisp details in a manner reminiscent of Jeff Wall's photographs of staged scenes from the 1980s. Like Wall's photographs, the images by Karlsson Rixon with their cold technological lightning and painterly character harbor strong references to the visual languages of both film and art history. This mediated reuse is an example of what Jay David Bolter and Richard Grusin call 'remediation', described as a process of imitating and reshaping one medium through another (Bolter and Grusin 2000). According to Bolter and Grusin, the process of remediation follows two disparate logics. One is the logic of *hypermediacy*, making the presence of the medium itself and its opacity become apparent. The other is the logic of *immediacy*, the capacity of the medium to render what is represented transparent, giving the spectator an impression of authentic experience of reality. In the remediation process of Karlsson Rixon's photographs paraphrasing paintings, the logics of both immediacy and hypermediacy combine to make us aware of the paraphrased images as ideological representations mediated through painting, which affects their status in defining the 'Nordic'.

The logic of immediacy in the portrait series with its large formats and crisp details is established by the photographic medium itself. Photography is, through its historical claims to transparency, coded with a claim of 'truth'. The notion is that the camera capturing a 'moment' does not 'lie' since the indexicality of the medium deceives the eye into believing that the mediated representation is a 'true' image consistent with 'reality', despite necessary and disparate human interventions (such as choice of camera, of motif, angel, framing, focus, distance, colour/contrast, hue/saturation, sharpness/blur, lighting/filtering, analogue/digital processes, printing, etc.). The images in the series are charged with a documentary character and sense of 'truth' through the immediacy of the photographic medium, and it is this transparency that makes 'the Nordic' in the paraprased original paintings become *visible* as a myth, revealing the constructed character of 'Nordicness' in them.

As for the logic of hypermediacy in the portrait series, the staged scenes in the individual photographs are like *tableaux vivants* mimicking the composition of the original paintings. Several fin-de-siècle artists of the Nordic National Romantic tradition worked with the camera as a tool and used photographic images as their models for painted images. The portrait series thereby engages

in an adaptation process of remediations that spans a century and contains several stages of recycled mediated representations. In this remediation process, the logic of hypermediacy in the portrait series has an effect on the immediacy of the painted 'originals', which make us acknowledge the National Romantic paintings as 'objects' and the hypermediacy of painting. This makes the paintings lose their simple relationship to the 'real' that they might previously have enjoyed, and the artificiality of painted representations and their illusion of reality become apparent.

The remediation process with its simultaneous logics of hypermediacy and immediacy also helps to make the visual discourse of Nordicness comprehensible as an *ideological* discourse marked by operations of power and domination. Thus a key aspect of visual language is touched upon in the portrait series, which makes the spectator aware of techniques and patterns for telling/narrating/writing visually, and also for visual reading and looking practices. It is in the unravelling of the discursive practices of visual representation and interpretation that the impact of the series becomes a forceful imaginary intervention into the visual discourse of Nordicness, delivering both a deconstruction of notions established by the tradition of National Romanticism and a simultaneous articulation of alternative identifications of Nordicness. With *Portraits in Nordic Light*, Karlsson Rixon suggests that Nordicness might be inhabited by many cultural identities, regional 'origins', skin colours, and sexualities in a global, mediated world in which the sign of 'the Nordic' is a well known discursive framing.

Works Cited

Appadurai, Arjun (2005). "Grassroots globalization and the research imagination". In Arjun Appadurai (ed.): *Globalization*. Durham & London: Duke University Press, 1-21.

Appadurai, Arjun (2008). *Modernity at Large: Cultural Dimensions of Globalization*. Minneapolis: University of Minnesota Press.

Augé, Marc (2006). *Non-Places: Introduction to an Anthropology of Supermodernity*. London & New York: Verso.

Bauman, Zygmunt (2000). *Globalisering*. Lund: Studentlitteratur.

Berg, Anne-Jorunn (2008). "Silence and Articulation: Whiteness, Racialization and Feminist Memory Work". *NORA – Nordic Journal of Feminist and Gender Research* 16: 4, 213-227.

Billig, Michael (2008). *Banal Nationalism*. Los Angeles & London: Sage.

Bolter, Jay David and Richard Grusin (2000). *Remediation: Understanding New Media*. Cambridge, Mass. & London: Massachusetts Institute of Technology Press.

Butler, Judith and Gayatri Chakravorty Spivak (2007). *Who Sings the Nation-State?*. London, New York & Calcutta: Seagull.

Dyer, Richard (2008). *White*. London & New York: Routledge.

Edwards, Folke (2000). *Från modernism till postmodernism: Svensk konst 1900-2000*. Lund: Signum.

Facos, Michelle (1992). "Richard Bergh's Nordic Summer Evening: Cultural Differences in Interpretation". *Konsthistorisk tidskrift / Journal of Art History* LXI: 4, 152-160.

Fiske, John (1996). *Media Matters: Race and Gender in U.S. Politics*. Minneapolis & London: University of Minnesota.

Gómez-Peña, Guillermo (1997). "The Cruci-Fiction Project". *The Drama Review* 41:1, 147-151. Accessed September 24, 2009: www.jstor.org/pss/1146577.

Hall, Stuart [1995] (2008a). "New Cultures for Old?". In Timothy Oakes and Patricia L. Price (eds.): *The Cultural Geography Reader*. London & New York: Routledge, 264-274.

Hall, Stuart (2008b). "Introduction: Who Needs 'Identity'?". In Stuart Hall and Paul du Gay (eds.). *Questions of Cultural Identity*. London: Sage, 1-17.

Hultman, Marianne (ed.) (2006). *Today – Tomorrow – Forever: Annica Karlsson Rixon – Selected Works 1991-2006*. Norrköping: Norrköpings Konstmuseum.

Hägg, Göran (2003). *Svenskhetens historia*. Stockholm: Wahlström & Widstand.

Karlsson Rixon, Annica, Fanny Ambjörnsson and Gertrud Sandqvist (2006). "A conversation between Annica Karlsson Rixon, Fanny Ambjörnsson and Gertrud Sandqvist". In Marianne Hultman (ed.): *Today – Tomorrow – Forever: Annica Karlsson Rixon – Selected Works 1991-2006*. Norrköping: Norrköpings Konstmuseum, 57-73.

Karlsson Rixon, Annica and Anna Viola Hallberg (2008). "State of Mind". *Talkin' Loud & Saying Something: Four Perspectives of Artistic Research – ArtMonitor: A Journal on Artistic Research* 4, 59-85.

Lärkner, Bengt (2007). "1900-1950". In Lena Johannesson (ed.): *Konst och visuell kultur i Sverige: 1810-2000*. Stockholm: Signum, 136-222.

Mitchell, Don [1996] (2008). "California: The Beautiful and the Damned". In: Timothy Oakes and Patricia L. Price (eds.): *The Cultural Geography Reader*. London & New York: Routledge, 159-164.

Mouffe, Chantal (2005). *The Return of the Political*. London & New York: Verso.

Nittve, Lars and Margareta Helleberg (eds.) (1987). *Implosion: Ett postmodernistiskt perspektiv*. Moderna Museet katalog nr. 217. Stockholm: Moderna Museet.

Robach, Cilla (2005). "Scandinavian Design". In Jan Brunius (ed.): *Signums svenska konsthistoria: 1950-1975*. Lund: Signum, 261-263.

Sandström, Sven (1988). "Fotografin efter sekelskiftet". In Sven Sandström (ed.): *Konsten i Sverige – Del 2: Från 1800 till 1970*. Stockholm: Norstedts, 435-441.

Sassen, Saskia (2005). "Spatialities and Temporalities of the Global: Elements of Theorization". In Arjun Appadurai (ed.): *Globalization*. Durham & London: Duke University Press, 260-278.

Spivak, Gayatri Chakravorty (1999). *A Critique of the Post-Colonial: Toward a History of the Vanishing Present*. Cambridge, Mass. & London: Harvard University Press.

Spivak, Gayatri Chakravorty (1990). *The Post-Colonial Critic: Interviews, Strategies, Dialogues*. Ed. Sarah Harasym, S. New York & London: Routledge.

Tomlinson, John (2003). "Globalization and Cultural Identity". Accessed October 10, 2009: www.polity.co.uk/global/pdf/GTReader2eTomlinson.pdf.

Tomlinson, John (1999). *Globalization and Culture*. Oxford: Polity Press.

Varnedoe, Kirk (ed.) (1982). *Northern Light: Realism and Symbolism in Scandinavian Painting 1880-1910*. New York: The Brooklyn Museum.

Werner, Jeff (2007). *Medelvägens estetik: Sverigebilder i USA – del 2*. Hedemora/Mörklint: Gidlunds.

Widman, Dag (1988). "Konsthantverk, konstindustri, design: 1895-1975". In Sven Sandström (ed.): *Konsten i Sverige – Del 2: Från 1800 till 1970*. Stockholm: Norstedts, 465-615.

Notes

1 'Konstnärsporträtt – representation av konstnären som modell för kulturell framtoning, mytbildning och konstruktion av historia', www.konst.gu.se/utbildning/forskarutbildning/doktorander/annica_karlsson_rixon/, accessed February 4, 2011.

2 According to a list of works in the exhibition catalogue *Today – Tomorrow – Forever* (2006), the series include the following titles: *Portrait of Annika von Hausswolff and Johan Zetterquist* (1997), *Winter Morning at Santa Monica Beach* (1997), *Early Summer Evening in Los Angeles* (1997), *The Artist Ingrid Eriksson* (1997), *The Artists' Luncheon* (1997), *Double Portrait* (1998), *Double Portrait (Annika von Hausswolff and Johan Zetterquist)* (1997), *Double Portrait (Johan and Åse Frid)* (1997), *Double Portrait (Katja Perrey and Brenda McIntyre)* (1998), and *Monika at Devils Ridge* (1999/2006). See "Lists of works" in Hultman (ed.) 2006: 77.

3 For example, films such as Kjell Grede's *Hip hip hurra!* (1987), a romantic narrative of the Skagen colony in northern Denmark with the actor Stellan Skarsgård playing the main character P.S. Krøyer. The film title was taken from one of P.S. Krøyer's most famous paintings, *Hip, hip, hurra!* (1888), which is in Gothenburg Art Museum.

4 This repeats the slogan 'Give us Denmark Back' by the Danish Peoples Party (Dansk Folkeparti), used in an advertising campaign in 2008, which was accused of being stolen from the deceased singer Natasja's 2007 hit entitled "Gi' mig Danmark tilbage", with an opposite agenda. A parallel but reversed appropriation was made summer 2009 when the slogan 'Ge oss Sverige tillbaka!' from the Democrats of Sweden (Sverigedemokraterna) was taken up by the music group Timbuktu & Promoe in the song titled "Ge oss Sverige tillbaka!", with an opposite agenda, like Natasja's hit. Videos of the songs by both Natasja and Timbuktu & Promoe can be found on YouTube.

5 For example, *Per Hallström and his wife Helga* (1904) by Richard Bergh, *Double Portrait of Heinrich and Pauline Hirschsprung* (1877) by P.S. Krøyer, and *Double portrait of Marie and P.S. Krøyer* (1890) by P.S. Krøyer together with Marie Krøyer.

6 The represented subjects are, from the front and clockwise from left to right: Charles Lundh, Eilif Petersen, William Peters, Michael Ancher (standing), Degn Brøndum, Johan Krouthén, Oscar Björck, and Christian Krogh (right foreground).

7 The represented subjects are, from the front and clockwise from left to right: Kira Lynn Harris, Karin Johansson, Mika Kimoto, Ruth Katz (standing), Andrea Claire, Catherine Hollander, Georgia Metz, and Maria Karlsson (right foreground). See "List of Works" in Hultman (ed.) 2006: 77.

Beyond Predatory Nationalism
On Contemporary Aesthetic Re- and Deconstructions of Danish Identity

By Carsten Stage

The aim of this article is to investigate and describe the different ways in which Danish artists represent national identity or Danishness in contemporary artworks. My claim is that the works I am analysing can be understood as different responses to global flows of mediated information and the creation of new conditions for the cultural processes and experiences within the national territory. Hence I understand globalization as referring to this empirical increase in transnational exchanges (Held et al. 2000; Tomlinson 1999) traceable in the construction of transnational political institutions, internet based communities without geographical anchoring, global public spheres facing major media events, the movement of people travelling more or less voluntarily across great geographical distances, and also in the constant intertwinement of external impulses in the everyday culture of local life. Some of the artworks seem to focus primarily on the deterritorializing dimension of globalization – or the weakened link between culture and territory (Appadurai 2008; Tomlinson 1999) – creating a new cultural logic, which disrupts the traditional concept of nationalism by describing culture, politics, and territory as overlapping or isomorphic categories (Frello 2003; Gellner 2006). Others try to define a new concept of national identity fit to meet the challenges of cultural globalization by pointing at cultural complexity as something that needs to be incorporated into the national imaginary.

Initially I want to stress that I do not see globalization as a transition point from a time in history when national culture was something stable and fixed to a time of complexity and hybridity. As described by Anthony P. Cohen in *The Symbolic Construction of Community* (1985), symbolic communities often work as a framework for complex practices, camouflaging the fact that people

may perform actions like raising the flag, singing the national anthem, and participating in national rituals for very different reasons and with different levels of engagement and seriousness. Cohen's point is that traditional communities are often more culturally complex than they seem at first sight because the common symbolic framework helps to keep the state of complexity unnoticed and unthematised (Cohen 2004). Globalization makes the simplified idea of a coherent national culture more difficult to uphold because of the explicit presence of different religions, symbolic frameworks, skin colours, and ethnicities within the same society. As such, following Birgitta Frello's discussion of globalization and hybridity, the flows of globalization disturb the implicit idea of the nation as culturally pure rather than converting cultural homogeneity into cultural complexity (Frello 2005).

By addressing the issue and problems/potentials of nationalism[1] as such, and not only certain ideas about what Danish identity is or should be, aesthetic objects often seem to approach the discussion of national identity in more abstract or theoretical ways than everyday public debates. A discourse analysis of aesthetic objects allows for fundamental discussions concerning the relation between nationalism and globalization. My approach to the empirical objects will not be that of the art historian looking at the inherent structures of each particular piece or the traditions that the objects deal with, but rather of the analyst investigating contemporary discourses on national identity as they are played out in an aesthetic field. This means of course that these art objects are seen primarily as cultural objects embedded in social structures of meaning production, inscribed in a broader network of discourses (Foucault 2005). In taking this approach the goal is to point out certain discursive strategies and mechanisms that are also relevant outside a Danish context, since they could be used in the reproduction of any given national identity (Wodak et al. 2005).

I will approach national identity as a type of social identity reproduced by a certain discursive logic (Billig 2006; Calhoun 2002; Frello 2001; Jørgensen and Phillips 2006; Wodak et al. 2005; Özkirimli 2000). This logic understands collective identities as based on individuals' membership of a people with a common culture that inhabits a certain territory. Seeing national identity as reproduced by discourse means that its forms of existence and social consequences rely on the ways in which people identify with certain national subject positions constructed and circulated through discursive processes (Jenkins 2006). 'Identities are thus points of temporary attachment to the subject positions which discursive practices construct for us [...]. They are the result of a successful

articulation or "chaining" of the subject into the flow of the discourse', as Stuart Hall notes (Hall 2002: 6). This approach implies first of all that national identity loses a natural inner coherence or ontologically objective status, and thus Danish identity can be imagined and reproduced in many different ways. Danish identity is not a singular and ontologically existing phenomenon, but a social identity category, which in its various forms is used by individuals as a way of identifying themselves and others as part of a certain national we-group. In this way national identity exists, but only as an impossible object consisting of a hypercomplex and continuously evolving assemblage of different identification processes. As such, ideas of a homogenous national identity or unified national culture are always more of a fantasy promoting a certain national discourse than a method of describing reality. This point is underlined by the fact that the definition of terms such as Danish identity and Danish culture is often the centre of discursive struggles.

Inspired by the discourse theory of Ernesto Laclau and Chantal Mouffe, I approach aesthetics as always already incorporated in a broader social field. Through the articulation of meaning – or by seeking not to articulate meaning – aesthetics always supports, uses, or renegotiates established discourses and participates in discursive struggles over how to interpret and momentarily fix the meaning of signifiers such as Danish identity (Laclau and Mouffe 2001; Møller and Thordsen 2008: 8). In line with Laclau and Mouffe I define discourse as a structured totality of articulations,[2] and furthermore I understand discourses as multimodal (Kress and Leeuwen 2001). From this perspective, a given discourse can be reproduced through many different types of expressions (e.g. in writing, speech, performances, moving images, or architectural constructions).[3]

To highlight the discursive strategies as broader patterns I present shorter analyses of several pieces in my article. A common thread in these works is a critical approach to either nationalism or the existing constructions of national identity. They accept a common idea of a crisis of Danishness, which must somehow be answered or reflected on. In this way the pieces tap into the ongoing debate about Danishness in the national public sphere. At least since the 1980s, but with greater intensity from the 1990s onwards, the substance, history, and (non)future of Danish identity has been intensely discussed and researched (Agger 2005; Böss 2006; Gundelach 2001; Hauge 2003; Knap, Nielsen, and Pindstrup 2005; Lundgreen-Nielsen 1992; Østergård 1992). An important reason for the evolution of the debate was the changing patterns of

immigration in the 1990s which made the Danish population visually more complex due to the arrival of immigrants from non-Western areas (Andreassen 2007: 23). The awareness of being a culturally multifaceted society motivated a range of reflections on how to deal with this complexity, on what values were fundamental to society, and on the future existence of a national culture. As a traditionalist-protective response to this situation the political party Dansk Folkeparti (The Danish People's Party) was founded in 1995. The party has been very successful in establishing criticism of non-Western immigration and the protection of (a certain construction of) Danish culture as a recurring key topic in public debates in Denmark. Another very tangible result of this increasing focus on local values and cultural complexity was the creation of various canons initiated by the Danish liberal-conservative government in order to define the nation's cultural backbone (cf. the 2006 canons of literature, architecture, film etc.) and fundamental principles (cf. the 2008 canon of democracy).

Many artists have also been taking part in these reflections on Danish identity – but most often opposing or redefining the nationalist-conservative agenda. An example is the film director Lars von Trier's flag campaign of 2004, when he urged Danes to turn the national flag upside-down in order to protest against the rising right-wing nationalism in Denmark and to support a more inclusive and tolerant version of Danish identity. Later he invited the Danish Minister of Culture at the time, Brian Mikkelsen, to participate in a flag burning event, which would take place if Trier's film were to be included in the abovementioned canon project. Trier's *The Idiots* (1998) did become a part of the film canon and as a response Trier sent a video to Brian Mikkelsen. Instead of burning the flag Trier decided to cut out the white cross, sew the red squares together again, and raise the (now all red) flag while playing "The Internationale".

In my article I will argue that contemporary artists intervene in the debates about Danish values and Danishness in two different ways. In describing these responses I use the discourse analysis work of Wodak et al., who suggest five different macro strategies in the discursive reproduction of national identity. One of them is a strategy of demontage, dismantling and destruction, which deconstructs 'parts of an existing national identity construct, but usually cannot provide any new model to replace the old one', while another strategy – the strategy of transformation – changes 'a relatively well-established national identity and its components into another identity the contours of which the speaker has already conceptualised' (Wodak et al. 2005: 33). Trier's different ways of changing the national flag in order to criticise right-wing nationalism

and to support a humanistic or left-wing version of Danishness are examples of the latter. Following this my main claim is that the artworks under investigation oscillate between 1) a *discourse of pragmatic transformation* of national identity that articulates political projects of emancipation, and 2) a *discourse of deconstruction* that points out the necessity of transgressing national identity in order to construct new types of communities that can answer the globalized logic of human movement and multiple loyalties. The co-existence of these strategies raises the more theoretical question, which I will address after the analysis, of whether one should take a denouncing or a renegotiating standpoint when it comes to understanding the problems and potentials of narratives about a national we in an era of cultural globalization.

Beyond nationalism – RememberMyName and Superflex

The series of posters called *To be Danish is a dangerous idea* (2004) by the street artist working under the pseudonym HuskMitNavn (RememberMyName) is an example of a deconstructive approach to national identity.[4] The series consists of posters hanging on city walls seeking to affect the recipient and public discourse instantaneously and informally. These street posters show grotesque figures characterised by both aggressive and humoristic features, but all include the text 'To be Danish is a dangerous idea' ('At være dansk er en farlig ide'). This statement is not qualified in any systematic way by the posters, but some of the figures seem to be weighed down by the bubble containing the slogan, thereby creating the impression that national identity represses the individual. Another group of posters does not imply domination, but connects the slogan to facial expressions of anger and aggression. As such, national identity seems to be either threatening the represented figures or talking through them as aggression. In Wodak's terms, one can argue that the discursive strategy used here is deconstructive. The posters' way of addressing national identity as an inherently problematic concept indirectly points out the need for alternative identity categories, but does not develop them.

Another example of this deconstructive line of thinking is the visual installation *Rebranding Denmark* by the artist group Superflex. *Rebranding Denmark* (2007) consists of a 115 x 153 cm LED display constantly repeating the same visual sequence showing a Danish flag slowly being burned from the bottom right corner by yellow and orange flames.[5] The sequence ends with the visual destruction of the flag and a totally yellow display, but after just a brief span of

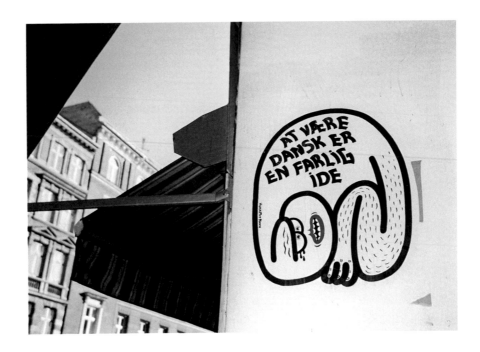

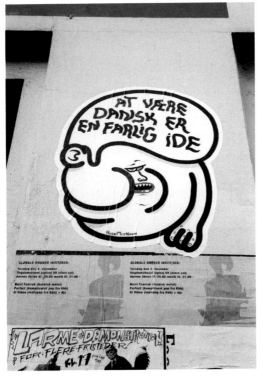

RememberMyName: *To be Danish is a dangerous idea* (2004). Street posters. Photographs: RememberMyName. Printed by permission of the artist.

© Superflex: *Rebranding Denmark* (2007). LED display. Photograph: Superflex.

blackness, the burning of the flag begins again. This piece comments on the so-called cartoon crisis that followed the publication of twelve drawings of the Islamic prophet Mohammad by the Danish newspaper *Jyllands-Posten* in September 2005. In the beginning of February 2006 the publication caused a range of demonstrations, burnings of the Danish flag, and boycotts of Danish products primarily in the Middle East and parts of East Asia, but most importantly also violent attacks on Danish embassies in Jakarta, Damascus, Beirut, and Teheran.

According to the text following *Rebranding Denmark*, it is a response to a statement made by brand expert Tyler Brule, who proclaimed that the global turmoil of the cartoon crisis put Denmark on the world map and that this could have a lot of potential brand value. The artwork points to 'the seemingly arbitrary relationship between value and intention in the mechanisms of branding' (Superflex 2007), for it is a paradox that a burning flag can be transformed into a symbol of Danish idealism and freedom of speech, becoming a symbol within a branding concept. As I see it, *Rebranding Denmark* does not primarily

address issues of branding, but rather formulates a critique of contemporary forms of nationalism by means of the trivialising effect of visual repetition. The emotional importance of nationalism is diminished by the continual erasure of one of its master symbols. The goal for Superflex is not to help Denmark take advantage of the attention it had during the crisis, but rather to criticise the nation's lack of ability to act in a globalized situation. The cartoon crisis is thus not approached as an opportunity to rebrand the nation, but – by playing on the Danish meaning of the word 'brand', which simply means 'fire' – to attack or symbolically burn down the nation. From this perspective, nationalism is part of the problem motivating the crisis, not something to be saved or strengthened by means of the crisis.

The LED display works as a kind of flag-burning machine that deprives the flag of its symbolic significance within a nationalist imaginary. The yellow and black monochromes ending the act of flag burning lay bare the empty centre of the nation, as William Connolly would put it (Connolly 1999). On the one hand, the flag burning produces a shocking effect for the person treasuring it, but on the other hand, it potentially has a postnational or deconstructive outcome since the act of endless repetition transforms what would normally be an unusual spectacle into a banal act. The negation of the symbolic core of the nation thus becomes a mundane mode of being, rather than something to prevent. *Rebranding Denmark* could be described as an attempt to denationalise the gaze of the viewer, or to strip away the sacralising emotional attachment to national symbols by creating a visual experience through which the negation of the nation becomes ordinary. Following Edmund Husserl, the artwork tries to create a sort of epoché effect, where the collectively acquired respect and care for the flag as something objectively important is set aside in favour of an awareness of the way it becomes socially consequential in a problematic way (Husserl 1997: 99).

According to Superflex, the burning Danish flag became a symbol of 'a nation that seems incapable of dealing with its changing demography, hence it[s] lack of inclusion of its religious, racial and ethnic minorities' (Superflex 2007). This criticism's intertwinement with the continuous negation of the core national symbol underlines the deconstructive goal of this artwork. In identifying nationalism as linked to repression of individuality and discrimination of minorities, both RememberMyName and Superflex seem to suggest that cultural and individual plurality and nationalism do not mesh. This is due to the fact that national identity is based on a distinction between cultural members and non-members

in order to draw a line between those who belong and are protected by the state and those who do not belong and are treated as dissidents or visitors. Hannah Arendt points out that the concept of nationalism collides with the concept of human rights because the individual living on a national territory does not derive its inviolability from simply being a human being, but from being a rightful member of the national community. According to Arendt, cultural affiliation becomes more important than human dignity within the logic of nationalism (Arendt 1968: 295), and this seems to be part of the implicit agenda of the above-mentioned artworks. Nationalism transforms the newly arrived immigrant into a stranger instead of an individual with rights that do not disappear in a move across national boundaries. From this perspective, nationalism is bound to create problems in an era when migration and flows of people are increasing: it prevents the creation of communities that treat the newcomer as an equal. Instead he/she will have to adjust to the culture of 'the hosting people' in order to become an equal member of the community. As I see it, it is this attempt to expose the inherent problems and dangers of the concept of nationalism that drives the deconstructive artworks of RememberMyName and Superflex in their quest to change the way the nation and national symbols are perceived.

Redefining national identity – Ellen Nyman and Lise Harlev

In 2007 the Danish singer Natasja performed one of that year's biggest hits in Denmark. Her song proclaimed that Denmark should regain its lost values of tolerance towards cultural differences. It was included on the album entitled *I Danmark er jeg født* (*Denmark is my birthplace*), which is an intertextual allusion to a well-known song in Denmark based on a text by the author H.C. Andersen. Another singer named Isam B, who is a Muslim, made a cover version of this tribute to Denmark on his solo album of 2007. In contrast to RememberMyName and Superflex, national identity is not explicitly problematised per se by these singers, but rather used as a discursive framework that makes it possible to articulate a vision of another kind of community where cultural and religious differences are perceived not as a threat to, but rather as a part of, national culture. The projects of the artist duo DEFENDING dENMARK are further examples of a line of thinking in which the affirmation of the nation is closely linked to a transformation of the nation. The discursive strategy used by Natasja, Isam B, and DEFENDING dENMARK is therefore not deconstructive, but rather pragmatic and transformative in its approach to nationalism. It is

pragmatic because national identity is accepted as the dominant way of talking about community and solidarity, and transformative because this framework is used to articulate a concept of Danishness in opposition to other politically prominent and culturally exclusive ideas of the nation.

The Danish artist Ellen Nyman's performance *Election Night* (2001) also takes a clear transformative approach to national identity.[6] The performance was part of an art project entitled "Spacecampaign". During the campaign Nyman named herself Alem and made different public appearances dressed in a yellow headscarf that left only her face visible. During election night 2001 Nyman/ Alem sang the Danish national anthem while the leader of the Danish right-wing nationalist party (The Danish People's Party), Pia Kjærsgaard, entered the parliament building as one of the winners of the election. Kjærsgaard's success was mainly a result of her nationalist critique of immigration; she had focused on Muslim immigrants as cultural strangers who could only be integrated into Danish society if a very restricted amount of immigrants entered the country. Because of the moment she chose to perform it, Nyman's performance was broadcast live on one of the Danish public channels, thus reaching a very large national audience. As one of the viewers accidentally witnessing this performance, I recall the way it disturbed Kjærsgaard's arrival, because it exposed the problems of the type of excluding nationalism represented by this politician.

Nyman's performance was an attempt to change the widespread preconception of the veiled Muslim woman as a cultural stranger, but at the same time it was an act that redefined national identity as a category able to contain different religions and ethnicities. Nyman furthermore used the logic of the media to create a spectacle at the right place and the right time, suggesting a more pluralist version of nationalism on a night that was connected with scepticism of the Muslim minority in Denmark. By taking over and changing a subject position (the veiled Muslim woman Alem) and renegotiating the picture of the Muslim as an unfamiliar person, Nyman created what Judith Butler calls a performative act of disidentification (Butler 1997). Nyman's performance is interesting because of the way national identity is affirmed as the relevant playing field. By saluting the nation – and for a moment accepting the excluded position offered to her character within a certain logic of nationalism – it became possible for Nyman to rearticulate her position inside this framework and potentially affect the discursive processes of constructing national identity.

My last examples of the transformative method of reproducing national identity are two works by Lise Harlev, a Danish artist based in Berlin, who

© Lise Harlev: My own country (2005).
Offset prints. Photograph: Ildikó Hermann.
Printed by permission of the artist.

© Lise Harlev: Noget jeg kender (2007).
Stained Glass. Photograph: Anders Sune Berg.
Printed by permission of the artist.

talks not with the voice of a minority within the Danish nation, but as a Dane living in voluntary exile reflecting on her affiliation with and attachment to Denmark. Harlev often uses posters and reflective slogans of all kinds. Her work investigates how at the same time one can have a close affiliation with and a reflexive and geographically distanced relationship to Denmark. In this way, she creates an ambiguity toward being Danish and her works can be said to investigate the conditions of a national cultural experience in a globalized situation. *My own country* (2005) addresses this highly self-reflexive experience of criticising 'one's own country' often at the same time as one defends or represents it.[7] *Noget jeg kender* (*Something I know*; 2007) is a kind of escutcheon with the Danish version of the text 'Danishness is something I know but can't say what it is' (Harlev's translation) also pointing to the paradoxical experience of knowing what it means to be Danish, but not being able to grasp the complexity of Danishness with all its mundane and banal features represented by a bicycle pump, an umbrella, a designer chair, and a seagull.[8]

Harlev's work combines the experience of displacement with the experience of national belonging in order to show the flaws in the idea of a symbiosis of culture and territory and to investigate the actual bonds between persons and places. Harlev reflects on, analyses, and criticises national identity while at the same time acknowledging that nationality can motivate feelings of belonging. This shows how deterritorialization constantly motivates reterritorializing reflections concerning cultural homeliness (Tomlinson 1999). Harlev furthermore demonstrates how national identity becomes less a way of defining one's place of residence and loyalty, but at the same time continues to produce emotional attachment. In this way, these artworks are transformative because of their attempt to investigate new ways of being Danish following the processes of globalization. Harlev simply analyses a globalized type of national identification that does not depend on residence, on a feeling of cultural knowledge, or on uncompromised loyalty.

Both Nyman and Harlev embrace national identity while at the same time suggesting new ways of being Danish, in which belonging is a dynamic concept or a paradoxical experience always disturbed by experiences of not belonging. In doing so these artists keep discussing national identity in order to be able to affect it, rather than leaving it up to others to tell the stories about the national us. Nyman and Harlev – but also Natasja, Isam B and DEFENDING dENMARK – in other words use the established category of national identity, but renegotiate its meaning and structure. In that way RememberMyName's and Superflex's analysis of nationalism as a problem is replaced by an aesthetic practice which uses the discursive components of nationalism, and the possibility of talking into an already established collective framework, to push it in a new direction. From this transformative perspective, the problem is therefore not nationalism as such, but rather certain types of nationalism and certain ways of using nationalism as part of culturally exclusive narratives.

Predatory identities and project identities

The implicit key problem raised by the two discourses is whether or not national identity can be detached from a problematic concept of cultural homogeneity in favour of a national identity independent of ethnic and religious backgrounds. If the discourse of transformation is right, the flows of globalization could result in a national identity that treats cultural complexity in a flexible way, allowing newcomers to become new nationals. The more

pessimistic attitude of the deconstructive discourse is that globalization is going to make national identity defensive or even predatory towards signs of difference – incarnated by minorities (Appadurai 2006) – in order to prevent cultural destabilisation. Arjun Appadurai in *Fear of small numbers* (2006) points to the dangerous relation between nationalism and globalization, show-ing that the flows of the latter motivate fantasies of purity and an anxiety of incompleteness in the former. According to Appadurai the dynamics created by globalization are postnational, while the framework for understanding them is often nationalistic and upholds the distinction between minority and majority, making the minority a destabilising phenomenon. In this way cultural complexity becomes a problem that must be handled, stabilised, and perhaps also purified. In *Modernity at Large* (1996) Appadurai therefore concludes: 'This vicious circle can only be escaped when a language is found to capture complex, nonterritorial, postnational forms of allegiance' (Appadurai 2008: 166).

Judith Butler theoretically presents the more pragmatic position in her recent book *Who sings the Nation-State?* (2007) – co-authored by Gayatri Chakravorty Spivak – in which she uses the example of illegal immigrants in Los Angeles. They went on the streets to demonstrate for 'their right to have rights' by singing the American national anthem in different national languages, thereby using the anthem to point at new ways of belonging to the nation. Butler, following Arendt, acknowledges that nationalism often ends up transforming individuals into strangers without legal rights. In line with her analysis of hate speech in *Excitable Speech* (1997) Butler nevertheless maintains that even the possibility of entering the struggle for recognition from a marginalised position must be approached as an invitation to speak up and to perform the marginalised sub-ject position in another way. To understand what happens when the national anthem is sung in a foreign language she furthermore introduces the term 'to alloy', meaning to mix two metals and thereby give them new qualities. The singing of the anthem alloys the familiar tribute to the nation with citizens from multiple backgrounds. In addition, Butler states that 'to make the demand on freedom is already to begin its exercise and then to ask for its legitimation is to also announce the gap between its exercise and its realization and to put both into public discourse' (Butler in Butler and Spivak 2007: 68-69). Here the de-mand for recognition – independent of the way this demand is performed – is the essential event because it motivates some sort of awareness of a potential lack of recognition.

Using the categories of Castells, the transformative artworks discussed here follow the Butlerian line of thinking by seeing national identity as a kind of 'project identity' in which 'the building of identity is a project of a different life, perhaps on the basis of an oppressed identity, but expanding toward the transformation of society as the prolongation of this project of identity' (Castells 2001: 10). The deconstructive artworks, in contrast, seem to follow Appadurai in his description of national identity as an identity form in danger of becoming a predatory identity because of its focus on cultural homogeneity. Instead of deciding between these opposite ways of approaching the potential consequences of national identity I would stress the importance of both perspectives. They point implicitly to the Janus-faced character of nationalism, which on the one hand can be used to legitimate narratives of cultural purity and ownership, but on the other hand has the potential to address and negotiate new ideas of the common values of a given society. As such, the discourses of deconstruction and transformation show that national identity is always an unfinished project, but also a project that must be continually scrutinised to prevent the predatory side of nationalism from becoming dominating.

Following this the discourses can be said to complement more than oppose one another. The discourse of deconstruction approaches national identity constructions as problematic because they seem to overemphasise homogeneity and therefore constantly produce cultural strangers. From a more theoretical perspective, it is therefore very relevant to recognise imaginaries of national homogeneity as often imprecise and potentially problematic. Seen from the perspective of everyday identification processes these imprecise imaginaries are nevertheless constantly used in people's understandings of themselves and their surroundings. This means that the ability to affect these imaginaries in a certain direction very much depends on whether or not one is willing to participate in these constructions of national we-imaginaries – or what Iver B. Neumann calls 'as if stories' (Neumann 1999: 215) – thereby daringly claiming what Danishness *is* or *should be* although one knows that national identity will never be a unitary concept. From this perspective, deconstruction and transformation seem to be crucial discursive strategies for establishing communities where recognition, equality, and the possibility of belonging do not rely on religious backgrounds, origin, or uncompromising loyalty. The first confronts the problems of already established ideas of 'a national we' repressing the complexity of individual identities or excluding certain types of subjectivities. The latter participates in the dirty job of telling stories of national values in order to

challenge the dangerous idea of national homogeneity as something out there to be preserved and defended against foreign impulses.

Works Cited

Agger, Gunhild (2005). *Dansk tv-drama. Arvesølv og underholdning*. Copenhagen: Samfundslitteratur.

Andreassen, Rikke (2007). *Der er et yndigt land. Medier, minoriteter og danskhed*. Copenhagen: Tiderne Skifter.

Appadurai, Arjun (2006). *Fear of Small Numbers. An Essay on the Geography of Anger*. Durham: Duke University Press.

Appadurai, Arjun [1996] (2008). *Modernity at Large. Cultural Dimensions of Globalization*. Minneapolis: University of Minnesota Press.

Arendt, Hannah (1968). *Origins of Totalitarianism*. New York: Harcourt Inc.

Billig, Michael [1995] (2006). *Banal Nationalism*. London: Sage.

Butler, Judith (1997). *Excitable Speech. A Politics of the Performative*. New York: Routledge.

Butler, Judith and Gayatri C. Spivak (2007). *Who Sings the Nation-State?* London: Seagull Books.

Böss, Michael (2006). *Forsvar for nationen. Nationalstaten under globaliseringen*. Aarhus: Aarhus University Press.

Calhoun, Craig (2002). *Nationalism*. Buckingham: Open University Press.

Castells, Manuel [1997] (2001). *The Power of Identity*. Oxford: Blackwell.

Cohen, Anthony P. [1985] (2004). *The Symbolic Construction of Community*. London: Routledge.

Connolly, William E. (1999). *Why I Am Not a Secularist*. Minneapolis: University of Minnesota Press.

Foucault, Michel [1969] (2005). *Vidensarkæologien* (originally *L'archéologie du savoir*). Aarhus: Philosophia.

Frello, Birgitta (2001). *Contextualising Discourse Analysis*. Working Papers 17/2001: Copenhagen Peace Research Institute.

Frello, Birgitta (2003). *Identiteter på spil. Medierne og krigen i Kosovo*. Copenhagen: Forlaget Politiske Studier.

Frello, Birgitta (2005). "Hybriditet: Truende forurening eller kreativ overskridelse?" In Henning Bech and Anne Scott Sørensen (eds.): *Kultur på kryds og tværs*. Aarhus: Klim.

Gellner, Ernest [1983] (2006). *Nations and Nationalism*. Malden: Blackwell.

Gundelach, Peter (2001). "National identitet i en globaliseringstid". *Dansk sociologi* 1, 63-80.

Hall, Stuart [1996] (2002). "Introduction: Who Needs 'Identity'? " In Stuart Hall and Paul du Gay (eds.): *Questions of Cultural Identity*. London: Sage.

Hauge, Hans (2003). *Post-Danmark. Politik og æstetik hinsides det nationale*. Copenhagen: Lindhardt og Ringhof.

Held, David, Anthony McGrew, David Goldblatt, and Jonathon Perraton (2000). "Global Transformations: Politics, Economics and Culture"". In Chris Pierson and Simon Tormey (eds.): *Politics at the Edge – PSA Yearbook*. London: Palgrave.

Husserl, Edmund [1907] (1997). *Fænomenologiens idé*. Copenhagen: Hans Reitzels Forlag.

Jenkins, Richard [1996] (2006). *Social Identity*. London: Routledge.

Jørgensen, Marianne W. and Louise Phillips [1999] (2006). *Diskursanalyse som teori og metode*. Copenhagen: Roskilde Universitetsforlag/Samfundslitteratur.

Knap, Torben F., Morten Nielsen, and Jacob Pindstrup (eds.) 2005. *Hvad er så danskhed?* Aarhus: Hovedland.

Kress, Gunther and Theo v. Leeuwen (2001). *Multimodal Discourse. The modes and media of contemporary communication*. London: Arnold.

Laclau, Ernesto and Chantal Mouffe [1985] (2001). *Hegemony and Socialist Strategy. Towards a Radical Democratic Politics*. London: Verso.

Lundgreen-Nielsen, Flemming (ed.) (1992). *På sporet af dansk identitet*. Copenhagen: Spektrum.

Møller, Marie. Ø. and Sara N. Thordsen (2008). "Preface". In Marie Ø. Møller and Sara N. Thordsen (eds.): *Æstetik og politisk magt*. Uppsala: NSU Press.

Neumann, Iver. B. [1998] (1999). *Uses of the Other. "The East" in European Identity Formation*. Minneapolis: University of Minnesota Press.

Superflex. 2007. "Rebranding Denmark". Text introducing *Rebranding Denmark*. Accessed August 13, 2009: http://www.superflex.net/projects/rebrandingdenmark/index.shtml.

Tomlinson, John (1999). *Globalization and Culture*. Cambridge: Polity.

Wodak, Ruth, Rudolf de Cillia, Martin Reisigl, and Karin Liebhart [1999] (2005). *The Discursive Construction of National Identity*. Edinburgh: Edinburgh University Press.

Østergård, Uffe (ed.) (1992). *Dansk Identitet?* Aarhus: Aarhus University Press.

Özkirimli, Umut (2000). *Theories of Nationalism. A Critical Introduction*. New York: Palgrave.

Notes

1 I use the concept nationalism to describe theories or ways of thinking that affirm the nation as a key concept, not to designate a certain political, right-wing movement.

2 'we will call *articulation* any practice establishing a relation among elements such that their identity is modified as a result of the articulatory practice. The structured totality resulting from the articulatory practice, we will call *discourse*'. (Laclau and Mouffe 2001: 105)

3 'Any discourse may be realised in different ways. The "ethnic conflict" discourse of war, for instance, may be realised as (part of) a dinner-table conversation, a television documentary, a newspaper feature, an airport thriller, and so on. In other words, discourse is relatively independent of genre, of mode and (somewhat less) of design'. (Kress and Leeuwen 2001: 5)

4 http://www.huskmitnavn.dk/view.php?id=47&origin=%2Fstreet.php, accessed July 15, 2009.

5 http://www.superflex.net/projects/rebrandingdenmark/, accessed July 15, 2009. Smaller parts of the following analysis and discussion have previously been published in Danish in my book *Tegningekrisen – som mediebegivenhed og danskhedskamp*, 2011, Aarhus University Press.

6 http://buildingsocieties.wordpress.com/2007/07/25/ellen-nyman/, accessed July 7, 2009.

7 http://www.liseharlev.com/my-own-country.html, accessed July 7, 2009.

8 http://www.liseharlev.com/noget-jeg-kender.html, accessed July 7, 2009.

Multilingualism in Contemporary Nordic Literature: Jonas Hassen Khemiri[1]

By Christian Refsum

Johan Gottfried von Herder and Alexander von Humboldt saw the mother tongue as the most important symbol of belonging within a given nation, a position that has had a tremendous influence in the post-romantic era. Several critics have, however, focused on the problematic aspects of seeing language as an authentic expression of a people and the decisive criterion of nationality. The Italian philosopher Giorgio Agamben, for example, writes that 'Romantic ideology [...] tried to clarify something that was already obscure [the concept of people] with the help of something even more obscure [the concept of language]' (Agamben 2000: 65). The fate of the Roma people is for Agamben but one reminder of how the ideological symbiotic correspondence between people and language has legitimized the repressing of minorities through state politics. Agamben suggests, in contrast to the romantic ideology, that 'All peoples are gangs and coquilles, all languages are jargons and *argot*' (ibid: 66). The task of 'breaking at any point the nexus between the existence of language, grammar, people and state' is therefore not only linguistic or literary, but 'above all, political and philosophical' (ibid.: 69).

The example of the Roma people is also suggestive in another sense. It is a reminder that questions of language and identity concern the individual directly in his or her daily life, in the streets, at school, and in job-seeking situations. For European authorities the Roma people have represented a problem. Agamben, however, suggests seeing 'the problem', the culture of the Roma people, as a model for potential challenges and solutions for the understanding of the relationship between people, place, and language as a whole.

Since the beginning of the 21st century was characterised by migration on a previously unknown scale, and digital technology has given us the ability to communicate simultaneously with people on the other side of the globe, it is not surprising that questions of translation, translatability, and multilingualism are central to contemporary sociolinguistics. In this discussion on the relationship between people and language, I will focus on literary multilingualism as a means of reflecting upon questions of politics and identity in relation to transculturalism.

Multilingualism can be defined as 'the co-presence of two or more languages (in a given society, text or individual)' (Baker 2001: 157). Whether we speak of multilingualism in a society, text, or individual, there are no absolute, but only gradual borders towards an ideal and fictive monolingualism.[2] All languages have been developed in some kind of exchange between different rules and conventions, and often in some kind of relation to other languages. Still, some societies, texts, or persons can be said to be *more* multilingual than others. In Norway, as in the other Scandinavian countries, it is expected that adults can speak English in addition to their own language. Many people also have competence in Sami, Urdu, Hindi, French, German, etc. India has twenty-two official languages (and many more vernacular languages are spoken), and must, due to this variety, use English as a common, neutral language. Such a situation is common in Africa as well as Asia. This prompted Susan Sontag to write the essay "The World as India" in order to describe the multilingual situation of globalization (Sontag 2007). English is also more and more commonly used to communicate over the language barriers within the Nordic countries. When I speak Norwegian in Copenhagen today, young people respond in English, something that was unheard of twenty years ago. There is also a growing tendency of English use within national public domains, such as in the university sector or in business.

Jonas Hassen Khemiri

Jonas Hassen Khemiri is probably *the* contemporary Scandinavian writer for describing and discussing multilingualism in society, in literature, and most persistently in the individual. Khemiri was born in 1978 in Stockholm. His debut *Ett öga rött* (*An eye red*[3]) (2003) was a huge success both commercially and among critics. The language in the novel was immediately recognised by the critics as an immigrant language described as Rinkeby Swedish, a common

denominator for young suburban slang, named after a particularly multicultural area in Stockholm. In several interviews Khemiri has expressed discontent with readings identifying the novel's language as an authentic expression of Rinkeby Swedish.[4] Still, it is necessary to present what is normally meant by the term in order to grasp the important nuances of the book as well as of Khemiri's later writings.

In Rinkeby and other Swedish suburbs new ways of speaking have been developed by second and third generation immigrants who speak Swedish with modified grammar and loanwords from Turkish, Arabic, Persian, Urdu, Spanish, and English.[5] It is also common to speak with a staccato intonation. Regarding the grammar, common syntactical rules for inversion of the subject-verb-object order are often discarded, as in the opening of *Ett öga rött*: 'I dag *det* var sista sommarlovsdagen och därför *jag* hjälpte pappa i affären' (Khemiri 2003: 9, my italics). In standard Swedish one would normally write 'I dag var *det den* sista sommarlovsdagen och därför hjälpte *jag* pappa i affären.'[6] The constructivist aspect of Khemiri's project should not be underestimated and in *Ett öga rött* the use of so-called Rinkeby Swedish is one of several strategies by which the protagonist and unreliable narrator experiments with different roles, identities, and signs of social belonging. The fact that the protagonist does not live in Rinkeby, but in Søder, a middle class neighbourhood with fewer immigrants, is a hint that the novel is about a teenager romanticising Arabic and immigrant culture and not an authentic and simple expression of the immigrant experience written in 'immigrant language', if such a thing ever existed. Magnus Nilsson (2008) and Wolfgang Behschnitt (2010) have argued convincingly that Swedish readers and critics were very keen to find and celebrate authentic immigrant stories from the new Sweden at the time the novel was published. Behschnitt quotes Annina Rabe's article in *Svenska Dagbladet*, August 8, 2003:

> There is just no end to how much all of us within the cultural establishment want to show how we sympathise with the multicultural society. [...] A writer like Jonas Hassen Khemiri is the wet dream of every publishing house and every culture journalist. (Behschnitt 2010: 79, my translation)

Both Nilsson and Behschnitt discuss the deeply problematic aspects of this cry for ethnicity and authenticity, and why it is important for a writer like Khemiri to object to ethnification and authentification.

The construction of 'immigrant identity' and 'immigrant language' takes place at various levels in society. One could argue that even for the teenagers in Rinkeby, Rinkeby Swedish is a constructed phenomenon. And in terms of literature, there is a vast difference between speaking slang in the streets and modifying grammar and style within the literary institution the way the writer Khemiri does in *Ett öga rött*. Khemiri has actually invented a literary style based on an oral multiethnolect. This style might give the impression of a phonetic transliteration in order to reproduce a dialect on paper, but it is better regarded as a literary style mimicking difference, trying to destabilise language. Khemiri's stylistic experiments are in any case highly interesting with regards to the complex relationship between social, personal, and literary multilingualism.

Within sociolinguistics the term 'multiethnolect' has been developed in order to describe discourses or styles such as Rinkeby Swedish.[7] One advantage of this term is that it avoids the negative connotations of labels like 'blattersvenska'[8] and 'rinkebysvenska'. The term 'multiethnolect' is not used to describe an inaccurate use of language, but rather a particular style that obeys certain codes mastered by a limited group of people. A multiethnolect is therefore like a dialect, except that users of a given multiethnolect have diverse ethnic backgrounds.

As Wendelius (2002) has shown, Swedish immigration literature was quite extensive by 2000.[9] However, most books written by immigrants in Swedish do not differentiate from other Swedish books with regards to linguistic norms.[10] The explanation for this might be that the literary institutions have had a limited tolerance towards the use of multiethnolect. But self censorship among immigrants can also be a part of the explanation; the use of a multiethnolect might give the impression that the speaker/writer is not completely aware of the language norms. For many immigrants it is therefore important to use the language as correctly as possible, in order not to seem like a fool. Such considerations are analysed in both *Ett öga rött* and Khemiri's next novel *Montecore. En unik tiger* (2006; English edition *Montecore* 2011), which describes the relationship between grammar, lexicon, politics, and power.

There is no doubt that the publication of *Ett öga rött* helped raise the political question of the status of 'immigrant language' in Sweden: should new means of expression from the suburbs be considered as equal or as inferior to more traditional standard Swedish? How many, and which, if any, of the specific slang words from Rinkeby and other suburbs should be included in the Swedish dictionary? Are such new loanwords as 'guss' (girl) and 'keff' (bad, wrong) enriching the

Swedish language, or are they symptoms of a decline?[11] As *Ett öga rött* was very well received, it contributed to the propagation of such questions.

One claim of this essay is that even though Khemiri writes in a specifically Swedish context, his novels still have relevance for understanding a wider Scandinavian cultural situation. Though multiethnolect has been relatively rare in Swedish literature, it is even more so in Norwegian and Danish. This can partly be explained by the fact that Sweden has received more immigrants than the other Scandinavian countries, and that immigration started earlier here. Still, striking similarities have been documented within the Nordic countries with regards to the development of multiethnolect. So-called Rinkeby Swedish has clear parallels to 'Kebabnorsk' (Kebab Norwegian) which is spoken in the Eastern parts of Oslo, and 'perkerdansk' (Perker Danish; 'perker' is a pejorative expression for a person of Middle Eastern origin). The existence of these multiethnolects raises questions that deserve to be asked in all the Scandinavian countries: How are such linguistic developments treated by the national language councils? How are they treated by television and newspaper editors? How are they treated by influential members of the literary institution (critics, editors in publishing houses, writers, etc.) who define what counts as good language? To what extent is a multiethnolect seen as pollution or as a natural development with regards to the linguistic hygiene of the national language? And, by extension, the health or otherwise of the country? These are some of the deeper political issues that Khemiri's novels probe. Since Khemiri's work offers a highly competent and current analysis of the importance of language (the primary criteria for national belonging, according to the romantic paradigm) both in a political and existential perspective, it is necessary to present his work in more detail.

Ett öga rött describes a conflict between the fifteen-year-old Halim and his father. The father, who is doing all he can to be a well integrated immigrant, dislikes the fact that his son romanticises everything Arabic and identifies with and participates in immigrant culture. The son observes how the father suffers because of his limited language skills, how accent, grammar, and lexicon function as markers of social identity. As we follow Halim's diary, the novel maps out connections between language, identity, power, and not least, the lack of power.

When Halim complains to his father that he is no longer is offered Arabic lessons at school (due to economical considerations), the father says that it is more important for Halim to learn Swedish. He also reproaches Halim for choosing to speak Swedish like an immigrant. It is vital to the story that Halim

has no difficulty speaking the way his father and teachers want him to. One could add that from a sociolinguist point of view there is a vast difference between the language of the first generation of immigrants (who strive to learn the new language) and the second or third generation who use multiethnolect consciously. The Swedish spoken by first generation immigrants is less conventionalised, does not function as a marker of identity for groups of teenagers, and is not, as in the case of Rinkeby Swedish, the result of a conscious choice. As will be evident, these points are essential to understanding Khemiri's novels.

It is not farfetched to see a parallel between Halim's language games and those of the writer, Khemiri. Both master standard Swedish and experiment with a hybrid language. Halim does this in his private life, with his friends, in his diary, and at school. Khemiri does it in writing within the literary institution in order to make art. For Halim, the use of multiethnolect becomes a means of exploring various identities, something which becomes even more evident as we understand how he operates as an unreliable narrator in his diary. For Khemiri, the use of multiethnolect is a means of pushing and exploring the borders of literary language. By giving multiethnolect a place in a literary work he exposes controversies of language and politics, as well as of language politics. It is easy to accept that young people speak Rinkeby Swedish among themselves, or that rappers use such a language. But when a novel written in this language is recognised as good literature, it is an indication of changes in the norms of the literary institution.

Montecore

Even if nearly every page of *Ett öga rött* explores themes related to multilingualism, whether in relation to literature, society, or the individual, it is only in Khemiri's next novel, *Montecore. En unik Tiger*, that this exploration is developed into an explicit and more systematic discussion. In this book, in which the author engages in an entertaining play with masks, the protagonist 'Jonas' becomes an author – like Jonas (Hassen Khemiri) in the real world. He receives a letter from his father's childhood friend, Kadir, suggesting that he and Jonas should write the biography of Jonas' father, who has disappeared.

Montecore. En unik tiger consists partly of Kadir's letters to Jonas, Jonas' sketches for the book about his father, and Kadir's and Jonas' comments on each other's texts. Kadir also includes translations (from Arabic to Swedish) of some old letters presumably sent by Jonas' father to him.

Like Halim in *Ett öga rött*, Kadir is an unreliable narrator who presents himself and his father in the best possible light and, towards the end of the book the suspicion that Kadir is actually the father's pseudonym becomes overwhelming. It is striking how well Kadir knows the thoughts of Jonas' father in situations where only the son and the father were present.

Kadir's first letter is written in a hybrid language:

Deviner who writes these phrases to you? It is KADIR who is pushing the keys!!! Your father's most antique friend!

(Devinera vem som skriver dig dessa fraser? Det är KADIR som knappar tangenterna!!! Din fars mest antika vän!). (Khemiri 2006: 13)

The Swedish sentences are characterised by traces of French grammar and lexicon. The first word in the paragraph above is identical to the French verb 'deviner', which means to guess or presume. Later Kadir writes 'I have 54 years' / 'jag har 54 år' (Khemiri 2006: 29), a sentence which looks like a literal translation of the French 'J'ai 54 ans'. The standard Swedish equivalent of this expression is rather 'Jäg *är* 54 år' / 'I *am* 54 years old'. Kadir also omits articles and inversions in a few places, though this device was more striking in *Ett öga rött*. While Halim's language could be identified and reterritorialized as Rinkeby Swedish by readers and critics, Kadir's idiosyncratic language resists such simplifying reading strategies to a stronger degree. *Montecore. En unik tiger* can therefore, from one point of view, be said to create a more fruitful confusion than the bestseller *Ett öga rött* as the reception of the latter showed that it could be used to strengthen stereotypes towards immigrants. It suited the taste of a reading public who wanted stories of immigrants in a framework that was easily identifiable and recognisable. The cosmopolitan deterritorialization carried out by *Montecore. En unik tiger* is more resistant to familiar types of reterritorialization.

Kadir's language is a striking feature of *Montecore. En unik tiger*. But Kadir, for his part, calls attention to Jonas' use of Swedish in his debut novel. He has read reviews of the novel on the Internet and has the following comments:

Despite your protests you are celebrated for having written a book on 'cleancut Rinkeby Swedish'. Obviously you have given life to 'the history of the immigrant' in a language that sounds like you have lowered a microphone down into any immigrant neighbourhood. Didn't you write that your book was about a

Swedish-born man breaking out of his language intentionally? What happened to your declared exploration of the theme of authenticity?[12]

This is only one among several passages in which Khemiri makes fun of the critics of *Ett öga rött* who missed the novel's conscious experimentation with conventions regarding literary and spoken language. And shortly after this passage it becomes clear to what extent the conscious experimentation is related to a conflict with the father:

To me, your novel seems penetrated by inconsequence and it seems dirty with exactly those ugly words condemned by your father. 'Gussar'? 'Baxa'? Why does the book use exactly the language your father hated the most? No surprise people misunderstand.[13]

Kadir is not only condemning the use of taboo words, but also multiethnolect, even though he himself is involuntarily writing a hybrid form of Swedish. Jonas, the writer of a novel that strongly resembles *Ett öga rött*, has Swedish as his first language and is not confused with regards to language norms (as Kadir is). Ironically, the one who consciously plays with multiethnolect as a literary device is condemned in an unintentionally multilingual style.

This irony mirrors the considerate, emphatic, and antagonistic relationship between father and son. Their ambivalent relation is, to my mind, not only central in the novel; it is also the plot's *primus motor*.

The father's concern for his son is expressed through almost self-effacing attempts to adjust to explicit and implicit demands of the Swedish society, in order to provide Jonas (not Yuones, as the father emphasises) with the best possible starting point for becoming just like *a svenne* (slang for a Swedish person). The father does all that is in his power not to *contaminate* his son with the feeling of being an outsider. On the other hand, Jonas expresses his affection for his father by defending every characteristic of his personality that deviates from Swedish norms. Here, language is of vital importance. The son wants to expose exactly those traits that the father is trying to hide. And it is paradoxically this mutual thoughtfulness that leads them to break all contact. This is the background for the father's disappearance, which is retold retrospectively in the letters included in the novel.

The father's difficulties in getting assignments as a photographer disappear overnight when he changes the sign on the door of his photo studio. He writes 'PET

PHOTOGRAPHER KRISTER HOLMSTRÖM'/'HUSDJURSFOTOGRAF KRISTER HOLMSTRÖM' in big letters and 'Abbas Khemiri' in small letters underneath (Khemiri 2006: 230). After this, it is as if the father loses more and more of his identity to his Swedish alter ego Krister. But the symbolic change of identity is still not enough. The difficulties in obtaining respect and recognition continue:

> Daddies learn themselves everything there is to know. But still. Just one wrong preposition is all that is needed. Just one 'an' that should have been an 'a'. Then [...] the pause that shows that no matter how hard you try, we will always, ALWAYS see through you.[14]

The novel exposes how important language can be for acceptance into a society, but also how difficult it is to familiarise oneself with the nuances of a new language. It also shows that tolerance in the Scandinavian countries towards both poor language skills (the father) and multiethnolect (Jonas) is limited. Jonas' linguistic revolt is motivated not least by his concern for his father:

> But dad, you also have a language of your own! [...] only daddies speak Khemirian. A language which is a mixture of all languages, a language that is extra everything, with slippages and merged proper words, special rules and daily exceptions. A language that is Arabic swearwords, French love declarations, English photography-quotations, and Swedish verbal jokes.[15]

Large parts of the novel take place in the 1990s, a decade when there were particularly strong tensions between immigrants and racist gangs in Sweden. The so-called *Lasermannen* later came to symbolise the hateful racism of this period.[16] Jonas' father arrived in Sweden in the 1980s and he explains the racism of the times by saying that his fellow immigrants did not make sufficient efforts to get jobs or to integrate themselves into Swedish society. Jonas sees his father's criticism as a betrayal. He feels a need to defend all immigrants and starts the organisation BFL, Blatte for Life.

The father disappeared from Sweden after his photo studio was destroyed by a racist gang, but according to Kadir (the father's alter ego) he now operates as a successful photographer of international celebrities.

A central theme in the book is the father and son's common, strong feeling that they are not completely accepted as Swedish citizens. This indicates that in

Scandinavian countries there are certain expectations about the ethnic homogeneity of the population. This is certainly not exclusive to Scandinavian culture, though societies exist that have a longer tradition of perceiving themselves as multicultural. In preparing this article I did not find many Danish experiments with multiethnolect, even though the preconditions for such experiments are also present in Denmark.[17] On the other hand there are literary testimonies problematising what it means to be Danish and what can be expected of Danish people. In this context Maja Lee Langvad's text "Dette er Danskerloven" ("This is the law of the Danish") from *Find Holger Danske* (Langvad 2006: 46) is highly relevant in proclaiming a fundamentalist and static law of the relationship between nation and people.

1. You shall not believe that you are Danish because you are born in Denmark.
2. You shall not believe that you are Danish because you speak Danish fluently.
3. You shall not believe that you are Danish because you are a Danish citizen.
4. You shall not believe that you are Danish because you live in Denmark.
5. You shall not believe that you are Danish because you respect the Danish laws.
6. You shall not believe that you are Danish because your grandparents think so.
7. You shall not believe that you are Danish because you raise the Danish flag in your garden.
8. You shall not believe that you are Danish because you call someone newly Danish.
9. You shall not believe that you are Danish because you will die for Denmark.
10. You shall not believe that you are Danish because you feel Danish.
 (Langvad 2006: 46, my translation)

Langvad, who was raised in Denmark by adoptive parents, presents here an absurd expression of the experience of being kept at a distance due to some signal of ethnic difference. Langvad's book gives a description of how an adopted person experiences both being included as a Danish person, but also how Danish (and Scandinavian) culture in various situations is excluding. No matter how Danish you become, you are still not Danish enough! Such a logic of exclusion will, however, in the end paradoxically free the construction of 'Danishness' of all content, as the text demonstrates. Thus, Langvad is both diagnosing a

fundamentalist law, and pointing at how the same law, in its absurdity, becomes impossible to defend.

In Khemiri's books we find three different strategies for confronting versions of ethnic fundamentalism comparable to that expressed in Langvad's text. The father in *Montecore. En unik Tiger* tries in vain to become (like) a Swede, but fails, has a psychological breakdown, and flees the country. In *Ett öga rött* Halim responds in a completely different way. He fantasises and experiments with establishing an uncompromising militant immigrant identity, proclaiming a black companionship against the ethnic Swedes, a solution which seems to be rejected in the course of the novel. In *Montecore. En unik tiger*, Jonas, however, tries to establish a hybrid, intercultural identity as an alternative to ethnic fundamentalism. While his father cannot get rid of his feeling of being a stranger, the son seeks a new hybrid identity.

First the father:

> I am NOT an immigrant! [...] How long shall I wander? I am Swedish. I have lived half of my life here ... (Khemiri 2006: 296)

Then Jonas:

> [...] we are neither completely Swedish, nor Arab, but something different, something third, and the awareness of not having one simple communion strengthens us in creating a new union, a new communion without borders, without history, a Creole circle where everything is blended, mixed, and hybrid.[18]

Both *Ett öga rött* and *Montecore. En unik tiger* can be read as attempts to create linguistic and literary expressions on the basis of a new demographic and medial situation, and at the same time as performative experiments with models of identity. The two books are Nordic contributions to the growing body of international prose that explores cultural hybridity and contributes to World Literature in a different sense from the one Goethe had in mind when he coined this term in the early 19th century. Khemiri's books are fruits of internationalisation and they deserve to be discussed in an international perspective. I will therefore look at Khemiri's novels in a larger Nordic, and global, perspective.

How newness enters the world

In the age of globalization World Literature has become one of the most debated terms in literary theory.[19] Discussions about world literature, however, rarely touch on multilingualism. The term has been used in various ways to describe the best books in the world, books of international relevance, the international commercial literary market, and a cosmopolitan idea. One can, however, discuss to what extent contemporary processes of globalization actually promote the kind of rich exchange between different cultures that Goethe had in mind when in 1827 he said to his secretary J. P. Eckermann that 'the age of world literature is beginning, and everybody should contribute to hasten its advent' (Eckermann 1959: 173-174).

The problem of the homogenisation of world culture, which is much debated in globalizaton theory, has been a theme in literary theory at least since Erich Auerbach's classic essay on "The Philology of World Literature"/"Philologie der Weltliteratur" from 1952.[20] Auerbach is proud to belong to the tradition that began with Goethe, and he proclaims that 'in any event, our philological home is the earth: it can no longer be the nation' (Auerbach 1967: 310). According to Auerbach, the existence as well as the study of world literature is threatened. He fears a process of globalization that hollows out the richness of national cultures and their dynamic meeting points in world literature. For him richness in the national culture is a precondition for richness in the world culture made possible by translation, and globalization is threatening both. Following Auerbach's perspective one could argue that Khemiri's books are the result of a weakening of the uniqueness of both Arab and Scandinavian culture. His books would then not be seen as opening a dialogue between two rich cultures; instead they would be destined to remain a mix (of minor quality) of both.

Homi K. Bhabha gives a very different account of globalization forty-two years after Auerbach's pre-structuralist, pessimistic, humanist reflection. In *Locations of Culture* Bhabha presents an expanded concept of translation, so-called 'cultural translation', and he reads Salman Rushdie's novel *The Satanic Verses* as a story of such a translation. He also sees the Caribbean poet Derek Walcott as an example of a writer who has described a similar form of cultural translation, particularly in his poem "Names". Bhabha calls the result *cultural hybridity*, a condition that includes new forms of differentiation, not the homogenisation that Auerbach feared: an old identity related to a network of national or cultural presuppositions starts to engage in a complex interplay with a new system

of cultural preconditions, as in both Khemiri's novels. Bhabha's point is that hybridity does not represent a decline. On the contrary, it is through translation and hybridity that 'newness enters the world'. Bhabha therefore develops a theoretical ground for the appreciation of migration, diaspora, translation, interculturalism, and code switching as means for obtaining new forms of individual and social identity. This kind of hybrid identity has been discussed regularly within the humanities and social sciences in the last fifteen years.[21]

Since the 1960s and especially the 1970s Scandinavian culture has been increasingly multilingual and hybrid. It is, however, only after 2000 that one can argue that multilingualism and hybridity have become a trend in Scandinavian literature.[22]

The tradition within modern literature for experimentation with multilingualism and hybridity can be divided into two forms. Both are represented in contemporary Nordic literature. Khemiri resembles novelists like Rushdie and Arundati Roy who have written about the hybridization of culture, exploiting multilingualism to renew the English language. This tradition goes back at least to Chinua Achebe's *Things Fall Apart* (1958) and Jean Rhys' *Wide Sargasso Sea* (1966).

The other tradition is poetic, more experimental, and goes back to writers as different as James Joyce (*Finnegans Wake*), T.S. Eliot ("The Waste Land"), and Poul Celan. The Norwegian writer Øyvind Rimbereid has written a long poem called "Solaris Korrigert" ("Solaris Corrected") which is a vital contribution to this tradition. Both Khemiri and Rimbereid relate to a particular historical experience requiring a political engagement, though on very different grounds. While Khemiri addresses current debates on immigration, racism, and identity directly, Rimbereid's project is both utopian and dystopian. The utopian project is the invention of a completely new poetic science fiction language, whilst the dystopian aspect involves prophecies of ecological disasters.

Whereas Khemiri is renewing the Swedish language on the basis of certain tendencies in spoken Swedish, Rimbereid construes a new language inspired by international oil terminology in the North Sea, mixing influences from languages such as Norwegian, English, Old Norse, German, and Dutch.

Both writers are, if not breaking, at least reinventing 'the nexus between the existence of language, grammar, people, and state', to quote Agamben, and this task is 'all political and philosophical'. Khemiri describes in an exemplary fashion how experiments with multilingualism represent a sort of everyday cultural diplomacy (or activism) in which the stakes are not only acceptance at school,

at work, between friends, and within the family, but also the self-respect of the individual. There is, however, a huge difference in carrying out such linguistic negotiation processes of demarcation and transgression in the everyday life of a young immigrant and in the literary institution. Through works of literature, such negotiations can be seen both as aesthetic and linguistic experiments on a micro-level and as performative actions in a broader political perspective. Literature here takes part in a process of deterritorialization in the sense described by John Tomlinson, for whom literature is signalling the weakening or dissolution of the connection between everyday lived culture and territorial location (Tomlinson 1999). But it is also relevant to speak of deterritorrialization in a wider, more Deleuzian sense (Deleuze and Guattari 1975), implying the destabilisation of any sort of assembly, be it linguistic, ideological, or psychological. This is especially true with regard to the work of Rimbereid, who destabilises notions of poetry, science fiction, and national language in a radical manner that opens completely new possibilities for (literary) experience.

In very different ways Khemiri in Sweden and Rimbereid in Norway are deterritorializing the Swedish and Norwegian languages and national identities, forwarding new reading and writing practices. However, Rimbereid's Solaris-language is so different from standard Norwegian that it requires a greater effort to read. Together the two books exemplify not only the use of multilingualism, the stretching of language norms, but also the flourishing of new, idiosyncratic languages. Here are the opening lines from "Solaris korrigert":

> WAT *wul aig bli*
> *om du kreip fra*
> *din world til oss*
> SKEIMFULL, *aig trur,*[…].
> (Rimbereid 2005: 9)

To a Norwegian reader with competence in English this hybrid language seems very unfamiliar, but not impossible to decipher. The effect resembles that of reading a text in a language in which one has a limited competence. Swedish readers of Khemiri's novels will at times have similar experiences, though not to the same degree as with "Solaris korrigert". From one point of view Khemiri's novels can be seen as attempts at giving an adequate linguistic expression to a certain identity, or creating a language relevant to such an identity. But from another point of view one can claim that he instead, like Rimbereid, forces the

Norwegian or Swedish reader to read with a limited knowledge of the language codes involved in the literary experience. He is forced to read as a non-native speaker. In this way literature not only expresses identity or nationality; through defamiliarisation and deterritorrialization literature demonstrates that the native speaker does not and cannot own his own language. Literature thus turns us all into immigrants.

Anglification and hybridization

On the one hand our new global situation seems to promote several new and specialised discourses, dialects, multiethnolects, and languages. All of these tendencies could be seen as deterritorializing. But deterritorialization is always in some way related to new forms of reterritorialization; this is particularly clear in a global perspective. Whenever deterritorialization takes place via neologisms, minor, hybrid, or multilingual literature, there is a need for reterritorialization. It would therefore be naïve to see hybridization and multilingual textual practices as progressive in and of themselves.

The emergence of new computer languages, multilingual styles, and multiethnolect, whether they be literary or not, should be viewed in connection with the fact that English is becoming more and more widespread. One might say that as more and more minor, specialized, or hybrid languages are developed, English will prove itself to be stronger as a *lingua franca*. On the other hand, English is also constantly deterritorialized. My last example is from a poetry collection written in idiosyncratic English (also called 'finglish') by the Finnish poet Aki Salmela.[23] The title of Salmela's collection of poems *Words in Progress* alludes to Joyce's *Finnegans Wake*, and the poems have partly been written by sampling discussions of poetry available on the Internet, partly by transferring the samples several times through the translation service of the Internet company *Babel Fish*. The result is English that demonstrates the potential of English to serve not as a monolithic global language, but rather as a playground for various experiments in various parts of the world:

> Xerox just gave you language. More unfortunate tendencies poured in. The effect is in setting the parameters of work, naked. And the good parameters are executing a come. (Quoted from Strøm 2009)

As the Norwegian critic Cathrine Strøm (2009) has observed, such English texts are not evidence of the homogenisation of a global, English, Americanized culture. Rather, they are the expression of a genuine cosmopolitanism which in the framework of Ulrich Beck can be described as a renegotiation of national and social loyalties. In this context it is striking how Khemiri in his latest play *Fem ganger Gud* (*Five Times God*) lets one of his characters speak first English and then 'Svengelsk', a mixture of English and Swedish (Khemiri 2008: 186).

The various literary texts mentioned and discussed in this article present only a few significant examples of how Nordic languages and literatures take part in a worldwide exploration of multilingualism and hybridization. I would, however, like to stress how tendencies of hybridization and deterritorialization on the one hand and anglification on the other are not only mutually interdependent, but also, in fact, as in the Finnish example (and in a more complicated manner in Rimbereid) intertwined.

Works Cited

Agamben, Giorgio (2000). *Means Without End: Notes on Politics.* Minneapolis, London: University of Minnesota Press.

Andersen, Paul Bjelke (2008). *Til folket (2008-2010).* Oslo: Flamme forlag.

Andersen, Paul Bjelke (2010). *The Grefsen Address.* Finland: Ntamo.

Andersen, Paul Bjelke (2010). *NAVNET – et dikt, for høytlesning på dansk og norsk.* Aarhus: Edition After Hand.

Auerbach, Erich (1967). "Philologie der Weltliteratur". In *Gesammelte Aufsätze zur Romanischen Philologie.* Bern & München: France Verlag. Translation into English by Edward and Marie Said, "Philology and Weltliteratur". *Centennial Review* 1 (Winter 1969).

Baker, Mona (ed.) [1998] (2001). *Routledge Encyclopedia of Translation Studies.* London & New York: Routledge.

Behschnitt, Wolfgang (2010). "The Voice of the 'Real Migrant' – Contemporary Migration Literature in Sweden". In Mirjam Gebauer and Pia Schwarz Lausten (ed.): *Migration and Literature in Contemporary Europe.* Munich: Meidenbauer.

Berman, Antoine (1984). *L'épreuve de l'étranger. Culture et traduction dans l'Allemagne romantique: Herder, Goethe, Schlegel, Novalis, Humboldt, Schleiermacher, Hölderlin.* Paris: Gallimard.

Clyne, Michael (2000). "Lingua Franca and Ethnolects in Europe and Beyond". *Sociolinguistica: internationales Jahrbuch für europäische Soziolinguistik* 14, 83-89. Tübingen: Max Niemeyer.

Deleuze, Gilles and Félix Guattari (1975). *Pour une literature mineure.* Paris: Minuit.

Derrida, Jacques (1996). *Le monolinguisme de l'autre, ou, La prothèse d'origine.* Paris: Galilée.

Doggelito, Dogge and Ulla-Britt Kotsinas (2004). *Förortsslang.* Stockholm: Norstedts.

Eckermann, Johann Peter (1959). *Gespräche mit Goethe in den letzten Jahren seines Lebens.* Wiesbaden: F.A. Brockhaus.

Forster, Leonard (1970). *The Poet's Tongues: Multilingualism in Literature*. London: Cambridge University Press.

Jørgensen, J. Normann and Pia Quist (2008). *Unges sprog*. Copenhagen: Hans Reitzels forlag.

Khemiri, Jonas Hassen [2003] (2006). *Ett öga rött*. Stockholm: Norstedts Pocket.

Khemiri, Jonas Hassen [2006] (2007). *Montecore. En unik tiger*. Stockholm: Norstedts / Månpocket.

Khemiri, Jonas Hassen (2008). *Invasion!: pjäser, noveller, texter*. Stockholm: Norstedts / Månpocket.

Kongslien, Ingeborg (2007). "New Voices, New Themes, New Perspectives: Contemporary Scandinavian Multicultural Literature". *Scandinavian Studies* (US) 79: 2, 197-226.

Kotsinas, Ulla-Britt (1990). "Svensk, invandrarsvensk eller invandrare. Om bedömning av främmadedrag i svenskt talspråk". In Gunnar Tingbjörn (ed.): *Andra symposiet om svenska som andraspråk i Göteborg 1989*. Stockholm: Skriptor, 244-273.

Langvad, Maja Lee (2006). *Find Holger Danske*. Copenhagen: Borgen.

Lindholm, Audun (2008). "FOR aig veit existen af vorld — Om Solaris korrigert". In Janike Kampevold Larsen and Stig Sæterbakken (ed.): *Norsk litterær kanon*. Oslo: Cappelen Damm.

Nilsson, Magnus (2008). "Litteratur, etnicitet och föreställningen om det mångkulturella samhället". In *Samlaren. Tidskrift för svensk litteraturvetenskaplig forskning*. Uppsala: Swedish Science Press, 270-304.

Paul, St-Pierre and Prafulla C. Kar (eds.) (2007). *In Translation: Reflections, Refractions, Transformations*. Benjamins translation library vol. 71EST. Amsterdam: Benjamin.

Quist, Pia (2000). "Ny københavnsk 'multietnolekt'. Om sprogbrug blandt unge i sprogligt og kulturelt heterogene miljøer". *Danske Talesprog* vol. 1. Institut for Dansk Dialektforskning. Copenhagen: C. A. Reitzels Forlag.

Rimbereid, Øyvind (2005). *Solaris Korrigert*. Oslo: Gyldendal.

Rimbereid, Øyvind (2006). *Hvorfor ensomt leve*. Essays. Oslo: Gyldendal.

Sontag, Susan (2007). "The World as India". In Paolo Dilonardo and Anne Jump (eds.): *At the Same Time. Essays and Speeches*. New York: Farrar Straus Giroux.

Spitzer, Leo (1967). *Linguistics and literary history: essays in stylistics*. Princeton: Princeton University Press.

Strøm, Cathrine (2009). "Barbarer i alle land, foren eder". *Vagant* 1. Oslo: Aschehoug.

Tomlinson, John (1999). *Globalization and Culture*. University of Chicago Press.

Wendelius, Lars (2002). *Den dubbla identiteten: immigrant- och minoritetslitteratur på svenska 1970-2000*. Uppsala: Centrum för multietnisk forskning.

Notes

1 This article is a revised version of an article that appeared in *Edda*1 (2010): "Flerspråklighet i nyere skandinavisk litteratur: Jonas Hassen Khemiri og Øyvind Rimbereid".

2 Jacques Derrida discusses such issues in an autobiographical manner in *Le monolinguisme de l'autre, ou, La prothèse d'origine* from 1996.

3 I have here copied the somewhat strange effect of placing the verb after the noun in the English translation.

4 In an interview with Espen Eik in the Norwegian literary journal *Vinduet* December 19, 2006 (http://www.vinduet.no/tekst.asp?id=465, accessed September 5, 2009), Khemiri expresses how he strongly opposed the campaign of his publishing company, which marketed the book as the first novel written in Rinkeby Swedish.

5 The Swedish sociolinguist Ulla-Britt Kotsinas (1988 and 1990) has written about this on several occasions. See also the slang dictionary *Förortsslang* (*Suburbs-slang*) that she published together with the rapper Dogge Doggelito in 2004. Several different labels have been used to describe such 'immigrant-language' as Rinkeby Swedish, for example 'miljonsvenska', 'albysvenska', and, not least, 'blattesvenska'. The Swedish language council recommends the term 'förortssvenska' (suburban Swedish). All these labels are explained on Swedish Wikipedia. For a more detailed presentation, see Bijvoet and Fraurud (2008).

6 This is nearly impossible to translate since discarding inversion of the subject-verb-object order is conventionalized in Scandinavian languages. A similar effect (hermeneutically, but not linguistically) to what Khemiri obtains may be given by the sentence '*It was today* the last day of the summer holiday and therefore *in the shop I helped dad*' instead of the more likely '*Today, it was* the last day of the summer holiday and therefore *I helped dad in the shop*'. Later quotations from Khemiri in this essay are all translated by me. Since traces of multilingualism are very hard to translate, the translations will not do justice to the original, but they are included in order to provide a basic understanding. When my argument comments directly on linguistic features in the original, I quote both the original and the translation.

7 A 'multiethnolect' is a way of speaking that is developed when speakers with a different ethnic background are speaking a new language. They then tend to blend in different words and grammatical traits from various languages and cultures. The concept has been developed in Clyne (2000) and Quist (2000). For a more popular presentation of the concept and phenomena, see *Jørgensen and Quist (2008: 114-118)*.

8 In Rinkeby Swedish the word 'Blatte' is used about a Swedish person who, in contrast to a 'Svenne', has an ethnic background that is not European or Anglo-American, most often Arabic, Spanish-speaking, or African.

9 See also Satu Gröndahl (ed.): *Litteraturens gränsland. Invandrar- och minoritetslitteratur i nordisk Perspektiv* (2002) and Ingeborg Kongslien "New Voices, New Themes, New Perspectives: Contemporary Scandinavian Multicultural Literature" (2007).

10 Two exceptions: Alejandro Leiva Wenger: *Till vår ära* from 2002 violates several syntactical, ortographic and lexical rules. After the publication of *Ett öga rødt* in 2003, Marjaneh Bakhtiari published *Kalla det vad fan du vill* in 2005.

11 This debate was particularly intense in the spring and summer of 2006, and it primarily took place in *Dagens nyheter*, *Svenska Dagbladet*, and in the journal *Gringo*. In *Dagens nyheter* the different contributions to the debate were collected under the title 'Debatt: Blattesvenskan!' Ebba Witt-Brattström, a famous professor in literature, started the debate by arguing for a strengthening of the Swedish education by providing education in maternal languages. Other central contributors to the debate were, among others, Åsa Mattsson, Alejandro Leiva Wenger, Olle Josephson, and Farnaz Arbabi. Several problems were debated: questions about education in maternal languages; about whether multiethnolectic words should be included in the Swedish dictionary; and what kind of contribution such words actually represented. Åsa Mattsson argued for example that at least one third of the words in Dogge Doggelito and Ulla-Britt Kotsina's dictionary *Förortsslang* (*Suburbs slang*) were sexist or/and homophobic (*Dagens nyheter*, April 28, 2006). The contributions to this debate in *Dagens nyheter* are still available on the Internet as of September 2009.

12 'Trots dina protester celebreras du för att ha skrivit en bok på "tvättäkta Rinkebysvenska". Tydligen har du gett liv åt "innvandrarens historia" på et språk som låter som om man "sänker ned en mikrofon" i valfritt innvandrarområde. Skrev du inte att din bok handlade om svenskfödd man som bryter sitt

språk med intention? Vad hände med din påstådda exploration av "autenticitetstemaet"?' (Khemiri 2006: 39)

13 Din roman tycks mig hålad med inkonsekvenser och smutsad med just dom fula ord som din far fördömde. 'Gussar'? 'Baxa'? Varför använder boken just det språk som din far hatade mest? Ingen surpris att folk missförstår. (ibid.: 39-40)

14 Pappor lär sig alt som finns att kunna. Men ändå. En enda felaktig preposition är alt som behövs. Ett enda 'ett' som börde varit ett 'en'. Sen [...] pausen som visar at hur mycket du än försökar kommer vi alltid, ALLTID att genomskoda dig. (ibid.: 239)

15 Men pappa, du har ju också ett eget språk! [...] bara pappor pratar khemiriska. Ett språk som är alla språk blandade, ett språk som är extra alt med glidningar och sammanslagna egenord, specialregler och dagliga undantag. Ett språk som är arabiska svordomar, spanska frågeord, franska kärliksförklaringar, engelska fotografcitat och svenska ordvitsar. (ibid.:107-108)

16 See Gellert Tamas' *Lasermannen – En berättelse om Sverige* (2002). The book tells the story of the so-called Laser Man who shot eleven people with dark hair or skin in Sweden in 1991 and 1992.

17 Jeff Matthew's use of slang in *Halaity* (2001) is similar in certain respects of the use of multiethnolect.

18 [...] vi är varken helt suedis eller helt arabis utan något annat, nogåt tredje och innsikten om att inte ha ett enkelt kollektiv växer oss till att skapa ett eget fack, ett nytt kollektiv som saknar gränser, som saknar historia, en kreoliserad krets där alt är blandat och mixat och hybridiserat (Khemiri 2006: 293)

19 Here I restrict myself to mentioning three new Nordic contributions to the study of World Literature. Stefan Helgesson has summed up the discussion on the term and phenomena in a conclusive remark in volume four of the extensive anthology *Literary History: Towards a Global Perspective* (2006). Mads Rosendahl Thomsen has presented several of the most important texts in Danish translation in *Verdenslitterær kritikk og teori* (2008). He has also presented his own interpretation of the discussion in *Mapping World Literature* (2008).

20 For some reason Edward and Marie Said chose the title "Philology and Weltliteratur" for their translation of the essay in the *Centennial Review*.

21 One recent critic of Bhabha, Harish Trivedi, claims in "Translating culture vs. Cultural translation" (Pierre and Prafulla 2007) that Bhabha represents a dubious turn in translation theory by creating confusion about what translation actually is about. The thirst for exotic voices in the west is paving way for literature written by assimilated immigrants which has little to tell about the culture they or their parents have emigrated from. Instead of translating genuinely different voices one promotes seminal different, hybrid writers which suits the European literary market and presents little resistance to what is already well established in the European literary institution. The arrogant disinterest in genuine eastern and southern culture and literature are hidden by the hype of certain hybrid 'cultural translators'. What is needed, according to Trivedi, is real translations from really different countries, not more about hybridity in London.

22 In addition to the writers mentioned later in this article, the Norwegian writer Paal Bjelke Andersen is particularly interesting in this perspective. In *Til folket (2000-2008)*, and later in *The Grefsen Address*, he has sampled phrases from the New Year speeches made by the Nordic prime ministers and combined them into a literary collage in which the various poems focus on mechanisms of inclusion and exclusion. These poems challenge at the same time the conventions of the lyric (understood as a subjective genre), the idea of a Nordic community, and this community's relations to the rest of the world. Since he includes Icelandic and Finnish side by side with Danish, Swedish, and Norwegian in *The Grefsen Address*, very few will be able to understand all the texts. In *Navnet* Andersen has listed names of fallen Danish and Norwegian soldiers along with Afghan civilians who were been killed during the Afghanistan war between 2001 and 2010.

23 As early as the 1920s Finnish immigrants in the USA had developed a pidgin language called Finglish.

Figurations of the Hybrid.
Julie Edel Hardenberg's Visions
for a Post-Postcolonial Greenland

By Lill-Ann Körber

'After all, the beautiful thing about cultural blends is that they are the result of love', said Greenlandic photographer and artist Julie Edel Hardenberg when interviewed by the Greenlandic TV channel KNR about her photography book *The Quiet Diversity* (KNR 2005).[1] In her book, Hardenberg suggests the acknowledgement and celebration of diversity as a condition for a liveable postcolonial Greenland. This article's main focus lies in pointing out figurations of the hybrid as manifestations of diversity in Hardenberg's work. I would like to argue that ethnic or cultural hybridity in this context does not simply mean a superficial image of a rainbow nation. Instead, it boasts subversive potential in that it offers a double critique of Danish hegemony on the one hand and dichotomous and essentialist Greenlandic identity politics on the other. *The Quiet Diversity* even offers a reflection of de- and reterritorialization processes in the specific situation of today's postcolonial Greenland. Hardenberg presents a loosening of ties between ethnicity, nationality, territory, and a feeling of belonging. As I will show, she questions notions of authenticity and originality by using strategies of de- and recontextualisation, by creating unexpected analogies and kinship relations, and by suggesting a do-it-yourself attitude towards Greenlandic nation building processes.

Hardenberg presents Greenland as a globalized and complex society and as a place where the relation between identity and territory is marked by postcoloniality. *The Quiet Diversity* must be read as a comment on the most recent high tide of a Greenlandic struggle for political and territorial souvereignty. The climax of a Greenlandic nation building process so far has been the implementation of Self Rule in 2009, which meant a greater autonomy in administration, economy,

Julie Edel Hardenberg: *Nonstereotypes* (2005) © Julie Edel Hardenberg.

and jurisdiction, the recognition as a separate people according to international law, and the introduction of Greenlandic as the country's official language. Accordingly, there is a demand for a re-conceptualisation of the connection between Greenlanders and their country beyond the dualistically structured status of a post-colony. Hardenberg's visions or visualisations of these reterritorialization processes reach beyond the widespread but backward-looking figures of a unity between mankind and nature as embodied in the traditional figure of the hunter. Her version of Greenlandicness is something that can be acquired, worn, and mixed with elements from a global flow of images and consumer goods. Diversification and hybridization, as well as the desire for national homogeneity and purity, are displayed as global phenomena that are common to both Denmark and Greenland. Greenland, not even a sovereign nation, is a transnational entity *per se*: it is politically and historically linked to the Danish Kingdom, geographically to Northern America, topographically to the Arctic, and it is moreover subject to the economic interests of at least Denmark, the EU, and the USA (cf. Schymik 2009). So what is a Greenlander, Julie Edel Hardenberg?

Julie Edel Hardenberg

Hardenberg can be described as both a very local and a pan-Nordic person at the same time. Born in 1971 as the daughter of a Greenlandic mother and a Danish father, she was educated at art schools in Kokkola, Finland, Trondheim, Norway, and Copenhagen, Denmark. With degrees in both art and art theory and communication, she can be said to have had a double education as artist and theorist, and is, moreover, an acute observer and debater of cultural processes in Greenland. Her work regularly intervenes into Greenlandic politics and the public spaces of Nuuk and Greenland. One example is her latest book, *Move On* (2008), in which she collects stories of fellow Greenlanders who are successfully struggling with childhood experiences of alcohol abuse and domestic violence, integrating these into an artist book. Another example is her contribution to the celebration of Greenlandic Self Rule: an exhibition with the title *210609* in the culture centre Katuaq in Nuuk, where she presented Greenlanders' wishes and hopes for Self Rule as expressed in letters she had collected by various means, including starting a Facebook group (Hardenberg 2009a and 2009b). Additionally, she put up a giant Greenlandic flag on the infamous Blok P in the centre of Nuuk.

Hardenberg's work never consists of one single image or installation alone. The work rather evolves in processes of varying duration and integrates series of stories, images, or performances. The ongoing flag project for example consists of, among others, the Blok P *Our flag* (*Erfalasorput*, 2009) and strait jackets made out of the Greenlandic and Danish flags that Hardenberg entitled *Rigsfællesskabspause* (2005): the United Kingdom of Denmark, which includes Denmark, Greenland, and the Faroe Islands, taking a break. She also created an evening gown made of the Greenlandic flag with Danish flag wings, which she wore for a dinner with the Danish queen Margrethe II in the context of the Self Rule celebrations, removing the Danish wings for the occasion. Hardenberg hopes to have her flag works exhibited at the new National Gallery that is to be built in Nuuk (Hardenberg 2010). *Move On, The Quiet Diversity*, and the *210609* catalogue (Hardenberg 2009b) function as carefully composed artist books on several levels: they are an intermediate result and documentation of the artistic process, and they integrate different visual and verbal means of expression. Moreover, Hardenberg stresses that the books are her art works, and thereby refuses notions of originality beyond reproduction and commodification. Hardenberg often presents herself, her face, family, and life story as a point of departure for her performative negotiations of social phenomena. At the same time, by collecting and exhibiting letters, notes, and diary entries by all kinds of people in *Move On* and *210609* she gives a voice to those who are not heard generally. In so doing, she problematises notions of authorship and representation as they are often debated in postcolonial theory, arguably most prominently by Gayatri Chakravorty Spivak (1994).

Hardenberg's *The Quiet Diversity* is published by Milik in Nuussuaq, a one-woman publishing company. Its first trilingual edition (Greenlandic, Danish, English) sold out within a few months. The current third edition (2008) sells everywhere in Greenland: in souvenir shops, supermarkets, and on the boat along Greenland's south and west coast, the Arctic Umiaq Line. Its popularity confirms Birgit Kleist Pedersen's characterisation of *The Quiet Diversity*'s reception as 'enthusiasm to gratefulness' for 'a necessary book that was published at the right moment when the nationalist rhetoric is increasingly sharpened on the political scene' (Pedersen 2009: 93).[2] The book consists mainly of photographs. Together with their series' titles and subtitles in Greenlandic, Danish, or English, they form a witty and at times very moving unity. The photographs were exhibited in Nuuk in 2005 and in the North Atlantic House in Copenhagen in 2008. Hardenberg donated a range of them to Ilimmarfik, Greenland's uni-

versity's new campus and research centre, where they can be seen in the foyer. Hardenberg is reluctant to produce more copies of the single photographies because she is not in full control over the development process that would have to take place in Denmark and because, according to her, it is the whole book that is the art work, not necessarily the single photograph (Hardenberg 2010).

In 2006, *The Quiet Diversity* was nominated for the Nordic Council's Literature Prize, causing some stir in the press, which felt that the concept of literature had been stretched too far in this case (Ifversen 2006). Hans Anthon Lynge, one of the most prolific contemporary Greenlandic writers, argues in his laudation on the Nordic Council's website for *The Quiet Diversity*'s accomplishment 'in its concious, clever, poetic and even humourous approach to notions of ethnic and cultural identity' (H.A. Lynge 2006). Lynge thereby rejects a desire for the purity and exclusiveness of one certain means of expression. Additionally, he hints at Hardenberg's concious border crossing both mediawise and with regard to borders between languages, ethnic groups, and so-called cultures.

Greenlandic identity politics

In order to understand Hardenberg's approach, it should be contextualised in a general debate about identity politics in Greenland. It seems that the postcolonial relation between Greenland and Denmark has always produced Selves and Others. In her book *The Arctic Promise: Legal and Political Autonomy of Greenland and Nunavut* (2007), legal scholar Natalia Loukacheva has examined the Danish-Greenlandic colonial history of the 20th century and found different social utopias. According to Loukacheva, who is the director of the Polar Law program at the University of Akureyri in Iceland, the Greenlandic elite's motto during the first uprising of Greenlandic nationalism in the 1910s can be summed up as 'as Danish (European) as possible and as Greenlandic as necessary' (Loukacheva 2007: 23). A modernisation of the society modelled after the Danish example was advocated, and the Danish language and a European education were seen as the vehicles. In the 1970s, the political mobilisation and wish for self-determination reached a peak, eventually resulting in the introduction of Home Rule in 1979. This time, the motto was inversed; the aim was 'a society as Greenlandic as possible and as Danish as necessary' (Loukacheva 2007: 28). Loukacheva interprets 'the quest for self-determination and autonomy' as 'a product of nationalism and a unique Inuit identity' (Loukacheva 2007: 29). According to political scientist Ulrik Pram Gad, the latter excludes Danes

living in Greenland, and Danish-speaking Greenlanders (Gad 2009: 145-47). Gad points out that Greenlandic identity discourses are marked by a 'basic essentialism' (Gad 2009: 147) and describes 'the Greenlandic identity politics of the last decades of the 20th century [...] as the Danish Empire *dichotomizing back*' (Gad 2009: 148).

What Gad asks for is a 'post-post-colonial Greenlandic identity; an identity transcending the constant reference to the colonial Other: Denmark' (Gad 2009: 149). One obstacle, according to him, is the difficult task of communicating 'complex and nuanced pictures of differentiated hybridity' (Gad 2009: 147). It is precisely here that I see potential for the arts, and where Julie Edel Hardenberg's *The Quiet Diversity* enters the debate. So far, Greenlandic art and cultural policy have remained to a large extent within a postcolonial logic. Hardenberg and art critic Iben Mondrup point out that Greenlandic artists have been 'committed to showing and representing Greenland culture as something particular and different' (Hardenberg and Mondrup 2008: 38). In so doing, they have met a cultural policy that orientated itself towards the indigenous or Greenlandic versus the Danish or global. According to Hardenberg and Mondrup, the privileged strategy has been the exposition and distribution of Greenlandic cultural heritage. Depictions of nature and mythology meet an attentive audience that is both local and global (Hardenberg and Mondrup 2008: 38, Thisted 2003). New approaches seem to be necessary to reveal and overcome the postcolonial and to image the post-postcolonial.

Carsten Juhl, lecturer in art history and theory at the Royal Danish Academy of Fine Arts and Hardenberg's former teacher, recently criticised the persistent coloniser-colonised dichotomy in Greenlandic-Danish affairs. According to Juhl, whose open letter "To read the process in Nuuk" ("At læse processen i Nuuk") was published on Mondrup's blog archive ibenmondrup.dk, this dichotomy is not only noticeable in the debate about 'Danification' versus 'Greenlandization', but even in recent critical postcolonial readings of e.g. influential Greenlandic-Danish artist and writer Pia Arke's (1958-2007) work (Juhl 2010). At the end of his text, Juhl formulates his ideas for resistance against the prevalence of race that he sees at stake in this context. As a central – if abstract – figure, he puts forward the 'mixed, [...] and with it the a-identitary, maybe even anti-identitary. And this can only be anti-ethnic or at least turned against a different horizon than the division of people in ethnic groups, nations, native areas and so forth' (Juhl 2010).[3] The only example for figurations of 'the mixed' named by Juhl is Hardenberg's *The Quiet Diversity* that he calls 'a brilliant start' ('en strålende

begyndelse') of the project of creating an inclusive Greenlandic society (Juhl 2010).

Lynge emphasises 'the mixed', too, in his reading of *The Quiet Diversity*. For him, it is not an abstract figure, but 'a clear statement about Greenland's reality; the Greenlander is, like everyone else, a 'hybrid', a 'crossbreed', both ethnically and culturally' (Lynge 2006).[4] Lynge, Juhl, and Gad seem to be inspired by concepts that recall postcolonial theorist Homi Bhabha's explorations of 'cultural hybridities that emerge in moments of historical transformation' (Bhabha 1994: 2). These hybridities are put forward as utopian spaces 'in-between the designations of identity' that allow us 'to think beyond narratives of originary and initial subjectivities' (ibid.: 4). In other words, the hybrid is a central utopian figure because it allows us to think identity beyond the division between the Self and the Other, beyond figurations of division and fragmentation (cf. Mondrup 2005: 14), beyond imaginations of the authentic and pure, beyond categories like ethnicity, nation, or race, and because it allows for the replacement of identity politics by alliance or coalition politics with the common goal of an inclusive society.

The Quiet Diversity can be understood as a political project within the outlined context. In the following paragraphs, I will try to point out Hardenberg's strategies for highlighting the utopian potential of hybridization by focusing on her negotiation of the categories and concepts of nation, authenticity, and ethnicity.

Playing ethnicity

Hardenberg's treatment of ethnicity can be described as a deconstruction of purity, of exoticism, and of the Self-Other dichotomy. In her images, difference is not presented in the sense of a clash of cultures, but as a reason for attraction rather than rejection. In a recent article series in *Le Monde diplomatique*, ethnic identity is described as 'a concept that can be deduced from religion, history, race and culture' and that is very well suited to be instrumentalized for an elite's retention of power or, the other way round, as a foundation for political resistance against subordination. According to the article on autochthonous people in the Americas, the formation of ethnic identities is only partly based on objective criteria like 'culture, language, community oriented social structures, bonds to a particular area', but also 'on a rather subjective sense of belonging' (Lemoine 2010).[5]

Julie Edel Hardenberg: *Swedish Army Anorak, Norwegian Dog Pelt* (1999). © Julie Edel Hardenberg.

What Hardenberg does is to show the limits, exclusions, and arbitrariness involved in the formation of an Inuit ethnic identity in Greenland as the basis for anticolonial resistance and for a Greenlandic nation building process. In her 1999 photography series *Swedish Army Anorak, Norwegian Dog Pelt*, which is used as an ornament or frame to the introductory article by Iben Mondrup, Hardenberg puts people with all kinds of skin, hair, and eye colours and features into a stereotypical 'eskimo' outfit: an anorak with fur collar. The effect, enhanced by repetition, is quite amazing: anyone can look like an Inuit. Even if you do not see any face at all behind the anorak's fur collar, as in the last picture of series, the sign 'Inuit' works immediately. Hardenberg's use of one of the most ubiquitous auto- as well as heterostereotypes goes beyond its unmasking as a stereotype: it shows that elements of a supposedly authentic culture are not linked to an exclusive group of people by an essential bond. The bond, and therefore identification, is a choice, the images seem to say, which does not make it less valid at all. The above cited 'subjective sense of belonging' which seems necessary for Greenland's way to further independence, is not reserved for a particular ethnic group.

The notion of cultural authenticity is even more radically exposed as a masquerade in the portrait series *Playing Ethnic* (2005). The series shows four Greenlandic girls and four Greenlandic boys of about the same age, all with the supposedly distinct sign of Kalaallit culture, the fur collar. But, in addition, their faces are painted in what can either be read as pseudo African war paint or as a hint to traditional Greenlandic mask dance. The hair is styled with gel and fake plaits. As opposed to classical 'eskimo' portraits in which men wear their hair long and the women in topknots high on the head, it is here the girls who wear their hair long and open. The result is an eclectic multi ethnic

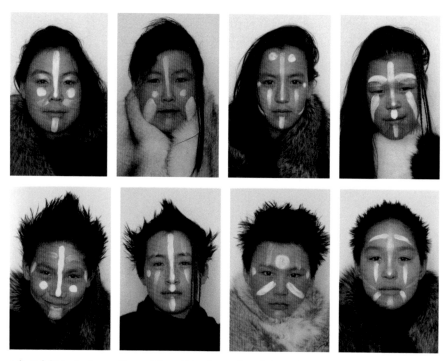

Julie Edel Hardenberg: *Playing Ethnic* (2005). © Julie Edel Hardenberg.

look that would correspond more to the Western fashion industry's desire for exoticism than to one ethnic group's desire for self-representation. Hardenberg shows that these desires can be two sides of the same coin. Elements of a supposedly authentic culture or ethnicity can be a commodity on the global market square, and can at the same time serve for distinction and identity formation (cf. Bjørst 2008: 18).

The two functions of ethnicity – identity formation and branding – can be observed in a recent example from Greenlandic-Danish popular culture. According to Kirsten Thisted, Greenlandic Copenhagen-based singer Julie Berthelsen's success with her Nuuk choir on the popular Danish TV show *All Stars* can be traced to her clever merging of Greenlandic tradition and globalized pop culture (Thisted 2010). The choir's performance of US pop star Lady Gaga's song *Bad Romance* with allusions to Greenlandic mask dance in terms of choreography and makeup is very reminiscent of the hybridization of Inuit ethnicity markers that Hardenberg brings into focus in *Playing Ethnic*.

A recent heated debate about the Danish fashion designer Peter Jensen further indicates Hardenberg's acuteness in the analysis of contested areas in

today's Greenland: in 2009, Jensen used traditional Greenlandic costumes as inspiration for a collection of, among other items, high-heeled boots. He was accused of violating property rights and appropriating Kalaallit culture for his own profit while at the same time speaking up against the Greenlandic seal hunt and therefore robbing the producers of authentic Greenlandic costumes and boots of their source of income. Greenlandic reactions included those who welcomed a case of nation branding for free that would hopefully direct the world's attention towards Greenland as well as those who organised a public demonstration against Jensen. Both sides set up Facebook groups, and the kamik-inspired boots were sold in Danish branches of the international fashion chain Topshop (cf. Mondrup 2009).

Authenticity and the folklorizing gaze

But Hardenberg does not stop at the surface. If clothes and attire are arbitrary and one can shop identity like one shops fashion, what does one turn to in quest of the authentic, if not the body? In debates about migration and integration, the visible signs of difference are still often presented as something incircumventable. The issue of 'passing' as a member of the majority and/or a

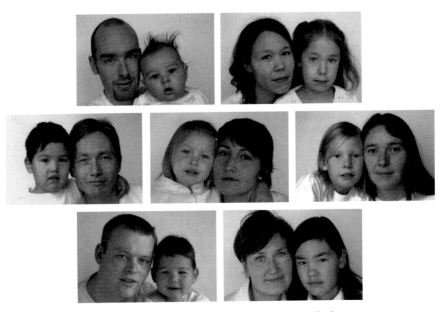

Julie Edel Hardenberg: *Parents and children* (2005). © Julie Edel Hardenberg.

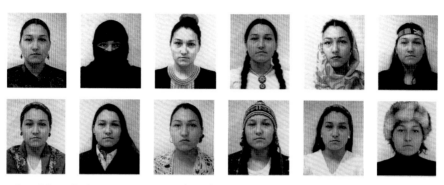

Julie Edel Hardenberg: *Is it about that?* (1999). © Julie Edel Hardenberg.

society's privileged group is a classic in migration and postcolonial narratives. In Hardenberg's images, even the visible, seemingly 'easily read ethnic features' (Mondrup 2005: 21), are ambiguous signs of kinship. She shows that ethnicity and race when attached to skin colour, eye colour, and shape, as well as hair colour and texture, do not work as adequate categories for either describing and locating people or building a collective identity. This is illustrated very clearly in her series *Parents and children* (2005). Kinship and belonging are taken literally here – as bodily bonds. The artist figures in the series herself: the picture in the centre is a self-portrait with her blond and blue-eyed daughter. Greenlanders come in all shapes and colours, the message seems to be, and it is futile to try to identify the degree of Danishness or Inuit blood in them.

The diversity of today's Greenland does not stop at 'Danes' and 'Greenlanders' having children with each other, however. For as soon as one believes oneself to have acquired an eye for Inuit features, Hardenberg confronts us with the image of a pair of sisters. Half-Inuit, half-middle-European, one thinks, although it is difficult to be sure about any categories anymore after looking through the book. But what does the caption say? 'Our mother is from China and our father is from Australia' (Hardenberg 2005: 58). A similar deliberate confusion is created with the artist as the protagonist in the series *Is it about that?* (1999), which is placed as an ornament or frame above the introductory article. The series is a masquerade with all kinds of exotic and 'foreign' attributes when seen from a Western and white perspective. Dependent on clothes, jewellery, and hairstyle, Hardenberg passes as, among others, Indian, Russian, Native American, Eastern Asian, or Arabic. The images can be read as a staging and visualisation of deterritorialization: our looks no longer say anything about our localisation in a globalized world.

The same is true with yet another series from 1999, *Made in…*, in which the face of an Inuit-looking (or Asian? Or would it be better to give up on descriptions like these altogether?) woman, this time without any attributes at all, is placed in holes in different nations' flags. We realise that she could live exactly anywhere. Hardenberg makes us reflect upon the exoticising gaze that is deeply embedded in the history of colonialism and its documentation as well as the representation of the Other. She thus continues Arke's work, who states in her major art and documentation project *Stories from Scoresbysund* (2003) that she found Danish archives full of photographs of her East Greenlandic family members while the family itself had neither camera nor a family album. According to Arke, photography is 'an important part of the language of colonialism'. It 'helps to conquer, to gain territory, to take possession of it' (Arke 2010: 11). Like Arke, Hardenberg does not reverse the gaze, but makes it strange. Her project is more complex than a simple 'imagining back' that would not necessarily question underlying dualistic structures. In her images, it is neither whiteness nor blackness or Asianness that is strange, but the categorising gaze itself that permanently tries to locate and identify the Other which Lynge calls 'a folklorised perspective on the other' ('et folkloriseret syn på det anderledes', H.A. Lynge 2006).

But, as stated above, Hardenberg's diversity and hybridity approach does not stop at criticising power relations and revealing the West's 'eskimo' stereotypes, but reaches further towards the quest for authenticity and purity in general. Thus she attacks Greenlandic identity politics for perpetuating the same stereotypes and dichotomies as the West, a folklorised perspective on the Self, so to speak. In doing so, she agrees with Thisted who stresses in her analysis of examples of well-meaning critiques of Western 'eskimo' representations that the 'representation of Greenlanders is not something that "we" do to "them" in a one-way fashion. Greenlanders are both co-producers of the rest of the world's images and to a large degree producers of self representations' (Thisted 2006: 75).[6] According to Thisted, both sides sometimes tend to underestimate the represented peoples' ability to decode, laugh about, use, or make fun of stereotypes.

Originality vs. ambiguity

Hardenberg's strategy is to appropriate and deconstruct stereotypes at the same time. She shows all the stereotypes and obviously loves all things 'truly Greenlandic', but de- and recontextualises them in order to make them strange,

less 'original' and more ambiguous. This strategy is not only applied to portraits and people, but even to things. One example is a collection of six patterns of the traditional women's pearl collar that she juxtaposes on one double page with pieces of flower embroidery and pieces of crochet work, both of them elements of the Western Greenlandic attire's traditional boots, the kamiks. By zooming in on the patterns and arranging them in a regular order of rectangles of equal size, hence creating visual analogies, she abstracts them from their function and meaning and makes their decorative aspect enjoyable for everyone irrespective of their cultural background and ambitions. They are, obviously, only a detail or cut-out from a larger entity, and it takes our knowledge, socialisation, or fantasy to imagine the context they stem from. Hardenberg here takes the notion of projection surfaces very literally: meaning is not essentially attached to things, but is dependent on the point of view of the person or collective who looks at or uses something. What looks like an interesting and beautiful pattern, texture and colour to those unfamiliar with the Greenlandic festive costume is a celebration of tradition and identity to others. Hardenberg's most open and effective play with the Greenlandic traditional costume is her photograph *Nonstereotypes* where she lets three smiling black children wear it against the background of a seemingly typical Greenlandic landscape (Ill. 1).

Hardenberg displays her strategy of seriality and juxtaposition throughout the book. In combining the two, the exception appears as the rule. The effect of juxtaposition is not that of a clash of incompatible elements, but of analogies that went unnoticed before. Another example of a play with juxtapositions is a series of images of Nuuk living rooms. Throughout the series, we have an overview of the room on the left page and several smaller detail images on the right, presenting the images with the association of a *pars pro toto*. The rooms look like a combination of Scandinavian – or actually globalized – IKEA style with wooden floors and white walls and an eclectic collection of ethnic details; they completely meet the recommendations of international glossy interior magazines. Again, Hardenberg focuses on the order of things and finds and exposes analogies.

To pick another example, she photographs a living room wall with both a poster of Jan Vermeer's *Girl With a Pearl Earring* (1665) and a portrait of an Inuit lady with the traditional topknot hairdo, complemented by a real bead necklace pinned onto the poster. The analogy includes the soft colours, the bust portraits of anonymous women, and the focus on jewellery. Even their globalized status is comparable, if in a very different sense. The Vermeer picture is an international

icon and a commercial success, at least since Tracy Chevalier's bestselling novel with the same title (1999) and its film adaptation from 2003, starring globally recognised actress Scarlett Johansson. The portrait of the Inuit woman is iconic in the sense of the tradition of frontal images of representatives of indigenous cultures like the ones named above in the context of Arke's *Stories from Scoresbysund*. Despite their different positions in asymmetrical international relations, both function as icons for cultural heritage and have become commodities in a global flow of goods and people since early modernism and its first wave of colonialism and imperialism. Today, the flow can wash them ashore both in a central European historical building or in an apartment in a prefabricated house in Nuuk. The apartment itself is a celebration of global diversity and the hybridity of today's Greenland in its juxtaposition and simultaneous unity of continental cow skin and Greenlandic sledge dog skin, of do-it-yourself and industrially produced elements.

Doing the nation

Hardenberg's interventions into identity construction processes in today's Greenland concern both individual and collective identities. Thus, she deals with both the family as society's smallest and the nation as its largest entity, and very often she links the two. A powerful project in this respect was the giant *Our Flag* (*Erfalasorput* in Greenlandic) that was raised on Blok P in central Nuuk in the context of the celebration of the Self Rule's introduction in June 2009. Blok P is the biggest housing unit in Greenland and a notorious symbol of the Danish centralising urbanising policy of pre-Home Rule days that, together with other measures, went under the name of G60. The building is 200 metres long and houses 500 people, which is about one percent of Greenland's population. It dominates every view of the city and it is still a very ambivalent sign of modernity versus the creation of social problems, mirroring the Danish colonial rule's ambivalent approach of development to self-help that could also be interpreted as ambition to gain better control of the population, and that resulted in the gathering of people in the cities. Blok P figures prominently in visual media's approaches to urban Greenland. Among them are the TV programme *Qapuk!* on contemporary Greenlandic culture and society that was broadcast from a temporary studio set up in Blok P, and the controversial Danish TV documentary *The flight from Greenland* (*Flugten fra Grønland*, 2006) that put its main focus on social problems and corruption and declared the Greenlanders un-

196

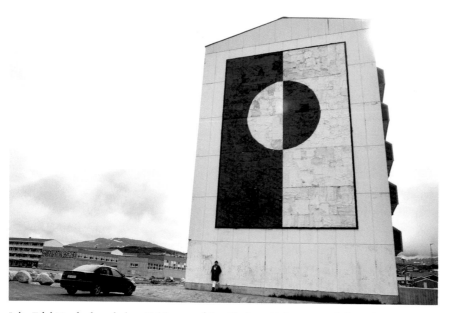

Julie Edel Hardenberg below *Erfalasorput* (*Our Flag*) on Blok P in Nuuk (2009). © Julie Edel Hardenberg.

able to handle today's challenges. Because of its bad condition and the social problems connected to it, Blok P will be dismantled within the next few years and will be replaced by smaller units of subsidised housing.

Our Flag was 8 x 12 metres in size and assembled from vintage fabrics and clothes that were collected with the help of newspaper advertisements. Because there were not enough pieces in red and white, they were painted over after having been sewn together by Julie Edel Hardenberg and students at Piorsaavik, a school and workshop supporting underprivileged young people. Considering the working process and the location, *Our Flag* is a complex comment on the Greenlandic nation building that reached a new stage with the introduction of Self Rule. The giant national flag is simultaneously an emphatic and a very humble gesture. The Greenlandic flag was only designed in 1985 and is thus only a couple of years older than the teenagers who assembled it. Hardenberg's version of the national flag is made of secondhand fabric and is pieced and cobbled together, the opposite of seamless. The nation building process is here a construction in a literal handicraft sense; the art project can be read as a performance of nation building. The nation is secondhand in a more literal sense, too, since Greenland has been centralised and adminis-

trated by Denmark and only now gets the chance to be conceptualised by the Greenlanders themselves. The bits and pieces that *Our Flag* is made of point at Greenland's diversity and heterogeneity. It is made to look more homogeneous by being painted over, like you would paint an old piece of furniture. But even from a distance, its unruly texture would not go unnoticed. At the same time, the flag is a tender and affectionate comment on the craft aspect of the Greenlandic cultural heritage and to the young people designing and creating the nation today. 'Do-it-yourself!' seems to be the call to action, if the nation is not meant to be a straitjacket like in another one of Hardenberg's pieces, the abovementioned *Rigsfælleskabspause*.

Our Flag was taken off Blok P after three months and burned by the city authorities. It was argued that it had to be taken down before the autumn storms started, and neither the municipality nor Greenland's government felt responsible for providing the space and money to have it stored (Hardenberg 2009c, Petersen 2009). Both Greenlanders and German Copenhagen-based journalist Marc-Christoph Wagner tried to intervene in this decision with debate articles in the newspaper *Sermitsiaq*, stressing *Our Flag's* symbolic value for a united Greenland under Self Government. Hans Peder Kirkegaard, a student of tourism in Qaqortoq, highlighted his identification with a new Greenland uniting fishermen, hunters, and modern cosmopolites like himself, a vision of Greenland that he saw embodied in *Our Flag* (Kirkegaard 2009). Wagner pointed at *Our Flag's* potential as an inclusive and integrating symbol for today's Greenland as opposed to most national flags that tend to symbolise the exclusiveness of nations (Wegner 2009). The burning of *Our Flag* is thus to be seen as an act of iconoclasm different from other examples of flag burning: it was not burned out of opposition towards hegemonic ideas of the nation. Instead, it is a sad, but outstanding, example of the lack of infrastructure for contemporary art in Greenland and for the indifference of the Greenlandic public and authorities towards contemporary art in general, and its potential political power and social function in particular. Greenland's minister for Culture and Education hastened to say that the disposal of *Our Flag* should not be confounded with the disposal of Self Rule Greenland which it symbolises (Petersen 2009). Nonetheless, the event makes clear that Hardenberg walks on contested terrain both with her artistic public space approach and with her do-it-yourself attitude towards the nation in the making.

Conclusion

The Greenland that Hardenberg envisions makes the very best out of the historical coincidence of a decolonising and nation building process with today's wave of globalization. It is the vision of a simultaneously globalized and locally anchored Greenland that is open to anyone as long as there is equality. The highly constested question of who counts as a Greenlander (cf. Thomsen 1998) is answered in a seemingly simple manner: anyone is invited. In order to open up the discussion about Greenlandicness and diversity, Hardenberg effectively deconstructs images and imaginations that form the basis for an identity politics dependent on essentialist notions of ethnicity. Some of the markers of ethnic belonging are revealed as superficial attributes that can be appropriated by anyone who feels a connection to them. Karsten Ifversen downplays the political explosiveness of Hardenberg's hybridity vision, but sums it up in an accurate way:

> In the candy store of humanity, there is only mixed sweets; everything else is ideology, the work seems to say. Identity should be something one can put on and off like clothes, nothing inscribed in the body [...] One does not need to choose between native and global cultures, they coexist nicely, in her pictures. (Ifversen 2006)[7]

What is underestimated by Ifversen and others is the existential dimension of Hardenberg's work, as proven by the violent flag burning incident. It is not only about a sweet and colourful multicultural get-together, but about the future for a country which is facing challenges that are common for a postcolonial society, but that nonetheless influence people's lives dramatically: massive social problems, unequal power relations and chances, experiences of dependence, nationalist movements, colonial arrogance on the side of the former colonisers, debates about language and identity. Has Greenland really been 'The best colony in the world?', Aviâja E. Lynge asks provocatively (A.E. Lynge 2006). Are the Nordic countries really 'exceptional' when it comes to their position in global phenomena such as colonialism, migration, and treatment of indigenous people (cf. Jensen et al. 2009)? The sheer existence of Greenland brings with it a challenge for the 'imagined community' (Anderson 1991) of the Nordic countries based on a 'kinship' of peoples, languages, histories, and territories. When Høgni Hoydal, Faroese member of the Danish parliament and of its

North Atlantic group, declares 'We certainly all belong to the Nordic family', this is a reminder of the flexible borders and diverse composition of 'the Nordic countries' (Hoydal 2006). Hardenberg's intervention into Greenlandic nation building processes and identity politics hence concerns both Greenlandic and Danish domestic and foreign politics and the formation of a Nordic self-conception.

The combination of a postcolonial situation and globalization brings with it particular reterritorialization phenomena. In the case of Greenland, they can be summed up as the shaping of an ethnic identity, in Arke's words "Ethno-Aesthetics" (Arke 2010), or as Thisted has put it, "Eskimo-exotism" ("Eskimoeksotisme", Thisted 2006). Self-representations paradoxically correspond to Western imaginations. Hardenberg exposes these identity politics as 'playing ethnic', and emphatically calls for coalition politics instead. One 'imagined community' is replaced by another, but the new one is based on an alliance towards a common goal and not on the inclusion of some and the exclusion of others according to arbitrary categories.

Instead of looking backwards and shaping an identity from a fixed set of supposedly authentic attributes, Hardenberg focuses on the possibilities offered by the open situation that is created by decolonisation and globalization. A first step towards openness is the acknowledgment of the society's diversity and hybridity and showing – that is how artist and writer Mette Moestrup reads Hardenberg – 'diversity as a positive and opportunity creating condition' (Moestrup 2007).[8] As I have shown, Hardenberg visualises this utopia by replacing culture clashes with analogies and highlighting kinship where it is least expected. A central figure that can be said to embody the utopia by overcoming dichotomies and any imaginations of purity is the hybrid. Hardenberg stresses hybridity as a general condition for all the Greenlanders in *The Quiet Diversity*, their families, and their lives' circumstances. In so doing, she abstracts the concept from any embodiment in one person. Nevertheless, the utopian and revolutionary potential seems as promising as the drastic vision of Danish writer Lotte Inuk's protagonist in her 2004 novel *Sultekunstnerinde* (Starvation artist), located in 1970's Greenland: 'The bastards are the most beautiful, here and everywhere else […] All the best salvaged from both fallen worlds, a new beginning, a Phoenix arisen from the ashes, a whole new kind of human being' (Inuk 2004: 133).[9] The future Greenlander – a phoenix?

Works Cited

Anderson, Benedict [1983] (1991). *Imagined Communities. Reflections on the Origin and Spread of Nationalism* (rev. ed.). London: Verso.

Arke, Pia [1995] (2010). *Ethno-Aesthetics/Etnoæstetik*. Copenhagen: ARK, Pia Arke Selskabet & Kuratorisk Aktion. Accessed March 16, 2011: http://www.rethinking-nordic-colonialism. org/files/pdf/ACT5/ESSAYS/Arke.pdf.

Arke, Pia [2003] (2010). *Stories from Scoresbysund. Photographs, Colonisation and Mapping.* Copenhagen: Pia Arke Selskabet & Kuratorisk Aktion.

Bjørst, Lill Rastad (2008). *En anden verden. Fordomme og stereotyper om Grønland og Arktis.* Copenhagen: BIOS.

Bhabha, Homi K. [1994] (2004). *The Location of Culture.* New York, Oxford: Routledge.

Gad, Ulrik Pram (2009). "Post-colonial identity in Greenland? When the empire dichotomizes back – bring politics back in". *Journal of Language and Politics* 8:1, 136-158.

Hardenberg, Julie Edel (2005). *Den stille mangfoldighed/Nipaatsumik assigiinngisitaarneq/The quiet diversity*. Nuussuaq: Milik Publishing.

Hardenberg, Julie Edel and Iben Mondrup (2008). "An appetite whetted". In Katherine Goodnow and Haci Akman (eds.): *Scandinavian museums and cultural diversity*. New York, Oxford: Berghahn Books, 37-41.

Hardenberg, Julie Edel et al. (2008). *Move On/isumassarsisoq aaqqissuisorlu*. Nuussuaq: Milik Publishing.

Hardenberg, Julie Edel (2009a). Facebook Group for the 210609 project. Accessed March 16, 2011: http://www.facebook.com/group.php?gid=84102411920.

Hardenberg, Julie Edel (2009b). *210609*. Catalogue for exhibition at Katuaq, Nuuk.

Hardenberg, Julie Edel (2009c). "Erfalasorput". Unpublished statement about the burning of the artist's *Our flag*.

Hardenberg, Julie Edel (2010). Conversation with Julie Edel Hardenberg in Nuuk on June 3, 2010.

Hoydal, Høgni (2006). "Neo-Colonialism with a Human Face – the Cosy Self-Colonization in Danish Home Rule". Accessed March 16, 2011: http://www.rethinking-nordic-colonialism. org/files/pdf/ACT2/ESSAYS/Hoydal.pdf.

Ifversen, Karsten R.S. (2006). "Hvad er en grønlænder? Julie Edel Hardenberg er billedkunstner og indstillet til Nordisk Råds Litteraturpris". *Politiken*, February 12, 2006. Accessed March 16, 2011: http://politiken.dk/kultur/boger/faglitteratur_boger/article137460.ece.

Inuk, Lotte (2004): *Sultekunstnerinde*. Copenhagen: Tiderne skifter.

Jensen, Lars et al. (2009). "Hvad er Nordic Colonial Mind?" Accessed March 16, 2011: http:// postkolonial.dk/Nordic_Colonial_Mind/Hvad_er_Nordic_Colonial_Mind.

Juhl, Carsten (2010). "At læse processen i Nuuk – Åbent brev til venner i Grønland och Danmark (+ Sverige och Norge)", March 20, 2010. Accessed March 16, 2011: http://ibenmondrup. dk/?p=1142.

Kirkegaard, Hans Peder (2009). "Jeg er grønlænder!" *Sermitsiaq* 35 (August 28, 2009).

KNR (2005). "Den stille mangfoldighed…" *KNR Nyheder*, October 22, 2005. Accessed March 16, 2011: http://www.knr.gl/index.php?id=297&type=98&tx_ttnews%5Btt_news%5D=7923&tx_ttnews%5BbackPid%5D=844&cHash=6f4eebc2e7.

Lemoine, Maurice (2010). "Mutter Erde und ihre Elektrifizierung. Indianische Identitäten in Lateinamerika". Dossier "Das Volk als Erfindung" ("The People as Invention"). LE MONDE *diplomatique*, international insert to *tageszeitung*, May 2010, 16f.

Loukacheva, Natalia (2007). *The Arctic Promise. Legal and Political Autonomy of Greenland and Nunavut*. Toronto: Toronto University Press.

Lynge, Aviâja Egede (2006). "The Best Colony in the World". Accessed March 16, 2011: http://www.rethinking-nordic-colonialism.org/files/pdf/ACT2/ESSAYS/Lynge.pdf.

Lynge, Hans Anthon (2006). "Julie Edel". Accessed March 16, 2011: http://www.norden.org/da/nordisk-raad/nordiske-priser/litteraturprisen/tidligere-prisvindere-og-nominerede/nominerede-2006/julie-edel.

Moestrup, Mette (2007). "Sprogpolitik og kulturkamp". *Information*, July 25, 2007. Accessed March 16, 2011: www.information.dk/134071.

Mondrup, Iben (2005). "Den stille mangfoldighed". In Julie Edel Hardenberg: *Den stille mangfoldighed*. Nuussuaq: Milik Publishing, 13-15.

Mondrup, Iben (2009). Documentation of the debate on Danish fashion designer Peter Jensen's Greenlandic costume collection. Accessed March 16, 2011: http://ibenmondrup.dk/?p=649.

Pedersen, Birgit Kleist (2009). "Studium og punctum – æstetisk oplevelse af fotoværkerne Sabine (2004) og Den Stille Mangfoldighed (2005)". In Karen Langgård et al. (eds.): *Grønlandsk kultur- og samfundsforskning 2008-09*. Nuuk: Ilisimatusarfik/Forlaget Atuagkat, 77-100.

Petersen, Lotte Bornemann (2009). "Vores flag brændes". *Sermitsiaq* 38 (September 17, 2009).

Schymik, Carsten (2009). "Grönland in Selbstregierung. Die EU als Chance für den Weg in die staatliche Unabhängigkeit". *SWP-Aktuell* 49. Accessed March 16, 2011: http://www.swp-berlin.org/common/get_document.php?asset_id=6244.

Spivak, Gayatri Chakravorty [1988] (1994). "Can the Subaltern Speak?" In Laura Chrisman and Patrick Williams (eds.): *Colonial Discourse and Post-Colonial Theory: A Reader*. New York: Harvester/Wheatsheaf, 66-11.

Thisted, Kirsten (2003). "Grønlandsk kunst". Accessed March 16, 2011: http://www.bryggenart.com/groenlandsk_kunst.php.

Thisted, Kirsten (2005). "Postkolonialisme i nordisk perspektiv: relationen Danmark-Grønland". In Hanne Bech and Anne Scott Sørensen (eds.): *Kultur på kryds og tværs*. Aarhus: Klim, 16-42.

Thisted, Kirsten (2006). "Eskimoeksotisme – et kritisk essay om repræsentationsanalyse". In Lene Bull Christiansen et al. (eds.): *Jagten på det eksotiske* (= KULT 3). Roskilde: Institut for Kultur og Identitet, 61-77.

Thisted, Kirsten (2010). "Her kommer de nye grønlændere". *Politiken*, May 29, 2010. Accessed March 16, 2011: http://politiken.dk/debat/kroniker/article982197.ece and *Sermitsiaq*, June 4, 2010 (Danish and Greenlandic).

Thomsen, Hanne (1998). "Ægte grønlændere og nye grønlændere – om forskellige opfattelser af grønlandskhed". *Den Jyske Historiker* 81: 21-55.

Wagner, Marc-Christoph (2009). "Vores flag?" *Sermitsiaq* 34 (August 28, 2009).

All translations from German and Danish by Lill-Ann Körber, except the excerpt from Lotte Inuk's *Sultekunstnerinde*, translated by Thomas E. Kennedy: http://www.charlotteinuk.dk/ translations/Kennedy_overs.pdf, accessed February 12, 2011.

Image credits: © Julie Edel Hardenberg

Notes

1 'Det smukke ved kulturblandinger er jo at de er et resultat af kærligheden' (KNR 2005)

2 'fra begejstring til taknemmelighed […] en nødvendig bog, der udkom på det rette tidspunkt, mens den nationalistiske retorik i stigende grad skærpes på den politiske scene' (Pedersen 2009: 93)

3 'Det blandede […] og dermed det a-identitære, måske endog anti-identitære. Og det kan kun være anti-etnisk eller i det mindste vendt mod en anden horisont end opdelingen af mennesker i folkeslag, nationer, hjemstavn osv.' (Juhl 2010)

4 'taler deres tydelige sprog om Grønlands virkelighed: grønlænderen er, ligesom alle andre, en "hybrid", en "krydsning", det være sig etnisk som kulturelt' (H.A. Lynge 2006)

5 'Kultur, Sprache, gemeinschaftlich orientierte Sozialstrukturen, Bindung an eine bestimmtes Gebiet […] aber auch auf ein eher subjektives Zugehörigkeitsgefühl' (Lemoine 2010)

6 'repræsentationen af grønlænderne er ikke ensidigt noget "vi" gør ved "dem". Grønlænderne er både medproducenter på omverdenens billeder og i høj grad producenter af selvbilleder' (Thisted 2006: 75)

7 'I menneskehedens slikbutik er der kun blandede bolsjer; alt andet er ideologi, synes værket at sige. Identitet bør være noget, man kan tage af og på som en klædedragt, ikke noget, der er indskrevet i kroppen. […] Man behøver ikke vælge mellem oprindelige og globale kulturer, de lever jo fint sammen, i hendes billeder' (Ifversen 2006)

8 'mangfoldighed som et positivt og mulighedsskabende vilkår' (Moestrup 2007)

9 'Bastarderne er de smukkeste, hér som alle andre steder […] Alt det bedste reddet i land fra begge forfaldende verdner, en ny begyndelse, en fugl Fønix opstået af det udlevedes aske. En helt ny slags menneske' (Inuk 2004: 133)

Emotional Landscapes: The Construction of Place in Björk's Music and Music Videos

By Mathias Bonde Korsgaard

In 1997, the Icelandic singer Björk released *Homogenic,* which she carefully marketed as her 'Icelandic album', even retrospectively declaring in an interview that 'it was very obviously supposed to be a love album to Icelandic nature' (Hemingway 2002). In the same interview, she also likens the musical progression of the album to stories from Icelandic mythology and says that she thought of the track "Jóga" as a sort of national anthem, thereby directly situating the album in a specifically Icelandic context. However, for all of the album's purported 'Icelandicness', the lyrics of the opening track, "Hunter", rather suggest an interrelation between the homely or Icelandic on the one hand and the worldly or global on the other. For instance, the first vocal line of the song is: 'If travel is searching / and home what's been found / I'm not stopping / I'm going hunting'. These lyrics clearly bring the relation between the homely and the worldly into play, and in this respect they can be said to mirror a characteristic feature of Björk's overall musical project – namely her tendency to fuse the Nordic aspects of her music with impulses from popular music and other non-Nordic musical cultures.

On one level, Björk's music is exploratory and worldly – her music is open to numerous genres and musical traditions and she is constantly on the search for new sounds, for new and exotic instruments that are foreign to popular music, and for novel approaches to creating music including the application of digital technologies. But at the same time, Björk's music also retains aspects of a specifically Nordic sound. In this way, Björk is able to express a composite or hybrid identity that incorporates Icelandic, multicultural, and global impulses, thereby interrogating what it means to be Icelandic in the face of the growing processes of globalization.

Thus, Björk's musical project might be regarded as a quest for a specifically Icelandic musical identity in the increasingly globalized cultural field of popular music. Her music contains unmistakable markers of an insular Icelandic identity that colour it with a certain 'Nordic otherness', and this insertion of global popular music into a specifically Icelandic context might be considered an act of reterritorialization. The creation of an Icelandic brand of popular music is achieved both through the incorporation of musical features that allude to Iceland or the Nordic region and through indicating a relation between the music and the natural landscapes of Iceland, something which is carried out both aurally in the music and visually in the music videos. In Björk's music and videos, the relation between music and place is consistently questioned as the alleged 'Icelandicness' of her music is counterbalanced by the global drives of popular music.

Nature and technology

As has also been pointed out by several others, much of Björk's music revolves around the traditional dichotomy between nature and technology (Dibben 2009a; Dibben 2009b; Marsh and West 2003; Middleton 2006; Nielsen 2003). On a basic level, the relation between nature and technology could be seen to correspond to the relation between the local and the global in Björk's music. Along this line of thought, the global impulses in Björk's music and videos seemingly find an expression in her engagement with (digital) technology and popular music, whereas the Icelandic impulses find their expression in her preoccupation with nature and musical traditions. However, the relationship between nature and technology is not maintained as a simple binary opposition. Rather, she interrogates this relation by embedding one within the other, letting the two co-exist or even merge, thus deconstructing the apparent dichotomy (Marsh and West 2003). So what might seem to be a straightforward dichotomous relation turns out to be a more complex interrelationship that evades simple binary oppositions such as nature vs. technology, Icelandic vs. global, acoustic vs. electronic, (global) popular music vs. Icelandic musical tradition, (wo)man vs. machine, and so on. As a whole, Björk's artistic project seems to revolve around a constant dismantling of such stable oppositions through interrogations of the relation between music and place, giving rise to a musical identity that is arguably both Icelandic and global at the same time.

Throughout Björk's work, technology is infused with a feeling that it is natural, domestic, humanly, or even something to be engaged with emotionally; conversely, the natural and the human are technologised in an aspiring post-human aesthetic. To Björk, nature and technology are part of the same continuum and this is conveyed both musically and visually. In interviews, she also expresses this belief, for instance when she states that to her 'electricity comes from nature' (Palmer 2001: 125), or when she indicates that it is possible to relate emotionally to technology (she admits 'I take technology personally' (Berry 1998), for example, and describes the album *Vespertine* as 'a love affair with a laptop' (Martin 2002: 167)).

Musically, the superficial observation may be made that Björk fuses technology and nature by integrating both electronic and acoustic sources in her music (ostensibly a feature of much popular Icelandic music, often labelled generically as 'folktronica'). However, it is not possible to simply equate the acoustic elements with nature and the electronic with technology. For instance, Björk has likened the electronic beats of the song "Jóga" to the volcanic eruptions of Icelandic nature (Hemingway 2002), thereby connecting an electronic element to a natural phenomenon. According to Paul Sullivan, some of the beats on *Homogenic* are even concretely based on actual samples of volcanic activity (Sullivan 2003: 121). Moreover, Björk's application of digital technology has involved similar attempts to fuse nature and technology. One such instance concerns her use of the concrete sounds of objects found in her home, what Björk herself has called 'non-instrument instruments' (in *Minuscule* (2003), a documentary that explores the creation of Björk's album *Vespertine*). By synthesising these non-musical sources and converting them into instruments, Björk is able to give her electronic sound a sense of homeliness and even of organicity, as the sounds derive directly from her home. In *Minuscule*, Björk also explains how many of the textural sounds that play a central role on *Vespertine* were created in a similar way by recording the sounds of nature and then digitally magnifying or manipulating them, once again leading to an intertwining of the technological and the natural.

Furthermore, some of the elements of Björk's music lean towards the aesthetics of the electronic genre known as 'glitch', a certain type of music that is constructed from the sounds of malfunctioning electronic equipment (hence the term 'glitch', meaning a technical malfunction). One of her songs, "Unison", explicitly acknowledges the inspiration from glitch-music by quoting a track by the German glitch group, Oval, entitled "Aero Deck". The aesthetics of glitch

reveals the human side of digital technology by pointing towards the human faultiness and irrationality underlying the malfunctioning machinery, thereby indirectly indicating that digital technology is only as faultless as the humans who construct it (Cascone 2000; Sangild 2003: 111). So by sampling Oval and using the sounds of glitches, Björk's approach to technology is actually instilled with something humanly.

The predominantly *a cappella* album *Medúlla* also contributes to the subversion of a directly oppositional relation between nature and technology, not by way of 'naturalising technology', but by 'technologising nature'. The singing voice is often in itself considered the most natural element of a musical piece, given that its source is the human body. In the case of Björk, her voice is often thought to be exceptionally natural due to a characteristic feature of her particular singing style, namely the almost excessive emphasis on non-lyrical sounds such as breathing, sighs, moans, whispers, screams, shouts etc. One would then think that an album composed of almost nothing but voices would strengthen the music's natural character, also given that the album title refers to 'the inner or deep part of an animal or plant structure' (according to a documentary on *Medúlla*, called *The Inner or Deep Part of an Animal or Plant Structure* (2004)). However, many of the voices on *Medúlla* have been processed through various technologies, giving them an inhuman, instrumental quality. Per Reinholdt Nielsen even suggests that the various modulations and manipulations of the human voice heard on *Medúlla* give rise to 'an a capella cyborg sound' (Nielsen 2003: 236, my translation), the technologically mediated and altered voices being a further indication of a musical technologisation of the human.

Björk's music videos

However, popular music is of course not only a matter of sound – there is almost always some sort of visual complement, whether in the form of album covers and sleeves, press photos, the visual aspect of a given musical performance, or music videos (Goodwin 1993: 8). In music videos, the musical construction of place happens both sonically and visually. Music videos offer a global template to be filled out with localised content, and sometimes this local colouring takes the form of a negotiation of the relation between music and place, though the sense of place and space in music videos often seems unstable and fluctuating (Vernallis 2004: 110). Björk often uses the music

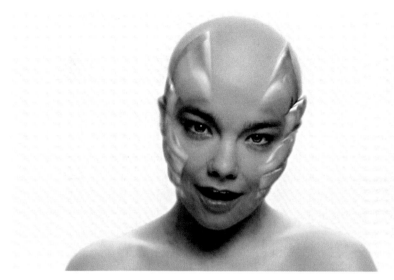

Still from Björk's "Hunter" (1998), dir. Paul White, © Björk & One Little Indian.

video format in this way to deal with the relation between music and place: her videos frequently depict Icelandic nature ("Jóga", "Who Is It", and "Triumph of a Heart"), and even more frequently they represent nature as such (for instance, the forest in "Human Behaviour" and in "Isobel", the jungle in "Alarm Call", and the mountains and rivers in "Wanderlust"). A recurrent image is that of Björk situated in natural settings, and often the indication of a direct relation between Björk and nature is even more explicitly stated as images of her face are superimposed over images of nature (for instance in "Isobel" and "Earth Intruders").

But just as frequently the depictions of Björk relate to technology, with her sometimes being depicted as a sort of cyborg figure (the lesbian Björk robots being assembled in "All Is Full of Love", the bald, shape-shifting Björk in "Hunter", and the digitally animated and strangely inanimate Björk in "Jóga"). Throughout her career, the visual representations of her have flirted with ideas of a becoming-animal or a becoming-machine (on 'becoming' see Deleuze and Guattari 2002: 232-309), or even both as in the music video for "Hunter" – here she is seen in the process of becoming a machinic polar bear, signifying both 'technological' globalization and 'natural' Nordicness, once again collapsing nature and technology into one, and simultaneously merging animal, human, and machine in an organic cyborg, the image never settling into one or the other.

Her image is effectively built around such depictions that present her in a constant state of metamorphosis. It seems that Björk is incessantly shedding her skin in much the same way as other famous pop chameleons do (David Bowie, Madonna, and others) by creating new looks and sounds for each album. Thus, the visual representations of Björk found in her music videos often express a state of becoming, a sense of metamorphosis or change (for instance in "Cocoon"), her visual identity being in a state of flux. Through images depicting organic structures or nature ("Jóga", "Nature Is Ancient"), images of birth ("Where Is the Line"), images dealing with sexuality and focusing on the human body ("Pagan Poetry", "Hidden Place", "Cocoon") as well as through the application of metaphors for life (the eggs in "Venus as a Boy" as well as the 'Venus' of the title), the videos emphasise that the question of identity is both fluid and able to contain various oppositions, that identity is subject to constant changes, to a constant becoming. The power of such visual morphing lies in the fact that it 'breaks down and collapses *boundary distinctions*' (Sobchack 2000: xvi), in this case mainly the boundaries between nature and technology.

Björk's use of cyborg figures and her overall treatment of the relation between nature and technology indirectly echoes some of the thoughts found in Donna Haraway's famous "Cyborg Manifesto". Haraway writes that in the cyborg world '[n]ature and culture are reworked; the one can no longer be the resource for appropriation or incorporation by the other' (Haraway 1991: 151) – this is also pointed out by Charity Marsh and Melissa West in relation to Björk (Marsh and West 2003: 196). This reworking of the relation nature/culture applies not only to the cyborg world that Haraway describes but also to the Iceland that Björk constructs musically, where the division between nature and culture (or in this case, technology) cannot be firmly upheld. Thus, the Icelandic identity that Björk expresses in her music is not merely that of being at one with nature and immersed in the mythology and musical traditions of Iceland, but is as much about engaging with technology and experiencing the impact of globalization.

Nowhere does Björk suggest a direct relation between her music and Iceland as clearly as in the music video for the song "Jóga", directed by French music video *auteur*, Michel Gondry, who has worked with Björk more than once. He directed the videos for "Human Behaviour", "Army of Me", "Isobel", "Hyper-Ballad", "Bachelorette", and "Declare Independence", many of which also engage in a negotiation of the relation between nature and technology (or nature

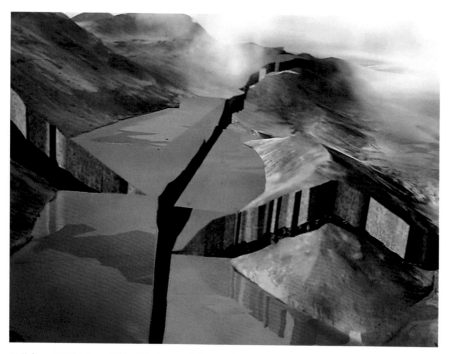

Still from Björk's "Jóga" (1997), dir. Michel Gondry, © Björk & One Little Indian.

and culture), like the "Jóga" video. As already indicated, "Jóga" is soaked in a nationalistic discourse through the use of 'volcanic beats' and Björk's labelling it as a national anthem. Musically, the string arrangement heard in the song also helps to situate it in an Icelandic context by introducing reminiscences of the Icelandic musical tradition of *tvísöngur* (meaning 'twin song' – see below). Furthermore, the lyrics may be said to partially reference ideas of nationality, particularly through the striking phrase 'state of emergency' that contains dual meanings: emotional state vs. nation-state, and crisis vs. emergence (Dibben 2009b: 137; see also Thomson 2006: 155). Moreover, the music video further underlines the nationalist agenda by representing a very specific Icelandic site. According to Nicola Dibben, the natural setting depicted is that of Þingvellir (translates into 'Thing Fields'),[1] a place of special historical importance as 'the historic seat of the Icelandic parliament' as well as the home of the national symbol 'Fjallkonan' ('the mountain woman') whom Dibben believes Björk to represent in this video (Dibben 2009b: 137).

On the surface, the video thus seems to be marked by a crude symbolism that further underlines the construction of an Icelandic identity. It is composed

solely of images of Icelandic nature shown in all its majesty, free from any hu-
man intervention or presence (apart from the occasional appearances of an
inanimate Björk). In this way, the video seems to hint at a relation between the
beauty of these natural landscapes and the beauty of Björk's song. At the end of
the video, the camera delves into the inner part of Björk's body only to reveal
that the landscapes are also to be found inside her and that in place of her heart
there is an island shaped like Iceland. Apparently, the aim of the music video is
to accentuate the idea that this song shares a special relation to Icelandic nature
and that this somehow emanates from Björk's inner Icelandic nature (through
the use of quite a literal metaphor).

However, by allowing the volcanic beats to manifest themselves visually as
tectonic plates pulling apart, the video also opens itself up to another reading.
This connection between the sound of the beat and the plates pulling apart
could be viewed in two different ways: either the tectonic plates are causing the
eruptive sounds of the beat, or else the beats are inflicting these disturbances
upon the landscape. The first view would be in concordance with Björk's own
viewpoint that technology and electricity come from nature (which is given
a humorous formulation in the lyrics for the song "The Modern Things", in-
cidentally).[2] The second view would indicate that technology (and globaliza-
tion with it) is changing Iceland. Both these perspectives point towards the
entanglement of nature and technology, and on closer inspection the video's
images of nature are not that natural after all. Once the tectonic plates are pulled
apart, it becomes clear that the images of the landscape have been subject to
a technological mediatization, having been digitally processed. Furthermore,
the jerky and mechanical camera movements that are seen right from in the
beginning of the video indicate the manufactured nature of the images. In the
words of Claire Thomson, the images in the video posit their relationship to
the landscape in the form of an 'oscillation between – and fusion of – the real
and the unreal' (Thomson 2006: 156) – or alternatively, of the natural and
the technological. And the constructed, unnatural character of the images of
Icelandic nature is further exposed by several correspondences between sound
and image (the vocal line 'Push me up to' followed by the camera pushing itself
towards the sky, the connection between the line 'Emotional landscapes' and
the landscapes seen, the connection between the beats and the tectonic plates,
etc.).

Popular music and place

That Iceland is encountered by means of technological mediation in the "Jóga" video is indicative of the fact that Björk's way of relating music to place takes into account both the natural and the technological. Places are increasingly experienced through mediation, and it is not uncommon to relate to them technologically, whether by synthesising the concrete sounds of our everyday environments in making music or by digitally processing images of nature, as in the "Jóga" video. In this way, our understandings of place are often mediated through audiovisual popular music, and similarly our understandings of popular music somehow seem to be entangled in our understandings of place (see also Connell and Gibson 2003; Stokes 1994).

Throughout the last fifteen to twenty years, much academic attention has been given to the relations between music and place. Many musicologists (and ethnomusicologists in particular) have subjected this relation to analysis or theorisation, zooming in on matters of music, identity, place, nationality, ethnicity, and/or globalization (for instance, Bennett 2000; Biddle and Knights 2007; Connell and Gibson 2003; Dawe 2004; Gebesmair and Smudits 2001; Lipsitz 1994; Stokes 1994; von Glahn 2003; Whitley et al. 2005). This comprehensive interest in the relation between music and place may in part have arisen from the increasing processes of globalization, given that the deterritorializing forces of globalization pose a challenge to any straightforward understanding of the relation between cultural practices (in this case, popular music) and place, making further academic endeavours necessary in order to grasp the issue in its full complexity.

Still, the notion that certain musical schools, scenes, sounds, genres, or styles share a connection with specific places permeates much of the discourse that surrounds popular music. There are numerous examples of places thought to have fostered specific musical expressions, from Nashville country to the 'Merseybeat' of Liverpool to the division between the Berlin and Düsseldorf schools of early German electronic music in the 1970s, all the way to the somewhat slippery concept of different 'world musics', roughly referring to the endless array of indigenous folk musics that 'belong' to specific cultural localities (for a more comprehensive list, see Connell and Gibson 2003: 98).

Correspondingly, Icelandic popular music of the '90s and '00s is consistently described in terms of a specific Icelandic or Nordic character with Björk as the leading figure (see Ahonen 2007: 44; Connell and Gibson 2003: 93-95; Dibben

2009a; Dibben 2009b; Gray 1998; Grimley 2005: 37; Martin 2002: 167; Marzorati 2001; Pytlik 2003: 120). Quite often, the purported 'Icelandicness' of the music made by Icelandic artists is thought to relate directly to the geographical and topological features of the country. Allegedly, the musical distinctiveness of these artists has to do with their ability to transmit the natural landscapes found in Iceland musically, as if the vast spaces, the mountains, volcanoes, glaciers, and geysers find a sonic expression in their music. This relation is furthermore often suggested in Icelandic music video – in studying Icelandic music video, Nicola Dibben notes how approximately half of the videos that she takes into account either depict Icelandic nature or feature signifiers of Iceland (Dibben 2009b: 135). In addition to this, the musicians themselves occasionally take part in reinforcing these beliefs in interviews and press releases – for instance, the already mentioned marketing of *Homogenic* as an 'Icelandic album'.

In this way, the music is sometimes seen as expressing the musicians' lived experience of being Icelandic. In the case of Björk, her music is almost always identified as expressing a distinctively Icelandic identity. But paradoxically Björk has been living outside of Iceland in places such as London, Spain, and Manhattan for the main part of her solo career – and her 'Icelandic' album was mostly recorded in Spain. Commenting on being pigeonholed as Icelandic, Björk also points out that her lived experience is not so much a matter of being rooted in Iceland, but rather a matter of being constantly on the move: 'literally speaking I'm not particularly Icelandic because I'm always travelling' (Ingólfsson 2005).

The mobility brought about by globalization (and specifically by air travel) means that popular musicians are constantly travelling the world, touring in far away destinations, only seldom being home (whatever 'home' means). While, as John Tomlinson puts it, the experience of globalization for most people is 'not felt in travel but in staying at home' (Tomlinson 1999: 150), the opposite is surely the case in the lives of international pop stars. Being of Icelandic origin at the same time as 'living globally', Björk's artistic project takes on the form of a search for an Icelandic musical identity, looking at her native Iceland from the outside. In her music and her music videos, Björk negotiates what it means to be Icelandic in a global world by fusing markers of a traditional Icelandic identity with inputs from other cultures and from the global repertoire of popular music. Consequently, the negotiation of identity and place in Björk's musical output could be said to arise from a tension between 'globalization (facilitated by geographical mobility, and digital communications) and the idea of national identity' (Dibben 2009a: 42).

Popular music, globalization and media technology

However, if globalization involves a weakening of the ties between culture and place (as suggested by Tomlinson 1999: 128), any notion that specific musical sounds relate to specific geographical locations should be approached with some caution. Following Tomlinson (and the basic premise of this publication), popular music, like all other cultural practices, is subject to concurrent processes of de- and reterritorialization, and subsequently any firm bond between music and place/territory is destabilised. Hence, the relation between music and place should not be regarded as a sort of simple environmental determinism since this often leads to a somewhat suspect romanticisation or idealisation of place as an evident point of origin that unquestionably makes itself heard in the music. As Martin Stokes points out, music does not simply reflect place but rather provides 'the means by which the hierarchies of place are negotiated and transformed' (Stokes 1994: 4). In this way, popular music becomes an arena for the renegotiation of place, with the connection between music and place in a constant state of flux, oscillating between fluidity and fixity (terms adapted from Connell and Gibson 2003: 10), with fluidity referring to the transnational flows of music, sounds, musicians, music videos etc. and fixity mainly referring to attempts to tie musical practices to places.

Although popular music often serves to suggest an idea of place, it just as frequently involves notions of movement and mobility. On a general level, music has an inherent mobility stemming in part from its non-signifying nature. However culturally encoded specific musics may be, the notes and rhythms of music can be 'understood' or appreciated across specific cultural and linguistic backgrounds since music does not communicate a message in the traditional sense (aside from the message found in the linguistically encoded lyrics, of course). In this way, popular music has an inbuilt global appeal allowing it to easily transgress borders. Referencing Simon Frith and George Lipsitz, Ian Biddle and Vanessa Knights argue that 'popular music is perhaps *the* cultural product that has crossed (and continues to cross) boundaries and frontiers most frequently, just as it has demarcated and consolidated local cultural spaces' (Biddle and Knights 2007: 7). The relation between popular music and place is then one of both movement and demarcation – popular music continues to flow across borders with relative ease, while also serving to define or delineate place and space.

A further change to the relation between music and place revolves around the increasing mediatization of music. The patterns of production, distribu-

tion, and consumption of popular music have been thoroughly altered by the development of new media technologies, which in turn has lead to altered configurations of music/place. Since the advent of recorded sound with the invention of the gramophone in the 1870s, music has gradually taken on the role of an object or a commodity, thereby moving from the realm of 'representation' to that of 'repetition' (Attali 1985). According to Jacques Attali, the category of 'representation' implies a situation in which the musical work is only heard once in a unique here-and-now situation, whereas the category of 'repetition' relates to the objectification of music brought about by the fixation of sound in the recording, which then leads to a situation in which the musical work can be heard numerous times in different places (roughly corresponding to the division between the work of art as a singular, 'auratic', unique act on the one hand and as an object of mass (re)production on the other (cf. Benjamin)). A main consequence of the shift from representation to repetition is that music is severed from its place of origin, given that it becomes replicable in a number of other places. But conversely, the objectification of music makes it materialise in a concrete physical form, and thereby it also implies a certain fixation of music. In this way, the recording of music means that it is no longer 'predicated on its own immediate disappearance' (Cutler 2007: 138), but that it instead becomes a material object, takes on a physical form, and attains a place in this respect.

Further technological advances since the gramophone, such as the inventions of magnetic tape in the 1920s and of multi-track recording in the 1960s up until recent developments in digital technology, have all changed the nature of music and our perception of it. In this manner, recorded sound has historically undergone an increasing process of dematerialisation, thereby losing its physicality, the recording no longer being confined to a concrete object but existing as immaterial data instead. This has meant that the global distribution of popular music has been made easier, and consequentially sound is now nowhere and everywhere at the same time: it flows readily across the globe while still being immaterial in a sense, not being visible and not necessarily emanating from a here-and-now performance. Thus, the relationship between live and recorded, between performance and mediatization, and between 'representation' and 'repetition' has undergone a process of gradual inversion (Auslander 1999). Originally, recording was meant to 'document' a performance, but now the opposite is just as often the case – the performance is expected to replicate the idealised performance created in the recording.

Apart from easing the creation and dissemination of music, its digitisation has generated altogether new modes of production, distribution, and consumption. Björk's music is a case in point regarding new recording practices. For instance, her music is reportedly often created on the move through the aid of mini-DAT machines (Gittins 2008: 88). So, if the place of recording is somehow able to make itself heard in the recording, then the music created through the aid of mini-DAT machines or other types of mobile recording equipment communicates mobility rather than stasis, reflecting a sense of moving through multiple places rather than of staying put in one place.

This practice of recording in multiple places has been common since the invention of multi-track recording in the 1960s. Multi-track recording allowed music to be recorded in different places at different times, the recording becoming an imaginary and idealised (and often impossible) performance across time and place. This ability to create the different tracks of the recording in more than one location has been extended further by recent digital technologies, and many of Björk's recordings can be seen as this type of constructed performance, created in disparate places. In *Minuscule,* one of the members of the San Francisco-based group Matmos, with whom Björk collaborated on *Vespertine,* explains how she would send them MP3s across the Atlantic which they would then rework and return in the same way. Musicians are thus able to cooperate across enormous geographical distances without ever necessarily meeting face to face. Consequently, the idea that a recording captures a musical performance taking place in a specific location cannot be unproblematically maintained. Any otherwise stable relation between music and place is destabilised – not only may recording take place in different places at different times, but musicians are also frequently on the move, taking in impressions from dissimilar places to create hybrid styles (and here Björk is also no exception: see below).

In the light of these developments, the relation between popular music and place cannot be said to be simple or static. Attempts to reconnect musical practices to specific places run the risk of simply romanticising the local as a stamp of subversive authenticity while simultaneously rejecting the inauthentic 'placelessness' of the global. The concepts of de- and reterritorialization offer themselves as apt alternative tools for analysing the fluctuating relation between music and place as one of both fixity and fluidity (or of 'complex connectivity'), hopefully leading to an analysis that attends to the intricate co-existence of aborescent structures and rhizomatic lines of flight, to speak in Deleuzian terms. The sounds of music traverse and penetrate localities, passing through places

while simultaneously becoming embedded within them through consumption or by serving as a source of inspiration, thereby generating new music. Thus, deterritorializing forces are countered by acts of reterritorialization, understood as attempts to re-infuse popular music with a sense of 'locality' or 'spatiality' – or, as John Connell and William Gibson put it, 'mobility triggers new attempts at fixity' (Connell and Gibson 2003: 46).

Hybridization, collaboration, and the commodification of difference

As a result of the increased accessibility of diverse indigenous musics brought about by new cycles of distribution, it could be argued that 'musical influences have become increasingly hybrid' (Connell and Gibson 2003: 11). In the case of popular music, the global dissemination of different musical styles often leads to surprising fusions of quite dissimilar impulses, to 'a cross-fertilisation of local and international sounds' (Shuker 2002: 72). For instance, much of Björk's artistic output is haunted by an odd Japanese influence, apparent in some of her visuals (from the cover art of *Homogenic* to the music video for the track "Cocoon"), but also in her music, most noticeably on the album *Drawing Restraint #9*, which features the traditional Japanese shō flute and the traditional singing of the Japanese Noh theater (Nielsen 2003: 246).

On closer inspection, much of Björk's music contains signifiers of various musical cultures that are neither Icelandic nor particularly Nordic. Björk's alleged Nordic sensibility is thus counterbalanced by a tendency to incorporate sounds and styles that are associated with other localised musical cultures. Even though Björk is often attributed a significant authorial authenticity, many of her songs are works of collaboration – a fact that others have pointed out as well (Ahonen 2007: 48; Malaway 2010; Michelsen 1996; Nielsen 2003: 96). Those musical expressions that stand out as non-Nordic often emanate from the contributions made by the musicians with whom she collaborates.

According to Timothy D. Taylor, this trope of collaboration is frequently called upon in discussions concerning the interactions between Western music and its 'others' (Taylor 2007: 126-27), often with the purpose of invoking a sense of respectfulness towards the musical cultures with which the Western musicians engage. The incorporation of the expressions of local, non-Western musical cultures in Western popular music often serves to evoke ideas of musical authenticity and difference, for instance by drawing on notions of the original-

ity and uniqueness of the musical cultures in question and by hinting at their 'untouched' nature. In the global arena of popular music, locality is thus often presented as a unique flavouring, as a difference or otherness, in order to differentiate otherwise seemingly similar musical products. It seems that credible places somehow endow popular music with commodity value – described by Taylor as 'the commodification of difference' (Taylor 2007: 123). Drawing on Roland Robertson, John O'Flynn describes this sort of exploitation of the local as 'a process of "glocalization": that is, the promotion and production of localized difference for global consumption' (O'Flynn 2007: 29). By drawing on place-specific musical cultures, the otherwise placeless character of global popular music seeks to be reconnected with place through an act of reterritorialization, the aim being to market the music through its locality.

Regardless of whether or not Björk's way of engaging with other musical cultures is a matter of exploitative appropriation or respectful synthesis (the latter suggested by Marsh and West 2003: 195), it is safe to say that much of the 'otherness' of her music originates from the diversity of influences and the general stylistic eclecticism of the music, a feature that is sometimes claimed to be its very trademark (Michelsen 1996). Thus, many of the musicians with whom she has collaborated concretely signify a specific 'Nordic otherness', for instance a Greenlandic choir on the tour following *Vespertine*, an Icelandic string octet on *Homogenic*, the Danish electronic musician Thomas Knak on *Vespertine*, and her longstanding collaboration with the Icelandic poet, Sjón.

But apart from these collaborators from the Nordic region, Björk has frequently teamed up with other musicians that help to instill her music with a more general musical otherness or even exoticism, including collaborators from South America (the Brazilian composer Eumir Deodato, on the album *Post*), from North America (the Canadian Inuit throat singer Tanya Tagaq, on *Medúlla*), from the Orient (the Japanese shō player Mayumi Miyata, on *Drawing Restraint #9*, and the Chinese pipa player Min Xiao-Fen, on *Volta*), and from Africa (the Malian kora player Toumani Diabaté, as well as the Congolese group Konono N°1, on *Volta*). Many of these collaborators represent other musical cultures through their distinct playing or singing styles and through the instruments they play, many of which are directly associated with specific continental, national, or regional musics – this goes for the shō, the pipa, and the kora, as well as the likembé played by Konono N°1.

In this way, Björk's music is attributed with a hybrid character, making it seem worldly and almost exotic at times. Björk's exploration of the relation

between music and place in globalization thus not only centres in on Iceland or the Nordic region, but also involves many other distinct localities. However, for all of these exotic influences Björk's music still maintains aspects of a particularly Nordic sound. The abovementioned likening of the electronic beats to volcanic eruptions is but one example. Daniel M. Grimley has pointed to the sense of spatial wideness evoked by the tension between the closeness of Björk's voice and the general vastness of the music's timbral layers as another way of consolidating the music's spatial aspects, indirectly hinting at the North as characterised by spatial wideness (Grimley 2005: 48-49). Grimley also attributes the general clarity of timbre with an ability to evoke a sense of musical Nordicness, a view also held by Nicola Dibben who suggests that there is an link between the ice of the Nordic landscapes and 'the "twinkly" high frequency percussive sounds of the music box' (Dibben 2009b: 136). Furthermore, Björk sometimes uses concrete sounds that serve to indicate natural phenomena associated with the North such as the footsteps walking through snow on the track "Aurora" (Dibben 2009b: 136).

Moreover, some parts of Björk's music contain direct references to traditional Icelandic music. This is especially evident in the use of parallel fifths in some of the string arrangements on the album *Homogenic*, this harmonic relation being a recurrent feature of the ancient Icelandic tradition of *tvísöngur*. In the opening track "Hunter" there are two passages in which two cellos play a two-bar motif in parallel fifths (1:12-1:36 and 2:48-3:43), and according to one of the members of the string octet who played on the album this is instantly recognisable as Icelandic (he is quoted as having said: 'As soon as you hear that, you know right away this is Icelandic music' (Gittins 2008: 89)). The relation to the tradition of *tvísöngur* is even more explicit on the following track, "Jóga", the song that Björk has described as a national anthem. According to Arní Heimir Ingólfsson, who has written extensively on the tradition of *tvísöngur*, this song is one of the most prominent examples of the parallel fifths of *tvísöngur* in contemporary Icelandic popular music given that 'parallel fifths played by two cellos provide the harmonic underpinning for virtually the entire song' (Ingólfsson 2003: 253).

This preoccupation with the Icelandic musical tradition is also evident elsewhere in the popular musical scene of Iceland. For instance, Sigur Rós have collaborated with Steindór Andersen to engage with the Icelandic rhyming tradition of *rímur*, combining their brand of post-rock with *rímur* in both performance and on an EP entitled *Rímur* (2001) – a combination that was also

attempted in the 1980s, when The Sugarcubes and other performers from the early Icelandic punk movement collaborated with Sveinbjörn Beinsteinsson, a performer of *rímur* (Sullivan 2003: 71-72). The fusion of old and new is also evident in another release featuring the abovementioned Andersen, *Rímur & Rapp* (2002), which seeks to indicate a continuity between the chanting style of *rímur* and the techniques of modern rap. Worth noticing also is the fact that the Icelandic record label Smekkleysa (a.k.a. Bad Taste), which has played a quintessential role in forging a new Icelandic popular musical identity, has also taken an interest in releasing new classical Icelandic music as well as *rímur* and *tvísöngur* (Nielsen 2003: 51).

If travel is searching …

This sort of attention to the Icelandic musical tradition is but one of the ways in which Björk situates her brand of popular music in an Icelandic context. Other ways in which she infuses her music with an Icelandic character include the tendency to relate the music to Icelandic landscapes or nature (both sonically and visually) as well as her choice of instrumentation and collaborators. However, it is also clear that Björk's imagined Icelandic musical identity is not a naïve, romanticist, retrospective journey back through the country's musical tradition. Rather, Björk's musical project is concerned with letting the sounds of musical tradition co-exist with the sounds of modern popular and electronic music. By reworking the relation between nature and technology, Björk is able to shape an Icelandic popular musical identity that is as concerned with the impact of globalization and new media technology as with Icelandic nature. Throughout her artistic output she works towards the construction of an Icelandic musical identity through relating music to place; however, the relation between music and place is always negotiable, since music is inescapably tied to movement. Accordingly, multiple places and cultural identities are brought into play in Björk's music as a consequence of the hybrid character of her musical influences and her music's general stylistic diversity and heterogeneity, and of her multifaceted employment of digital technologies. This curious amalgam of different musical sources (from Iceland to Mali and ever onwards) makes Björk's musical construction of place hard to pin down: even though she seems to work hard to situate her music in an Icelandic context, her work is driven not only towards this sort of reterritorialization – it also involves the vast array of sounds made available by the deterritorializing forces of globalization and

by new musical technologies. To return to the lyrics from "Hunter", it would seem that Björk has indeed found her musical home, or her Icelandic musical identity, *through* travelling, through an openness towards impressions from elsewhere, through looking at Iceland from the outside.

Works Cited

Ahonen, Laura (2007). *Mediating Music Makers. Constructing Author Images in Popular Music.* Ph.D. Dissertation in *Finnish Society for Ethnomusicology*, Publ. 16.

Attali, Jacques (1985). *Noise: The Political Economy of Music.* Minneapolis: University of Minnesota Press.

Auslander, Philip (1999). *Liveness. Performance in a Mediatized Culture.* London & New York: Routledge.

Bennett, Andy (2000). *Popular Music and Youth Culture: Music, Identity and Place,* Basingstoke: Macmillan.

Berry, Colin (1998). "Sno-Koan". *Wired* 6: 06.

Biddle, Ian and Vanessa Knights (eds.) (2007). *Music, National Identity and the Politics of Location: Between the Local and the Global.* Aldershot: Ashgate.

Cascone, Kim (2000). "The Aesthetics of Failure: 'Post-Digital' Tendencies in Contemporary Computer Music". *Computer Music Journal* 24: 4.

Connell, John and Chris Gibson (2003). *Sound Tracks. Popular Music, Identity and Place.* London & New York: Routledge.

Cutler, Chris (2007). "Plunderphonia". In Christoph Cox and Daniel Warner (eds.) (2007): *Audio Culture. Readings in Modern Music.* New York: Continuum.

Dawe, Kevin (ed.) (2004). *Island Musics.* Oxford: Berg.

Deleuze, Gilles and Félix Guattari (2002). *A Thousand Plateaus: Capitalism and Schizophrenia,* translated by Brian Massumi. London: Continuum.

Dibben, Nicola (2009a). *Björk,* London: Equinox.

Dibben, Nicola (2009b). "Nature and Nation: National Identity and Environmentalism in Icelandic Popular Music Video and Music Documentary". *Ethnomusicology Forum* 18: 1.

Gebesmair, Andreas and Alfred Smudits (eds.) (2001). *Global Repertoires: Popular Music Within and Beyond the Transnational Music Industry.* Aldershot: Ashgate.

Gittins, Ian (2008). *Björk. Human Behaviour.* London: Carlton Books.

Goodwin, Andrew (1993). *Dancing in the Distraction Factory: Music Television and Popular Culture.* Minneapolis: University of Minnesota Press.

Gray, Louise (1998). "The Idea of North". *Wire* 177.

Grimley, Daniel M. (2005). "Hidden Places: Hyperrealism in Björk's *Vespertine* and *Dancer in the Dark*". *Twentieth-Century Music* 2: 1.

Haraway, Donna (1991). "A Cyborg Manifesto: Science, Technology, and Socialist-Feminism in the Late Twentieth Century". In *Simians, Cyborgs and Women: The Reinvention of Nature.* New York: Routledge.

Hemingway, David (2002). "Björk: The Icelandic singer guides David Hemingway through her forthcoming Greatest Hits". *Record Collector*, August 2002.

Ingólfsson, Árni Heimir (2003). *"These Are the Things You Never Forget": The Written and Oral Traditions of Icelandic Tvísöngur*. Ph.D. Dissertation, Harvard University.

Ingólfsson, Árni Heimir (2005). "Björk's Expanding Territory: Drawing New Boundaries". In *Nordic Sounds* 2005: 04.

Lipsitz, George (1994). *Dangerous Crossroads: Popular Music, Postmodernism, and the Poetics of Place*. London: Verso.

Malaway, Victoria (2010). "Harmonic Oscillation in Björk's 'Triumph of a Heart' and 'Who Is It'". *MTO* 16: 1.

Martin, Bill (2002). *Avant Rock: Experimental Music from the Beatles to Björk*. Chicago: Open Court.

Marsh, Charita and Melissa West (2003). "The Nature/Technology Binary Opposition Dismantled in the Music of Madonna and Björk". In René T. A. Lysloff and Leslie C. Gay Jr. (eds.) (2003): *Music and Technoculture*. Middletown: Wesleyan University Press.

Marzorati, Gerald (2001). "Nordic Tracks: How Did Reykjavik Become a Global Pop Laboratory?". *The New York Times*, April 22, 2001.

Michelsen, Morten (1996). "The Magic of Reality, the Reality of Magic". *Nordic Sounds* 1996: 04.

Middleton, Richard (2006). "'Last Night a DJ Saved My Life': Avians, Cyborgs and Siren Bodies in the Era of Phonographic Technology". *Radical Musicology*, vol. 1.

Nielsen, Per Reinholdt (2003). *Björkmusik*. Copenhagen: Tiderne Skifter.

O'Flynn, John (2007). "National Identity and Music in Transition: Issues of Authenticity in a Global Setting". In Ian Biddle and Vanessa Knights (eds.) (2007): *Music, National Identity and the Politics of Location: Between the Local and the Global*. Aldershot: Ashgate.

Palmer, Tamara (2001). "A Different Sort of Bird". *Urb*, vol. 11: 87.

Pytlik, Mark (2003). *Björk. Wow and Flutter*. Toronto: ECW Press.

Sangild, Torben (2003). *Støjens Æstetik*. Copenhagen: Multivers.

Shuker, Roy (2002). *Understanding Popular Music*. London & New York: Routledge.

Sobchack, Vivian (2000). *Meta Morphing. Visual Transformation and the Culture of Quick-Change*. Minneapolis: University of Minnesota Press.

Stokes, Martin (1994). *Ethnicity, Identity and Music: The Musical Construction of Place*. Oxford: Berg.

Sullivan, Paul (2003). *Waking Up In Iceland*. London: Sanctuary.

Taylor, Timothy D. (2007). *Beyond Exoticism: Western Music and the World*. Durham: Duke University Press.

Thomson, C. Claire (2006). "Incense in the Snow: Topologies of Intimacy and Interculturality in Friðriksson's *Cold Fever* and Gondry's *Jóga*". In C. Claire Thomson (ed.) (2006): *Northern Constellations: New Readings in Nordic Cinema*. Norwich: Norvik Press.

Tomlinson, John (1999). *Globalization and Culture*. Oxford: Polity.

von Glahn, Denise (ed.) (2003). *The Sounds of Place: Music and the American Cultural Landscape*. Boston: Northeastern University Press.

Vernallis, Carol (2004). *Experiencing Music Video*. New York: Columbia University Press.

Whitley, Sheila, Andy Bennett, and Stan Hawkins (eds.) (2005): *Music, Space and Place: Popular Music and Cultural Identity*. Aldershot: Ashgate.

Music

Andersen, Steindor with Hilmar Örn Hilmarsson and Erpur Eyvindarson (2002): *Rímur & Rapp*, label unknown.

Björk (1993). *Debut*, One Little Indian.

Björk (1995). *Post*, One Little Indian.

Björk (1997). *Homogenic*, One Little Indian.

Björk (2001). *Vespertine*, One Little Indian.

Björk (2004). *Medúlla*, One Little Indian, Atlantic Records.

Björk (2005). *Drawing Restraint #9*, One Little Indian.

Björk (2007). *Volta*, One Little Indian, Atlantic Records.

Oval (1996). *Systemisch*, Thrill Jockey.

Sigur Rós with Steindor Andersen (2001). *Rímur*, Krúnk.

Film & Video

Björk (2002). *Greatest Hits – Volumen 1993-2003*, One Little Indian.

Björk (2005). *The Medúlla Videos*, One Little Indian.

Björk (2009). *Voltaïc*, One Little Indian.

Gestsdottír, Ragnheiður (dir.) (2003). *Minuscule*, One Little Indian.

Gestsdottír, Ragnheiður (dir.) (2004). *The Inner or Deep Part of an Animal or Plant Structure*, One Little Indian.

Notes

1 Here, the word 'thing' means 'assembly' or 'parliament', and is thus not to be understood in its normal English usage (meaning 'object'), though these two meanings of the word are etymologically related.

2 Some of the lyrics are: 'All the modern things / like cars and such / have always existed / They've just been waiting / in a mountain / for the right moment [...] They've just been waiting / to come out / and multiply and take over / It's their turn now'.

New types of transnational communities
and social relations

Art, Aid, and Negotiated Identity

The Family Pictures of *Hornsleth Village Project Uganda*

By Kristin Ørjasæter

Imagine one hundred large photographic portraits of black people posing with their new identity cards as if they were prisoners identified only by an ID number. In the autumn of 2006, the Danish artist Kristian von Hornsleth displayed these portraits in Pressen's Gallery in central Copenhagen.[1] Even before the exhibition, the Collaborative Art Project between Hornsleth and villagers of Buteyongera was well known in Denmark because of the project's information leaks. But at the exhibition the media coverage was massive; Hornsleth was accused of colonial exploitation.[2] Professor of philosophy and art science Boris Groys, however, looked at the project through a different lens in Hornsleth's book documenting the project and accompanying the exhibition. Groys comments on a certain willingness in Danish art to address the European attitude towards the non-European in provoking ways. The examples Groys mentions are film director Lars von Trier, author Peter Høeg, and Hornsleth himself. 'I am just interested why [sic] Danish artists and intellectuals get involved in these intellectual discussions. They do not have this experience of the feeling of accumulated guilt that almost all nations have,' Groys says. It is 'a different guilt,' Hornsleth responds: 'We are so well off that we are ashamed when looking at other cultures. Everything is charity now in Denmark' (Scheller 2007: 87). The intensity of these cultural feelings, guilt and shame, loads *Hornsleth Village Project Uganda* with a powerful provocative dimension.

The book in question is called *Hornsleth Village Project Uganda 2007. We want to help you, but we want to own you*. It was written mainly by members of Hornsleth's project crew and edited by Hornsleth himself. It contains the exhibited portraits and documents the entire project leading up to the exhibition. In the introduction, Hornsleth describes *Hornsleth Village Project Uganda* as an art work consisting of several disparate elements:

100 people from a small village in Uganda made a free trade deal with Kristian von Hornsleth.

The deal was that the villagers all change thier [sic] name to 'Hornsleth' in exchange for household animals.

Each person went through the official legal name change process.

A national Uganda ID card was issued to each person to show their new 'Hornsleth' name.

Each person was photographed holding their new Hornsleth ID.

The 100 photographed people are the 100 first to take the name 'Hornsleth' and they are representing the whole community.

The portraits are defined as an original art work.

The total art work is a series of 100 photos of 120 x 100 cm to be presented in selected international galleries and museums.

A professional documentary film crew is filming the process for Danish National TV DR2.

International art critics, philosophers and local partners has [sic] contributed with texts for this book about the project.

A community based organization, a CBO, called 'The Hornsleth Village Project' was formed according to local legal practice, and according to agreement with the village opinion leaders.

A total of 300 animals, pigs and goats, were traded with 300 families.

A locally well known animal redistribution system was implemented.

When these animals breed, half of the outcome can be kept by the family, and half is redistributed to other families.

Thousands of people will in five years have traded names for animals from this project if it runs as planned.

Stop donations, start free trade!

Don't worry, this is art! (Hornsleth 2007: 9)

The last sentence has the character of a manifesto. However, throughout the book, one gets an impression that the crew did worry about the combination of art, charity, and free trade. Art critic Staffan Boije af Gennäs discusses the project's neocolonial aspects. It has a white provider, who is also the art director. And it has black receivers of animals and new names, who are the models for the art work. The subtitle, *We want to help you, but we want to own you,* underlines the ambiguity in the white position. It also presents the character

of negotiation that governs the relationship between The North and The South, white people vs. black people, artist vs. villagers. On the other hand, local representative Richard Mulondo refers to the name shift as a gift trade, negotiated brotherhood, and democracy by which the villagers benefited. In his article, he underlines how art and aid have both taken on the shape of economic negotiations in this project:

> It all started when Mr. Kristian made his first visit to Uganda. I came to know Kristian through my brother DAVID who works for MR. BIRGER, a Danish investor here, who is Kristian's friend and mine, too. When we met David, Birger, Michael [Germany] and me, Mr. Kristian shared with us his vision of what he wanted to do for his art project. In the beginning, to me it sounded weird for the entire village to add his name to theirs. It was really going to be impossible in my sense. But Mr. Kristian went ahead to explain that it was trade between the villagers and him. They give him something by taking up his name and in return, he gives them something [money or animals]. There were also other benefits of taking up HORNSLETH's NAME. These included
> – villagers will be able to trade with outside world under the HORNSLETH name.
> – villagers were passports bearing Hornsleth name to theirs for free.
> – the name given to the villagers was to bring us together under one family regardless of your tribal, religious, political background and ideologies.
> – villagers were to get money in form of animals to boost their income and many other benefits.
> The task was left to explain it to the villagers, and David and I organised a village meeting for Christian to meet the villagers. Kristian himself explained to the villagers about his art project and what he requires of them and what they get from him. They agreed to trade with him by taking up his name. Later that day, he talked to the opinion leaders and all agreed on what was to be done with the money Kristian was giving, that they should have them in form of pigs, goats and sheep. And each villager will take one of his choice. (Mulondo 2007: 43)

Local representative David Kateregga makes an effort to convince the reader that the village's participation is a political stance: 'One of the ideas of the art project is for people around the world to understand that aid is given to poor countries with one hand and demands are given with the other hand. In other

words: the aid is conditional, it is pure business and not really something that will benefit the poor countries in the long run' (Kateregga 2007: 37).

The international mass media condemned the project without taking the villagers' voices into consideration. The name shift seemed to be the most provocative element of the project as it was not temporarily staged, but a real change, proven by the documented identity cards. A year later, harsh comments on the project's ethical attitude were still being repeated in Nordic mass media. On September 19, 2007 the Swedish art critic Stefan Jonsson, a writer for the leading Swedish newspaper *Dagens Nyheter*, pointed to Hornsleth as a key example of contemporary art projects that 1) cross ethical borders, and 2) invite the press to write about them. Jonsson argued that even though Hornsleth's project focuses on the white exploitation of blacks, the articulation of the project is an exploitation in itself.[3]

A central point in the ethical art criticism articulated by critics who, like Stefan Jonsson, are disgusted by the project, is that Hornsleth directed the discussion: he had the idea and directed the project. In Uganda he hired local helpers; in Denmark he hired photographers who went with him to Buteyongera; he hired writers and cameramen to document the project and a PR agency to create and manage media attention; he communicated with art critics who would praise the project and art critics who would criticise it.[4] According to Jonsson, Hornsleth treats his African collaborators and project staff like dogs and pigs.[5]

My own interest in *Hornsleth Village Project Uganda* 2006 and its reception stems from an urge to understand more about how the colonial discourse on Africa that is staged by the project functions. It is a transnational collaborative art project that, in my interpretation, focuses on the ambivalent European attitude towards Africans, the European shame or guilt, and the current neocolonial exploitation of Africa. It is loaded with provocation towards the colonial attitude present in the aid system. Still, the mass media is provoked by the artist's colonial methods, and neglects to listen to the voices of the villagers involved in the project. How does the project involuntarily (?) succeed in turning the media aggression towards itself instead of towards the system it criticises? Is there perhaps a deep gap between the inside perspective of the project (the way the collaborators look upon the entire event) and the outside (the way a lot of people not involved in the project interpret it)? In my opinion, the colonial discourse is at stake here, but not only in the project. Our knowledge about Africa and Africans was constructed during the period of colonialism; this colonial knowledge still rules the western perspective on

African villages like Buteyongera. *Hornsleth Village Project Uganda* stages this arrogant attitude in a most visible way, but it looks like the project's audiences transform the shame thus activated into aggression towards the artist. My question would be if the audience represented by the reception in the press as a consequence of this, are missing their own implication in the photographs presented to them?[6]

This article will focus on only two aspects of the entire project: 1) the final product, i.e. the photographic portraits that have been exposed in art galleries, and 2) the colonial discourse that is embedded in these portraits. In both cases I will endeavour to deepen the understanding of the complex relationship between the inside and the outside of the project in order to explore what it is exactly that the project does, and how it invokes artistic, theoretical, and neocolonial conceptions on shame and guilt.

Photographic portrait and cultural identity

The portrait of Hornsleth Janet Namono presents her as an Other. The presentation of the subject's identity is a crucial question in all portraits; the subjects of *Hornsleth Village Project Uganda* are presented according to the representation of the colonial discourse. All the portraits are '*enface*', that is, they only show the heads and shoulders of the subject, and each subject holds up his or her identity card displaying their new full name, date of birth, and an *enface* photograph. The serious manner of the photograph on the identity card is replicated in the photograph taken for the project. One could say that the two portraits mirror each other, creating a sense of '*Verfremdung*'. But the estrangement of the pose also reflects the iconographic convention of the photographic identification of prisoners, in which the prisoner holds his or her identification number in the same way that Hornsleth Janet Namono is holding her new identification card. Another comparison can be made here: before abolition, slaves were identified by their masters' names. The Hornsleth name is her new identity, but it is not only a sign of her imprisonment; it also signals the artist Hornsleth's empowerment as white man and Master.

From the perspective of those involved in the project, these portraits articulate the colonial power structure of ongoing identity negotiations. The power structure is acted out in the shape of a global family album that consists of one hundred large portraits. From the inside perspective, family is the central identity category. As Mulondo points out: '-the name given to the villagers was

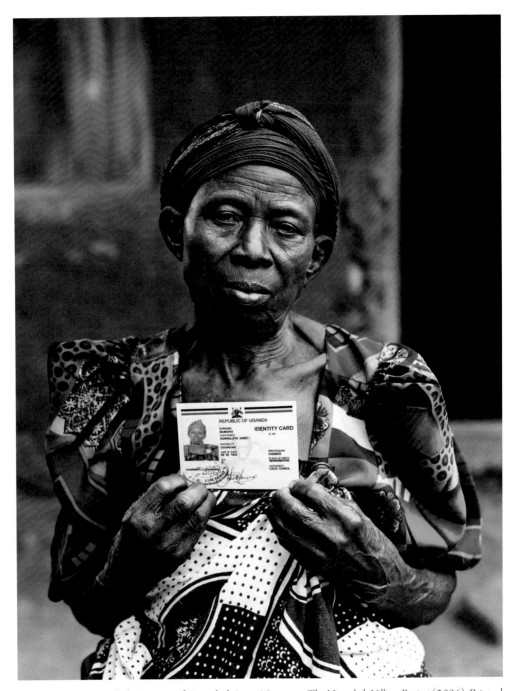

© Kristian von Hornsleth: Portrait of Hornsleth Janet Namono. *The Hornsleth Village Project* (2006). Printed by permission of the artist.

to bring us together under one family regardless of [our] tribal, religious, political background and ideologies' (Mulondo 2007: 43). It is worth noticing that family was often used as a metaphor for the social connection between white Masters and black hired crews in colonial literature, such as Livingstone's and Stanley's notes and diaries. *Hornsleth Village Project Uganda* restages colonialism's power structure of a white provider as head of the social group, providing for black subalterns. The project stages this familial relationship in a way that both repeats the power structure that governed transnational cultural meetings during colonialism and reveals today's neocolonialism in the aid system: *We want to help you, but we want to own you.*

From the inside of the project, the political statement made is quite clear. However, it is more difficult to make these conclusions from the outside. The staging of the villagers' identity as Other provokes a cultural memory that Groys called guilt and Hornsleth called shame, and the audience, including Stefan Jonsson, responded to with anger.

In *La Chambre Claire. Note sur la photographie* (1980), Roland Barthes describes photography as an agglutinated medium (Barthes 2001: 14-15), meaning that it 'sticks' to the object. Looking at a photograph, one notices the thing or the person in the picture, not the medium. The one hundred large portraits dominated by serious faces, inscrutable eyes, and hands holding up identity cards showing the subjects' new name make a thorough impression on the audience because they imitate the typology of the prisoner and reflect colonial abuse. The medium itself attracts no attention. The spectator who observes a photographic portrait identifies with the photographer's position. As the photographer in this case is presented as a colonial master, the audiences who find themselves in his position have no choice but to partake in the project's repetition of the colonial power structure. The spectator is thus staged in an abusive neocolonial role.

According to Barthes, the spectator who meets the gaze of the photographed subject may feel a sense of contact (Barthes 2001: 99; 104). The portrait may be seen as a metonymic representation of the subject, and a metonymic meeting consequently takes place. The audience might even 'recognise' a speaking voice from the photographed gaze, as if the portrait is delivering a message to the audience's conscience; the spectator might therefore feel obliged to speak on behalf of the portrayed subject. In this case, the serious manner in the gazes of the one hundred portraits can be interpreted as a testimony to the villagers' anger at being enslaved. In *Testimony. Crises of Witnessing in Literature, Psychoa-*

nalysis, and History, Shoshana Felman and Dori Laub make the point that as the witness is a medium for the experience of someone else, they cannot fully understand the significance of the testimony (Felman & Laub 1992: 24). In the case of *Hornsleth Village Project Uganda* one might conclude that the audience is seduced into occupying a witness position without investigating whether the testimony is necessary. A witness speaks on behalf of someone who does not possess a voice of their own to speak about a traumatic experience. The witness gives significance to the experience of the voiceless. But why does the audience think that Hornsleth Janet Namono and the ninety-nine other villagers have no voices of their own?

'The [photographic] portrait is [...] a sign whose purpose is both the description of an individual and the inscription of social identity', John Tagg argues in *The Burden of Representation. Essays on Photographies and Histories* (Tagg 1988: 37). Celia Lury states this even more definitively in *Prosthetic culture. Photography, memory, and identity*, where she writes that photography has a history of serving the characterisation of man (Lury 1998: 43). Tagg and Lury agree that portrait photography has played an important part in the definition of mankind and its social identity. As the portrait genre dominated the early years of photography, it was defined as the medium through which the individual's self-understanding was made visible. But in the early years of anthropology, photography was also used for phrenological purposes; anatomic features made man's inner character visible. 'Photography can thus be seen as both the instrument and the object of a comparative taxonomy that seeks to encompass the entire range of human variations,' Lury argues, and goes on to explain that photography served the mapping of human difference (Lury 1998: 51). In 1955, The Museum of Modern Art in New York showed an exposition called *The Family of Man* (curated by Edward Steichen), consisting of 503 photos chosen to represent humanity. Most objects were staged within a cultural context, some without. Together they demonstrated the diversity of mankind. The one hundred portraits of *Hornsleth Village Project Uganda* must be viewed in the same perspective. But as the subjects of this exhibition were staged to demonstrate one kind of identity, the project does not signal diversity. In *Kampen om ansigtet. Fotografi og identifikation* (2006), Mette Mortensen argues that family portraits present likeness and tell the story of the family's myth. A family album stages the collective identity of the family, the family character traits, and the family story, as well as the individuality of each family member. A family album represents each individual's role in the family's chronicle (Mortensen

2006: 93). The identity of the transnational Hornsleth family is present in the one hundred portraits, which insist on individual difference but most of all on a collective Hornsleth identity. The provocative element of the Hornsleth family photographs is that the collective colonially structured identity overrules the individual. At the heart of the photographic portrait there is a negotiated contract between the photographer and the subject about self-presentation, according to Lury (Lury 1998: 45). *Hornsleth Village Project Uganda* is highly provocative because of the contract's colonial attitude towards the subjects. Thus, what the audience tends to see is the photographer's attempt to steal the sitter from him- or herself, to borrow a phrase from Lury (Lury 1998: 46).[7] The audience reacts to the crime they are witnessing and neglect the artistic theme of the portraits, signaled in the accompanying book's ambiguous subtitle, *We want to help you, but we want to own you.*

However contested, a cultural memory analysis might give an even more specific explanation of the audience's immediate reaction to the stolen identity of the portrayed subjects. In "Projected Memory. Holocaust Photographs in Personal and Public Fantasy" (1999), Marianne Hirsch argues that cultural memory is transmitted through storytelling and culture. The presence of a coded object invokes a cultural projection, i.e. cultural memories can be transformed into personal ones. The projection is brought forward by the gaze of the audience when it meets the gaze of a coded photographed object; when the audience observes the photographs they might decipher the codes attributed to the subject and translate them into transmitted cultural memory (Hirsch 1999: 8). In other words, the spectators might identify with the object. By meeting the gaze of the Other in the photograph, they are led to project the cultural narrative (in this case the colonial history of white people making black people into slaves) as if it were their own personal memory experience, and consequently they may feel that they are witnessing the portrayed subaltern's emotions. The audience might even become angry on their behalf and feel obliged to act as witness to their supposed anger. Thus the act of watching the gaze of Hornsleth Janet Namono might raise a cultural memory of slavery and colonialism. The audience cannot fully identify with Janet; but they might project their own feelings into her gaze and feel obliged to testify on her behalf. The spectators' outside perspective on the art project and the photographs may lead them to testify to something they believe has happened on the inside. In fact, what they are doing is testifying to something that they only know from the production of Otherness in their own cultural memory.

In postcolonial theory, representation of the Other has been regarded as an ethical question ever since Gayatri Chakravorty Spivak asked "Can the Subaltern speak?" in 1983.[8] The answer was 'No'. Not: no, the subaltern cannot speak, but: no, her voice is not heard, she is not regarded as an agent in history, rather she is represented by someone else (Spivak 1999: 272). In the 1988 edition of her book, Spivak focused on the coloniser, only to conclude that he did not listen to the colonised subaltern. In 1999, when she asked the question once again, she directed her attention to the female subaltern of the post-colony. The answer remained the same. The subaltern is not even heard in her own culture because her references are still not regarded as relevant. Therefore no one listens – not even her own relatives (Spivak 1999: 274). Even though the references to colonialism and postcolonial theory are frequent, ethnocentrism is not dead, not even in the postcolonial era, Spivak concludes (Spivak 1999: 311). From the inside perspective of the *Hornsleth Village Project Uganda*, it is easy to agree. When the audience testifies to a cultural memory they overrule the villagers' voices in the portraits. The audience neglect to ask whether its testimony is asked for and act accordingly, as if the villagers have no voices of their own. Thus the audiences fulfill the colonial message of the subtitle: *We want to help you, but we want to own you.*

Artistic investigations into the colonial discourse

From the inside, *Hornsleth Village Project Uganda* stages a repetition of the colonial power structure between white and black people and thus reveals their mutual importance with respect to each other's social identity, together with their identity's affinity to the power structure. From the outside perspective, the project has led its audience into repeating the colonial white man's attitude towards the Africans so far as to neglect to listen to the villagers' own voices. The artist is caught on the threshold, having arranged both perspectives and coded the colonial discourse on Africa into the portraits. He thus gives new insight into the way colonial knowledge about Africa and the Africans is still vivid in western attitudes towards an African village.

The Othering process that is made visible from both perspectives is known as the colonial mapping process, which was developed by explorers, missionaries, and journalists in pre-colonial times, such as the British Mungo Park (1771-1805), James Kingston Tuckey (1776-1816) and David Livingstone (1813-1873), and the British-American Henry Stanley (1841-1904). All of

them wrote about their experiences in travel accounts that were structured as mapping-processes.[9] But they did not limit themselves to describing topography. Mungo Park's story focuses on one anthropological question at a time, such as etiquette, eating habits, family structures, and so on (Park 1799/1800). Tuckey was instructed to collect all kinds of arts and crafts including plants, minerals, cooking utensils, and objects used for ritual séances. Climatic conditions, to-pography, mountains, waterways, wildlife, as well as the tribes' ways of living, morals, habits, and mentality were also some of the things he was supposed to explore in order to widen the European knowledge of Africa and the Africans (Tuckey 1818: xxxvif). In his instructions there was even a list of which words he was expected collect from all the different languages he would meet on his journey. All these explorers described their experiences of the foreign by comparing them with familiar examples from home, addressing their reading public with metaphors it would be able to recognise.[10] These travel accounts were regarded as trustworthy because they documented first-hand experience in the service of The Royal Geographic Society, and they had an immense impact because they were widely read. In this manner, African culture was identified from the outside. The mapping process that was meant to develop knowledge about the foreign continent and its culture resulted in a consolidation of the superiority of the familiar culture of home.[11]

Hornsleth Village Project Uganda uses the codes of this colonial knowledge discourse for its own artistic purpose, which is to highlight how humanist aid prolongs the cultural definition of Africans as the Other with no voices of their own. Thus, this project focuses on the way the prolonged life of the western knowledge of the African Others functions as a hindrance to authentic transcultural meetings.

In contemporary anthropology, several studies have touched on the way art can represent cultural difference in a more enlightening way than anthropology itself is capable of.[12] For instance, the Uruguayan anthropologist Fernando Coronil expresses an optimistic point of view not on the science he practices but on the capacity of art to question the dichotomy between the west and the rest. In "Beyond Occidentalism: Toward Nonimperial Geohistorical Categories" (1996), his line of argument follows the established critique of the colonial dis-course. Like Edward Said, on whose shoulders Coronil stands, he claims that Western knowledge is far from neutral. Underlying this postulation is the in-sight that all knowledge is dichotomic and all dichotomic knowledge is imperial. Even the so-called neutral sciences, such as geography, are closely connected to

the economical invasion of the colonies (Coronil 1996: 52-53). Coronil demonstrates that Western knowledge about the rest of the world is a question of power and definition. However, his ambition is not only to reveal the imperial methods of science but also to establish non-imperial methods and form new identity categories. As such, his attention is drawn to literature. In order to create room for his own vision of non-imperial geohistorical categories, he looks for 'a decentered poetics' (Coronil 1996: 52). I will suggest that if one has to go outside scholarly knowledge to create new categories, photography might be an even better choice than literature because it is regarded as the medium of identity, whereas literature is known for its ability to create fictive characters.

Hornsleth's portraits are filled with colonial poetics and do not create new identity categories. What they can do, though, is reveal that art's capacity to create new understandings of cultural difference does not solely depend on the quality of the artist and the models, their work together, and their will to partake in and create a transnational community like the photographed Hornsleth family.[13] The colonial discourse is too deeply rooted to be easily transcended. *Hornsleth Village Project Uganda* offers a painful insight into the complex identification structure of the white position as provider and oppressor both from the inside of the project, i.e. the portraits, and from the outside, i.e the aggravated audience. It is not a coincidence that the message about family is not listened to. The contemporary mapping process dilutes the audience's ability to listen to the voices of the subalterns.

Hornsleth Village Project Uganda unveils an ambiguity with respect to the speaking voice and raises the central question that Coronil neglected to articulate thoroughly: What does it take to decode the perspective of the colonial discourse? The experience of *Hornsleth Village Project Uganda* highlights to what extent the dynamics of a cultural meeting depend on the insight into the personal impact of the knowledge discourse that is revealed.

Conditioned transcultural meetings

In the aftermath of *Hornsleth Village Project Uganda* one has to ask whether it blurred any insight into the continued life of colonial knowledge, or rather shed new light on it. The important question that *Hornsleth Village Project Uganda* asks is whether cultural meetings can be arranged on equal terms for both parties. Can the different prejudices and the unequal power structure that were the result of colonialism be overcome?

In the huge body of writing on globalization theory, there is not a single answer to this question. However, this volume has been inspired by a more optimistic point of view on cultural globalization theory. Roland Robertson offers a dialogic perspective to the ongoing interconnection between cultures with the term *glocalization* (Robertson 1995: 40); from the perspective of glocalization it ought to be possible to create a multicultural Hornsleth family identity. What *Hornsleth Village Project Uganda* underlines, though, is the audience's reluctance to accept the change in the power structure inherent in the knowledge of the Other stemming from colonialism.

In *Globalization and Culture*, John Tomlinson characterises the conditions of social life in the globalized world as a 'complex connectivity', which is 'the rapidly developing and ever-densening network of interconnections and interdependences' (Tomlinson 1999: 2; 9). People from all over the world are brought together by a high degree of mediated accessibility and travel. But even though physical distance is easily overcome, cultural distance remains to be dealt with. 'Local life occupies the majority of time and space', as Tomlinson simply puts it. Thus, the measure of the degree of globalization is connected with the 'displacement' brought upon the locality by globalization (Tomlinson 1999: 9). In my understanding of connectivity, the globalized world is a network society with a potential to destabilise and change local communities. As a collaboration between a Danish artist and one hundred African villagers, *Hornsleth Village Project Uganda* might be seen as a transnational cultural encounter which has changed the village of Buteyongera. But the lack of respect towards the villagers' participation in the project is still vivid in its Nordic reception.

I sympathise with Robertson's and Tomlinson's will to see the old dichotomies of cultural difference in new perspectives. Still, I want to argue that cultural globalization theory presents maybe too optimistic a point of view on cultural meetings. The possibility of establishing a sense of 'we' across borders has increased, but it is not necessarily guaranteed to be successful. Even though the connection between Denmark and Buteyongera involves a collaborative investment in an art project, the *Hornsleth Village Project Uganda* demonstrates that the repeated cultural division between 'we' and 'them' is not easy to dispel. At the heart of this project is a family name; despite the fact that one hundred portraits document the Ugandans as members of the Hornsleth family, the reception of these portraits interprets the black Hornsleths as 'them' and the white one as 'us'. Thus, it is tempting to conclude that the art project demonstrates how deeply rooted the division is, and how hard it is to establish a transnational 'we'.

However, *Hornsleth Village Project Uganda* does demonstrate a perspective *on* western knowledge discourse and cultural memory: the 'dis-placement' of Buteyongera into Hornsleth Village is a result of the collaborative art project. In the prolongation of the colonial power structure that seems to govern the mind of the reception, this cultural encounter is not regarded as an interpenetrative exchange. Rather, the local community that is staged as a colonial cliché in the project is transformed in the reception into the same cliché on the basis of the old, scholarly knowledge of what Africans are, i.e. they are not 'us'. The value of *Hornsleth Village Project Uganda* is that it reveals that colonial discourse is not dead at all, but continues to structure our inability to listen to the cultural Other.

Works Cited

Andersen, Frits (2010). *Det mørke kontinent? Afrikabilleder i europæiske fortællinger om Congo.* Aarhus: Aarhus University Press.

Barthes, Roland [1980] (2001). *Det lyse rommet. Tanker om fotografiet.* Translated by Knut Stene-Johansen. Oslo: Pax forlag.

Conrad, Joseph [1899] (1982). *Heart of Darkness.* London: Dent, Everyman's Library.

Coronil, Fernando (1996). "Beyond Occidentalism: Toward Nonimperial Geohistorical Categories". *Critical anthropology* 11, no. 1.

Felman, Shoshana and Dori Laub (1992). *Testimony. Crises of witnessing in literature, psychoanalysis, and History.* New York and London: Routledge.

Felman, Shoshana (1993). *What Does a Woman Want? Reading and Sexual Difference.* Baltimore: The Johns Hopkins University Press.

Gennäs, Staffan Boije af (2007). "We want to help you but we want to own you". In *Hornsleth Village Project Uganda 2007.* Copenhagen: Futilistic Society Publishing.

Hirsch, Marianne (1999). "Projected Memory: Holocaust Photographs in Personal and Public Fantasy". In Mieke Bal (ed.): *Acts of Memory. Cultural Recall in the Present.* Hanover: University Press of New England.

Hornsleth Village Project Uganda 2007. Copenhagen: Futilistic Society Publishing.

Jonsson, Stefan (2007). "Kristian von Hornsleth: 'Hornsleth Village Project Uganda'". In *Dagens Nyheter* September 19, 2007. Accessed October 19 2009: http://www.dn.se/kultur-noje/konstrecensioner/kristian-von-hornsleth-hornsleth-village-project-uganda-1.529560.

Kateregga, David (2007). "Open letter to people in doubt about the Hornsleth Village Project". In *Hornsleth Village Project Uganda 2007.* Copenhagen: Futilistic Society Publishing.

Livingstone, David [1857] (2006). *Missionary Travels and Researches in South Africa. Journeys and Researches in South Africa.* Produced by Alan. R. Light and David Widger. Project Gutenberg. Accessed March 28 2011: http://www.gutenberg.org/files/1039/1039-h/1039-h.htm

Lury, Celia (1998). *Prosthetic Culture. Photography, memory and identity*. London and New York: Routledge.

Melberg, Arne (2005). *Å reise og skrive. Et essay om moderne reiselitteratur*. Oversatt av Trond Haugen. Oslo: Spartacus.

Mortensen, Mette (2006). *Kampen om ansigtet. Fotografi og identifikation*. Ph.d.-thesis. Copenhagen University.

Mulondo, Richard (2007). "About the Hornsleth Village Project in Buteyongera (Mukono District] – where p'ple have added a name of Hornsleth to their names". In *Hornsleth Village Project Uganda 2007*. Copenhagen: Futilistic Society Publishing.

Park, Mungo (1799/1800). *Travels in the Interior Districts of Africa: Performed under the Direction andPatronage of the African Association; in the years 1795, 1796 and 1797. By Mungo Park, Surgeon*, 4th ed. London: Bulmer and Co.

Phillips, Richard (1997). *Mapping Men and Empire. A geography of adventure*. London: Routledge.

Robertson, Roland (1995). "Glocalization: Time-Space and Homogeneity-Heterogeneity". In Mike Featherstone et al. (ed.): *Global Modernities*. London: Sage Publications.

Scheller, Jörg (2007). "Why this is contemporary. Interview with Boris Groys with [sic] Kristian von Hornsleth". In *Hornsleth Village Project Uganda 2007*. Copenhagen: Futilistic Society Publishing.

Schneider, Arnd and Christopher Wright (ed.) [2006] (2007). *Contemporary Art and Anthropology*. Oxford: Berg.

Spivak, Gayatri Chakravorti (1999). *A Critique of Postcolonial Reason. Toward a History of the Vanishing Present*. Cambridge, Mass. and London: Harvard University Press.

Stanley, Henry M. (1872). *How I found Livingstone; Travels, adventures, and discoveries in Central Africa; Including four months' residence with Dr. Livingstone*. London: Sampson Low, Marston, Low, and Searle.

Stiebel, Lindy (2001). *Imagining Africa. Landscape in H. Rider Haggard's African Romances*. Westport, Connecticut and London: Greenwood Press.

Tagg, John (1988). *The Burden of Representation. Essays on Photographies and Histories*. Minneapolis, MN: University of Minnesota Press.

Tomlinson, John (1999). *Globalization and Culture*. Chicago: The University of Chicago Press.

Tuckey, James Kingston (1818). *Narrative of an Expedition to explore the river Zaire, Usually called the Congo, in South Africa, in 1816 Under the direction of Captain J. K. Tuckey, R.N.* London: John Murray, Abenarle-Street.

Notes

1 Pressens Gallery is cituated in the building of the newspaper *Politiken*. Kristian von Hornsleth, born 1963, was educated at the Royal Art Academy's Architectural school in Copenhagen 1988-94. He works in a postmodern and conceptual tradition. Latest projects: *Deep Storage Project* (2010), *The Hornsleth Arms Investment Corporation* (2008), *Hornsleth Village Project Uganda* (2006).

2 See http://www.dn.se/kultur-noje/konstrecensioner/kristian-von-hornsleth-hornsleth-village-project-uganda-1.529560, acessed October 19 2009, http://klassekampen.no/48151/article/item/null, accessed October 19 2009, http://www.hornsleth.com/Hornsleth/Home/Media/Articles/

Articles, accessed March 28 2011, and http://www.hornslethvillageproject.com/Uganda-Village-Project/Media, accessed March 28 2011.

3 'Men provokationen och olusten bottnar förstås inte i att Hornsleth visar att människor exploaterar varandra, och att vita exploiterar svarta. Den verkliga provokationen är outtalad och följer i nästa led: vi exploiterar varandra, och vita exploaterer svarta, och låt oss fortsätta med det.' (Jonsson 2007, http://www.dn.se/kultur-noje/konstrecensioner/kristian-von-hornsleth-hornsleth-village-project-uganda-1.529560, accessed October 19 2009).

4 'Kristian von Hornsleth står för idé och samordning. I Uganda har han anställt lokala medhjälpare. I Danmark har han städslat fotografer som rest ned och fotograferat. Han har anlitat författare och filmare som dokumenterat projektet, en pr-firma som ser till att det skapas uppmärksamhet. Han har knutit upp konstkritiker som ska prisa projektet och andra konstkritiker som ska såga det.' (Jonsson 2007, http://www.dn.se/kultur-noje/konstrecensioner/kristian-von-hornsleth-hornsleth-village-project-uganda-1.529560, accessed October 19 2009).

5 'Huruvida Hornsleth undanröjer fattigdomen eller förvärrar den spelar ingen roll. Saken gäller något enklare, som är svårare. Man kan skänka någon sin gris. Men kan man begära hans eller hennes namn i utbyte? Måste europén behandla afrikanen som människa? När kan konsten behandla andra som hundar och svin?' (Jonsson 2007, http://www.dn.se/kultur-noje/konstrecensioner/kristian-von-hornsleth-hornsleth-village-project-uganda-1.529560, accessed October 19 2009).

6 The phrase is borrowed from Shoshana Felman (Felman 1993: 19), who uses it to indicate that the reason a certain topic is of so much interest to her that she has written a book about it is that it touches on a part of her own story that she was not previously conscious of.

7 Mette Mortensen (2006) also focuses on the connection between photography and characterisation. An identity-portrait asks: Who is that person? What does he represent? Mortensen argues that any identity photograph involves a dual perspective: the subject is portrayed from the outside by the photographer, but still presents the subject's presentation of him- or herself because even though the photographer takes the picture, the subject will still stick to his or her own version of self-presentation in order to make their own identity recognisable (Mortensen 2006: 16).

8 The term 'subaltern' is Antonio Gramsci's, who used it to define the underclass of the colonies. 'Subaltern Studies' was the title of a scholarly field that studied the agency of low status groups in history. Spivak gave the lecture "Can the Subaltern speak?" in 1983. It was published in 1988 and rewritten in 1999.

9 In 1587, Gerard Mercator presented the first map of the world, *Orbis Terrae Compendiosa Descriptivo*, which was dominated by depictions of coastlines. The inner parts of Africa, Australia, Asia and America were not yet known but the desire to fill in the empty sections of the map became a quest for exploration projects in the centuries to come, Richard Phillips argues in *Mapping Men and Empire* (Phillips 1997: 6).

10 The Swedish professor of comparative literature Arne Melberg make the same point in *Å reise og skrive* (2005) referring to Francois Hartog's presentation of Herodot: Herodot wanted to translate what seemed to be different (*l'alterité*) into the known (Melberg 2005: 26/Francois Hartog: *Le miroir d' Hérodote*, 1980: 225).

11 The scientific purpose of exploring also left room for heroic self-presentation. The adventurous survival and immense self-control testified to by the travelers is akin to that of adventure story heroes. Their travel accounts are filled with breathtaking stories about near fatal attacks from both wildlife and people. These accounts have inspired adventure stories such as those written by H. Rider Haggard and Richard Burroughs. Both authors structure their novels around the heroes' journeys. The stories are narrated in first person, and the mapping-quest is transformed into a quest for ivory, or a lost white man, or treasure. The adventure stories are not historically reliable, but they are built on reliable sources. In *Imagining Africa. Landscape in H. Rider Haggard's African*

Romances (2001), Lindy Stiebel makes a similar point when she discusses the influence of Mungo Park, David Livingstone, Richard Burton, and John Speke on Haggard's romances. The explorers' travel accounts constructed an image of Africa which met with the Victorian public's desire to be entertained, she argues. Haggard knew Africa only from reading (Stiebel 2001: 16ff). The same argument has been made about Burroughs by, for instance, Frits Andersen (Andersen 2010: 592). Even modernist novels such as Joseph Conrad's *Heart of Darkness* (1899) have contributed to the prolongation of the image of Africa as the place where white men either die or demonstrate their heroic qualities. Despite the fact that *Heart of Darkness* also marks the beginning of a critique of the testimonial value of the travellers' accounts of their encounters with the local habitants, as Andersen (2010) argues, the colonial attitude of the travel accounts made room for a continued 'orientalist' description of Africa and Africans throughout the first half of the twentieth century (Andersen 2010: 376).

12 In *Contemporary Art and Anthropology* (2006), Arnd Schneider and Christopher Wright explore the anthropological and artistic modes of representation and argue that in anthropology, the Other is represented by the scientist's appropriation, but the objective representation that used to be the ideal has now been questioned. In representational art, on the other hand, the subjective experience of the Other is searched for and acknowledged through the artist's subjectivity, thus the audience gets to know the other through their appropriation of the work (see Schneider and Wright 2006: 26).

13 Another interesting example is *Miss Landmine*, by the Norwegian actor and director Morten Traavik. In 2007 he arranged a Beauty Contest in Luanda, Angola. As the title implies, the contestants were all wounded by landmines; they were provided with prosthesis from a Norwegian factory and received money to start a small business or get an education as a reward. In 2009, he attempted to arrange a similar contest in Cambodia. It was cancelled by the authorities, so the Cambodian contest was held in Kristiansand, a small town in Norway, where exiled Cambodians elected a Miss Landmine from full scale photographic portraits. In both the Angolan and the Cambodian cases similar contests were arranged on the internet (see http://www.miss-landmine.org/misslandmine_news.html, accessed March 28 2011). The photographs are accompanied by information about the dress, the jewels, and the designer, which is listed sided by side with information about the mine that blew the contestant's leg away; the weight and kind of explosives, manufacturer and nationality of origin are also listed. Thus, *Miss Landmine* focuses on how the life and identity of these women is controlled by the international war and development aid industries, as well as by the beauty ideals of their culture. The connection that is made between daily life (dresses and jewelry) and war (explosives) reveal a sense of random connection between their lives and the spectators' lives. The spectator can identify with some parts of their lives, but not others. More than Otherness, these portraits underline the familiar and ordinary elements of the women's lives which makes it possible to identify with the photographed subjects in ways *Hornsleth Village Project Uganda* does not allow. Thus, Traavik touches on the decentred poetics that Coronil asks for. However, Traavik has also met with harsh critique and the two projects have some similarities. Both have resulted in photographic portraits as well as development aid, and both are collaborative art projects in which the artist takes up a central position on the threshold between art and real life, where they are accused of unethical behavior by the art audience. A comparison of *Hornsleth Village Project Uganda* and *Miss Landmine* and their media coverage might perhaps deepen the understanding of the effect of coded photography as well as the continued life of colonial discourse.

National Identity Goes Queer with Adel Abidin

By Anita Seppä

The questions concerning the relation of identity and nationalist ideologies have become extremely important for the researchers of cultural globalization during the past three decades or so. In an era that has evidenced more people living across or between national borders than ever, this is hardly a surprise. At the moment, there are about 214 million migrants, 10 million refugees, and 26 million internally displaced people who have been forced to leave their homes due to famines and civil wars. In addition to this, the globalization process has also opened up new possibilities for more wealthy people to freely move around the globe in search of adventure, money, sex, or whatever.[1]

The massive diaspora that we witness today has also pushed many artists to face the themes of cultural hybridity and human solitude with new intensity. It might be argued that contemporary artists do not even have a choice: as the reality of globalization is increasingly transforming the structures of the modern world and everyday experience – including experiences of 'home', 'belonging', and 'being connected' –artists necessarily begin to use their work to reflect these changes. Even though there exists a long tradition of modern art that emphasises feelings of alienation from collective or natural origin, in contemporary art the urban nomads of our age drive the experiences of dislocation, incompleteness, and uncertainty 'to bold and frightening new degrees, in a way surely unimaginable to a late nineteenth-century Frenchman or to any unthinking citizen whose expectations are bound within a global imperium', as Frederick N. Bohrer comments (Bohrer 2008: 33).

Seen from this perspective, the much discussed notion of 'hybrid' identities not only refers to multiple and complex origins, influences, and interests, it also designates a name for the actual senses of incompleteness in the world. As Nikos Papastergiadis suggests, in the rush 'to find an alternative to aggressive

and chauvinistic forms of identity, the concept of hybridity has frequently been promoted to the position of a new form of global identity' (Papastergiadis 2007: 15). Yet, as he also reminds us, the mere celebration of hybrid identities is in danger of ignoring the deeper logic of modern cultural accumulation that also tends to turn hybridity into an occasional experience of exotic commodities that might be packed 'to sustain the insatiable trade in new forms of cultural identity'. What this means is that, when discussing the contemporary changes in cultural identities, we need to pay serious attention to the dual forces of connecting and displacing, moving and bridging, and to see these forces as operating together (ibid.).

As I aim to show in this text, the artistic strategies of Adel Abidin (b. 1973), who emigrated from Iraq to Finland in 2000, reflect the same problematic of the new transcultural or hybrid identities in the globalized world. By turning his own existence into an artistic object that could be characterised as a national 'weirdo' or 'queer', and by ironically relocating the mass media's representations of the cultural others, Abidin deals with the most searing questions of our era, such as: how to cope with difference and transnational identities within each culture; how to face the cultural other; and how to create new kinds of identities and communities in the age of massive diaspora and mass media.

The political force of Abidin's art is embedded in his ability to turn various ideological (national, Orientalist, racist) and nationalist discourses against themselves, in much the same spirit as Michel Foucault, who writes about the political usage of counter-discourses, or Homi K. Bhabha, who writes about colonialist mimicry.[2] A closer analysis of Abidin's artistic strategies also leads one to think of those actual theoretical discussions according to which all site-specific communities, nations included, are always heterogeneous, ideological, and hierarchically structured social artefacts that manifest unequal fields of power, no matter what their relation to globalization is. So conceived, it becomes much more important to study carefully the power relations within each local site than to see these sites as mere passive echoes of the power hegemony which has its centre globally 'elsewhere' (see also Crane 2002: 1-3; Berger and Huntington 2003; Appadurai 1990 and 1996).[3] As Abidin's art convincingly suggests, in this very important sense, all considerations of globalization must always begin at home.

From the imagined identities to the national queers

The idea of national identity as an imagined construction (Anderson [1983] 2006; Hobsbawm 1990) has been key to recent theoretical discussions on globalization and transnational identities because it offers tools for deconstructing more traditional views, according to which the roots of national communities should be sought from a collective, shared history among individuals affiliated by race, ethnicity, territory, and a common language. The notion of the imaginative nature of identity also allows us to discuss the fact that national identities and their active production via various ideological discourses very often tend to hide the heterogeneous, contradictory, and hybrid dimensions of human identity and human societies (Mercer 2007: 247; Hall 2007).

All identities, national identities included, have recently been interpreted far more in terms of differences, discontinuities, and ruptures than as something coherent, shared, and fixed. Seen in this way, the meaning of the word 'us' is never finished or completed, but keeps on moving in new directions, encompassing endlessly other, additional, or supplementary meanings (Hall 2007). Thinking about the same issue, Arjun Appadurai notes that 'what a new style of ethnography can do is to capture the impact of deterritorialization on the imaginative resources of lived, local experiences. Put another way, the task of ethnography now becomes the unraveling of a conundrum: what is the nature of locality as a lived experience in a globalized, deterritorialized world?' (Appadurai 1996: 52; Appadurai 2005: 3).

In a video installation called *Love song* (2006), Abidin aims to construct through artistic means the many-faceted experience of exile and alienation in the globalized world. In the description of this piece, he writes:

> When I came to Finland and tried to learn the Finnish language, I found it challenging. Since the language seemed so rhythmic, I started to wonder whether singing would make it easier for me to pick it up. I sat down, gathered all my courage, and composed this song. I never played the guitar before.[4]

The result is a parodic performance which imitates at once the canon of popular love songs, and the everyday usage of the Finnish language. While singing, Abidin makes a lot of mistakes in both grammar and in tone, which of course fits perfectly his intentions as an artist. The result is funny and ironic, but only on the surface. On a deeper level, the work brings forth many serious relevant

questions. By placing himself as an object in his own artistic representation Abidin seems to ask, first of all, how we perceive and define all those cultural others among us who do not perfectly master the language we expect them to speak in 'our' nation. At this level, his personal object of loss – home, culture, and mother tongue – is written in the strangeness of his language as well as in the gestures of singing and playing which seem more like mechanical repetition and imitation than something that comes straight from the heart.

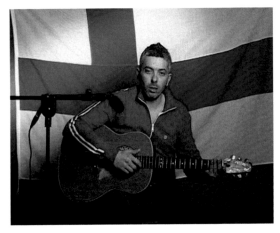

Adel Abidin: *Love song* (*Rakkauslaulu*) (2006). Video installation.[5]

As is the case for most immigrants, a certain void exists in Abidin's second language and gestures; a void that refers at once to something lost and something that has been recreated or invented (see also Bhabha 2008: 236-237). On a more political level, Abidin's installation can be seen as resisting those pathological ways in which the notions of national identity and 'us' have been experienced within the dominant regimes of visual representation in the West. These notions force the viewer to ask: who is this person, in reality, who is performing? What should we think of as his 'Finnishness', and how do we categorise this term generally? Is he one of us, or not? What remains hidden behind his noisy silence and evident alienation?

By placing himself and his acts under the Finnish flag, Abidin sets the Finnish identity into a stage of transformation, showing how national identity is always subject to the endless play of representation, ideology, and change. In this piece of art, the question of national identity in a globalized world is presented,

first of all, as a matter of constant re-creation, which acquires intelligibility on the grounds of the context that already exists, but which also generates new imaginative contexts that seek to transcend the limits of the actual place, time, history, and culture. As a result, all identities are soon turned into a matter of 'becoming something' through repetition and performance, rather than into something that has already existed or that can simply be found.

As I see it, the vital term in this artistic recreation of identity is a new kind of culturally hybrid discourse, which may both produce and transmit power, but which might just as easily be used to undermine and expose hegemonic power by its very own means. As Michel Foucault has pointed out, the discursive forms of counter-resistance are not universal, but far more strategic, particular, and empirical. Hence, when we analyse these counter-discourses, we need to make allowance 'for the complex and unstable process whereby discourse can be both an instrument and an effect of power, but also a hindrance, a stumbling-block, a point of resistance and a starting point for an opposing strategy' (Foucault 1980: 100-101).

In *Love song*, this kind of opposing discursive strategy is played out at least on two different levels. First, Abidin plays ironically with popular discourses on erotic love and heterosexual flirting, representing the masculine 'hero' as an active but not too effective or skilful individual who mainly succeeds in making people laugh at him. Second, and even more importantly, he turns nationalist discourses on identity into new kinds of counter-discourses by presenting 'the Finn' in the film as some sort of national queer who is literally 'strange', 'unusual', or 'out of synch'. At this level, his work also draws attention to the performative nature of *all* identities, inspiring the viewer to ask if national identity (like sexual identity) is a natural fact or a discursive construction that demands performative repetition (see Butler 1990: viii; McNay 1992: 21-22; Bordo 1993; Seppä 2003: 100-104). By repeating the performative acts of Finnishness 'wrongly' – for example, by using words such as 'paska' ('shit') in the wrong context and making many grammatical mistakes – he implicitly stresses the latter view.

Like the representations of sexual weirdos or queers in queer art, Abidin's national strangeness is also a political act in the sense that it questions normative and essential definitions of identity by refusing to fit to the limits of normality. By showing that national identity in practice becomes manifested through a series of acts that demand performative repetition (correct usage of language, habits, symbols, etc.), Abidin opens up the whole notion of national identity to self-parody, break-up, self-criticism, and those hyperbolic exhibitions of 'the

natural' that, in their very exaggeration, uncover its fundamentally imaginary status. This kind of parodic artistic deconstruction of national identity does not in itself mean the deconstruction of identity politics, however. Rather, it establishes as political the very expressions through which identity is articulated (Butler 1990: 146-148). So conceived, the term 'Finn' comes to present a whole series of new aspects that are not taken as natural or essential anymore, but that rather become politicised and pluralised; in other words, read anew in a critical light.

To call Abidin's representations of the 'Finnish men' queers might also be seen as somewhat problematic, however, because he is not especially interested in deconstructing the borders and norms of heterosexual masculinity, or to seek new 'third' sexual identities. In this respect, his alienating presentations of the nationalist weirdos seem to be more in line with what Bhabha has called 'colonial mimicry'. As Bhabha suggests, within the economy of racist or colonial discourse, mimicry emerges as an ironic compromise, one that presents the colonised (or 'orientalised') subject as *almost the same, but not quite* – that is, as Anglicized rather than as English, for example. Working against the racist imagination that produces its cultural Others through demand for indentity, stasis, and enlightenment rationality (never plural rationalities), mimicry is constructed around ambivalence and slippage, continuous excess and difference.

In this sense, it also expresses certain double articulations by appropriating the Other at the same time as it visualises power (Bhabha 2008: 122). As Bhabha formulates it: 'What emerges between mimesis and mimicry is a *writing*, a mode of representation, that marginalizes the monumentality of history, quite simply mocks its power to be a model, that power which supposedly makes it imitable.' Seen in this way, mimicry *re-presents* rather than repeats, diminishing in this act the truth-claims of racist and nationalist visions (ibid. 125; see also Hall 1996: 245). It simultaneously brings forth the broken and split character of the colonial subject, her/his homelessness in her/his own home, difficulties in feeling connected, and experiences of alienation, that is, her/his oppression and cultural emptiness.

This kind of recontextualisation of identity could also be described in terms of reterritorialization of identity or hybrid identity, taken that we understand these terms to refer to one's placing of the already existing cultural identities in ways that no longer necessarily belong to any particular place or political territory. In Abidin's artwork, we see a man who is both a Finn and a stranger to most Finns, an insider and an outsider, someone who we might get to know

and someone whose cultural background most probably also overcomes our understanding; a strange mixture of cultural elements combined into a new kind of hybrid identity.

Following Sarat Maharaj's analysis of hybrid identities in her article "Perfidious Fidelity: the Untranslablility of the Other" ([1994] 2003), we could say that there is always an element of 'untranslatability' in new mixtures of this kind. Therefore, to say that Abidin looks like a cultural hybrid (or a national queer), does not in fact entail any fixed or easily understandable meanings. Rather, it suggests that we see a (re)presentation of a living human individual whose essence should not be narrowed down into some new celebratory and reductive term. Instead, we should pay attention to the unfinished character of these new hybrid identities, and see them as a self-unthreading force which might also be used against themselves. At any rate, the result, as I see it, is an open-ended identity that is shot through with expressions and intimations of the untranslatable (Maharaj 2003: 299; see also Hall 1996: 237-238, 244).

Abidin's critical awareness of the power of media presentations is also strongly present in this piece. He offers us that kind of entertainment that we are used to consuming on a daily basis, but in ways that make us feel a bit confused, even ashamed (it might be the racist in me who looks and laughs at him behind this intellectual level of analysis). Through his imitative performance of a queer Finnish man in love, he manages to draw attention to the canonised normality of mass media representations, and to show how even slight deviations from the norm can be immediately perceived as 'weird'.

The Other's noisy silence

Similarly, in the video installation *Cold Interrogation* (2005) Abidin opens up perspectives on the everyday life of an immigrant who lives in a place where he is constantly seen as an other. In this work, viewers peer into a hole in a refrigerator, where they see and hear a videotape of a Finnish man asking well-meaning but also irritating questions, such as: 'Where are you from?', 'How did you end up in Finland?', 'Did you see Baghdad burning?', 'What does it feel like to ride a camel?', 'How is the situation in Iraq at the moment?', 'Are you Muslim? Sunni or Shiite?', 'How does freedom taste to you?', and 'Do all women in Iraq wear those funny veils?'.

Through these questions and their ironic projection on the refrigerator, Abidin shows how his personality and individual existence in Finland is con-

tinuously turned into a mere representative of the Muslims, Arabs, and Iraqis, whose thoughts, feelings, and strange habits 'true Finns' simply do not know or understand. At this level, the host of the local culture into which the 'stranger' has emigrated seems to welcome him only insofar as he does not transcend the limits of the existing clichés of strange others (Marks 2007). As a result, the cultural other becomes doomed into silence, no matter how much he/she tries to speak, sing, or shout. At another level, we could say that Abidin, in his turn, also objectifies the 'Finns' negatively in this piece by reducing them into one single irritating and loud (male) head who does not respect other people and their limits. This kind of production of the negative cultural other (Finn) is actually repeated in many of his works, and might be seen as some sort of 'Occidentalism' which, like Orientalism, simplifies various cultural others into imagined caricatures of reality (stupid and badly behaved Finnish men, for example).

The communicative ruptures between 'us' and the 'others' are also forcefully performed in a video installation called *Jihad* (2006), in which a man dressed as a mujahid stands in front of the American flag, reciting a message of hate and death from the Qur'an – as if he is just about to start shooting with his Kalashnikov. However, instead of picking up a gun this individual hoists a guitar and starts to sing Woody Guthrie's old folk classic "This Land is Your Land". Here, again, the other's stereotypical otherness is disturbed through Abidin's way of (re)placing the performing subject in a cultural territory that exists somewhere outside 'normality'. Instead of appearing as a typical Islamist terrorist who kills blindly for freedom, the performer comes out of the closet as a pro-American patriot who likes to play popular American folk music. The result can be interpreted, again, as one version of a national queer who disturbs and transgresses all normative clichés of Arabic and Islamic people, and turns national identities into a source of endless recovery and parody.

The same idea could also be expressed by saying that the Westerners' need for Orientalism is both presented and disturbed in these artworks. By turning the protagonist of the Orient into a national queer, Abidin shows that the Orient is 'not an inert fact of nature', as Edward Said has put it (Said 2003: 4). Instead, the Orient, just like all fixed identities, is an imaginative creation with no corresponding reality. Seen in this way, all those numerous media representations of the 'Arabs', 'terrorists', and 'subjects of evil' that we have seen during the past few years are seen, first of all, as manifestations of the cultural hegemony of the West that need to be interrupted and re-thought.

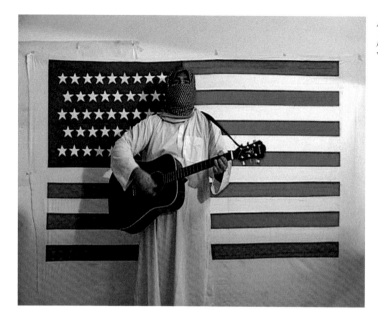

Adel Abidin:
Jihad (2006).
Video installation.

Seen in a wider context, Abidin's artistic acts are obviously not subversive in the sense that they would be able to eliminate the existence of Orientalism (or Occidentalism) or to solve the problems of all those in exile. Moreover, for some parties, such as extreme right-wing politicians and religious fundamentalists, cultural hybridity or queerness is surely not an emancipatory or political promise, but simply a form of heresy. In this sense, parodic usages of identity seem to be subversive only to the degree that people are able or willing to take them seriously. This notion is not to deny or lessen the importance of critical arts, but rather to affirm that there is no artistic practice that could effect global transformation in the living conditions of everybody – which, I believe, actually holds true in all kinds of political counter-discourses.

What this also means in practice is that the problems young Arab men face in Finland are certainly not the same as the ones faced by poor black women living in Nigeria. The discourses and representations that tend to make these individuals docile or oppressed in the globalizing world also differ significantly. Therefore, the task of both critical artist and theorist is, first of all, to study carefully how discourse, representation, and normalising power are linked to each other in each special case, and to develop specific creative critical responses to each oppressive power structure – just as Abidin is doing.

Imagining new neighbourhoods

The hybrid and contradictory character of national identities in the globalized world can also be discussed in terms of new 'neighbourhoods'. As Arjun Appadurai has proposed, in the current situation, in which the modern nation-state and nationalist propaganda face 'particular sorts of transnational destabilization' and in which 'spatial localization, quotidian interaction, and social scale are not always isomorphic' (Appadurai 1996: 178-179), it might be useful to distinguish the notion of the 'local' from that of what he calls the 'neighbourhood'. With the first term Appadurai refers to those actual settings in which social life takes place, as well as to a phenomenological quality that links a sense of social immediacy, the technologies of interactivity and the relativity of contexts. The second term 'neighbourhood' refers instead to those actually existing *social forms* in which locality as a dimension or value is variably realised (ibid.: 178-199). Yet we might ask what these terms actually mean, more precisely, and whether they are meant to be taken as actual utopias of a 'better' globalized world, or as mere descriptions of an actual lived world order.

As far as I can see, Appadurai's analysis entails both these two aspects. Firstly, the notion of neighbourhood is descriptive in the sense that it aims to show how, in a deterritorialized global world in which millions of people try to rebuild their experiences of home, homeland, and community – supposing that they do not end up as 'long-distance-nationalists' (Axford 1995: 165) – the social techniques of the production of the locals or natives needs to be distinguished from the more traditional nationalist ideologies of the nation-state. Even though these new neighbourhoods require older, already existing contexts against which their intelligibility can take shape, they also *produce* new contexts and new imaginative forms of identity. This context-generative dimension of new neighbourhoods is a crucial matter because it points to a theoretical angle on the relationship between local and global realities (Appadurai 1996: 184). How, then, does it do this?

As Appadurai suggests, the way in which new neighbourhoods are produced and reproduced requires 'the continuous construction, both practical and discursive, of an *ethnospace* (necessarily nonlocal) against which local practices and projects are imagined to take place' (ibid.; emphasis mine). By creating these new transcultural ethnospaces – in which the identity construction work is no longer based on commonsensical and unquestioned identities, but far more on the experience of transnational cultural flows and timely constructed experi-

ences of identity – each local culture not only mirrors, but also participates actively in the creation of the globalized world which consists, in the end, of those smaller units that are called local sites. Only through this kind of development, Appadurai suggests, does it become possible to create new kinds of deterritorialized ethno-landscapes that are inhabited by various kinds of others.

The utopian aspect of Appadurai's analysis is embedded in the idea that it is the creation of these new ethno-landscapes and neighbourhoods that will offer the political alternative in the present crisis of the nation-state. Against the technologies of national power, which aim to create a vast network of apparatuses to aid in the governing of all spaces considered to be under its sovereign authority, the power of the local neighbourhoods is at best manifested in the ability of a local community to create autonomous ethnospaces which create their own ways of interpreting and valuing, and building up material practices (Appadurai 1996: 186-191).

When thinking of this darker version of new neighbourhoods, it must be noted that there are also numerous examples of the conditions of extreme uncertainty, poverty, displacement, and despair under which locality can also be produced anew, as Appadurai points out. Such tragic examples as the Occupied Territories in Palestine, the Afganistan refugee camps in Pakistan, and the new urban wars that take place in many big cities come to mind. In these examples of new (global) local conditions, the production of neighbourhoods and locality has failed tragically, and the desolation of both a national and global landscape has turned cultural differences into scenarios of urban terror (Appadurai 1996: 193). Yet in Appadurai's view, it is important to note that these examples are usually of neighbourhoods that are much more context-produced than context-generative. In this respect, they do not actually deserve the name since they function as mere stages that hold companies, barracks, and sites for populations with 'a dangerously thin commitment to the production of locality' (ibid.).

One-way ticket to Baghdad

In the interactive video installation *Baghdad Travels* –presented for the first time in 2007 in the Finnish pavilion of the Venice biennale – Abidin sold one-way tickets to Baghdad via an imaginary travel agency called *Abidin Travels*. This website takes orders solely for flights to Baghdad (children not allowed), and offers actual information about the city to the visitors. The mythical and

culturally rich past of the city is not celebrated on these webpages, however. Instead, the information consists of brute facts of the war situation and a kind of crude parody of the Western mass media and its way of representing the Iraqi situation. This is an actual presentation of transcultural localities; one that has indeed tragically failed to produce new neighbourhoods.

The critical shock effect of *Baghdad Travels* is produced at once by its exceptionally 'cheap', shocking, and flat graphics, and by the texts, which tell the viewers things such as '[t]here aren't any interesting sights left, because all the beautiful places you might have heard about have either been destroyed or looted'. In a looping video included in the work, Abidin illustrates the everyday life of the Iraqis during the Western occupation. To this visual material is added a voice-over of an American woman, who welcomes new visitors to Baghdad, and lists the tourist attractions of the city. The video also shows American soldiers playing and singing in one of Saddam's palaces during July 4 celebrations. For viewers, it soon becomes evident that, at the moment, these Americans are actually the only 'tourists' in Baghdad – tourists that destroy at least as much as they give, and bring at least as much grief and sorrow as experiences of joy or transcultural development (see also Marks 2007).

The shocking brochure-like texts are accompanied on the webpages by even more terrible pictures of weeping women, destroyed buildings, and a mass of dead bodies. For all those who might consider having a holiday in Baghdad – for example, those who sip their wine glasses in Abidin's exhibition openings, or those who consume Western news programmes on Iraq and the war – Abidin offers a series of shocking warranties, which are at once terrible and ironic:

> If there is an explosion in your vicinity, DO NOT remain an onlooker. Above all, DO NOT run or you will be targeted as a terrorist. It is suggested that you hurt yourself in some way so that you will look like a victim and be taken to hospital.

Considering the effects of this artwork, Laura U. Marks comments that

> the violent contrast between these images and the tourism narrative reveals the American occupation and its propaganda to be an abomination, an obscenity. *Abidin Travels* thus opens an abyss between what is communicable about life in Baghdad today, which is transparently a sheet of lies, and what is incommunicable because it is too real: and into this abyss you fall. (Marks 2007, 88)

For me, *Baghdad Travels* suggests also that the production of new neighbour-hoods in the globalizing world is indeed a very fragile process – not least in the occupied areas – and that the possibilities for their realisation are always variable and incomplete (see also Appadurai 1996: 193). Since Abidin does not live in the era of great revolutions but amidst the powerful representations of the mass media, digital technology, and postmodern versions of truth, his main weapon in the critique of these issues is irony and the subversive usage of the power discourses themselves.

Third identities of diasporic art

Despite the recent focus on identity as a means of resolving various cultural and political dilemmas, it also seems increasingly clear that identity is not only a solution but also a problem for all those who live between cultures. Nicholas Mirzoeff correctly comments that, in the present global diaspora, this actu-ally means all of us (Mirzoeff 1999: 26). As I have suggested in this article, in a globalizing world, the experience of national identities and local sites has turned into a continuous flux of movement and, together with this, into new kinds of culturally hybrid identities, which necessarily change our experiences of ourselves, our communities, and our nations.

By analysing the work of Adel Abidin, I have tried to show how contempo-rary artists try to find, if not solutions, at least creative viewpoints and reactions to these problems. Through parodic uses of the actual identity discourses, Abidin's art tends to release laughter, which, at its best, can be truly distracting. Furthermore, his works might also be seen as paving the way for new forms of hybrid identities without which new neighbourhoods cannot be realised. Like Abidin's artistic queer figures seem to suggest, this re-creation of identities has to be constructed out of little pieces rather than found already waiting, in the form of some kind of *ur*-language which all of us recognize when we see or hear it.

In an email discussion I had (in English) with Abidin a short while ago he considers these issues. For me, these few phrases of his express very well the actual challenge that all artists who work with the issue of globalization and transnational identities have to face, in one way or another (I'll leave the lan-guage unedited here on purpose):

I think after leaving your country, the place of your childhood and family, here you lose the connection to the place, your belonging will be not for a place or a country anymore, you will belong to the notion of time. You will find that the place is very limited to you and your capacity as a human first and an artist at the second. Here in this very position we will find the successful artist from the unsuccessful one. The successful artist will start digging out for the third identity by looking at the two different cultures and abbreviated them into a very new identity a unique one. The unsuccessful one will suffer the negativity of being isolated and not being able to approach further.

Even though these 'third identities' are still easily located in the margins of society, it also seems that if something has changed during the globalization process, it is exactly the relation of the margins to the centre. As Stuart Hall, a Jamaican-born cultural theorist, puts it in a paper he delivered in 1987: 'Now that, in the postmodern age, you all feel so dispersed, I become centered. What I've thought of as dispersed and fragmented comes, paradoxically, to be the representative modern experience!' (Hall 1996: 114). I'd like to think that Hall's comment expresses at the same time one of the deepest actual challenges – and also promises – of all diasporic art, Abidin's works included.

Works Cited

Anderson, Benedict [1983] (2006). *Imagined Communities. Reflections on the Origin and Spread of Nationalism.* London & New York: Verso.

Appadurai, Arjun (1990). "Disjuncture and difference in the global cultural economy". *Public Culture* 1990: 2, 1-24.

Appadurai, Arjun (1996). *Modernity at Large. Cultural Dimensions of Globalization.* London & Minneapolis: University of Minnesota Press.

Appadurai, Arjun (ed.) [2001] (2005). *Globalization.* Duke University Press: Durham & London.

Axford, Barrie (1995). *The Global System. Economics, Politics, and Culture.* Oxford: Polity Press.

Berger, Peter L. and Samuel P. Huntington (eds.) (2003). *Many Globalizations. Cultural Diversity in the Contemporary World.* New York: Oxford University Press.

Bhabha, Homi K. [1994] (2008). *The Location of Culture.* London and New York: Routledge.

Bohrer, Frederick N. (2008). "Borders (and Boarders) of Art: Notes from a Foreign Land". In Kamal Boullata (ed.): *Belonging and Globalization. Critical Essays in Contemporary Art & Culture.* Lebanon: SAQI, 27-40.

Bordo, Susan (1993). *Unbearable Weight: Feminism, Western Culture, and the Body.* London: University of California Press.

Butler, Judith (1990). *Gender Trouble. Feminism and the Subversion of Identity*. New York: Routledge.

Crane, Diana (2002). "Culture and Globalization". In Diana Crane, Nobuko Kawashima and Ken'ichi Kawasaki (eds.): *Global Culture. Media, Arts, Policy, and Globalization*. New York: Routledge.

Hall, Stuart [1987] (1996). "Miminal Selves". In H.A. Baker, M. Diawara and R.H. Lindeborg (eds.): *Black British Cultural Studies: A Reader*. Chicago and London: University of Chigago Press, 114-119.

Hall, Stuart [2003] (2007). "Cultural Identity and Diaspora". In Jana Evans Braziel and Anita Mannur (eds.): *Theorizing Diaspora. A Reader*. Singapore: Blackwell, 233-246.

Hobsbawm, Eric J. [1990] (2008). *Nations and Nationalism since 1780. Programme, myth, reality*. Cambridge: Cambridge University Press.

Huddart, David (2006). *Critical Thinkers. Homi K. Bhabha*. New York: Routledge.

Maharaj, Sarat [1994] (2003). "Perfidious Fidelity: the Untranslability of the Other". In Jason Gaiger and Paul Wood (eds.): *Art of the Twentieth Century. A Reader*. New Haven and London: Yale University Press (& The Open University), 297-304.

Marks, Laura U. (2007). "This Land is Your Land". *Framework. The Finnish Art Review* 2007: 7, 80-90.

Mercer, Kobena [2003] (2007). "The Aesthetics of Black Independent Film in Britain". In Jana E. Braziel and Anita Mannur (eds.): *Theorizing Diaspora. A Reader*. Singapore: Blackwell Publishing, 246-260.

McNay, Lois (1992). *Foucault and Feminism. A Critical Introduction*. Cambridge: Polity Press.

Mirzoeff, Nicholas (1999). *Introduction to Visual Culture*. London: Routledge.

Papastergiadis, Nikos (2007). *The Turbulence of Migration. Globalization, Deterritorialization and Hybridity*. Cambridge & Malden, Mass.: Polity Press.

Robertson, Roland (1992). *Globalization: Social Theory and Global Culture* London: Sage.

Said, Edward W. *Orientalism* (1978/2003). London: Penguin Books.

Scholte, Jan Aart [2000] (2005). *Globalization: a critical introduction*. Basingstoke/New York: Palgrave Macmillan.

Seppä, Anita (2003). *The Aesthetic Subject. Exploring the Usefulness of Foucauldian tools in Feminism*. Helsinki: Yliopistopaino.

Notes

1 On these statistics, see also "Global Migration: A World Ever More on the Move". *The New York Times*, June 25, 2010; and The UN Refugee Agency's website: http://www.unhcr.org/cgi-bin/texis/vtx/home, accessed September 12, 2010.

2 As Bhabha comments, Foucault's book *Les Mots et les choses* (*The Order of Things*, 1966), offered him a new way of thinking of the 'uncanny' in the context of the 'discourse of Man'. In his text, Foucault attempts to show how historical, psychoanalytic, anthropological, and other scientific discourses came into being and started to order knowledge in a specific way, with the timeless figure of Man at the centre. Foucault's suggestion – which has greatly influenced many later postcolonialist debates – is that we should look again at 'our' ways of dividing and ordering this knowledge, to see how culturally relative these epistemologies actually are.

Although Foucault himself never makes any sustained references to the history of colonialism, and this lack considerably lessens the importance of his analyses of Western knowledge, Bhabha suggests that the postcolonial perspective is strongly at work in Foucault's text. As Bhabha puts it, history confronts its uncanny doubles in Foucault, and 'the post-colonial perspective is subversively working in his text' (Bhabha 2008: 281; see also Huddart 2006: 91).

Bhabha's way of describing 'colonial mimicry' in terms of cultural discourses and power is also very Foucauldian by nature. They both share the view that mimicry (or 'counter-discourse', as Foucault expresses it) always offers an opening for political agency, and sometimes even a model for this agency. When considering the effects of mimicry, Bhabha also refers to Foucault's genealogical method, suggesting that the partial presence of colonial mimicry brings forth a gaze of otherness, that 'shares the acuity of the genealogical gaze which, as Foucault describes it, liberates marginal elements and shatters the unity of man's being through which he extends sovereignty' (Bhabha 2008: 126-7).

3 There are, of course, other interpretations of globalization. Noam Chomsky, for example, interprets globalization as a term that is closely linked to 'neo-liberalism' (Chomsky 2006). Good overviews of the discussion can be found in Berger and Huntington 2003; Scholte 2005; Robertson 1992; and Crane 2002.

4 http://www.adelabidin.com/index.php?Itemid=53&id=64&option=com_content&task=view, accessed November 15, 2010.

5 All images in this text are found in Adel Abidin's official web page http://www.adelabidin.com/

Band Attack – Deterritorializing Political Borders

By Camilla Møhring Reestorff

In 2001 the dramatist, actor, musician, and writer Claus Beck-Nielsen declared himself dead. One year later, the corporation Das Beckwerk was formed with the aim of passing on the life and work of Claus Beck-Nielsen.[1] One of Das Beckwerk's numerous activities is the band Claus Beck-Nielsen Memorial, which was founded to play and record the songs left by the late Claus Beck-Nielsen. In 2006 the record *The European Dream Scream* was released and in June 2008 the second album, *Freedom on the March*, followed. The tracks are written and performed by Some Body - who bears a striking resemblance to the late Claus Beck-Nielsen – and the lyrics are a mixture of English and Danish, implying a transnational perspective. Despite Das Beckwerk's Danish origin, Claus Beck-Nielsen Memorial addresses a pan-Nordic audience, performing mainly in Denmark, Norway, and Sweden.

This paper will analyse and discuss Das Beckwerk's attack on the Danish government's culture battle (*kulturkamp*) and the international war against terror; according to Das Beckwerk's album *Freedom on the March*, both are a part of a militarised neo-liberalism. The overarching frame of the analysis is the question of how an artistic practice can deterritorialize political patterns. In answering this, I suggest that, instead of perceiving Das Beckwerk as an artist producing representations, we perceive him as an artistic political agent who generates political events by reproducing and visualising societal structures. I argue that this indicates an aesthetic practice, the main potential of which is its ability to establish discursive negotiations through political events. This event-producing aesthetic practice will be discussed in relation to the ongoing renegotiation of the Nordic countries. My main argument is that when artists participate in the current negotiation of the Nordic nation-states, it not only

involves a transformation of the artistic practice, but also a renegotiation of the role of art and culture within the Nordic countries.

Political events and culture battles

How does a politically engaged artistic practice affect politicians' perspectives on art and culture? And what is its role in the current renegotiation of the Nordic nation states? One answer to these questions is that politically engaged artists, and their art, emerge as a distinct political opposition, widely addressed by politicians as opponents in what has come to be termed a culture battle.

On January 1, 1972 a Nordic Culture Agreement (Nordisk Kulturaftale), agreed to by the Nordic Council of Ministers (Nordisk Ministerråd), became effective. The agreement refers to the Collaboration Agreement of 1962 between Denmark, Finland, Iceland, Norway, and Sweden. The core aspect of the Nordic Culture Agreement is the 'arm's length' principle, which aims to guarantee that public resources for culture are distributed independently of political and economical interests. Art Councils were established to serve this purpose. In the 1980s the arm's length principle became the foundation of cultural politics in Iceland too, and in the 1990s Greenland, the Faroe Islands, Åland, and the Sami all entered into cultural collaboration. The principles of the agreement are, of course, operationalised with variations in each country, and the arm's length principle is not just a Nordic phenomenon. Nevertheless, the Nordic version of this principle is characterised by a distinctive artistic involvement. These principles of the Nordic Culture Agreement seem to be problematic in relation to the current negotiation of the nation-states.

In Denmark a culture battle was initiated in 2003. Former Prime Minister Anders Fogh Rasmussen launched it in 2003, in an interview in the newspaper *Weekendavisen*, entitled "Kulturkamp" ("Culture Battle"). He said:

> It is my opinion that to set the agenda in the value debate changes the society far more than these legislative changes. I'm talking culture in a broad sense: it is the outcome of the culture battle that determines the future of Denmark. Not economic politics. Not technocratic changes in the legislative system. (Fogh Rasmussen January 17, 2003)

This notion that culture matters, hence the culture battle, has resulted in several government-initiated strategies of reterritorialization. Dominant exam-

ples are the Fogh Rasmussen government's attempts to anchor and canonise culture (2006) and democracy (2008) within the territorial borders of the nation-state as well as the newspaper *Jyllands-Posten*'s famous cartoon initiative.[2] Within these initiatives, art and culture are defined as fixed objects that represent and symbolise the nation. A variety of art political events, such as Das Beckwerk's, more or less explicitly challenge and oppose the culture battle against cultural diversity. One recent and very successful example is the initiative Aktion Auktion (Action Auction), in which 120 artists donated artworks to an auction. The money raised, DKR 618.500, was given to Iraqi refugees who had been expelled from Denmark and forced to return to Iraq. Art political events such as these have made the leader of the anti-immigrant Danish People's Party (Dansk Folkeparti), Pia Kjærsgaard, attack what she calls the elitist cultural-radicals and the political artists. In a long interview in the newspaper Politiken, she says:

> Artists must stop believing that they can be artists and simultaneously act as left-wing politicians. Stick with the art. (Kjærsgaard August 4, 2009)

It is worth mentioning that the following day she was appointed to membership of both the Art Council and the Art Fund. The Danish culture battle first and foremost concerns national cultural coherence but it also indicates that the Nordic Culture Agreement's emphasis on cultural self-determination is believed to facilitate cultural-radical elites, and that it is the values of these cultural-radicals which must now be fought.

The culture battle has been and is primarily a Danish affair. Yet it seems to be a current trend in the Nordic countries to criticise the 'cultural elite', and attempts to copy the Danish culture battle's defence of the nation-state and battle against the principles of the Nordic Cultural Agreement have been made in both Norway and Sweden. The Norwegian and Swedish initiatives, however, have not had the same degree of impact as their Danish counterpart. Their suggestions, such as that of the Norwegian Progress Party (Fremskrittspartiet) to make a Norwegian Canon of Culture, have been dismissed. In the election campaign in 2004 the Norwegian red-green alliance launched the first Cultural Promise in which they promised to increase the funding for culture so that 1% of the state budget would be spent on culture by 2014.[3] When the red-green alliance was elected for government, the Minister of Culture at the time, Trond Giske, followed up on the promise and increased funding for culture to 2 billion NKR

between 2005-2009. In 2009 he declared the promise fulfilled and launched the Cultural Promise II for the period of 2010-2014.[4] The Cultural Promises are of importance because they emphasise that art, culture, and sport are important political issues that increase the wealth of the society. As a result of the Cultural Promises, the cultural budget in Norway has been dramatically increased; this has lead to some protests and the appearance of a notion of a culture battle. At the Norwegian 2009 election the right wing, represented by the Progress Party, was opposing what they defined as 30 years of cultural-radical dictatorship. Asle Toje, a supporter of the Progress Party and researcher at the Norwegian School of Management, was then initiator of the Norwegian culture battle, which he directly linked to the Danish one:

> Today Norway is what Denmark would have been without Fogh's battle against the elitist upper class. A Norwegian clash has arisen several years later than in Denmark because Norway hasn't been under economic pressure. […] But now the people have had enough. (Toje August 28, 2009)

In opposition to this version of the cultural political situation, more than two hundred persons from Norway's cultural life launched a web manifesto (www. kulturkampen.no). Even though 22.9% of the electorate cast their vote for the Progress Party, the winner of the election was the red-green coalition led by Prime Minister Jens Stoltenberg. The red-green coalition instituted the Cultural Promise II, an assurance that 1% of the state budget must be targeted for culture by 2014. So though the culture battle is underway in Norway, it is still far from obtaining the influence it has in Denmark.

The situation in Sweden resembles the one in Norway; the concept of a culture battle has yet to emerge as a broadly supported governmental initiative. Yet there are some incipient signs of a culture battle. In 2009 the Christian Democrats' Minister of Social Affairs, Göran Hägglund, attacked the cultural left wing.

> Within the cultural left wing (kulturvänstern) the average Svenssons and their Svensson life has long been seen as the obvious object to throw suspicion on and mock. This has been evident in film and books for more than thirty years. But recently this tendency has spread to large parts of public life. It does not just concern Reclaim, the street runnings and 'artists' who live to provoke and spread discomfort in the public sphere. It also concerns a general political

trend. The Swedish radical elite has become the new supreme. (Hägglund September 17, 2009)

This is in continuation of the Swedish Minister of Culture Lena Adelsohn Liljeroth's critique of the Konstfack art college. Her critique was sparked by an exhibition, in February 2009, of the graffiti and video artist NUG's Masters Degree project from Konstfack art college, "Territorial Pissing". In "Territorial Pissing" a masked man is filmed while graffitiing a subway car with spraypaint, questioning the ways in which we define territorial boundaries and belongings. Lena Adelsohn Liljeroth stated that: 'Graffiti is in its nature illegal. This is not art' (Adelsohn Liljeroth 2009). This statement, and the debate about art and culture that followed, indicates that the principles of self-determination are under threat, hence the pressure on Konstfack.

The culture battles in the Nordic countries, whether in full swing as in Denmark or merely incipient as in Norway and Sweden, prove that the Nordic Cultural Model is under pressure; they also concern the renegotiation of the understanding of the Nordic nation-states as cultural units based on shared values and cultural identity. In the following I wish to investigate how Das Beckwerk and Claus Beck-Nielsen Memorial's *Freedom on the March* participate in this cultural political battlefield, giving rise to an artistic practice that initiates political events.

Freedom on the March and the war against terror

Freedom on the March criticises the idea that democracy can be implemented by force. The focal point is that the 'war against terror', the invasion of Iraq and Afghanistan, and the naming of Iraq and Afghanistan, as well as Iran, as part of 'the axis of evil' is an unchallenged moral scandal. This view is elaborated in *I sammenbruddets tjeneste* (*In the service of the breakdown*; 2008), a conversation book between Das Beckwerk and the art historian Mikkel Bolt, in which the war against terror is seen as part of a militarised neo-liberalism led by the leaders of the Western world, which criminalises all forms of resistance and protest (Bolt and Beckwerk 2008: 18). Following this, they perceive the Danish culture battle as a national pendant to the international war against terror, and they conclude that the consequence of this political environment is that democratic systems of justice are suspended in many places. From this critical position Das Beckwerk's productions attempt to establish an alternative discourse: a discourse that does not subscribe to the idea of democracy as a nationally-anchored rule of the

people, but instead acknowledges that power and power hierarchies also exist within a democracy and between democratic states, and that our present-day democracy and justice system are characterised by a 'state of emergency', a term deriving from Giorgio Agamben.

Das Beckwerk attempts to establish the individual and the artwork as agents on the global stage. Globalization generates a transformation in the political system, which provides a variety of different agents - e.g. media, politicians, and artists - with new political opportunities. The transformation of the political system is due, in part, to a disturbance in the conceptualisation of culture. Culture is undermined as a point of reference for locality because globalization renders visible the reality that cultural identity as well as political and economical coherence is not merely generated and anchored in localities, but also in flows and international exchange. When John Tomlinson uses the continuous interregnum between deterritorialization and reterritorialization (terms deriving from Deleuze and Guattari) to define the essence of cultural globalization, he points to this dissolving of culture, identity, and place, while recognising that deterritorialization constantly meets with attempts to renegotiate the culture-place relation. If one perceives culture as Tomlinson does, it suggests that human life consists of an order established through symbolic representations and distinctions that contribute to the continuous life stories of individuals. These stories are concentrated in three main areas: the economic sphere in which humans produce, exchange, and consume; the political sphere, which consists of practices around which power is centered; and the cultural sphere, which consists of the ways in which humans make their lives individually and collectively meaningful (Tomlinson 1999: 19). However, the continuum between de- and reterritorialization involves the necessity of rethinking these arenas of meaning appropriation, since politics increasingly centres on questions about the ways in which humans make their lives collectively meaningful through cultural identity, which becomes the main root of societal and political coherence. Thus the main cultural implication of globalization is that it transforms the negotiations of the economic and political spheres into cultural experiences, providing contemporary art with the opportunity to act in the arena of global political intervention and mark out a symbolic terrain of meaning construction. This is the political potential embraced by artists such as Das Beckwerk. Globalization makes it possible for Das Beckwerk to act within the societal sphere and offer a wide range of alternative deterritorialized localities. The conception of culture and identity as territorially bound is thereby made to compete with a range of deterritorialized spaces.

The universal man

Embracing the opportunities for cultural meaning production, Das Beckwerk attempts to establish an alternative discursive understanding of fixed identities and territorial borders. The question thus becomes: how can an artistic practice dissolve existing societal and political structures? Das Beckwerk's solution seems to be to make all sorts of identities collapse:

> Any fixed and stable identity is a limitation of opportunities [...] the fixed identity is always excluding because someone needs to be outside.
> (Bolt and Das Beckwerk 2008: 31)

The examination of these limitations is crucial in Das Beckwerk's production, which in the final analysis aims to abolish all limiting boundaries in favour of an unlimited space of opportunities. However, such a revolutionary upheaval to and maintenance of an unlimited space of opportunities is an impossibility: the potential of Das Beckwerk's projects is, rather, their ability to establish a number of politically inclined situations of, and for, negotiation. These negotiation situations should be understood in the light of Judith Butler's description of identity and discourse as subjects of continuous negotiation and ritualised patterns of repetition: as negotiations that constitute power structures.

Claus Beck-Nielsen's death declaration (and afterlife) must be understood precisely in this context. The death was declared in an e-mail on August 27, 2001 shortly after Claus Beck-Nielsen had wandered the streets of Copenhagen as Claus Nielsen who, with apparent memory loss and no state identity number, was excluded from Denmark's official administrative system and left to live on the street. The e-mail exemplifies both Nielsen's death and his afterlife, since it insists on Claus Beck-Nielsen being dead, yet maintains that he can be contacted by cell phone:

> Dear humans
> Shortly before midnight Wednesday 29th August Beckwerk@wanadoo.dk can no longer be found on the net. If anyone wishes to send a last greeting this is the final call. As of Thursday morning the only contact possible to the deceased is on cell phone 20 93 33 14. (Beck-Nielsen 2008: 177)

This living corpse or ghost might be construed as a body drained of identity, an experimental form or test subject, functioning as an open space, capable of entering into numerous different relations - like the ability of a ghost to walk through closed doors. The test subject is a potential universal or global (hu) man, who can be placed within a variety of political and aesthetic frameworks. And, as with a ghostly character, its non-presence disturbs, whether it is placed as a nameless subject in a social welfare office in Denmark or with an empty suitcase said to contain the democracy, in Iraq, the USA, or Iran. In *Freedom on the March* the lead singer, Some Body, refers thus to the late Nielsen, and the album has a rare performative character.

The test subject continuously challenges the patterns of enunciation and addressee. How is one to address a body without an identity or a name? And how is one to perform the basic work of classification that allows us to map the world if the identification of 'who's who and what's what' (Jenkins 2008: 5) is denied? As has already been suggested by Michel Foucault, power is not solely connected to one sovereign figure, nor is it merely a tri-partition between the state as legislative power, as juridical power, and as executive power. Power is constituted through discourses and performative acts, which indicates a relation to the subject. This does not, however, imply a simple displacement of power from a sovereign figure (a person or a state) to all individual subjects. Hence, a complete emancipation of the subject would have provided Claus Beck-Nielsen with the absolute power to reject identification, which is clearly not the case. The emancipation is never complete, since enunciations and discourses consist of indefinite citations. We are only able to understand an enunciation and inscribe it discursively because we recognise earlier versions. In *Gender Trouble*, Butler describes gender as something performative: not predefined, but constituted through the repetition of enunciations, actions, and practices (Butler 1990: 25). These are not random and singular, but ritualised productions of power through bans and taboos (Butler 1993: 95). This ritualised production of patterns of repetition connects the power and the subject. Hence the subject can either be inscribed in the repetition patterns or try to differ from them. Ultimately, it is the subjective divergences from the patterns of repetition that necessitate negotiations of the discursive power. The declaration of Claus Beck-Nielsen's death exemplifies such a negotiation, since it problematises the subject position through the rejection of both name and identity.

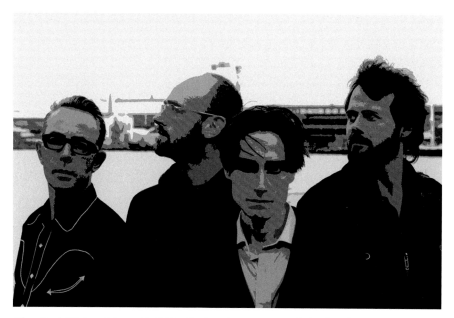

Claus Beck-Nielsen Memorial. © Das Beckwerk – visit: www.dasbeckwerk.com.

Claus Beck-Nielsen's declaration of his death can be interpreted as an attempt to escape from the symbolic order of language and its discursive determining patterns which form identity, through transformations and displacements of the late Claus Beck-Nielsen. Claus Beck-Nielsen's death questions the placement of the subject in limiting and closed structures; it could thus be said to approach the 'queer' by refusing to take any position. In Claus Beck-Nielsen Memorial the lead singer, who prefers to be 'Some Body. Not just anybody or nobody, but Some Body. That's it' (MySpace, October 25, 2007), exemplifies this. The lead singer thus incarnates the paradoxical death of Claus Beck-Nielsen by being *somebody* and therefore not dead, yet *some body*, that is an amount of body. The importance of the body was already underlined when Claus Beck-Nielsen, before the death declaration, stripped at the University of Copenhagen, allowing the audience to witness the body. While stripping, he described all the marks on the body. The obviously embarrassed audience was encouraged to clap their hands, to mark that this was a performance. Thus the performance on the one hand had a transgressive character that produced bodily intimacy between the stripping body and the audience that could literally feel the embarrassment on their bodies. On the other hand however the enforced clapping efficiently displayed the incited character of that

intimacy. The body's appearance underlines the impression of an undefined (some) body. The body is extremely thin, which supports the identity loss by denying any significant bodily or male appearance. Such an understanding is underlined in the music, where Some Body's voice alters between deep 'masculine' and fragile, light 'feminine' tones. That the identityless body is an amount, some, can be interpreted as an embodiment of the posthuman, a body that does not hold one single identity and instead redistributes identity. The posthuman body is not necessarily a technological cyborg; instead its defining characteristics are the construction of subjectivity. Accordingly the 'posthuman subject', in the words of Katherine Hayles, is:

> an amalgam, a collection of heterogeneous components, a material-informational entity whose boundaries undergo continuous construction and reconstruction. (Hayles 1999: 3)

That the identityless body embodies the posthuman is of importance not only because it is a way to redefine boundaries but also because it enables a redistribution of differences. According to Judith Halberstam and Ira Livingston the human '[...] functions to domesticate and hierarchize difference within the human (whether according to race, class, gender) and to absolutize difference between the human and the nonhuman' (Halberstam and Livingston 1995: 10). The posthuman, on the contrary, embodies multiple positions within the same body:

> The posthuman does not reduce difference-from-other to difference-from-self, but rather emerges in the patterns of resonance and interference between the two. The additive other (who is subordinated in several systems at once) is not necessarily the geometrically other of the posthuman, who may well be 'between between' in a single system. (Halberstam and Livingston 1995: 10)

Some Body is exactly such a posthuman 'between between' that embodies several positions (such as dead and alive). As a posthuman Some Body thus exemplifies that the denomination or naming of a subject is a reduction of the multiple embodied identities and thus that naming is inscribed in power patterns, as described by Louis Althusser: the subject is constituted linguistically through interpellation, through being addressed by name (Althusser 1971: 170-186). When Some Body rejects interpellation power is rejected, yet si-

multaneously social existence becomes problematic. This brings us back to the question of how an artistic practice can dissolve existing societal structures. The first step towards answering this must be to ask how the addressee can respond when interpellation is rejected and classification is hindered.[5] Richard Jenkins writes, with reference to Erwin Goffman, that:

> Individuals negotiate their identities within the interaction order. Mobilizing interactional competences within situational ('framed') routines, individuals present an image of themselves – of self – for acceptance by others. In my terms, this is the internal moment of the dialectic of identification with respect to public image. The external moment is the reception by others of that presentation: they can accept it or not. (Jenkins 2008: 93)

Therefore it is not possible for the subject alone to abolish identity. The addressee can simply dismiss Some Body's lack of identity in the external moment. Thus the dissolving of existing societal patterns becomes a question of a negotiation between internal self-identification and the external reception, by others, of the self. This entails that a discursive performance, such as the death of Claus Beck-Nielsen, is recognised and negotiated through dominant social patterns of repetition. So when approaching (the empirically existing) Some Body, the addressee must navigate between three positions: accept the death; through an aesthetic eye, play along with the pretence that he is dead; or dismiss the death declaration due to the prevailing structures in which it is presumed that a body has an identity. We are thus forced into a negotiation between an empirical observation of the body, and the death as established through the artwork. Thus the political achievement of Some Body is that we cannot see, hear or read about him without necessarily negotiating what he is, hence also negotiating or reflecting upon questions of identity and limitations.

Exemption of liability precluded

The double negotiation of societal limitations caused by the undefined body also challenges the conception of the war against terror. This is because there is a link between individuals and war, a link that *Freedom on the March* establishes by pointing out the distorted relation between human beings. This directs the addressee's attention to the actions of individuals (including oneself). The distorted relation between human beings is obvious in "Stay With Me":

Won't you stay with me baby
Won't you lie with me, maybe
Won't you give me a hug to make me feel
not so all alone
[...]
Won't you lie with me, baby
Won't you spit on me, maybe
Won't you mock, disassemble, and disregard me
Won't you kiss my forehead, when I
stroke your cheek
Will you lie with someone else, while I
pass away peacefully
Won't you sit on my grave to make me feel
not so all alone
[...]
Won't you piss on my grave to make me feel
not so all alone[6]

Loneliness and distorted human relations are major problems: the subject, *me*, asks for and accepts any kind of bodily closeness or intimacy, including someone sitting or pissing on his/her grave. Human relations are necessary, even though they may be connected with humiliation and mockery. Loneliness is related to the consumption patterns and self-production of the 'Western' world in "Hang on Jesus":

Hey, little sister
if you return
then bring a
Big Mac, Pacman, iPod, Jackass, laptop, Robinson,
YouTube, MySpace
back to your dad
if that is all we got

Hey, Jesus
if you return
then bring a
Hummer, Minuteman, Hawkeye, Shahab,

Taepodong, Honeywell, SS-20, Sikorsky, Trident,
Kalashnikov, Hercules, Fightinghawk
back to your dad
to show how human we are

Oh, no, Jesus
you better stay where you are
climb the cross
and bolt the nail
Hang on! Hang on!
You better stay where you are
Cross your feet, sing along
Something down here's going wrong[7]

The only things that Jesus can bring his father to document humanity are prod-ucts of materialism: Big Macs, iPods, and weaponry. This seems to indicate that humanity is in great need of absolution. Therefore Jesus must climb the cross, hit the nail hard, and stay hanging there. This illustrates the mutual relationships between the individual, art, politics, and war, and denies both the individual and the artist the opportunity to be different from the source of war. Human relations are not only constituted within politics but also on an everyday basis: no-one can be separate from societal structures.

When neither art nor individual can be thought separately from societal structures even an album such as *Freedom on the March* must be interpreted as an integral part of the Western world. The album is doubly positioned as a critical statement against the self-same societal structures from which it cannot be separated. The critique of the attempt to implement democracy through the war against terror thus holds a paradox that is found even in the title of *Freedom on the March*. Freedom marches forward, literally combining military rhetoric with the concept of freedom. Likewise the band is gathering, marching forward, and ready to attack: as they put it in "Hezbollah Wiped!", 'I'm gathering the band / We are ready to attack now'. Given that the band is ready to attack, Claus Beck-Nielsen Memorial and Some Body are positioned both as possessing power and as part of the United States' and its allies' war against Afghanistan, Iraq, terror, and the 'axis of evil'. The cover, which pic-tures Claus Beck-Nielsen surrounded by the stars and stripes, underpins this interpretation.

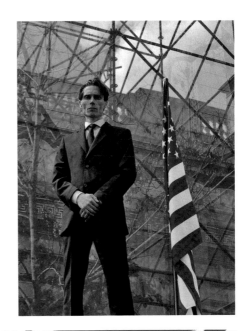

Some Body in front of the American
flag on the cover of *Freedom on the March*.
© Das Beckwerk – visit:
www.dasbeckwerk.com.

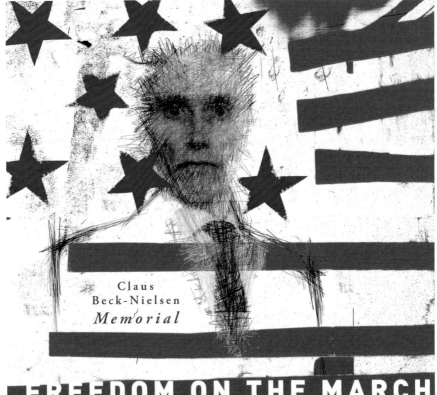

Claus
Beck-Nielsen
Memorial

FREEDOM ON THE MARCH

The cover furthermore draws on a classic conception of the American hero, constituting the late Claus Beck-Nielsen as an icon, on a par with movie heroes such as Arnold Schwarzenegger and Clint Eastwood and the pop icon Bruce Springsteen's track "Born in the U.S.A.". The reference to Springsteen holds contrasting meanings. On his album cover, Springsteen embraces the stars and stripes, i.e. the national symbol, but a critique is embedded in the song. "Born in the U.S.A." is not merely a tribute, as lyrics such as these indicate: 'I got in a little hometown jam / And so they put a rifle in my hands / Sent me off to Vietnam / To go and kill the yellow man'. Similarly, Some Body always performs in a dark grey or black suit, the uniform of the western man, indicating that war is not only a matter of military force, but a problematic side effect of the structures of everyday life and politics. Some Body and *Freedom on the March* simply reproduce problematic societal structures.

This constitutes a break with the idea of art as occupying a separate sphere, distinct from the rest of the Western world, from which it can stand aloof and criticise the societal sphere and its flaws. On the contrary, art is a part of the society in which it intervenes. This is obvious in *Freedom on the March* because someone else takes on the role of others; someone defined by the 'axis of evil' as exemplified in the song "Mullahocracy". "Mullahocracy" consists of quotations from Donald Rumsfeld and former president of the US, George W. Bush:

There are known knowns
These are the things we know
There are known unknowns
These are the things we know that we do not
know
But then there are
The unknown unknowns
the unknowns unknowns
These are the things that we do not know
we do not know

You know we have used force in the recent
past to secure our nation
All options are on the table

Mullahocracy (* 6)

> I called it part of the Axis of Evil for a reason:
> It's a real threat

The first quotation comes from Donald Rumsfeld and deals with what 'we don't know we don't know'. How this undefined threat is to be handled is stated in the next quotation, from Israeli television, August 2005, in which Bush talks about the Iranian nuclear weapons program. He states that all options, including military force, are on the table when it comes to national security. The song concludes with another Bush quotation from Fox News, December 2005, that even though something which is an 'unknown unknown' seems intangible, it is 'part of the Axis of Evil for a reason: It's a real threat', and therefore calls for concrete action. That this approach to the unknown has severe consequences for power relations between humans and communities, as well as the understanding of the concepts of freedom and democracy, is made clear in "The Freedom Hymn of the 20th Century":

> You'll be born in our moment of history
> You'll be born in the beat of our song
> You'll be free and you'll go where we want you to
> You're the day and the day will be done

This quotation suggests that the kind of freedom that is implemented by force, as a response to an unknown unknown, leads to suppression of those who are 'liberated'. The liberated are only free to the extent that 'we', the suppressors, decide. 'We' is comprehensive, related to both 'our moment of history' (Western political power) and 'the beat of our song' (the band).

The positioning of *Freedom on the March* as both suppressor and critic of suppression leads to the album being recognised as a continuation of the war against terror, but also as an ironic artistic statement. As is the case when approaching Some Body, the addressee must navigate between different poles when deciding upon the political statement that is made in *Freedom on the March*. When listening to *Freedom on the March* one is thus constantly forced to engage in the negotiation of Western democracy, the implementation of democracy through military force, and the territorial demarcation of national and global communities.

Repositioning art as a political event

But how should we understand art when it is intermingled with politics, simultaneously representing and criticising a suppressing power? Politically engaged art is, of course, nothing new. Recently it has been extensively discussed in accordance with Nicolas Bourriaud's idea of relational aesthetics. According to Bourriaud, art can change the realm of reality. Thus any direct critique of the society is in vain if it relies on the illusion of a marginal position (Bourriaud 2005: 33). Artworks that aim to raise a critique of culture and society must therefore abandon the idea of an autonomous art and art institution and instead test their resistance within the social field and create relations to the world. However, for Bourriaud this is a microutopian practice because the artwork's attempts define the future in the present by building concrete spaces (Bourriaud 2005: 48). Thus, by applying the logic of the microutopian space, relational aesthetics does not necessarily break with the separation of art from the societal sphere. The space of the microutopian is not an integrated part of the world, but a utopian potential since art is still, at least partly, an isolated sphere. Therefore the kind of political engagement and intervention that characterises Das Beckwerk's productions is not relational aesthetics. This, I argue, is due to the fact that the processes of negotiation involved cause the artwork's mode of operation to change.

Artworks such as Das Beckwerk's cannot fully be understood as part of an autonomous field functioning according to its own laws, independent of the social, political, and economic fields, as described by Pierre Bourdieu, for example. Such a field is constituted when it establishes its own autonomy, i.e. the specific laws applying to its field of power (Bourdieu 1993: 163). The artistic field is typically seen as the direct opposite of economic and political power, and a negative correlation exists between secular issues, that is money and power, and artistic value (Bourdieu 1993: 165). A complete separation has, of course, never existed, but with Das Beckwerk and *Freedom on the March* the negative correlation is explicitly challenged when it is positioned as contributing to the war against terror. Therefore a repositioning of the artwork takes place. When the key concept of the artistic field, that is, positioning the artwork as the Other of the Western world, is displaced it changes the function or mode of operation of the artwork.

Rather than a representation, the artwork can be understood as a reproduction and documentation of societal structures – a mode of operation that,

inspired by computer science, I will refer to as a model. Whereas a representation, according to Stuart Hall, has two meanings: description or depiction and symbolism (Hall 1997: 15), the model simply reproduces the original field's structures and visualises these structures functioning in different situations. When analysing Das Beckwerk's production and *Freedom on the March* as a model, it thus suggested that the culture battle and the war against terror are (re)shaped as an artwork. And it is preceisely the artwork's reproduction of societal and political patterns that renders their problematic character visible. This is evident in "Mullahocracy", in which the political statements about the 'unknown unknowns' and the firm distinction between good democratic states and evil made by Bush and Rumsfeld are (re)shaped by being put to music. When sung beautifully by Some Body the absurdity of the political statements becomes visible. *Freedom on the March* thus articulates problematic structures, logics, and discourses within the societal and political field by reshaping them as artistic events. In this context the event is not (necessarily) a major political or media rupture but simply the fact that artwork, by modelling societal structures, can create breakdowns in the discursive societal patterns and thereby contribute to the production of new political existences and discourses. *Freedom on the March* has so far not had much media attention (this has been achieved to a greater extent by some of Das Beckwerk's other projects), but because the borders between the artistic and societal fields have been dissolved it nevertheless participates in the renegotiation of the structures within the societal field.

Revolution

The mode of operation of *Freedom on the March*, when perceived as a model, is that it creates a state of exception by causing breakdowns in societal patterns. Das Beckwerk's desire to cause breakdowns in the established political system springs from the perception of the state as the guarantor of power, even though the character of this power is discursive and performative. According to Butler, a category such as hate speech cannot exist without the state. This is not to imply that the state vouches for every individual utterance, but rather that the state ratifies utterances. The legislative language of the state establishes and upholds a domain of acceptable utterances. This indicates that the role of the state is not just limiting, but is also the active production of utterances and actions, since it refers to what is allowed or prohibited (Butler 1997: 77). The state provides a legislative language to use in the discursive negotiations

of political questions. This state power becomes problematic if we recall how different political agents compete at the same phenomenological level in the symbolic meaning construction of the nation. In the case under discussion, this means that Das Beckwerk can stage political events in different public forums such as the Internet, the media, and art institutions, events the effect of which depends on the negotiation of political discourses. But even if the negotiation alters a discourse, it is still under the jurisdiction of the state and is not admitted to state institutions.

Das Beckwerk's solution to this 'distortion of power' is to induce a state of emergency and to attempt to throw down the gauntlet to state power. In the theory of Giorgio Agamben, a state of emergency suspends the existing judicial order and is therefore formally outside judicial consideration. Agamben nevertheless considers the state of emergency to be a space of possibility, a space open to the constitution of something radically new (Agamben 1995), which is a line of thought pursued by Das Beckwerk. A state of emergency is sought on an individual scale through the declared death of Claus Beck-Nielsen and the continuous performances of Some Body, as it is the final goal to establish a major revolution – or the 'Movement' of the masses as Foucault names it. The idea of the 'Movement' is problematic, because the 'Movement' can give rise to violence, which is an inexpedient risk, since Nielsen does not believe in '[…] revolution in a way that someone has to die for the utopia. Beside us self. I always want to crack a Nielsen' (Bolt and Das Beckwerk 2008: 75). The reference to 'us self' is a schizophrenic remark about Nielsen as a test person. The demand for the 'Movement' is further problematic because it requires an opposition between regime and people that does not seem to exist in the patchworks of the modern world.

The major revolution, or the endless space of opportunities, is thus an avant-garde utopia, and the potential of the art-political event lies rather in the modelling of situations of discursive negotiation. Das Beckwerk thus engage actively in the culture battle's renegotiation of the nation-state, and the achievement of its projects, as *Freedom on the March* exemplifies, is that they establish two interconnected negotiations with the addressee. The first concerns the identity of the individual, in questioning how to determine 'who is who and what is what'. This leads to a second negotiation between the brief moments of emergency established when 'who is who and what is what' is questioned and more extensive discursive changes are brought about in the understanding of both identity and territorial borders.

Works Cited

Agamben, Giorgio [1995] (2004). *Homo Sacer: Sovereign power and bare life*. Stanford: Stanford University Press.

Althusser, Louis and Étienne Balibar (1971). *Lire le capital: (nouv. éd. entiérement refondue): I-II*. Paris: Francois Maspero.

Appadurai, Arjun (1997). *Modernity at Large: Cultural Dimensions of Globalization* (3rd ed.). Minneapolis: University of Minnesota Press.

Beck-Nielsen, Claus (2008). *Claus Beck-Nielsen (1963-2001): En biografi* (2nd ed.). Copenhagen: Gyldendal.

Bolt, Mikkel, Das Beckwerk and Peder Holm-Pedersen (2008). *I sammenbruddets tjeneste*. Copenhagen: Gyldendal.

Bourdieu, Pierre (author) and Randal Johnson (ed.) (1993). *The Field of Cultural Production: Essays on Art and Literature*. Cambridge: Polity Press.

Bourriaud, Nicolas [2002] (2005). *Relationel æstetik*. Copenhagen: Det Kongelige Danske Kunstakademi.

Bürger, Peter (1974). *Theorie der Avantgarde*. Frankfurt am Main: Suhrkamp.

Butler, Judith (1993). *Bodies that Matter: On the Discursive Limits of 'Sex'*. New York: Routledge.

Butler, Judith (1997). *Excitable Speech: A Politics of the Performative*. New York: Routledge.

clausbeck-nielsen.net (2005). *Selvmordsaktionen: Beretningen om forsøget på at indføre demokratiet i Irak i året 2004*. Copenhagen: Gyldendal.

Claus Beck-Nielsen Memorial (2006). *The European Dream Scream*. Copenhagen: Das Beckwerk.

Claus Beck-Nielsen Memorial (2008). *Freedom on the March*. Aarhus: Geiger Records, Das Beckwerk, and Husets Forlag.

Deleuze, Gilles and Félix Guattari [1980] (2005). *Tusind plateauer: Kapitalisme og skizofreni*. Copenhagen: Det Kongelige Danske Kunstakademis Billedkunstskoler.

Fogh Rasmussen, Anders (2003). "Kulturkampen". *Weekendavisen*, January 17, 2003.

Halberstam, Judith and Ira Livingston (1995). *Posthuman Bodies*. Bloomington and Indianapolis: Indiana University Press.

Hall, Stuart (1997). *Representation: Cultural Representation and Signifying Practice*. London: Sage.

Hayles, Katherine N. (1999). *How We Became Posthuman: Virtual Bodies in Cybernetics, Literature, and Informatics*. Chicago and London: University of Chicago Press.

Hägglund, Göran (2009). "Sveriges radikala elit har blivit den nya överheten". *Dagens Nyheter*, September 17, 2009.

Jenkins, Richard [1996] (2008). *Social Identity* (3rd ed.). London and New York: Routledge.

Kjærsgaard, Pia (2009). "Jeg kunne blive en god kulturminister". *Politiken*, August 4, 2009.

Laclau, Ernest and Chantal Mouffe [1985] (2001). *Hegemony and Socialist Strategy: Towards a Radical Democratic Politics* (2nd ed.). London: Verso.

Maffesoli, Michel (1996). *The Time of the Tribes: The Decline of Individualism in Mass Society (Le temps de tribus)*. London: Sage.

Mouffe, Chantal (2008). "Agnostic Public Spaces, Democratic Politics, and the Dynamics of Passions". In Joseph Backstein, Daniel Birnbaum, and Svend-Olov Wallestein (2008):

Thinking Worlds: The Moscow Conference on Philosophy, Politics, and Art. Berlin: Sternberg Press.

Reestorff, Camilla Møhring and Carsten Stage (2011). "Canons and Cartoons: On National Identity, Strategies of Reterritorialization, and the Role of Universality in the Danish Cartoon Initiative and the Canon Projects." In Mads Anders Baggesgaard and Jacob Ladegaard (2011): *Confronting Universalities.* Aarhus: Aarhus University Press.

Reestorff, Camilla Møhring (2009). "Hvad fanden skal den hund her: I sammenbruddets tjeneste". *K & K* 107.

Toje, Asle (2009). "Kulturkamp eller skyggedans". *Information*, August 28, 2009.

Tomlinson, J. (1999). *Globalization and Culture.* Oxford: Polity.

Notes

1 After the death declaration Claus Beck-Nielsen's identityless body moved into Gladsaxe Theatre in Buddinge. The theatre is referred to as a reactor and combined with the name Das Beckwerk, which refers to a *kraftwerk* or a nuclear power station, Das Beckwerk is posed as a nuclear force that possesses the power or *kraft* to disrupt societal and political patterns. At Das Beckwerk's website the following could be read: 'The meltdown of Das Beckwerk is so strong that the impact will be universal: The radiation will not only affect and change life and its forms in the community of Buddinge, but also (and often imperceptibly) permeate the rest of the world: The third circle, the outermost, is the chaos, this so-called world that surrounds Das Beckwerk and Buddinge in all directions. In this chaos, the state machine Beckwerk operates, the face of which is Rasmussen: Slowly the state machine will eat through the chaos, imperceptibly the world of wars, dictatorships and so-called democracies we know will mutate into a world parliament: The Extraparliament' (my translation, quoted from Huang 2005: 317). Das Beckwerk is, in this quotation, equated with an atomic bomb or atom reactor that when it explodes causes severe damage.

2 The Canon of Culture consists of eight lists (of literature, music, film, visual art, architecture, stage performance, design, and children's culture) each containing twelve works said to define Danish Culture. Former minister of Culture, Brian Mikkelsen, initiated it. The Canon of Democracy consists of thirty-five texts, events, and persons said to define the road to modern democracy. For a further discussion of the canon initiatives and the cartoon initiative see Reestorff and Stage, 2011.

3 The cultural promise (Kulturløftet) was launched in 2004 and consists of fifteen concrete promises. The primary promise is to spend 1% of the state budget on culture by 2014. This increase in funding for culture was followed by the introduction of a culture law that sought to improve artists' conditions, to introduce children's cultural schooling, and to increase support for the film industry, music, dance and stage art. Furthermore, it was emphasised that Norway is a multicultural society.

4 The Cultural Promise II promised to increase funding for culture even further. Furthermore, it is strong signal of the political importance of culture. 'Art, culture, sports and voluntary work makes the society more rich and are crucial for human life quality, community and development. [...] The funding for art and culture is given an important lift also in 2010. The Cultural Promise increases culture's status as societal and political field. The government holds the vision that Norway is to be a leading culture nation that emphasizes culture in every aspect of the community life. Art and Culture have in itself a great value. Simultaneously an emphasis on culture is of great importance for other societal goals such as nutrition developments and the amount of jobs, integration, inclusion, health, learning and creativity.' (http://www.regjeringen.no/nb/dep/kkd/dok/regpubl/prop/2009-2010/prop-1-s-20092010/1.html?id=580429, accessed September 9, 2010).

5 I use the word 'addressee' because it implies a situation of communication. Das Beckwerk's production includes books, online documentations, CDs, theatre, and performances of all sorts, thereby making the addressee viewer, audience, listener, and reader.

6 The lyrics for "Stay with me" are partly English and partly Danish: 'Won't you stay with me baby / Won't you lie with me, maybe / Won't you give me a hug to make me feel not so all alone / […] Vil du ligge med mig, baby / Vil du spytte på mig, maybe / Vil du svigte mig og håne mig og skille mig ad / Vil du kysse mig på panden, når jeg stryger din kind / Vil du ligge med en anden mens jeg stille sover ind / Won't you sit on my grave to make me feel not so all alone / […] Won't you piss on my grave to make me feel not so all alone.'

7 The lyrics for "Hang on, Jesus" are partly English and partly Danish: 'Hey, lille søster hvis du kommer igen så tag en Big Mac, Pacman, iPod, Jackass, laptop, Robinson, YouTube, MySpace med hjem til din far, hvis det er alt hvad vi har / Hey, Jesus hvis du kommer igen så tag en Hummer, Minuteman, Hawkeye, Shahab, Taepodong, Honeywell, SS-20, Sikorsky, Trident, Kalashnikov, Hercules, Fightinghawk med hjem til din far to show how human we are […] Oh, no, Jesus you better stay where you are / Kravl op på korset igen og slå sømmet i bund and bolt / Hang on! Hang on! You better stay where you are / Cross your feet, sing along / Something down here's going wrong.'

Postscript

Ubiquitous Locality

By John Tomlinson

Unsuspecting readers of a book entitled *Globalizing Art* may have been surprised to find that the focus is predominantly not on the imaginative and representational space of the 'global' but, on the contrary, on the abiding significance of the *local*. But as this fascinating collection of essays demonstrates, in artistic expression, as in social and cultural analysis, it is locality and its transformation that we need to confront in coming to terms with globalization. It is in deterritorialized localities that we are obliged to construct our meaning systems, maintain a precarious foothold on existential security, negotiate a complex portfolio of identities, routinely deploy sophisticated technical-communicational skills, cope with the acceleration and contingency of everyday life, and fold in the challenges and surprises of cultural difference to our life-narratives. Across a remarkably rich and diverse spectrum of artistic practice and institutional context, the contributors to this book all illuminate, in different ways, this at once exhilarating and perplexing condition of globalized culture.

But before moving on to say a little more about the general transformation of locality, we should briefly address the idea of a 'space of the global' that is – quite deliberately and correctly, I would say – significantly absent from these discussions.

For what and where is 'the global'? The available answers to this question within a conventional conceptualisation of spatiality – that the global is the entire physical territory of the world, or, at least, the entire populated territory of the world – actually provide little help in understanding the economic, political, and cultural impact of globalization. For, in this sense, the space of the global, somewhat paradoxically, cannot be allocated a clear role in the process of globalization. It is not the same as global capitalism – by which we mean a flexible and fluid system of production and consumption networked across most if not all of the *localities* of the world (and showing great variation in its concentration within these localities). Neither is it a *political* space: for it is clear

that the nation-state system still vigorously polices divisions in the space of the global. Its real function is, arguably, a *symbolic* one: as the imagined other of the locality we inhabit and so as a gesture to all that either threatens or beckons to us from beyond. And perhaps as an index of a yet-to-be-achieved cosmopolitanism.

But important though this symbolic function may be, it provides little scope for aesthetic contemplation. This becomes clear if we try to conceive of appropriate visual metaphors for globalization: how many book jacket designs have fallen back upon that most banal stock image – communication satellites circling the earth? The difficulty of rendering satisfying representations of the space of the global is that we are not dealing here with a *locale* in Anthony Giddens's sense of, 'a physical setting of social activity' (1990: 18), but rather with a *process* which organises complex flows *across* locales. The global is manifested only in its complex distribution between networked sites of particularity. It is not much of an exaggeration, then, to say that the global *only exists* in localities. This is so in two senses. First, that the political, economic, and cultural manifestations of globalization only have their being within specific localities and the various modalities of movement between localities. And secondly, that the symbolic value of the space of the global that I have mentioned – as the 'other' of our locally embedded experience – only has its force when imagined as *another particularity*: negatively, for example, as the fear and distrust of *these particular* migrant communities; positively, as the imagination of *our particular geographically situated lives* lived out in the peaceful, just, environmentally sustainable world of cosmopolitan aspiration.

One interesting implication of this way of understanding globalization is that it entirely justifies the particularity involved in writing about globalization in the Nordic context. More than this, from the perspective of the cultural, it is through this thinking, imagining, and representing from the particular – from Nordic or Chinese or Southern European or African or Latin American perspectives – that we can most adequately grasp the 'totality' of cultural globalization. And this remains true even when we include the intrinsic mobility and hybridizing qualities of global-modern cultural practice and experience.

But, if we find the local not only thriving in globalization, but actually indispensable to the very way we conceive of global modernity, we must at the same time recognise how radically locality has been transformed in the process. And this indeed has been richly exemplified in the preceding chapters – from the 'remediation' of the town of Ljungaverk and the play of deterritorialization

and reterritorialization in Björk's 'Icelandic' music, to the interpretational and institutional issues of site specificity and aura in Nordic artistic production and curating, or the discursive struggles involved in contemporary artistic depictions of 'Danishness'. In reading these and the other discussions, we can be left in no doubt that the local is no longer – if indeed it ever was – a simple anchored site of dwelling.

One of the useful consequences of globalization is, indeed, that it has obliged us to confront the rather vague and overlapping criteria we have traditionally employed to conceptualise localities: as geographical co-ordinates; as a measure of demographic scale; as the sites of specific social formations – 'communities'; as a reference to existential attachment, even in terms of judgements of cultural value – so 'authentic' or 'parochial'. Nor do we escape these confusions if we attempt to concretise the idea of the locality in the form of a specific type of settlement, as is clear from the geographer David Matless's wonderfully ironic rambling definition of a village:

> A scale of meaning, often tinted with community; regularly small in anatomy; set in country or, if in the town, pretending to a like spirit of belonging; a site set apart for a true life; a site of inbreeding and bestial manners, of forelock tugging and pathetic servility; [...] a place for microcosmic stories and the ravelling of lives. (Matless 2004: 161-2)

Localities, then, are stranger places than perhaps we ever thought, and the impact of deterritorialization has been to increase our sense of their complexity and ambiguity. But at the risk of adding to this perplexity, I want to observe another emergent feature of localities – their capacity to be materially and geographically situated and *at the same time* mobile – indeed in a sense, *ubiquitous*. Let me explain this observation by using three examples from the Nordic region.

First, and simplest, we have to remind ourselves that localities have an indispensable material and geographical stipulation which no social, cultural, or economic process can overcome. The dramatic impact of globalization has tended in some ways to obscure or eclipse this determination, as we have become fascinated by the penetration of places by connectivity. However the hubris involved in supposing that globalizing technologies could entirely overcome geographical determinations was rather dramatically demonstrated in April 2010. For an event in a very precise location – the eruption of the Eyjafjal-lajökull sub-glacial volcano in Iceland (63° 38' N; 19° 36' W) combined with

particular meteorological conditions – contrived to shut down virtually all air travel across Western and Northern Europe for a period of around six days, allowing birdsong to be heard under the flight paths of London Heathrow for the first time in decades.

One lesson we might have learnt from this event – but probably didn't – is just how fragile and contingent the connectivity of globalization actually is. But it also reminds us never to let the deterritorializing properties of globalization trick us into underestimating the significance of material location for our embodied human condition. I rather labour this point about materiality, because it is essential to understanding the particular – but no less significant – *cultural* sense that I am now going to explore, in which localities can 'float free' of their geographical co-ordinates.

And so to my next example: the small town of Ystad in Scania province, southern Sweden. Ystad is well known as the setting of Henning Mankell's best selling 'Kurt Wallander' detective fiction and has now become globally famous not only from the novels but from two different television series. It has even attracted the attention of cultural theorists. Slavoj Zizek's article "Henning Mankell, the Artist of the Parallax View" (Zizek 2004) uses the mise en scène of Mankell's narratives as the pretext for an exploration of the status of the global and the local. Zizek argues that it is precisely the mundane, often drab, provincial environment of Wallander's Ystad – what he calls the 'eccentric local' – that is the appeal of the detective genre in the era of globalization. Zizek's point is that in Mankell's fictionalised (though 'real') Ystad we can contemplate, in micro, some defining aspects of deterritorialization: the structural economic instability deriving from unregulated capitalism and the incursion of various carriers of difference into settled localities. As Zizek observes, a recurrent theme is the triggering of often gruesome consequences in Ystad by events linked to less favoured parts of the world. Little Ystad's implausibly high murder rate is thus often complicatedly linked to questions of racism and xenophobia, the plight of refugees, the conditions of labour migrants, sex slavery, the trading of human organs in the Third World, Islamophobia, or the activities of criminal gangs from the post-communist states of eastern Europe.

The appeal of the fictionalised Ystad is thus by no means as a cosy imagined ideal of *Gemeinschaft* – an imagined place of retreat from the globalized world. It is, rather, as a space in which all the social and cultural anxieties of deterritorialization can be articulated and confronted. But – and this is the key point – these anxieties, though speaking to a general experience, nonetheless

require a *particular* location. And in the case of Ystad it is real place, a textual place, a media place, and an imagined place (you can read it, watch it, go to it, live in it, visit its websites). And it is all of these together, both for the people who actually live there and for us who chose to 'visit'. Ystad is a ubiquitous locality.

My last example, the City Hall in Oslo, illustrates in a different way the simultaneity of particularity and ubiquity – of being precisely here and at the same time everywhere. For this, of course, was the place where the imprisoned Chinese human rights activist and co-author of Charter 08, Liu Xiaobo, was due to be awarded the Nobel Peace Prize on December 10th, 2010. In the days leading up to the award ceremony, it was this very precise location – not just Norway or Oslo, but the Hall itself – that was the focus of feverish diplomatic activity on the part of the Chinese government. Not only did Beijing exert diplomatic pressure on a large number of nation-states to boycott the ceremony, it went to an enormous effort to ensure that none of its own private citizens were heading for the Oslo City Hall. News programmes around the world showed footage of the artist Ai Weiwei being turned back at Beijing airport, as he was about to board a plane for Seoul. In the end, nineteen countries withdrew from the ceremony, and a crackdown on travel by the Chinese authorities ensured that only expatriate Chinese could attend.

But a more sophisticated grasp of the nature of deterritorialized places on the part of the Chinese would have revealed the folly in their actions. For, of course – and partly as a direct response to the efforts of Beijing – Oslo City Hall immediately became a ubiquitous locality, 'attended' not only by the thousand-odd people physically in the Hall, but by millions across the world watching the ceremony on television or online. And though Chinese media censorship successfully prevented the majority of its citizens from 'attending' in this way, it could not defeat the growing number of Chinese dissident intellectuals, including independent journalists, writers, artists, academics, and lawyers, who are fairly routinely now 'scaling the wall' of state technological censorship of the Internet.

One result of this was that the empty chair on which Liu Xiaobo's Laureate medal and diploma were placed instantly became adopted as a symbol of the human rights struggle in China. Within days, Chinese state online word recognition censorship protocols had added the phrase *Kong Yizhi* – 'empty chair' – to their list of banned terms. But these protocols do not work with visual images. Thus it is that the very particular, elegant, blue silk upholstered

chair from the ceremony, with its stylised dove of peace, cut and pasted from an infinite number of web images, now appears on Chinese dissident blogs.

No doubt the Chinese government is unlikely, in the short term, to alter much its attitudes and policies on democratic participation and human rights. But, like all of us, it will increasingly have to adapt to a world in which its citizens routinely inhabit all manner of ubiquitous localities. And maybe this offers a glimmer of hope for the project of cultural and political cosmopolitanism: not as a dubious utopia of universal practice, taste and ideology, but as a multiverse of particularities from within which we may hope to construct common rich understandings of value, justice, and virtue.

Works Cited

Giddens, A. (1990). *The Consequences of Modernity*. Cambridge: Polity Press.

Matless, D. (2004). "Villages". In S. Harrison, S. Pile, and N. Thrift (eds): *Patterned Ground*. London: Reaktion Books, 161-164.

Zizek, S. (2004). "Henning Mankell, the Artist of the Parallax View", Lacan.com. (www.lacan.com/zizekmankell.htm.) Accessed February 28th 2011.

About the authors

Ulla Angkjær Jørgensen (b. 1963), PhD, Associate Professor of Art History, The Norwegian University of Science and Technology, Trondheim, Norway. Recent Publications: *Kropslig kunst. Æstetik, køn og kunstanalyse* (2007); "Cut Pieces: Self-Mutilation in Body Art" in *Violence and the Body. The Erotics of Wounding* (2008); "Haptic Routes and Digestive Destinations in Cooking Series: Images of Food and Place in Keith Floyd and The Hairy Bikers in Relation to Art History" (Co-author Anne Marit Waade) in *Journal of Tourism and Cultural Change*. Vol. 8, Nos. 1-2 2010. Research areas: 20th century art, contemporary art, visual culture, new media, feminism and gender perspectives on art history.

Mathias Bonde Korsgaard (b. 1983), PhD candidate at Aarhus University, Denmark. His current research focuses on music video aesthetics and the role of music videos in contemporary audiovisual culture. He has published several articles in the Danish online film journal *16:9* on such topics as the animated films of Pixar, the films of David Lynch, the work of the Danish filmmaker Jørgen Leth and interactive music videos.

Lill-Ann Körber (b. 1977), PhD, teacher and researcher at the Institute for Northern European Studies, Humboldt University, Germany. Most recent publication: "Den svenske verdensorden på West Kili. At være hvid i Afrika hos Jakob Ejersbo", *Kritik* 199 2011. Research areas: Postcolonial theory, contemporary Nordic literature and visual arts, the relations between Scandinavia and Africa, Greenland and the postcolonial North Atlantic.

Lotte Philipsen (b. 1971), PhD, Post-doc at the Department of Aesthetics and Communication at the University of Aarhus, Denmark. Publications include

Globalizing Contemporary Art: The Art World's New Internationalism (2010).
Main research areas: global and digital dimensions of contemporary art.

Christian Refsum (b. 1962), Dr. Art., Associate Professor, University of Oslo,
Norway. Main publications: The novel *Løftet* (2010), *Lyrikkens liv. Innføring
i diktlesning* (1997, with Christian Janss), *Litteraturvitenskapelig leksikon*
(1999, with Jakob Lothe og Unni Solberg), the novel *Ingen vitner for vitnet*
(2007), *Kyssing og slåssing. Fire kapitler om film.* (2004, with Eivind Røssaak),
En verden av oversettelse – fransk og dansk symbolisme sett fra Taarnet 1893-94
(2000).

Camilla Møhring Reestorff (b. 1982), PhD candidate at Aarhus University
with a project on 'Culture War: Cultural Political Canon and Art Political
Practice in the Globalized Nation State'. Recent publications include
"Rebranding Denmark. Premediating Denmark's Future" in *antiTHESIS*
21, 2011; "Canons and Cartoons: On National Identity, Strategies of
Reterritorialization and the Role of Universality in the Danish Cartoon
Initiative and Canon Projects" (co-author Carsten Stage) in *Confronting
Universalities* (2011). Reestorff's main research area is the intermingling of
art and politics in the Danish Culture War.

Carsten Stage (b. 1980), PhD, Assistant Professor, Department of Aesthetics
and Communication, Aarhus University, Denmark. Recent publications:
Tegningekrisen – som mediebegivenhed og danskhedskamp (2011);
"Consumption That Matters" (co-authored with Sophie Esmann Andersen)
in *Mediekultur. Journal of media and communication research* no. 49, 2011;
"Thingifying Neda" in *Culture Unbound* (forthcoming). Main research areas:
Cultural and media globalization, online participatory and DIY culture,
national identity, discourse analysis, the relationship between discourse
and affect.

John Sundholm (b. 1964), Senior Lecturer in Film Studies at Karlstad
University, Sweden, Reader in Cultural Analysis at Åbo Akademi University,
Finland, and member of the examination board of the PhD-program in Fine
Arts, Academy of Fine Arts in Helsinki, Finland. Latest publications include
contributions to *A History of Swedish Experimental Film Culture: From Early*

Animation to Video Art (2010). Main research areas: experimental film, minor cinemas and memory studies.

Bodil Marie Stavning Thomsen (b. 1956), PhD, Associate Professor, Department of Aesthetics and Communication, Aarhus University, Denmark. Recent publications: "The Haptic Interface. On Signal Transmissions and Events" in *Interface Criticism* (2011); "Antichrist, Chaos Reigns" in the online *Journal of Aesthetics and Culture*, vol. 1, 2009; "On the Transmigration of Images: Flesh, Spirit and Haptic Vision in Dreyer's *Jeanne d'Arc* and von Trier's Golden Heart Trilogy" in *Northern Constellations* (2006); "The Performative Acts in *Medea* and *Dogville* and the Sense of "Realism" in New Media" in *Performative Realism* (2005). Main research areas: visual culture, new media & film philosophy, especially Lars von Trier's films.

John Tomlinson (b. 1949), PhD, University of Bradford, 1985. Professor of Cultural Sociology, Nottingham Trent University, United Kingdom. Main Publications: *Cultural Imperialism* (1991); *Globalization and Culture* (1999); *The Culture of Speed: The Coming of Immediacy* (2007).

Eva Zetterman (b. 1957), PhD, Senior Lecturer in Art History and Visual Culture / Cultural Studies, Karlstad University, Sweden. Main publications: Frida Kahlos bildspråk – ansikte, kropp & landskap: Representation av nationell identitet (2003); "Från passiv jungfru till feministisk chicana. Yolanda López" Guadalupebilder" (2008); "Mural Painting in Mexico and the USA" (2010), "Mellan nordisk profil och platsbunden identitet: Göteborgs konstmuseum" (2011); "Från teori till konstnärlig praktik – några exempel på pedagogiska utmaningar" (2011). Main research areas: Visual representation of identity, street art, Chicana/Chicano visual culture, Mexican art.

Kristin Ørjasæter (b. 1959) Dr. Art., Director of the Norwegian Institute for Children's Books, Norway, Associate Professor at Aarhus University, Denmark, and Editor-in-Chief of the *Nordic Journal of ChildLit Aesthetics*. Main publications: *Åpninger. Lesninger i Hanne Ørstaviks forfatterskap* (2008, co-editor Hans Hauge); *Selvskreven. Om litterær selvfremstilling* (2006, co-editors Stefan Kjerkegaard and Henrik Skov Nielsen); and *Selviakttakelsens*

poetikk. En lesning av Camilla Wergelands dagbok fra 1830-årene (2002). Current research areas: The image of Africa in Nordic art and digitalized aesthetic practices in children's literature.